The Drawings of Daumier and Millet

The Drawings of Daumier and Millet

Bruce Laughton

Yale University Press
New Haven and London
1991

For Doris

Designed by Mary Carruthers
Set in Linotron Bembo by Excel Typesetters Company, Hong Kong
Printed in Hong Kong by Kwong Fat Offset Printing Co., Ltd

Library of Congress Cataloging-in-Publication Data

Laughton, Bruce.
 The drawings of Daumier and Millet/Bruce Laughton.
 p. cm.
 Includes bibliographical references and index.
 ISBN 0–300–04764–9
 1. Daumier, Honoré, 1808–1879—Criticism and interpretation.
2. Millet, Jean François, 1814–1875—Criticism and interpretation.
3. Art—Technique. I. Title.
N6853.D3L38 1991
760'.092—dc20

CONTENTS

PHOTOGRAPHIC CREDITS

PREFACE

THE RESEARCH FOR this book goes back a long way, to when I was first encouraged by Alan Bowness to write a short book on Daumier drawings, about twenty years ago. My subsequent perception of a rapport between Daumier and Millet as draughtsmen took place in the Cabinet des Dessins in the Louvre, that wonderful collection to which I was first introduced by Maurice Serullaz, and in which successive Chief Conservators and their colleagues have patiently suffered my constant demands to see the drawings and documents in their care ever since. I am particularly grateful to Mme Françoise Viatte, Mme Arlette Serullaz and Mlle Valentine de Chillas. At an early stage in my investigations I was luck enough to meet Robert Herbert, at the time when he was preparing his seminal Millet Retrospective Exhibition which opened at the Grand Palais in 1975. He has since taken a continued interest in my project up to the point of reading the final manuscript, and I am extramely grateful for his comments and criticisms. Also at an early stage I was encouraged and advised, in respect of Daumier, by the late Jean Adhémar, who made available to me the vast Moreau-Nélaton archive of documents and photographs in the Cabinet des Estampes in the Bibliothéque Nationale. Here, as in the Louvre, successive Chief Conservators and their staff have been consistently helpful, and I am particularly grateful to Mme Laure Beaumont Maillet.

Financial assistance for travel and research in Europe and the United States has been given to me by Queen's University Advisory Research Council on several occasions, and my most recent research in France was finally brought to completion with the aid of a grant from the Social Sciences and Humanities Research Council of Canada.

The methodology employed in this book is basically outlined in the first pages of the Introduction, and I will not attempt to summarise it here. It may be worth remarking, however, that the writing was done in two successive phases. The first, incomplete draft was made in the late 1970s and was very much a stylistic study, although with artists of this calibre it is impossible not to brood upon the meaning of their imagery as well. Work was then suspended for some four or five years, while another book was written about the Euston Road School in Britain – a subject of different interest, although drawing and the nature of perception is involved. Since returning to the present project I have entirely rewritten the original text and have added three new chapters. What has happened in the interim is that my interest in Daumier and Millet has broadened to encompass their artistic conceptions in relation to their respective social and political intents, and reflections upon these matters now intersperse with stylistic discussion. I have also taken a very broad view, in the end, of what constitutes 'drawing', in the sense that I think that for both of these artists it was a *process* centrally involved in

every medium in which they worked (in the same sense that it was with Van Gogh). In many places I have moved my discussion from one medium to another – from drawings on paper to lithographs or to oil paintings – without changing gear, as it were. This habit may well meet with objections from connoisseurs of drawings in a narrower sense, but I am unrepentant. In naming drawing as the basis of the art of these two individuals, I have been obliged to study their whole achievement.

It would be impracticable to acknowledge by name all the curatorial staff who have been of assistance over the years, by giving me access to drawings in study collections or storerooms in the museums of France, the United Kingdom and just about every other country in Europe, together with those in the United States, Canada and Venezuela. Nevertheless, it must be admitted that without the intelligent co-operation of these extremely busy, and in some cases manifestly overworked, individuals, serious study of original drawings would be impossible, since their public display is necessarily so limited. A glance at the acknowledgements to public institutions in the list of illustrations will give but a partial idea of the true extent of my debts in this manner. A similar patience and courtesy has been shown me by a number of private galleries and art dealers, many of whom are acknowledged in the list of illustrations. Many private collectors who have allowed me to see their collections or helped me to obtain photographs wish to remain anonymous, but I would like to acknowledge Mme Denise Feuardent, the late M. Claude Roger-Marx, and his daughter Mme R. Asselain for their assistance. I am also particularly grateful to John Sunderland and the Witt Library staff at the Courtauld Institute of Art, and to the staff of Messrs Christie's and Sotheby's respectively for helping me to track down and obtain photographs of many drawings. The late K. E. Maison left the photographs used for his 1968 *Daumier Catalogue Raisonné* to the Witt Library for consultation by scholars, and I am grateful to Mrs Stefanie Maison for giving me permission to reproduce some of these. I must acknowledge Robert Herbert again for allowing me to consult his Millet photographs and helping me to obtain additional prints of many of them. Finally, I would like to thank my colleagues in the Art History Department of Queen's University for their collective stimulus and encouragement and, not least, the successive 'generations' of students whom I have taught in this area for the intelligent input of their seminars.

My wife has read all the typescript, often in several drafts, with scrupulous and uncomplaining patience, and is still trying to teach me correct punctuation. Gratitude begins at home.

Bruce Laughton
Kingston, Canada. December 1989

PART I
Introduction

1 Links between Daumier and Millet

THIS BOOK IS about the drawings of Honoré Daumier and Jean-François Millet. It includes some comments on their stylistic heritage, the practices of their contemporaries, and their own creative contributions to the art of drawing. These two artists, who met in Paris just before the 1848 Revolution and thereafter pursued their different courses in parallel, were arguably the greatest innovators in drawing in France during the period *c.*1850–65, and during their last creative years (which encompassed the political disasters of 1870–1) each produced some of his finest works. To stress the importance of Daumier and Millet at the expense of Courbet may appear to be an heretical attempt to reshape nineteenth-century art history. I must emphasise that this book is about drawing, that is, about the use of the graphic media as a basic and essential part of the creative process. For Courbet, drawing did not play such a decisive part in his development as a painter as it did for some of his contemporaries. The art of drawing may be seen as a language of enormous flexibility, one that may reflect great variations in style, modes of perception and functional purpose. When one considers, for example, the differences that are apparent between the graphic languages of Delacroix and Cézanne, or between Ingres and Degas, the changes seem to consist in the *modes of perception* between the older and younger artist of each pair, although they are otherwise stylistically linked. This is partly due, I believe, to certain fundamental developments in the vocabulary of drawing as wrought especially by Daumier and Millet. Different though they were as individuals and in the manner of their careers, their relationship, I suspect, had a catalytic effect each upon the other. This can best be demonstrated by studying a substantial corpus of their respective drawings.

The arrangement of the book is both chronological and typological. Because we are dealing with a period that includes two major revolutions that affected the whole of French society, some subject matter is discussed that invites speculation upon the artists' respective degrees of political involvement. Some of the longer notes to the middle chapters interpolate biographical details which may throw light on such personal motives. I believe, however, that there may emerge certain philosophies, revelations even, about the nature of art that both Daumier and Millet contributed beyond their respective political beliefs, and which came to be of lasting significance for future generations of artists.

Occasionally, in the interest of keeping a continuous flow to the argument in hand, I have relegated discussion of the most recent literature to the notes. This

does not imply any disrespect for current art-historical methods; it merely makes clear that my intent differs from that of the social polemicists. My own discourse, however often it wanders from 'foreground' into 'background' and reverses their roles, remains primarily tied to the elucidation of the qualities of the works themselves.

With regard to the titles of the works cited I have opted for common usage rather than consistency and employed the titles by which the works are generally known rather than have them all in French or all in translation. Dimensions are given in centimetres. In the text, captions and notes, LD stands for Loys Delteil, *Le Peintre graveur illustré*, xx–xxix, *Daumier*, Paris 1925–30.

An enormous amount of work has been done by art historians in recent years towards establishing a canon of extant authentic works by both artists, and in the case of Daumier a very large amount of critical or merely appreciative literature has also been published. Many writers have observed in passing that there are certain similarities in subject matter and style between given works by Daumier and Millet, and that they knew each other, but exactly how they related has not been extensively demonstrated.

A brief account of their youthful careers, and some introductory remarks concerning the definition of 'drawing', followed by a summary of the documented aspects of their points of personal contact, will form the substance of this first chapter. The second chapter will attempt to define the styles and the parameters of usage of 'drawing' as understood in France during the first half of the nineteenth century, that is the convention inherited by Daumier and Millet. Discussion of their individual 'languages' and the dialogue which they may be seen to have developed, will begin in Part II.

Honoré Daumier, born in 1808 in Marseilles of artisan parents, migrated to Paris with his family at an early age and remained fundamentally a city dweller all his life.[1] His formal artistic training was brief and fragmentary. He had a few lessons from the elderly but distinguished academician Alexandre Lenoir, and drew from life models in the Académie Suisse and later in the atelier of Boudin, where fellow students were the painter Philippe-Auguste Jeanron and the sculptor Auguste Préault, both ardent republicans. At the same time, or rather at alternate points during his restless and insecure early years, he was learning lithography and produced a few cartoons, which were recognised as having merit by the publisher Ricourt in 1829 (later Ricourt was to say to him 'Vous avez le geste, vous'.)[2] By 1830 he was firmly embarked upon a career as a graphic illustrator, using lithography as his principal medium. His preferred drawing tools at this early stage were the pen and the lithographic crayon, which he used to draw directly on the stones.[3] From November 1833 he also began to draw in ink directly on woodblocks, from which wood engravings were cut by others.

His republican ideals were strong and clear by the time of the July uprising of 1830. This was soon noticed and exploited by his contemporaries, particularly by the editor Charles Philipon who took him on the staff of *La Caricature* early in 1831. Daumier's earliest lithographs had been rather stiffly drawn and conventionally shaded; what seemed to inspire him to a new fluency of expression was a good political target. He was imprisoned for six months for his vigorous libels of King Louis-Philippe (variously known by his enemies as 'the bourgeois king' and 'the banker king'), and by 1835 he had already reached his first peak of achievement as a lithographer, producing dramatic chiaroscuro effects for certain major prints such as *Rue Transnonain le 15 Avril 1834* which gained him lasting renown (Fig. 1.1). Even after government censorship put a stop to his political

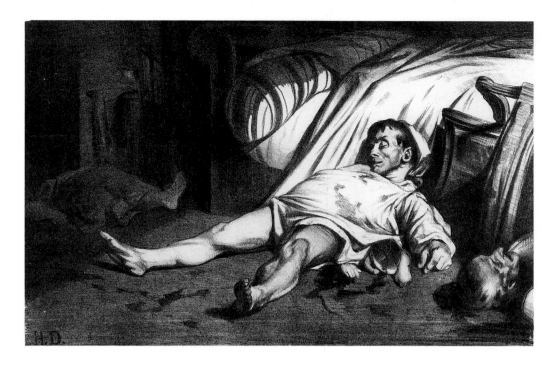

1.1 Daumier. *Rue Transnonain, le 15 Avril 1834.* Lithograph, published by L'Association Mensuelle in July 1834 (LD 135).

attacks, Daumier retained and developed his inventive powers in his lithographs through the 1840s. It was as a lithographer that his draughtsmanship was commended by Baudelaire and said to have been admired by Ingres.

There have been considerable differences of opinion between art historians about when Daumier began to paint, and how much of it he did before the advent of the Second Republic. Since the existing evidence is purely speculative this is not a very fruitful line to pursue: Daumier was simply not known as a painter before 1848, although it was known that he could model in clay. He must have done some painting for his friends to have persuaded him (Courbet in particular) to enter a state competition for an allegory of *La République* in that year, and it is generally assumed that he probably learned the rudiments from the republican painter Philippe-Auguste Jeanron, who had been an early comrade during his imprisonment in Ste Pélagie. What is more certain is that throughout his whole career, from the beginning, Daumier drew continuously on paper, as a basic creative activity to make tangible the numerous and recurring images that filled the melting pot of his visual memory. Few drawings survive that can be dated before 1848, but in many cases images that occur in later drawings can be recognised in earlier lithographs and/or wood engravings. There is no way of establishing, with a very few exceptions, a temporal relationship between the drawings and the lithographs based upon subject matter. Even though the prints are dated, the drawings form a separate group in Daumier's *oeuvre*, and dating them is generally done by a subjective analysis of style. Simple logistics support the proposition that the greater number of surviving drawings are from the latter part of Daumier's career, and these turn out to be the key to understanding his paintings.[4] During his lifetime Daumier's activities as a painter were essentially private. There are related images found in both his drawings and paintings, for example the scenes of urban proletariat life along the banks of the Seine in Paris, the *Saltimbanques* or strolling players passing by the fringes of society, and Daumier's very personal interpretation of scenes from Cervantes' *Don Quixote*. But his *oeuvre* taken as a whole is complex: all one can say is that Daumier as draughtsman is Daumier at source. To his contemporaries, his mastery was

revealed primarily in his lithographs. Millet would have been no exception in this view of Daumier, at least in the 1840s.[5]

Jean-François Millet, born in 1814 on the Normandy coast at Gruchy, a village hamlet some 12 miles west of Cherbourg, was the son of a small landed peasant farmer, with some well-educated but rigidly provincial relatives on his mother's side. His artistic talent was an unexpected discovery, and his hesitant beginnings developed probably only through the encouragement of his strong-willed, perceptive and pious grandmother, Mme Jumelin. His training was conventional, not to say conservative in the extreme, first at the provincial drawing school in Cherbourg and then at the Paris atelier of the academician Delaroche. Millet's first reactions to the metropolis seem to have been unhappy indeed, though his outward timidity is somewhat belied by his proud refusal to accept any further patronage from his master when he failed to win the Prix de Rome, leaving his atelier in 1839. Deeply introspective and far too well educated to fit the popular image of himself as a peasant painter, Millet's subsequent career was a sequence of more or less disastrous confrontations with modern urban life, as seen through the eyes of this biblically orientated moralist, conscious of the fast disappearing values of a rurally structured society. (It can be argued that a Virgilian ideal of poetic rusticity also affected his thought.) Before this moment of realisation occurred, Millet had enjoyed two or three years of the promise of success as a provincial portrait painter in Cherbourg. An attempt to make his name in the metropolis, accompanied by his first wife Pauline Ono, seems to have been made near the poverty line and came to an end with her death from consumption in Paris in 1844. Notwithstanding these setbacks, it emerges that Millet was talented with the brush to the extent of being able to work in different styles and treat different subject matter concurrently, and was also rapidly developing as a draughtsman. Millet's full originality as an artist becomes clear during his third and last period of residence in Paris (1846–9). This time he arrived on the proceeds of a successful sale of his portraits and pastoral pictures, held at Le Havre. He was now concealing from his pious family a liaison with a second young woman, Catherine Lemaire, who was to share his remaining years, and who was then about to give birth to the first of their nine children (27 July 1846). It is at this point, when his life was clouded with poverty and guilt but simultaneously uplifted by passion and creative activity, that Millet's life history begins to overlap with Daumier's.

In 1846 Daumier was approaching a new peak in his career as a lithographer for the daily satirical journal, *Charivari*. After years of financial struggle, he evidently felt sufficiently secure to venture into marriage himself (16 April 1846), and in his case also with a young woman, Alexandrine Dassy ('Didine'), who was to share the remainder of his life. Documentary evidence will show that the two young wives developed their own special rapport, and that in later years 'les Daumier' became personally involved in the affairs of the Millet family. The Daumiers set up house on the top floor of no. 9, Quai d'Anjou, on the Ile St Louis, which at this time harboured a kind of bohemian-intellectual society, situated midway between the working class and the bourgeois quarters of Paris. Geographically they were close to several of the overcrowded, depressed *arrondissements* occupied by the so-called '*classes dangereuses*' to the south and east, but also within reach of the middle-class districts to the west, on the right bank of the Seine, such as the Faubourg St Honoré. Here Daumier's large circle of friends and acquaintances included poets and writers such as Baudelaire and Théophile Gautier,[6] the other cartoonists and editorial staff of *Charivari*, several sculptors including Préault and Geoffroy-Dechaume, and the principal *plein air* naturalist painters whose subjects were most often associated with the forest of Fontainebleau. These latter were

loosely named 'the Barbizon School' in subsequent decades. Charles Daubigny was a neighbour, and Théodore Rousseau, Jules Dupré, Narcisse Diaz, Constantin Troyon and Camille Corot were frequent visitors to Daumier's studio.

In 1846 Millet was living in the rue Rocheouart, in the poor and outlying district of Montmartre, and initially his circle of friends was much smaller.[7] But here he did meet Troyon, and he was then 'discovered' by Diaz, whose own somewhat neo-baroque style in his figure paintings would predispose him to appreciate Millet's *manière fleurie*.[8] As a result of these encounters, by 1847 Millet had also met Rousseau and Daumier, together with their friend the animal sculptor Barye (who became a regular visitor to Barbizon in the 1850s), and the graphic artist Charles-Emile Jacque, whose large output had included some caricatures for *Charivari*. Jacque and his family were to accompany the Millets on their flight to Barbizon in 1849. In fact by 1848 Millet had been introduced to a large group of avant-garde artists, all of whom were opposed in the current Salon establishment, and all of them republicans to some degree. But there is no evidence that Millet was ever in close contact with the most provocative artist of his time, Gustave Courbet. Most contemporary critics recognised that their art was basically quite different in kind, and Millet was not often lumped in with the aggressive 'realist' camp of the mid-1850s. Some of Daumier's paintings of the 1850s might have been harder to separate from them, had they been seen in public, but his friend Champfleury wrote (in 1865) that Daumier was uneasy with 'hommes nouveaux', and that he and Courbet did not have a great deal in common.[9]

In the late 1840s, Millet was doing some remarkably fine drawings of the female nude, and producing with their aid small oil paintings in the hope of attracting a particular market.[10] Simultaneously he produced a series of vigorously executed biblical subjects aimed at the Salon, commencing with *Saint Jerôme* and concluding with an uncompleted *Hagar and Ishmael*.[11] And during this same period he began to produce images of manual workers which are the forerunners of his principal motifs for the ensuing fifteen years (see Chapter 4). Daumier's very few exhibited works between the years 1848 and 1850 are more limited in range, owing something to Millet's painting style but with clearer debts to both Rubens and Delacroix. The real link, or rapport, between Daumier and Millet will be more readily found in their private working drawings of the 1850s. Detailed study will show that initially, *c*.1847–9, their creative exchanges were rather subtle and perhaps unconscious, but both undoubtedly were interested in rendering labouring people, rural and urban, with empathy and understanding. The clue to this rapport is not just to be found in their subject matter (which was not, after all, unique to either) but more specifically in their drawing methods. The phrase 'drawing methods' rather than 'drawing styles' is used advisedly, because the object of this study is not so much to prove who influenced whom as to show how new methods of conception and perception in drawing came about in their work.

Artists show each other their drawings. Within the studio context, drawings explain better to artists 'where they are at'; they do not visit each other to make sales. By 1847 Daumier's qualities as a draughtsman were known to a wide audience through his published lithographs; Millet's drawings were known only to small-scale collectors. By about 1860 the situation had somewhat changed: both artists were working up elaborate drawings specifically for private sale (Daumier using watercolour and gouache, Millet concentrating more on pastels), at modest but not impossibly low prices. At the same time the source drawings, the 'first thoughts on paper', were of course continued by both. It is the period from around 1847 to *c*.1865 that will be central to this book.

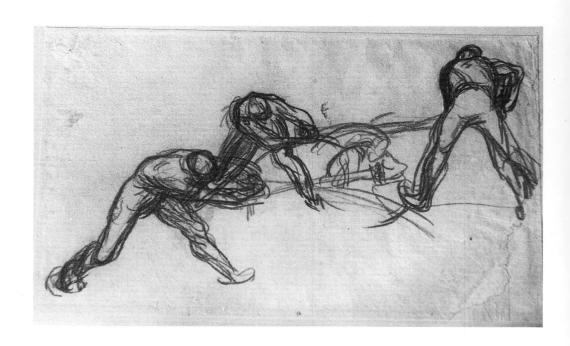

The Definition of Drawing

Both Daumier and Millet drew constantly from memory, covering sheets of paper with ideas for pictures, details of figures, movements, expressions. Millet also made rapid notes from models and from nature (unlike Daumier), but he was constantly redrawing and rethinking on paper in his studio. The analogies which can be made between each artist as he twists and turns the images which fill his imagination, to create new images in autonomous lines on paper, may perhaps be as revealing about the contents of their minds as the more finalised conceptions on canvas. Both were recognised as draughtsmen with unusual powers of expression: Daumier through his public career as cartoonist, and Millet (in his own lifetime) by some discerning connoisseurs and critics.[12] And when years later, in 1887, Camille Pissarro visited the first major Millet Retrospective Exhibition, he declared that Millet's drawings were 'a hundred times better than his paintings'.[13] That remark was made at an epoch when the quasi-philosophical question, 'What do we really see?' had undergone – and was undergoing – more searching examination in the light of developing French art theory and practice. In terms of drawing, Professor Robert Herbert has expressed the problem in a context closer to the period which we are about to discuss:

> Neither Millet nor Courbet were able overnight to adopt any kind of direct transcription of what he saw . . . [In *The Wood Sawyers*] our eyes follow the struggling action of the *lines* across the paper and, aided by remembered experience, this kinesthetic act produces in us a sense of the real act produced in the images. Millet's drawing was, therefore, a creative, and not an imitative act.[14] (Fig. 1.2)

So was Daumier's drawing.

The object of this discussion will be to show how two different artists, contemporaries, equally gifted and original, were able (perhaps encouraged by personal contact) each to modify very slightly all previous suppositions about how much the act of *drawing* could in fact express.[15] In other words, to show how they enlarged the language of drawing. One prerequisite of this would be to show what canons already existed by the middle of the nineteenth century. The finely

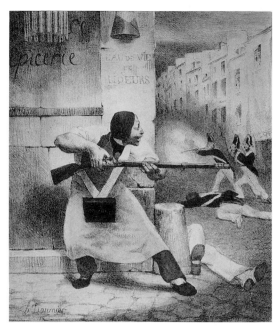

1.3 Daumier. *The grocer who was no fool sent them liquorice which was totally unsweetened, (L'epicier qui n'était pas bête...)*. 1830 Lithograph, published by Hautecoeur Martinet (LD 7).

1.4 Géricault. *Pity the sorrows of a poor old man whose trembling limbs have borne him to your door*. 1821. Lithograph, published by Rodwell & Martin in London with title in English. (Also published in Paris as *Le Pauvre Homme*).

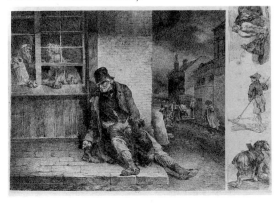

controlled contour with which Ingres utilised a neo-classical convention of arabesque in low relief on a flat surface, deriving for example from Flaxman's linear rendering of antique marble relief sculpture, had already been adapted by Corot for both figures and landscapes, the linear element in the latter being used to define overlapping edges in a laconic and concise manner. The Romantic convention of 'painterly drawing', perhaps best exemplified by Delacroix in his energetic but broken linear rhythms, which show how aware he was that 'line' is no more than a concept which has to be continually adjusted to allow the apprehension of volume as our nervous system perceives it, was at this period no revivalist notion but a continuous development from the great baroque draughtsmen of the seventeenth century, in particular Rembrandt and Rubens.[16]

Another aspect of drawing, one that is the inverse of the 'creative language' aspect in a way, is its employment as a means of *reproduction* or rendering of works of art in other media, by professional engravers and lithographers on wood, metal and stone. Engraving and lithography were the most widely used means of transmitting knowledge of the works of past Masters among artists in the period under discussion; they did not begin to be superseded by photography until the 1880s. In the case of engraving, artists in the past had also used it for the invention and distribution of original designs – Brueghel the Elder's woodcuts and Rembrandt's etchings are two famous examples that spring to mind – but where reproduction of existing designs was concerned the artist generally relied on the close collaboration of a craftsman-artisan working for him. The use of line by these highly skilled craftsmen to translate pictorial elements such as tone and colour into linear equivalents was very systematic and stable in its conventions. We shall see that Millet may have taught himself to draw in one fashion by studying engraved prints, though he developed a more personal formula using a wiry scrawl across the surface of the paper. Daumier frequently made drawings in pen for translation on to woodblocks for making prints, but he practically never made engravings himself of any kind. He made one etching, fairly late in life, to amuse friends. Millet on the other hand produced a small but serious body of etchings in which he recreated certain of his own paintings and drawings.

The medium of lithography is another story. Introduced into France from Germany early in the nineteenth century, its practitioners were shown official recognition by having work exhibited at the Salons from 1817 onwards. As with engraving, it was used both for book illustration (topographical works especially) and for reproducing works in other media. (Indeed it proved to be so versatile that it was even used to reproduce etchings.) In the lithography sections of the Salons from 1817 to 1824 the name of the lithographic publisher (who was usually but not always the printer) took precedence, in the catalogue, over that of the artist who created the original work[17] – a circumstance that might seem incredible to us now, were it not that the type of art so reproduced, often an oil painting that had scored a success at some previous Salon of recent years, would have been familiar enough to the contemporary public not to need any special explanation. The result was a kind of advertisement in retrospect for original artists, and a display of the versatility of lithography as a medium. As such, it was also taken up with enthusiasm by a number of artists of repute at that time, including Géricault in 1820–1, and Goya (in Bordeaux) in 1825. Géricault, like Delacroix after him, both collaborated with professional lithographers and made his own drawings on the stone. Daumier, as we have seen, embarked upon his career at the very beginning of the lithography boom in the 1820s. His earliest signed prints are competent and show a certain piquant humour, but they are not particularly distinguished until *The grocer who was no fool...* of 1830 (Fig. 1.3), which suddenly reveals Daumier's motivation at the time of the June Revolution and at the same time echoes a design of Géricault's, *Pity the sorrows of a poor old*

man . . . (Fig. 1.4) which had been drawn in London at the height of that master's realistic observations of the urban poor. From this point onwards Daumier seized precisely that aspect of lithography – its cheapness and popularity – that weakened the performance of many of its practitioners, and used it to achieve a unique mastery and fame of his own. Famous prints such as the *Rue Transonain* of 1834 are directly comparable to the lithographic achievements of Goya (compare the latter's *Bulls of Bordeaux* series executed in his old age, which exhibit the same richness of tones and flickering lights scraped out of the shadowed areas) as well as being emphatically involved with contemporary events, in the tradition of Géricault's *Raft of the Medusa* and Delacroix's *Liberty at the Barricades.* The softness and subtle pliability of lithographic chalk was something that Daumier perfected in its use over two decades – hence the respect accorded him by his contemporary 'Salon artists'. Mention has been made of Millet learning one aspect of his craft from studying engravings; in another chapter we shall see how he turned increasingly to black chalk, soft and slightly greasy, to obtain the tonal and atmospheric effects that he sought in his drawings of the 1850s.

Drawing style, then, is often modified by the medium employed, but what often determines it even more directly is the specific function that the artist is using his drawing to serve. To explain these factors more fully, Chapter 2 will be devoted to a survey, perforce somewhat perfunctory over so wide a field, of what canons of 'drawing language' were current during the first half of the nineteenth century, so that we may surmise more clearly what Daumier and Millet inherited, as opposed to what they invented for themselves.

Before going into that survey it may be useful to summarise the remaining evidence that survives to show the rapport between Daumier and Millet, during the period *c.*1847–65, in their personal lives. The use of biographical documentation as an art-historical tool has lately come under fire, as liable to subjective bias in its selection. Although the documentation available in this case is uneven in distribution, and in places even scanty, I shall nevertheless take the risk of criticism by setting it out here: the story is fascinating enough to be told.

Further Biographical Information

Millet left Paris for good in June 1849, for a variety of reasons which will be discussed, and settled in the village of Barbizon about 30 miles to the south, on the edge of the forest of Fontainebleau. Consequent upon his departure one may assume that he would meet Daumier on his fairly frequent visits to Paris. We are told that he sometimes finished his canvases at Diaz's studio, sometimes at that of the painter Eugène Lavieille; it also transpires that for several years he rented a 'local' or room in a house at 35, quai des Augustins, in Paris, presumably as a *pied-à-terre.*[18]

Daumier is also mentioned as visiting Barbizon, and once at least his signature is recorded in the register of the village inn, the Hôtel Ganne, in the year 1853.[19] Evidence of a close connection between the Daumier, Millet and Rousseau *families* becomes firmer in the mid-1850s. The well known letter from Millet to Daumier, dated 26 March 1855, in which he cheerfully invites himself and the Rousseaus to dinner, has a familiar and convivial tone.[20] Jean Adhémar asserts that this group, together with Corot, saw each other 'à chaque instant à Paris',[21] and met again during the summers in the valley of the Oise (which is, however, to the north of Paris, on the side opposite to Fontainebleau forest).

In the same year, 1855, a group project was discussed at Rousseau's house in Barbizon, to illustrate an edition of La Fontaine's *Fables* (see Chapter 9). Then, at the baptism of three of Millet's children on 20 September 1856, Mme Daumier

was present as godmother to the eldest son François. Thus, however tenuous the documented evidence of association between Millet and Daumier in 1847–8 may be, it becomes increasingly clear that by 1855–6 they were quite intimate friends. In March 1860 two separate events occurred which may or may not have brought them closer together. Daumier was sacked from *Charivari* and began to devote his whole time to painting, albeit at considerable financial loss; Millet signed the Stevens-Blanc contract which gave him a retainer of 1,000 francs per month in return for all his work for three years. The years 1860–3 turned out to be a most difficult period for both artists, during which each was highly likely to have been preoccupied with his own problems. Nevertheless, a number of specific references to Daumier occur in Millet's correspondence (the majority of which is addressed to Alfred Sensier as his agent in Paris) during the period 1861–4, and Sensier's own references to Daumier – usually news items – reciprocate these and continue until 1868.[22] On 20 September 1861 Millet wrote 'Les Daumier sont ici' in answer to a question by Sensier.[23] On 30 May 1863 the Daumiers apparently excused themselves from coming to the first communion of Millet's son, François, and his daughter Marguerite, 'for an irrefutable reason', according to Sensier. Millet replied, 'J'imagine de reste les raisons que les Daumiers ont pour ne pas venir'. In fact, at this point Daumier was desperately poor. By the end of 1862 he had been forced to sell his best furniture, and in 1863 he changed his address three times. His friends almost lost sight of him, and at the end of the year Millet asked Sensier to forward a letter. On 5 December 1863 Daumier moved from 28 rue de l'Abbaye to an apartment on the fifth floor of 20 boulevard Pigalle.[24]

By now Sensier knew that Daumier had returned to work for *Charivari* for a retainer of 400 francs a month – 'it was about time', he wrote to Millet on 21 November 1863, a month before the editors of the paper published their own announcement.

More unexpected is the extraordinary story of Madame Daumier taking into her own hands the problem of one of Millet's younger brothers, Jean-Baptiste (b. 1830), which requires some explanation. Jean-Baptiste had joined Jean-François at Barbizon in 1852, to study painting with him. He stayed until about the end of 1854, after which he moved to Paris, with Sensier set to keep an eye on him but apparently without much success at first.[25] In 1860 'Jean', as he was referred to, was asking Sensier to help him with his marriage plans, although he was in financial difficulties at the time. Jean did in fact get married at the end of July, and the couple went to stay at Barbizon in August. After about two weeks Millet betrayed somewhat mixed feelings in a letter to Sensier: Jean and his wife were 'always there'; everything was going swimmingly for the present; they thought of renting a room in the village but vacillated; Jean's habit of dawdling had not been cured by the marriage. The following spring Sensier reported from Paris that the unfortunate Jean's work had been refused by the Salon jury. Then in November 1863 Sensier visited Jean and his wife at Asnières, and wrote politely that he found 'ses dessins à la plume d'un excellent effet'. Not long after, the truth came out, if the following account by Sensier is to be taken literally. In a letter of 5 March 1864 he wrote to Millet:

> You know how lamentable the state of *Madame Jean* has become: physically, mentally, in every way. Madame Daumier has been to Asnières and there accomplished a *coup d'état*. She faced Jean with a number of sad truths, assuring him that his paintings would never sell, and that his manner of living would only bring about the ruin and the death of his wife. But, when he took refuge in the approbations that you, Rousseau, Daumier and myself seemed to have given him, she told him (without asking my opinion, you understand) that we

all thought the same on that subject, and that his only recourse was to take up sculpture again. Judge the bewilderment of Jean. For three days he did not utter a single word; then on the fourth, he arrived *chez Daumier*, saying that he had decided, after all, on sculpture. [Honoré] Daumier then immediately sent him to the sculptor working on the decorations of the Opera, where, for the last eight days, he has been working.[26]

Millet's reaction to this piece of news came from Barbizon on 8 March. 'The *coup d'état* of Mme. Daumier has had a good result in that it has determined Jean to take up sculpture again', he wrote to Sensier,

'but a very unfortunate one for him to receive this terrible blow, especially in learning what Mme. Daumier told him that we thought about him. No woman but her would have such a cheek. I positively suffer in thinking about what he must have gone through, and what he will be feeling still, he who has always feared that people thought him incapable of producing beautiful things in painting. I am going to write to him that you have told me about Mme. Daumier's escapade, and all that she thought would be good for him to hear to arrive at these ends, but say to him that she produced out of her own head ['*pris sous son bonnet*'] this reported opinion of ours; because he must suppose us all, and me particularly, to have deliberately misled him in this respect. Once more a blow – I am broken-hearted in thinking about what this unhappy Jean has had to experience'.[27]

These two letters, put together, tell us a good deal about the characters of Madame Daumier and Jean-François Millet respectively: the one capable of being exasperated by an idiot, and the other soft-hearted to a degree about a brother who had caused him trouble for years. With hindsight, we can now reflect that the effrontery Mme Daumier's 'escapade' was probably exacerbated in Millet's mind by a reversal of sexual roles, since she took an aggressive initiative. The details of this incident were not referred to by Moreau-Nélaton in his biography published in 1921, although he would have been fully aware of them. He prefers to stress the part played by Honoré Daumier himself, whose kind heart was moved by compassion for the needy *ménage* of Jean-Baptiste, and who persuaded Geoffroy-Dechaume to engage him in his workshop for the restorations of Notre-Dame.[28] It was Daumier's selfless regard for others, too, that caused Sensier to 'consult him' about the question of Millet's accepting the first-class medal awarded him at the Salon of 1864, when Millet was trying to get out of attending the ceremony. Daumier, who was nowhere near such honours as a painter himself, solemnly conveyed his opinion that Millet should not refuse, out of consideration for the Jury.[29]

Opinions about the frequency of Daumier's visits to Barbizon differ. Julia Cartwright states that he 'came from Paris on occasional visits',[30] but Moreau-Nélaton thought that his appearances at Barbizon were only of short duration, and the correspondence seems to support this deduction. Be that as it may, later in 1864 there are no less than five notes in Millet's hand about getting hold of Daumier to give him the address of a *perspecteur* to help him with the illusionist perspective of a ceiling painting, *Autumn*, which was part of a commission to decorate the Paris residence of a Monsieur Thomas of Colmar (see Chapter 6). Daumier eventually either did so or gave Millet some directions on the subject of perspective himself, meeting him in Paris before 29 November, when Millet conveyed his thanks. (Eventually, however, a *perspecteur* had to come to Barbizon.) Then in Sensier's biography of Rousseau we find evidence quoted that the Daumiers passed their *vacances* in 1865 again *chez Rousseau* at Barbizon – in

September, apparently.[31] But *vacances* may be a euphemism: at that time the Daumiers were as much involved in coping with Mme Rousseau's mental illness as Rousseau was himself.[32] This may have been the last time that Daumier and Millet were in close contact at Barbizon. By October 1865 Daumier was installed permanently in his little house at Valmondois (Oise), though he retained a studio in Montmartre until 1869. In June 1866, when the Millets were staying at Vichy for the first time, Daumier sent a message that a certain hanger-on, named Lambert, should be avoided; later in the year he sent another warning about a dealer who was irregular in his payments and sometimes forgot what he had commissioned. (Both messages were sent via Sensier's letters.) In effect, all the indications are that the families of the Millets, the Rousseaus and the Daumiers were extremely close over a period of nearly twenty years, and that they shared each other's misfortunes as well as their successes. The last direct reference to Daumier found in Millet's own correspondence is in a letter to Sensier dated 23 December 1868, referring to the memorial service held for Théodore Rousseau at Chailly the previous day. Millet says that he had sent, in very good time, invitations to Daumier and to the critic Théophile Silvestre (then also living at Valmondois) but neither came to the service. (These invitations had been sent to the two men and their wives at the request of Sensier, who was handling the delicate question of whom should be invited down from Paris on this rather private family occasion.)[33]

Those are about the limits of the evidence in the biographical documentation: not conclusive, but significant enough for our purpose. The rest of this study of rapport between the two artists must depend upon the evidence of the works that they produced, given that some chronology can be established for the works, and given the time parameters already indicated.

THE EXISTING CANONS of drawing in France at the start of the nineteenth century still devolved very much from the systems practised by J.L. David and his many students. David's painting *The Oath of the Horatii* of 1784 has been properly described as 'the painting which epitomises the whole French school of Neo-classicism',[1] both for its subject matter and its manner of execution. David prepared for this painting with extreme care by making numerous drawings, including clear notations of the whole design, studies for various parts, and definitive renditions of individual figures and groups in relation to the whole. The drawing illustrated here (Fig. 2.1) shows the group of the three sons of Horatius taking the oath of victory or death, in the exact form in which they would appear on the finished canvas. It is an artist's working drawing, executed in black chalk on fairly coarse brown paper. It establishes definitive contours and, within them, indicates a kind of relief modelling by shading away from the imagined light source, and heightening with white gouache the surfaces turned towards it. The paper is squared up for transfer to the canvas in proportion to the other elements that will be in the picture.[2] This drawing apparently has no pretensions to being a work of art in itself, although the skill of its execution might have been a cause for pride. In effect, it is more like an architect's projection of a structural detail. Yet there is an astonishing air of intellectual certainty about the drawing, a confidence in its plastic structure, a sense that thus and thus only shall be the contours, that is indeed the epitome of neo-classicism. Inevitably one thinks of carved sculpture when trying to describe the quality of its forms.

Yet if classical antiquity was David's source of inspiration here, it was the artists of the Italian Renaissance – particularly Mantegna and Leonardo – who were the ancestors of this precision method of modelling drapery, as if in grisaille. It seems likely that David wished to revive this tradition, or at least put it to his own service, towards the execution of a painting that in many other respects owed obvious debts to another great French classical revivalist, Nicholas Poussin.

Drawings that combine this degree of clarity and *force* (I am italicising a term lifted from Millet's critical vocabulary) áre rare in the nineteenth century. Efforts to continue David's tradition of purity of line were made by the second generation of neo-classicists, notably Girodet and Guérin, but only Ingres was able to develop it further into an aesthetic form peculiar to himself. Greater flexibility of line is found in David's smaller studies of individual nude figures, due to subtle variations in pressure of the artist's crayon. The procedure of making a sequence of studies for narrative figure compositions, consisting of 'première pensée' drawings in chalk or pencil, sometimes followed by tonal studies in broadly indicated washes, and then a definitive composition sketched in pen, oil paint, or sometimes a combination of the two, and even then followed by

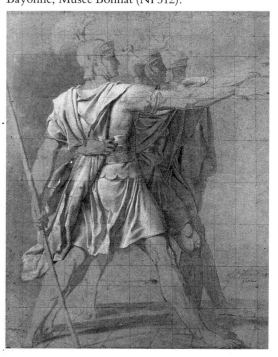

2.1 J-L. David. *The Three Sons of Horatius*: study for *The Oath of the Horatii*. 1784. Black chalk and white gouache on brown paper, 58.2 × 36.2. Bayonne, Musée Bonnat (NI 512).

additional studies for particular parts, remained common practice for a good part of the nineteenth century. These procedures derived from Renaissance practices and had become systematised in the seventeenth century, both in the Italian academies and by those foreign artists whose attachments were to Italy (Rubens, Poussin and Claude Lorrain being among the most famous examples). The procedures of picture-making became somewhat looser in France during the rococo period – whether it was the spontaneous oil sketching style of Fragonard or the cool and direct observation of Chardin – but the advent of David's great atelier reaffirmed a methodology of creation by stages, one that could be taught to pupils, and one in which drawing was an assigned discipline. His influence in this lasted well into the romantic period and beyond, in the studios of those artists who trained students aiming to exhibit at the Salons.

Géricault carried preparations for his major projects to an obsessive extreme, producing literally scores of drawings towards making one given painting; Delacroix was equally prolific, though he modified his ideas more often when working on the canvas. Most mid-nineteenth-century artists carried out more or less elaborate preparations for their paintings aimed at the Salon exhibitions, including Millet, and even Daumier's disorganised *oeuvre* more often than not contains drawings related to his oil sketches. Puvis de Chavannes carried such methods on a grand scale through to the second half of the century where, in modified form, we may perceive yet another classical revival in the relation of drawings to paintings in the works of Degas, Gauguin and Seurat. The cerebral argument, the philosophy of the contour – lost and found, as it were, at different periods – is one aspect of the history of drawing. (Cézanne was well aware of it, in his struggle to arrive at a positioning for his sensations of colour.)

Another aspect of the history of drawing is the practice of relief modelling. The imitation of relief by the gradation of light and shade was a practice recommended by Leonardo as basic to the art of painting. Perhaps the greatest virtuosi of what I shall call volumetric drawing were Michelangelo and Raphael. In the drawings of these masters their processes of thought can be perceived: ideas are born on paper, questions asked about them, modifications made, frustrations expressed, ideal solutions achieved. During the centuries that followed them, drawing tended to become less of a conceptual process and more of an empirical experience (particularly in the hands of Rembrandt), but nevertheless the great sixteenth-century draughtsmen remained the canon against which achievement was measured in the seventeenth century, and their works were frequently copied for the sake of study, both from originals and from engravings after the originals. Probably the greatest transmitter of this Italian tradition was Rubens, who exercised enormous influence on French art for more than two centuries after his death. A drawing such as *The Baptism of Christ* in the Louvre (Fig. 2.2), which was executed in about 1605 for a painting commissioned by the Duke of Mantua, shows the influence both of Michelangelo and of his pupil Sebastiano del Piombo in the volumetric, hard muscularity of its rhythmic forms. The shading of the relief modulations is executed with that peculiar delicacy that also characterised Michelangelo's handling of finely pointed, soft chalks. The derivations of this drawing are highly eclectic for, besides the Michelangelesque figures on the right and the figure of Christ borrowed from Sebastiano, mannerist transformations of classical types may be perceived in the figures of the women in the distance, and the angels on the left are more like Correggio than Michelangelo.[3] Such frank references to past exemplars were quite normal for the period, which was not inhibited by the cult of 'originality' characteristic of modernism.

'Volumetric' drawing, which amounts to a strong feeling for the plasticity of forms, persisted throughout the baroque period, especially when black, red and white chalks were employed. It continued to be practised with exquisite skill by

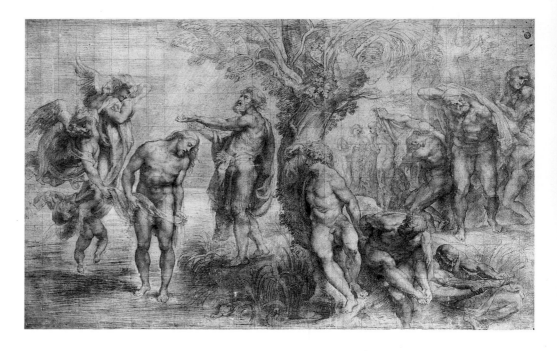

French rococo artists from Watteau to Boucher and was maintained (in a severer form) by David's contemporary Prud'hon. Watteau on occasion used a combination of black and red chalks, with white highlights, for his figure studies in a manner that is directly derived from Rubens' practice. There is a certain laconic precision about Watteau's draughtsmanship, however, that sharply distinguishes him from his Flemish predecessor. The *Portrait of Antoine de la Roque* (Fig. 2.3) is a very small study, executed in sanguine only, which shows the characteristic tautness of form found in Watteau's mature work. The little head is perceived as spherical to the touch, the speaking likeness of an orange possessed of humanity. And then a hardening of pressure on the crayon stroke that renders M. de la Roque's armpit precisely reveals to us the touching human relationship between his sensitive face and the awkward bunching of his shoulder, pushed upwards by a crutch. This style of drawing, which also merits the terms 'painterly' and 'natural', is moving in a direction away from the calculated processes of mannerist art. Towards the end of the eighteenth century it was to be temporarily eclipsed by new system, but the rococo element of naturalism would never be entirely forgotten.

By the turn of the century, the traditions of volumetric drawing and the neo-classical sharp-edged contour seemed to be mutually antithetic. David's greatest pupil, Ingres, developed a drawing system in which line was the governing factor. This is visible in his preliminary compositional sketches and detailed studies for paintings (of which there is a very large number)[4] and also in his remarkable portrait drawings. Although most of these were made as studies towards paintings, many are signed and inscribed, as complete statements in themselves. In *Portrait of Paganini*, inscribed 'Ingres Del. Roma 1819' (Fig. 2.4), only in the expressive mask of the face, and in the shading to show the thickness of the violin, does Ingres make the slightest concession to three-dimensional illusion. Line is used here both as contour and as a way of making decorative gestures. Ingres' linearism is of course partly due to the drawing tool that he is using – lead pencil – but a large proportion of his studies are in pencil, and his choice of this medium must be significant.

A closely similar linear aesthetic is found, surprisingly, in a relatively early portrait drawing by Corot (also in pencil) of a young girl, produced in about 1831

2.4 Ingres. *Portrait of Paganini.* 1819. Pencil, 29.9 × 21.8. Paris, Louvre (RF 4381).

2.5 Corot. *Young Girl with Beret.* c.1831. Pencil on yellow paper, 29 × 22.2. Lille, Musée des Beaux-Arts.

2.6 Prud'hon. *Seated Male Nude with Arm Outstretched.* c.1810–20. Black and white chalks on blue paper, 46.2 × 30.3. Cambridge, Fitzwilliam Museum.

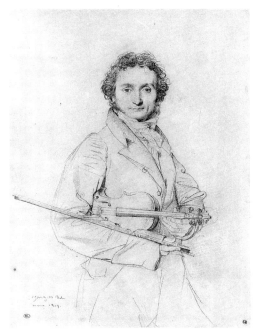

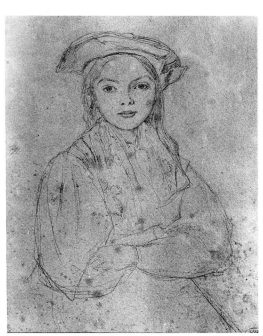

2.7 Ingres. Two studies for *La Grande Odalisque.* c.1814. Pencil, on three pieces of paper joined, 24.5 × 26.5. Paris, Louvre (RF 1451).

(Fig. 2.5). Corot had begun his career under strong classical influences, especially during his years in Italy, and although most people think of him as a 'tonal painter' this drawing shows that he possessed a feeling for linear design as well, which he reconciled visually as a matter of overlapping edges. More will be said about this in the context of landscape (Chapter 8).

In drawings of the nude, the two notions of plasticity, signifying a sensuous substance, and linearism, signifying ideal grace, are particularly difficult to reconcile. David's slightly younger contemporary Pierre-Paul Prud'hon managed to find a kind of solution which became immensely popular during the First Empire. Prud'hon has been aptly described as a sort of sensual classicist, due to the combined influences of Antiquity and Correggio.[5] His *Seated Male Nude with Arm Outstretched* was intended as a *tour de force* in drawing from a model posed in an artist's atelier (Fig. 2.6). It demonstrates Prud'hon's characteristic technique of closely hatched shading in black chalk on blue-grey paper, with light surfaces heightened with white and an element of *sfumato* introduced by stomping. Ostensibly a naturalistic rendering, the pose is highly artificial and rather meaninglessly dramatised. The barrel-chested young model is willy-nilly given the proportions of a Greek god. This kind of nude *académie* was practised in every major atelier in France throughout the nineteenth century as part of the curriculum of any art student who wanted a regular training with a view to a conventional career as an artist. The closer the pose of the model was to a statue from classical antiquity the better (hence the word 'statuesque' as a term of approbation). This practice again had its origin in the seventeenth century academies, and maintained its viability both for neo-classical and Romantic artists.

Ingres, in his nude studies as in his portraits, more often preferred lead pencil, though he did use the other traditional media with the exceptions of sanguine and wash. The sheet of studies for his *La Grande Odalisque* painting of 1814 shows clearly the nature of Ingres' peculiar obsession (Fig. 2.7). The intensely sensual character of this lady's body is expressed by the fine lines of a pencil guided by the artist's index finger, apparently making excursions along the contours extending upwards and downwards from the fulcrum of her hips, which have the

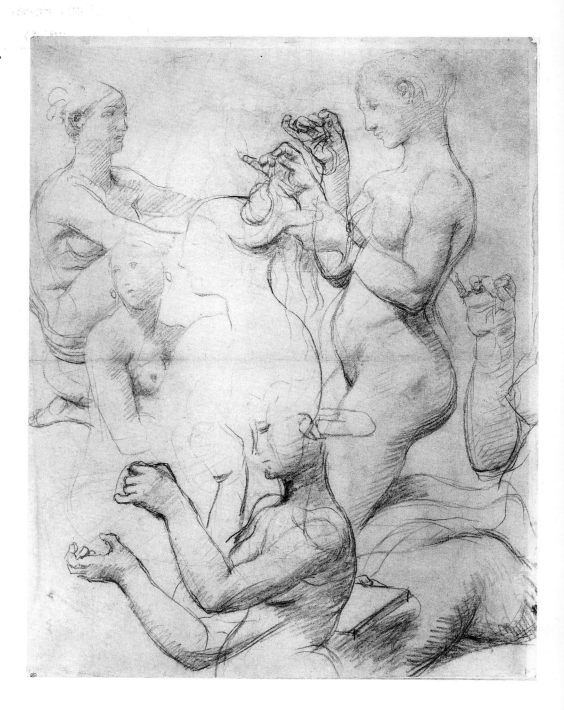

sinuousness of a snake. The top drawing is in fact a rendition of David's *Madame Récamier* portrait, nude and modified into more undulating rhythms.[6] His detailed studies of her fingers and toes add to the subtlety of expression in this whole sheet of drawings. There is some slight suggestion of light and shade around the *Odalisque*'s hips and thigh, but this convention for relief modelling takes second place to the line. When Ingres uses charcoal and black chalk, as in his late sheet of *Studies of Nudes* for *Le Bain Turc* (Fig. 2.8) his characteristically deliberate hatched shading does begin to suggest a painter's type of volume – by changes of tone – but note that these careful strokes do not affect the nature of the contours themselves, all of which seem to be individually studied and only modified for their special beauty as arabesques. We shall find an awareness of this peculiarly French tradition of the sensuous female nude, stemming from both the rococo

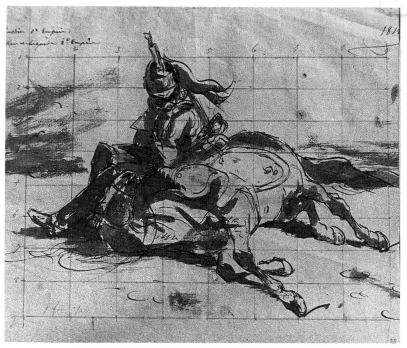
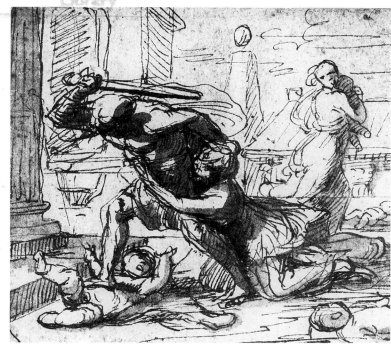

2.9 Géricault. *A Cuirassier and his Wounded Horse.*
1814. Pen and bistre wash, 23.2 × 26. Bayonne,
Musée Bonnat (NI 698).

2.10 Nicolas Poussin. Study for *The Massacre of
the Innocents. c.*1628–9. Pen and bistre wash, 14.6 ×
16.9. Lille, Musée des Beaux-Arts.

and the neo-classical modes of expression, in Millet's drawings of nudes in Paris in the 1840s.

If David had been the artist who projected the most ideal aspirations of the First French Republic and Napoleon Bonaparte's First Empire, Théodore Géricault was to be the one who could express the most foreboding images at the dissolution of the regime. His large painting *The Wounded Cuirassier*, which he completed in a great hurry for the Salon held under Louis XVIII, has been described as 'an allegory of defeat'.[7] The genesis of that painting was unusual in Géricault's *œuvre* in that for once apparently he did not make a great many preparatory studies, and those drawings that do exist are variants showing considerable differences from his final choice of design. One such is the drawing illustrated here of *A Cuirassier and his Wounded Horse* (Fig. 2.9). Executed directly in pen and bistre ink wash, this notation was evidently put down on the paper rapidly and spontaneously, as a single dramatic vision. As a compositional sketch, a *première pensée*, such a technique had ample precedents in the seventeenth century. Pen and wash was then frequently used as a medium both for trying out designs and for observations made from nature. Nicholas Poussin may be an unexpected example to choose, so accustomed are we to the classical organisation of his finished paintings, but in a rare drawing like the study for his painting *The Massacre of the Innocents* (Fig. 2.10) his initial conception is rendered with an inspiration as violent as the subject itself. The connection with Géricault here is one of analogy rather than of direct influence. Géricault of course had leanings towards the baroque ever since he had been a rebellious student in the atelier of the neo-classicist Guérin, as the number of his extra-curricular copies after Rubens, Van Dyck and Rembrandt attests. The curious suggestion of observed reality, another aspect of Géricault's sketch, also relates to the pen and brush drawings of Claude Lorraine executed in the Roman Campagna. A somewhat unusual feature of this drawing is that, cursory in treatment though it may be, it was immediately squared up for transfer to an oil sketch (it is inscribed *1 fois ½* – 'to enlarge one and a half times').[8] Its format is quite different from the scheme finally adopted for the *Wounded Cuirassier* painting, and the whole procedure

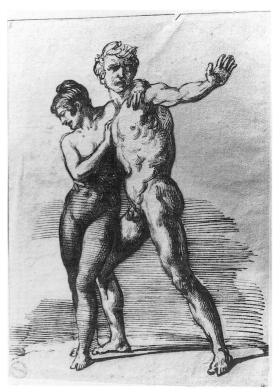

2.11 Géricault. *Satyr Seizing a Woman. c.*1816–17. Pen and bistre ink, 30.7 × 21.6. Bayonne, Musée Bonnat (NI 740).

2.12 Charlet. *A Beggar. c.*1830–40. Black chalk, heightened with white, on blue paper, 43.5 × 27.6. Paris, Louvre (RF 25,218).

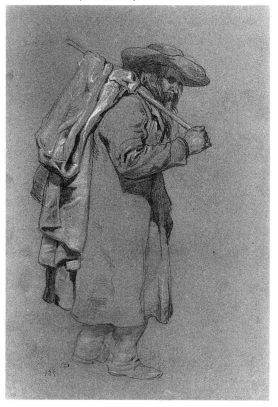

suggests impatience to proceed. The drawing provides a clear analogy with certain later works of Daumier.

Concurrently, an 'antique' style is found in Géricault's drawings even before his Italian visit of 1816–17, though it reaches a climax at that point. *Satyr Seizing a Woman* (Fig. 2.11) is a good example of the sculptural appearance of drawings in this style. The very regular hatchings in pen and ink used to render anatomical structure are close to the pen drawing style of Michelangelo. A great many of Géricault's drawings during this period were of erotic subjects; the present example is a relatively delicate one. On both counts – the controlled hatched strokes reminiscent of an engraver's lines, and the sensual subject matter from classical prototypes – Géricault's configuration may be seen as a precursor of certain of Millet's drawings, again produced in Paris in the 1840s. Of course Millet may not have known this particular drawing, which was purchased in the 1860s by the artist Léon Bonnat, but its type belongs to a common heritage of romanticised classical styles to which both Daumier and Millet would have been heirs before mid-century.

Another aspect of Géricault as draughtsman is that he appears to have completely assimilated English watercolour technique, using finely gradated washes in soft greys, blues and browns, applied Girtin-like over very sharp pencil contours. In *The Coal Wagon* (Fig. 2.13), a watercolour related to a lithograph published in his English suite of 1820, the horses, the figures and the cart are reinforced with fine pen lines, using brown ink.[9] The result is a kind of fresh naturalism that heralds the *plein-air* effects of the English landscapists who were noted at the Paris Salon of 1824. Géricault was very much of his time in perceiving the possibilities of this medium. Together with Bonington, he must surely have been a stimulus for Delacroix's enthusiasm for watercolours from the early 1820s onwards. At the latter's posthumous studio sale in 1864 there were large numbers of watercolours apparently dating from every phase of his career. This medium seems to have been used by Delacroix mainly for his private studies, in the form of costume notes, responses to landscapes seen when he was travelling or visiting friends in the country, and for investigations into the properties of colours, rather than for making works for sale. Daumier similarly used watercolour to fill out ideas in his exploratory drawings, but he also employed it to make finished drawings for sale to amateurs in the 1860s. Millet used watercolour in conjunction with both black chalk and pen in his landscape studies from the 1850s onwards.

Géricault was accompanied on his visit to England by Nicholas Toussaint Charlet (1792–1845), an artist of moderate talent who was also an expert lithographer, and who helped Géricault to make a lithograph of his famous *Raft of the Medusa.* Charlet did not care for London much, but he did partake of the 'new realism' that characterised Géricault's last style, and he was probably responsible as much as anyone for transmitting to subsequent generations a liking for low-life genre subjects. Many of his drawings are rather 'quaint' representations of soldiers in the country and of village life, in a sub-Dutch naturalistic style; in other drawings he glorified the Napoleonic era. In the Cabinet des Dessins in the Louvre, the Charlet collection includes a group of studies of beggars, all executed in black chalk on blue paper, heightened with white. They have the look of being drawn from life models, and one at least, *A Beggar with Coat Slung over his Back* (Fig. 2.12), is a clear precursor of the reportage-realist style commonly found in drawings by Courbet and his circle at mid-century. Inspired, no doubt, by the vogue for Spanish and Neapolitan baroque painting, it even anticipates one of Manet's sources of inspiration. In some ways, however, this type of realist drawing should specifically *not* be taken as a visual source relating to the imaginative recreation of things seen that characterises the drawings of Daumier

18

2.13 Géricault. *The Coal Wagon*. *c*.1820–2. Pencil, watercolour and pen, 18.7 × 30.2. Hartford, Conn., Wadsworth Atheneum.

and Millet, even though it represents the most popular drawing style contemporaneous with them.

This observation calls for a brief excursus on the subject of popular art. To define 'popular taste' in fine art, and its relation to 'popular prints' in the graphic media, is a complex task in any period. In the 1820s and 1830s in France, a bewildering variety of styles and subject matter was presented to the public at the Restoration Salons and after. In the previous chapter we noted how lithography sprang into prominence in France as the most popular medium of reproduction, that is in the making of 'art' images, in the most general sense, available to a wide collecting public at modest prices. When lithographs were exhibited at the Salons, their subject matter certainly included some rustic genre scenes, but equally popular were topographical landscapes (including architectural monuments of the Romanesque and Gothic periods), portraits of well-known contemporaries, and reproductions of historical and mythological paintings that had hung at Salons in the recent past, as well as well-known works by Old Masters. At the same time, popular prints were made of subjects from contemporary life, for publication both in cheap magazines (which were then proliferating) and as separate prints. A whole new dimension of art is found here from the 1830s on, and it was in this field that Daumier found himself earning his living.

Certain of Daumier's prints for *Charivari* reflect earlier, traditional themes for popular prints, for example, his *Water Carrier* of 1835 (Fig. 2.14). This was a character from the traditional series of images known as *Les Cris de Paris*, but one

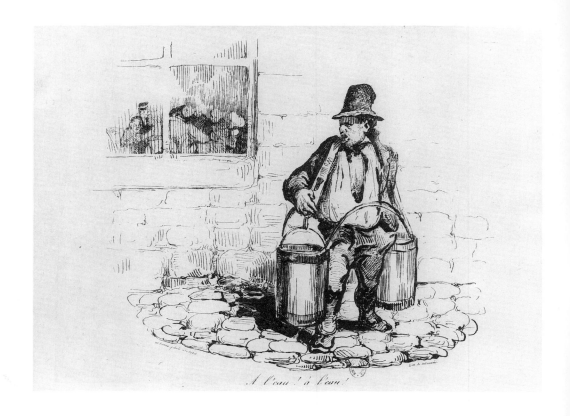

A l'eau! à l'eau!

who was still very much present in the streets of Paris of this era, and whom Daumier now represented as a fundamentally modern subject. His drawing style, using in this case a pen on the lithographic stone, is appropriately direct and simple for such a subject: everybody could 'read' an image that everybody knew. Indeed, this figure shouting 'A l'eau! A l'eau!' with an appearance of hoarse aggression, seems to be addressing the spectator directly. Given the political state of the times, he might even be conveying a veiled political warning about the state of the nation under Louis-Philippe, whose government was at that moment engaged in suppressing republican opposition and imposing severe censorship of the press.[10] In this case Daumier's medium is strictly that of 'popular art', but the strength and vitality of his drawing is actually increased rather than diminished by his need to communicate at this basic level.

Another subject for popular art was the promulgation of the Napoleonic legend, for which the neo-classical vogue in style was initially well adapted. However, as the grip of Romanticism increased after 1824, the memory of Napoleon and his victories became itself more subject to 'romantic' treatment. A very popular artist in this context was Auguste Raffet (1804–60), who had studied in the ateliers of Charlet and of Baron Gros. He produced illustrations for Baron de Norvin's *Histoire de Napoléon* published in 1827–8, and many other lithographs concerning the Napoleonic era. His drawing style was strictly that of an illustrator, with a rather painterly execution derived from Gros, Charlet and Géricault. For his military scenes he probably gleaned information from the battle paintings by his teacher, Gros. Look, for example, at the figure of Napoleon in the centre middle distance of Raffet's lithograph dated 1836 (Fig. 2.15), published with the following caption:

C'est là la grande revue A l'heure de Minuit
Qu'aux Champs-Elysées Trent César décéde! . . .
(Sedlitz, poète allemand)[11]

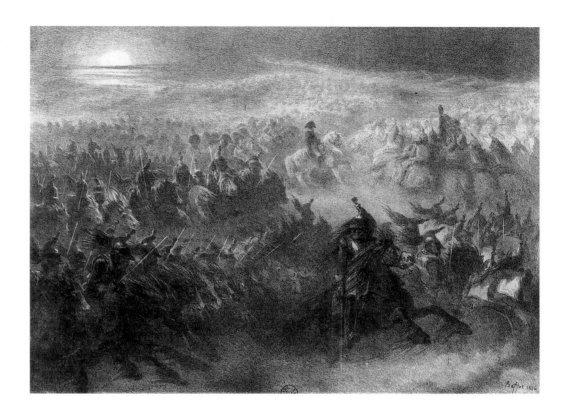

2.15 Raffet. *C'est la grande revue . . .* ('*La Revue Nocturne*'). Dated 1836. Lithograph, published by Gilhaut frères. Paris, Bibliothèque Nationale.

2.16 Decamps. *Beggars outside a Window. c.*1834. Black chalk, gouache and traces of bistre, on beige paper, 19.4 × 13.8. Providence, R.I., Rhode Island School of Design.

This somewhat grotesque fantasy indicates the way that the Napoleonic legend figured in the public mind by the time of the reign of Louis-Philippe.[12] Daumier was fully aware of it, and a much later drawing by him, possibly executed about 1863, sets two patriotic dreams in ironic juxtaposition. *Amateurs Looking at the Lithograph . . . by Raffet* (Fig. 2.17) shows this same print being admired by three enthusiastic collectors during the reign of the Emperor Napoleon III, as a nostalgic reminder, no doubt, of the by then mythic First Empire.[13] But behind them on a table is a small statuette of a 'Charity' group – a mother and three babies, nude, of the kind that Daumier himself had used to symbolise the Second Republic in a State competition in 1848 (see Chapter 5). Although Daumier frequently represented prints and pictures in generalised form in drawings of *amateurs*, he was rarely so explicit about what they were looking at.

The romantic attitudes prevalent in the 1830s coexisted with a current of naturalistic genre (bourgeois rather than heroic art) inspired by seventeenth-century Dutch artists. Before concluding this chapter it may be as well to glance at some of the other styles prevalent at the Salon, and the types of drawings associated with them. Minor artists like Martin Drölling and Louis Boilly had introduced *intimiste* genre scenes of contemporary life quite early in the century. The most outstanding exponent of this genre was himself also a romantic history painter and orientalist: Alexandre-Gabriel Decamps (1803–60). A near contemporary of Delacroix, his most ambitious Salon picture was *The Defeat of the Cimbri* (1834), but his small genre pieces and scenes of monkeys dressed in human clothing were equally well known. The freely handled impasto in his paintings earned him a reputation for being avante-garde like Delacroix himself, and his liking for chiaroscuro effects is also shown in his drawings. Early in his career Decamps produced a number of lithographs, some of them political cartoons and others of low-life subjects. His drawing *Beggars outside a Window* (Fig. 2.16) is somewhat reminiscent of Murillo, both in its naturalism and in the dramatic contrasts of lights and darks. Executed in a greasy black chalk which simulates the

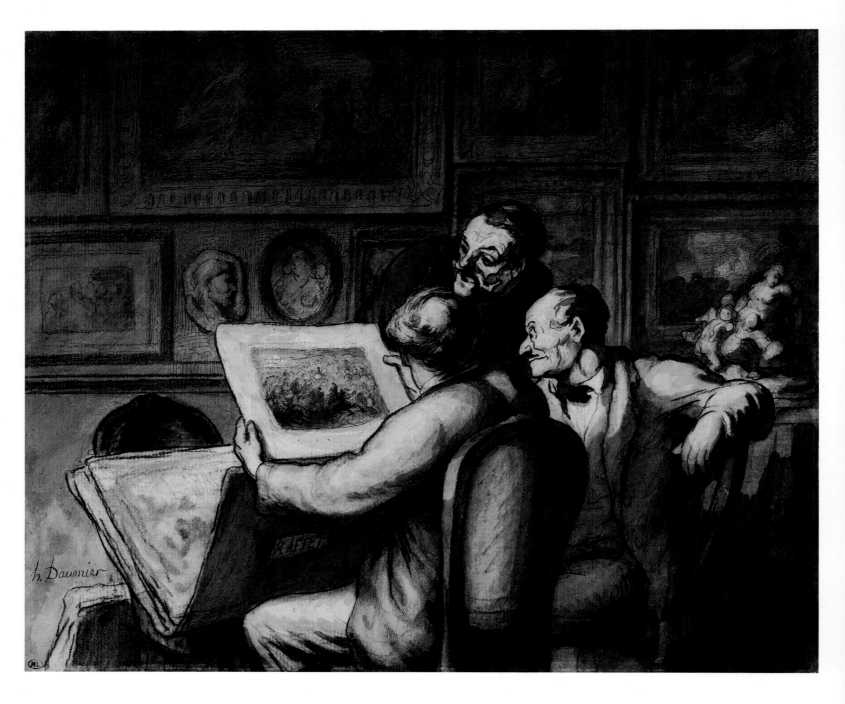

2.17 Daumier. *Amateurs Looking at the Lithograph 'La Revue Nocturne' by Raffet*. 1860s. Black and red chalks, watercolour and pen, 26 × 31. Paris, Louvre (RF 4036).

Facing page:
2.18 (*top left*) Jeanron. *A Street Vendor*. (Inscribed in another hand, *Jeanron 1831 ou 32*). Charcoal on greased paper, 32.3 × 13.4. Paris, Musée Carnavalet.

2.19 (*top right*) Daumier. *Liberty of the Press. (Ne vous y frottez pas!)*. Lithograph, published by L'Association Mensuelle, March 1834 (LD 133).

2.20 (*below*) Jeanron. *Girl Seated by a Seashore*. 1853. Etching, 24.3 × 32.8, printed by Delâtre. Paris, Bibliothèque Nationale.

effect of lithographic crayon, with light areas heightened with white gouache and some shadows deepened with bistre wash, it is in fact a direct study for a lithograph, published in 1834 (see Fig. 9.2 p.139), which is not unlike Daumier's technique at this period. Around 1830–1 Decamps had a series of twelve lithographs published by Gilhaut Frères called *Douze Croquis*, which all dealt with *paysagistes*, or country folk. They included *mendiantes* and travelling players in villages, people selling vegetables, and so on, in a sharply observed realist style that derived from Dutch precedents. In some respects Decamps is a precursor of both Daumier and Millet in such subject matter, though he is a less reflective artist than either. His genre paintings attained immense popularity with the Salon-going public, and he was able to capitalise on this success by repeating many of his subjects in the form of very saleable prints.[14]

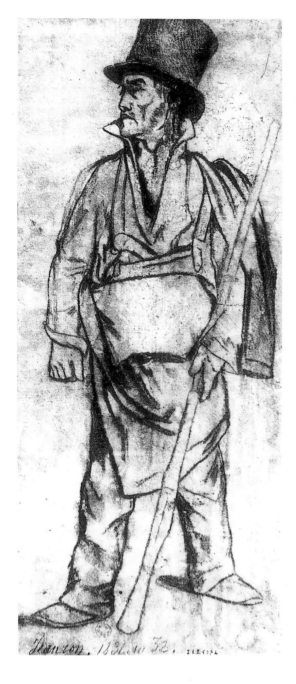

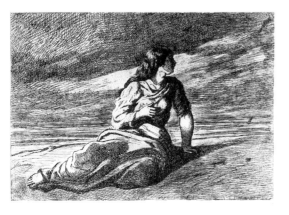

Philippe-Auguste Jeanron (1808–77) was an ardent republican and a friend of Daumier's from his youth. Like Daumier, Jeanron bitterly resented the suppression of civil liberties during the years following the July Revolution, which he regarded as affecting bourgeois and worker alike.[15] His drawing of a top-hatted artisan, carrying a long stick and wearing an apron full of tools (Fig. 2.18) appears to have a direct relation to the prints of the *Cris de Paris*.[16] The man carries himself with a proud proletarian air, very similar to that of Daumier's printer in the famous lithograph known as *Liberty of the Press* published in 1834 (Fig. 2.19). Daumier's political intent – to represent the press as socialist and working class in the face of oppression[17] – now overshadows and even obscures the origins of his iconography, which lay in popular representations of '*le bas peuple*'. Less obviously proletarian is Jeanron's etching *Girl Seated by a Seashore* (Fig. 2.20). This may be dated approximately to the time of its *dépôt legal* in the Bibliothèque Nationale in 1853, which would make it post-Second Republic. The forlorn girl does bear some resemblance to the common allegorical representations of *Liberty*, however, and the strength of Jeanron's execution justifies the respect with which he was regarded by his republican artist friends. Forced to abandon his political activities in 1850 by Nieuwerkerke (the man appointed as Director of Fine Arts by the Emperor Louis-Napoléon and, incidentally, hated by Courbet) Jeanron retired to paint landscapes in the south of France. He was given the respectable post of Director of the Ecole des Beaux-Arts at Marseilles in 1863. Not long after this, Millet's friend Siméon Luce was staying in Marseilles and wrote to him as follows: 'I don't go along with all the ideas nor all the [political] inclinations of this excellent Jeanron, but he is a man of great spirit who has passion in his art and who possesses a profound knowledge of history.'[18] Such *braves coeurs* were essentially the generation of artists who banded together in the 1830s and to whom Daumier and Millet, it will be argued, may be related as later adherents who transformed its artistic vocabulary towards new ends.

Notwithstanding all this, the major artist whose career dominated this generation for more than twenty years (from the death of Géricault until at least

2.21 Delacroix. Sheet of studies for *The Barque of Dante*. *c*.1822. Pencil on brownish paper, 27 × 20.1. Paris, Louvre (RF 9194).

1848) was Eugène Delacroix. His own contributions to the language of drawing will now be summarised briefly,[19] although his direct relations to Daumier and Millet's drawings will be further discussed more later on. In many respects Delacroix was literally the heir to Géricault's free spirit.[20] He worked in Géricault's studio while the latter was painting the *Raft of the Medusa*: he observed his compositional methods and drawing techniques, and he even posed for him. He accepted Géricault's methods of self-education by copying antique, Renaissance and baroque works of art, he understood the range of Géricault's tastes from England to the Orient, and (for a time at least) he emulated his involvement with contemporary history. Moreover, Delacroix was able to match Géricault's prolific creative energy, showing a capacity for cumulative invention of imagery unsurpassed since Rubens and Rembrandt. This last aspect is especially clearly expressed in Delacroix's drawings, of which more than 6,000 survive.[21]

Delacroix's natural tendency to draw by modelling volumes can be seen in some of his earliest productions. The sheet of studies of heads of the damned floating in the lake surrounding the infernal city of Dis, for his *Barque of Dante* painting of 1822, is a fair example (Fig. 2.21). The close-hatched pencil shading gives the effect of light shining on planes as if illuminating bronze. Contours are of minimal importance, except when they make a strong tonal contrast against an adjacent area, as in the right arm of the man shown against a blackish head, or along the back of the same man where he improbably leans against the surface of water as resistant as a sheet of glass. At the bottom of this same sheet are two masks in profile that must be copies from Graeco-Roman medals. In these the modelling is entirely rendered by shading, with practically no contours at all. It is as though the artist had been discovering the forms by mentally rubbing his thumb across the surface, like a landscape, rather than reaching for its edges. Yet the definition of a drawing style is never that simple. Even on the *Dante* sheet, with its controlled shading, we find a few lines superimposed (they stand for hair) in a freely decorative arabesque, signifying Delacroix's predilection for ornament.

Alongside studies for imaginary compositions, Delacroix made many drawings directly from nature, covering a wide variety of subject matter that included

2.22 Delacroix. *Three Studies of a Female Nude*. *c*.1840. Pen and bistre wash, 26.5 × 42. Paris, Louvre (RF 4617).

details of architecture, landscape, costumes (which evidently fascinated him as he liked to paint pictures of scenes from historical dramas and novels, particularly from Shakespeare, Goethe and Walter Scott), some very sensitive portraits executed in pencil and/or watercolour, and nudes. Notwithstanding his denunciation of 'realism' in later life,[22] Delacroix's visual curiosity was in the direct tradition of humanistic enquiry into phenomena. His drawings of nudes have a natural quality that denies artifice, and is reminiscent of Rembrandt. The sheet with *Three Studies of a Female Nude* (Fig. 2.22) may have been executed about 1840, and it could be a direct precursor of Millet's naturalistic studies of the nude towards the end of that decade. The way in which the fine pen lines (applied as though engraving in drypoint) are rather clumsily touched up with bistre wash, blotting and smudging the paper, actually increases the personal intimacy of the drawing as purely a sheet of studies, not made for sale.

Several writers (especially the late Claude Roger-Marx) have noticed the phenomenon of 'colour' suggested by black and white in the work of Daumier, particularly in the context of his lithographs.[23] This will be discussed in more detail later, but in the present context it is worth noticing Daumier's vivacious pen and bistre wash drawing, *Centaur Abducting a Woman*, datable about 1848–50 (Fig. 2.23). In its linear agitation it is perhaps closer to Delacroix than to Rubens, but in its effect it is a witty pastiche of a baroque idiom. It represents one stylistic extreme reached by the middle of the nineteenth century. (The date of *c.*1848–50 that I have suggested for it relates to the neo-baroque style of the paintings sent to the Salon by Daumier during this period.) Daumier is absolutely anti-classical in his style, yet (as in several of his lithographic caricatures) he shows an amused sympathy for the vitality of classical mythology.

By the mid-nineteenth century, then, style in drawing had become extremely flexible, depending not only on function but also on the artist's temperament. This is why it was possible to find such contrasts as between Delacroix and Ingres (though in some ways their confrontation became slightly artificial) and, a little later, between the Davidian neo-classical tradition and the new realism. The term

2.24 Courbet. *Self Portrait: 'L'Homme à la Pipe'*.
c.1849. Charcoal, 28 × 21. Hartford, Conn.,
Wadsworth Atheneum, gift of James Junius
Goodwin.

2.25 Courbet. *Seated Model Reading. c.*1847–9.
Charcoal, heightened with white, 56.2 × 39.
Chicago Art Institute.

'realism' as applied to drawing is not actually very useful, because in terms of
mimesis, or the illusion of mimesis, the limitations of the media used must make
it only relatively successful. It is significant that Courbet, the patriarch of
'Realism' with a capital R, did not do very much drawing, and when he did so it
was more often as a separate activity rather than as part of the development of his
ideas for paintings. His drawing style derives from the popular genre draughts-
men of the 1830s (for example Charlet and Decamps), and is not particularly
original, though on occasion he could practise it with great skill. The *Self-Portrait*
in black chalk in the Wadsworth Atheneum (Fig. 2.24) is a kind of demonstration
piece, advertising not only Courbet the man but in this case Courbet's skill in
organising the tonal range from black to white, to give the effect of strong,
dramatic illumination.[24] A charcoal drawing of about the same period (*c*.1847–9),
his *Seated Model Reading* (Fig. 2.25), is an attempt to imitate textures as literally as
possible (the hardness of the wooden chair, the pliable draperies, the softness of
the model's flesh, further hinted at by the *moulage* of a torso behind her), but it
comes out as a kind of *trompe-l'œil* at one remove: the 'real' soft textures are made
by the delicate handling of the stomped charcoal and the white chalk. Given
Courbet's predilection for handling oil paint, it is difficult to see how he could
have gone much further than this kind of achievement in drawing, and indeed
there is no further development in his drawing style. Vigorous as his attack was,
Courbet was unable to do more with drawing than recreate the rich black textures
that the invention of lithography had presented to the nineteenth century. To find
drawing taken further as a medium for creative thought and speculation, we must
look elsewhere.

PART II
Reality and Dreams
*c.*1845–51

3 Millet in Paris

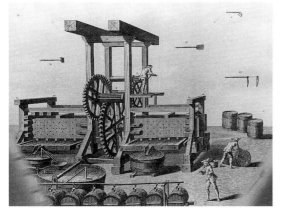

3.1 (Diderot, ed.). *Encyclopédie*. Plates. Vol. I (1762). *Culture de la Vigne*, III, *Pressoir à double Coffre*. Engr. by Benard.

3.2 (Diderot, ed.). *Encyclopédie*. Plates. Vol. X (1772). *Tourneur, I.* Engr. by Benard.

L'art n'est pas une partie de plaisir. C'est un combat, un engrenage qui broie.[1]

FOR MILLET IN 1847, art was a kind of fated combat: 'a grinding of gears which crush'. This laconic metaphor may incorporate a number of allusions.[2] The grinding or meshing of gears could at once be an urban-industrial image and a rural one, if one also thinks of mill-wheels and grindstones. It could also carry connotations of the industrial machinery of an earlier age, in which geared wheels of all sizes were turned by hand for almost every kind of mechanical process, from spinning-wheels to turning lathes and even huge wine presses (see Figs. 3.1 and 3.2). Millet was already looking for new subject matter besides the pastoral images summoned up in his *manière fleurie*, attractive though that fantasy world might have been to certain of his customers. Contrast, for example, the sensuous intimacy and Venetian colouring of his little painting of a *Sleeping Nude* of *c.*1845–6 (Fig. 3.3) with two paintings close to it in time: the so-called '*Good Samaritan*' of *c.*1847 (Fig. 3.4), and the so-called '*Quarriers*' (Fig. 3.5). Delicacy of paint handling is sacrificed to passion in both of the latter, and in both paintings the violence of the action strikes the viewer before its iconographical sigificance is grasped. The 'wounded man' supported by the 'Samaritan' looks like a staggering drunk, while the two men levering a huge stone in the *Quarriers* picture are exerting such frenetic energy that they appear to be fighting each other.[3] The paint handling is loose and gestural, suggestive of aggression.

During this period Millet was annually struggling to get accepted at the Salon. His most ambitious earlier painting, *St Jerome Tempted*, which had been rejected in 1846, was now ruthlessly cut up to provide some canvas for a medium-sized painting of *Oedipus Cut Down from the Tree*, submitted and accepted in 1847. It was painted, almost trowelled on in the thickness of the paint, in a feverish manner, bold enough to be compared (by one critic) to Tintoretto.[4] Millet was in combative mood, evidently regarding the battle for recognition as inevitable but equally, as the quotation suggests, as an unwelcome grind.

How were these tensions reflected in Millet's drawings? There is one instance in which it might be supposed that he illustrated his metaphor of the continual grind, perhaps even before he found words for it. On a small piece of grey paper he drew in black chalk a nude man: tall, big-boned but emaciated, he uses both arms to turn a handle, geared to a gigantic wheel twice his height (Fig. 3.6). The function of this wheel is not entirely clear. The axle suspended between two

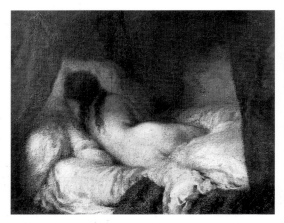

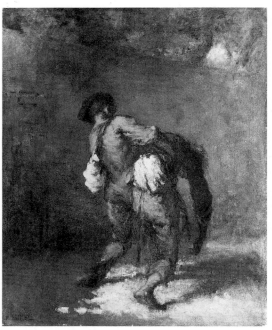

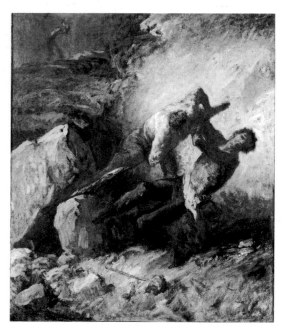

upright wooden posts resembles the great wheels used in industries of an earlier era, such as those illustrated in the plates of Diderot's *Encylopédie* (Figs. 3.1, 3.2). This particular wheel is big enough to wind a heavy cable. Alfred Sensier mentions, among the 'realistic' subjects that Millet painted during the period immediately prior to the revolution, a picture of 'des carriers tirant un treuil des moellons de Charonton'.[5] A figure down the slope beyond the wheel carries a large stone on his back, while further away another man seems to be rolling a heavy stone up a hill: Sisyphus, surely. Yet if this association was intended, the mixture of contemporary realism with classical myth is curious. Even more curious is the possible reading of human figures on the wheel itself, lying flat around its rim.[6] Are they tied to a wheel of fortune?[7] Or is he intending a more direct metaphor for the rack of the poor and underprivileged? Viewing Millet's creative procedures with hindsight, it seems most likely that in this drawing he began with a strictly realist representation of quarriers in mind, but moved towards broader symbolic overtones as the drawing progressed. It is unique in his *œuvre* at this early date, and carries within it the seeds of the type of symbolism that emerged later in his career. Stylistically it should be dated about 1846–7, and it does seem to connect with his statement quoted at the start of this chapter.

Of the many drawings that can be dated to Millet's pre-1848 Paris period, a number are of mythological subjects and of nudes. A good example is *L'Education d'un faune* (Fig. 3.7), in which a wild-looking man holds a young faun on his knee while teaching him to play the flute. His anatomy is similar to that of the man

Facing page:

3.3 Millet. *Sleeping Nude. c.*1845–6. Oil on canvas, 33 × 41. Paris, Louvre (RF 2402).

3.4 Millet. '*The Good Samaritan*' (Workman supporting a colleague). *c.*1847. Oil on canvas, 39.4 × 30.5. Cardiff, National Gallery of Wales.

3.5 Millet. '*The Quarriers*' (Workmen excavating debris in Montmartre). *c.*1846–7. Oil on canvas, 74 × 60. Ohio, Toledo Museum of Art.

3.6 Millet. *Man Turning a Wheel. c.*1846–7. Black chalk, 15.6 × 15.6. Paris, Louvre (GM 10,762).

3.7 Millet. *L'Education d'un faune.* 1846–7. Brown and black chalk, 21 × 16.9. Paris, Louvre (GM 10,447).

3.8 Millet. *Apuleius. c.*1846. Black chalk, 17.1 × 14.9. Ottawa, National Gallery of Canada.

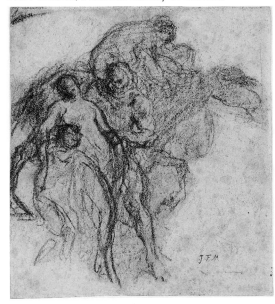

turning a wheel. The bony arm with broad flat triceps, and elongated thigh terminating in a massive knee-joint, seem to belong to an invented type of masculinity: not drawn from a posed model, but squeezed out of Millet's imagination by empathy.[8]

In his treatment of female nudes Millet used much softer contours. The tall lady in the drawing called *Apuleius* (Fig. 3.8), being supported by two attendants after her grotesque affair with the ass (the transformed Lucius Apuleius), is outlined just as firmly as the *Man Turning a Wheel*, but in rhythmic curves rather than angular transitions. These soft and pliable forms are again achieved, apparently, by empathy. There is a large group of drawings of this kind, whose subject matter ranges from 'intimate domestic' – Millet's wife getting in and out of bed – to scenes of myth and specific eroticism. Daphnis and Chloë, for example, are rendered as conspiring lovers of some sophistication; other couples engage in

3.9 Millet. *The Stone Cutter* (*Le Tailleur des pierres*). *c.*1846. Black and grey chalk, 31.5 × 26.2. (Sale Amsler & Ruthardt, Berlin, 28–9 Oct 1924, lot 637).

3.10 Carle Vernet. *Scieur de pierre* (*The Stone Cutter*) Lithograph from *Les Cris de Paris*, 1815.

3.11 Daumier. Two studies of a *Bricklayer's Mate Mounting a Ladder.* Black chalk, 33 × 27. (Present owner and location unknown).

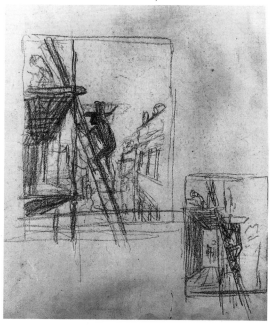

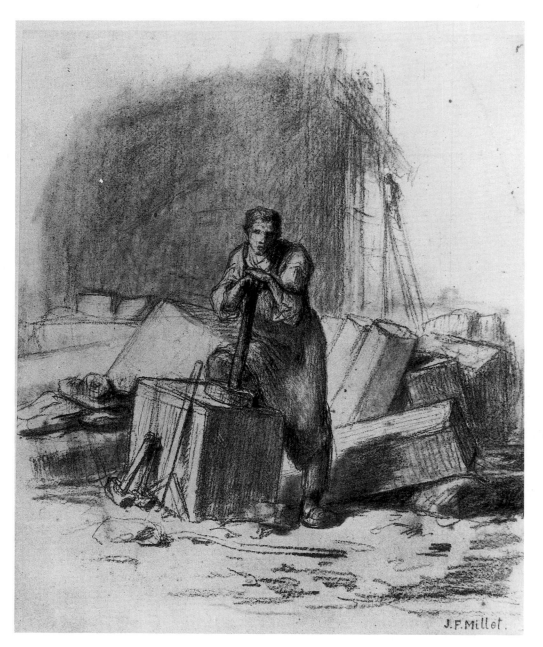

drunken orgies in vaguely Arcadian settings. Black chalk is the medium in which Millet most often brings these fantasies to life; some others are sketched in pen and ink with an incisiveness (and perhaps cynicism) comparable to Géricault at his most sexually obsessed. This aspect of his art, which continued for four or five years, will be discussed further in Chapter 5.

The Stone Cutter (*Le Tailleur des pierres*) (Fig. 3.9) is a quite different type of drawing. It appears to be a very direct representation of one of the artisans belonging to the ancient guild of masons, working on a building site.[9] It is executed in a close-hatched, tightly defined style, in two tones of black and greyish chalk with some stomping, and cannot be dated later than 1846. It could easily have been adapted by an engraver for an illustration of the trades of Paris; alternatively it might have been inspired by one such. Stone cutters often appear both in the *Cris de Paris* series of prints and in the illustrations to Diderot's *Encyclopédie*.[10] For the type shown in Millet's drawing, a fair analogy would be Carle Vernet's *Scieur de pierre* (Fig. 3.10), working out of doors with a very large

3.12 Daumier. '*Vois comme ils m'avaient abimé mes murailles...*' ('*Look how they've mucked up my chimney flues!*'). Lithograph, published in *Charivari* 19 September 1848 (LD 1623).

LOCATAIRES ET PROPRIÉTAIRES.

Nº 30.

Imp. Aubert & Cⁱᵉ

Chez Aubert Pl. de la Bourse.

— Vois comme ils m'avaient abimé mes murailles avec leurs conduits de cheminée...... on ne devrait pas permettre aux locataires de faire du feu!....

1848.114

wood-framed cross-saw. Millet's rendition of his stonemason is given a more anecdotal twist by the addition of another figure climbing the scaffolding behind him. That particular image is most commonly found among Daumier's lithographs on the rebuilding of Paris, from the late 1830s onwards. In fact an undatable, but possibly pre-1848 drawing in black chalk by Daumier of a labourer climbing a ladder (Fig. 3.11) seems to show some rapport with Millet in style as well as subject. Whether or not Daumier intended this as a study for a lithograph,[11] the two sketches on the recto shown here are enclosed in frames as though for a painted subject, to depict the worker *per se* – an idea that was perhaps never executed.

It is also possible to compare Millet's drawing technique in *The Stone Cutter* to Daumier's drawing style in lithographs. A fair comparison would be Daumier's cartoon in his series *Locataires et propriétaires*, where a proprietor watches workers demolishing a building (Fig. 3.12). If we ignore the joke caption, it can be looked at as a highly competent drawing, in a style explicit and functional, with neatly

3.13 Millet. *Men Working at a Forge, c.*1847–8. Black chalk, 13 × 12.8. Paris, Louvre (GM 10,468).

3.14 Daumier. *Un forgeron (Man Working at a Forge). c.*1850–5. Black chalk over charcoal, 28 × 21. (Sale Parke Bernet, New York, 28 October 1974, lot 106).

controlled vertically and horizontally hatched shading. Almost any lithograph by Daumier produced between 1846 and 1848 – the period under discussion – will show similar qualities, and it should be remembered that he was already famous for these cartoons when Millet arrived in Paris. The latter would not have hesitated to learn from Daumier's professional techniques of representation, and he certainly seems to have done so here.

Before we consider the relative involvements of Daumier and Millet with the 1848 revolution and its effects, a more discriminating look at some of their drawings dealing with working-class subject matter may be useful. It is well known that Daumier's very left-wing republicanism first manifested itself during the uprisings of 1830. When working people appeared in his ferociously anti-monarchist lithographs of 1830–5, they took on the dual roles of hero, as in the triumphant printer with fist clenched in *Ne vous y frottez pas!* (Fig. 2.19), and of oppressed class, as in *Prison Royal.*[12] However, during the period 1835 to 1848 direct political censorship prevented *Charivari* from publishing anything of a potentially subversive nature. Daumier's lithographs during this period were obliged to be harmless cartoons, essentially comedies of manners showing the pretensions and follies of the *petit bourgeois*. This was a class which Daumier knew well, and in a sense, and in a sense belonged to himself, by virtue of his trade as an artist-journalist; in another sense he did *not* belong to it in so far as his dependence on his lithographic stone for a living signified bondage to his employers. The number of occasions on which workpeople appear in his cartoons is small. The man climbing a ladder in the *Robert Macaire architecte* lithograph is presented distinctly backstage; likewise the men swinging picks in *Look how they've mucked up my chimney flues!* (Fig. 3.12) are quite subsidiary to the bourgeois who makes

32

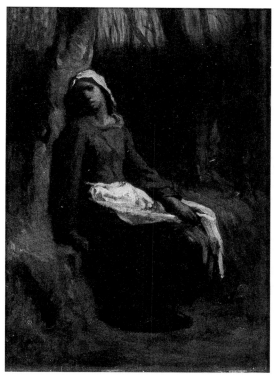

3.15 Millet. *La Délaissée (Abandoned Woman)*. 1847–8. Oil on canvas, 35.5 × 26.5. Oshkosh, Winsconsin, Paine Art Centre and Arboretum.
3.16 Millet. *La Délaissée (Abandoned Woman)*. 1847–8. Black chalk, 21 × 12.6. Boston Museum of Fine Arts (Gift of Miss Olive Simes, 1945).

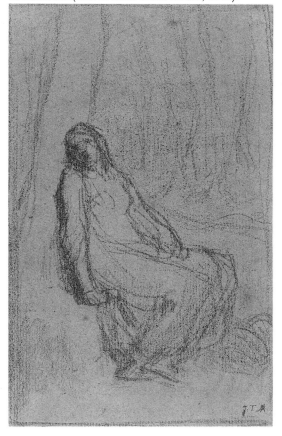

the comment. A rare example of an explicit reference to sympathy with the workers is the lithograph *Ouvrier and Bourgeois*, in which a top-hatted man looks greedily into a shop window full of food while a workman thoughtfully reads a newspaper across the street.[13] Daumier's feeling of triumph at the outcome of the 'February days' in 1848 was short-lived.[14] By the time of the June uprising he was already in disagreement with his editors, who wished the insurgents to be represented as hooligans.[15] It is ironic that there are such infrequent clues to Daumier's political sympathies in his published work, whereas Millet, whose politics was never very clear, was directly portraying the so-called *classes dangereuses* – inhabitants of the factory suburbs of Paris, peasant imigrants to the city, quarry workers, and so on – in the late 1840s, before we can find them in Daumier's surviving drawings.

Millet's painting known as *The Quarriers* (Fig. 3.6) of *c*.1846–7 has already been mentioned. Its real subject is navvies excavating debris in Montmartre, then on the outskirts of Paris, presumably in preparation for rebuilding. One of the two men desperately trying to move a large stone by leverage is reminiscent of a Michaelangelo slave in his pose.[16] It may be quite coincidental that the distant figure swinging a sledgehammer over his head looks like a first cousin to the men in Daumier's 'demolition' cartoons of 1848. But this image occurs in the work of both artists again and again: in Millet's case more frequently in drawings supposedly with rural settings. A man swinging a hammer or mallet over his head can also be using it to split wood. Yet Millet had not yet left Paris for the countryside of Barbizon and the Fontainebleau forest: his rural experiences were still confined to his youth in Normandy. His images of labour and poverty produced in Paris during the period 1846–9 take on a generalised form.

Millet's drawing of *Men Working at a Forge* (Fig. 3.13), similar to the *Man Turning a Wheel* in style, is clearly an urban subject. The very large furnace might be similar to the one described by Zola in his novel *L'Assommoir*, in the factory where he placed his character Goujet.[17] The figure holding the pincers on the left is rendered nude, with a large body and small head, while his companion on the right appears to be clothed. The drawing is awkward and clumsy, but the image it produces is arresting. We can find exactly the same subject in a group of drawings by Daumier in the late 1850s. Daumier's preliminary sketch for his own figure of *Un forgeron* (Fig. 3.14) may be compared to Millet's. Their interpretation differs: whereas Daumier characterises a gnarled, wiry, bald-headed man wearing an apron, Millet creates a more generalised, heroic image of a classical nude. (He might have been clothed in a more finished work.) But the first strokes of Daumier's drawing, in charcoal, show that he too conceived the figure as nude in the first instance.

A different theme, relating to the social issues of the time and again treated by both artists independently, is that of poverty and distress, particularly of women. Millet's painting, *La Délaissée*, and the preliminary drawing for it, deal with such an issue (Figs. 3.15, 3.16). Alexandra Murphy has argued that the painting, although clearly based compositionally on the drawing in Boston, has undergone a number of changes, including the adoption of peasant dress which presents 'an image of innocence, as well as deeply felt sadness'.[18] This is not to say that Millet had a Barbizon peasant in mind at this stage, since this picture was painted in Paris. The woman could be any household worker,[19] a peasant immigrant to the city perhaps, who for reasons which one must infer has lost her job and retreated to the forest. Her expression of total despair is more vivid in the drawing, where her anxiety is expressed by agitated lines, as well as her more scanty attire which suggests 'a sexuality which may be the root of her sorrow'.[20] Abandonment of females, and their consequent impoverishment to the point of death, was very much a current subject of investigation by emergent sociologists in the 1840s and

3.17 Millet. *La Mendiante* (*Mother and Child Begging*). 1848. Black chalk on grey paper, 33 × 20.5. Paris, Claude Aubry.

3.18 Daumier. *Une mendiante et deux Enfants* (*Woman Begging with Two Children*). 1850s. Black chalk and some grey wash, 19.6 × 24.2. Rotterdam, Boymans Museum.

1850s. Another drawing by Millet which closely relates to this theme is *La Mendiante*, in which a woman is begging on a street corner (a carriage passing in the background indicates the urban setting), perhaps holding out flowers or matches, while a small child shelters under her cloak (Fig. 3.17). Her extended stomach may suggest that she is pregnant. Robert Herbert sees this image as specifically belonging to 'the troubled year of Revolution in Paris',[21] though there was enough poverty in Paris to stimulate Millet most of the time. Again a comparison could be made with a similar subject drawn by Daumier, in this case in the 1850s, *Une mendiante et deux enfants* (Fig. 3.18). Here Daumier renders sadness and resignation primarily through the woman's features, evoked by a few light strokes of the chalk. Where Millet's beggar woman bends her head forward in a supplicating gesture, Daumier's stands more upright, arms hanging down to support her baby as in a sling. She stands resigned, her gaze directed downward to the child in front of her, she sings with open mouth to invisible passer-by.

Both situations just mentioned relate to that section of society which popular sociological literature classified as *Les Pauvres*, for example an essay by Moreau-Christophe in *Les Français peints par eux-mêmes*.[22] Mendicity, or begging,

34

3.19 Daumier. *Le Malade*. Lithograph, published in *La Revue des Peintres*, 1835. Paris, Bibliothèque Nationale (LD 255).

3.20 Daumier. *La Bonne Grand'Mère*. Lithograph, published in *La Revue des Peintres*, 1835. Paris, Bibliothèque Nationale (LD 254).

is described there as the fourth degree of misery, the direct result of indigence which drives the hopeless one out on to the street. This, the writer continues, is a social disease which if not prevented will lead to the lowest degree of misery – crime committed from want. Among the class of indigents may be found many who for one reason or another are *unable* to work; these include 'les filles abandonnées'. Another group in this class, presumably older than the first, are 'les femmes veuves ou déclassées'. More curiously included are 'les femmes nourrices ou enceintes': a reference to the still prevailing practice among the upper classes of putting their babies immediately out to wet-nurse: such wet-nurses, themselves with babies, would be very low on the poverty scale.[23] Millet's *La Mendiante* would, presumably, soon qualify for this classification.

Age and physical infirmity as a reason for poverty had also been noticed by Daumier. His early lithograph *Le Malade*, published in 1835 (Fig. 3.19),[24] forms a kind of counterpart to Millet's image of *La Délaissée*. The rural setting is unusual for him and uses fairly standard symbolism: an old gnarled tree stump with few remaining leaves; a low-roofed cottage on the edge of the forest; the cottager's daughter with a little bundle of faggots. The expression on the old man's face as he sinks down, literally by his last milestone, is intended to be easily read by all for its simple sentiment (not one usually associated with Daumier in his more robust moods). But at a deeper level this image does have to do with poverty, and the thinness of the line between life and death for those who live at the edge of the forest: a primeval concept which Millet would later develop. This particular print has more of an eighteenth-century look to it, a rural idyll artificially sweetened. Its Greuze-like sentiment is repeated in another print made for the *Revue des Peintres* in the same year, called *La Bonne Grand'mère*,[25] which, while it extols the

3.21 Millet. *The Old Woodcutter*. 1845–7. Black chalk on beige paper, 40.2 × 28.6. Paris, Louvre (GM 10,744).

virtues of family life, also gives the viewer a cottage interior clearly of a poorer class (Fig. 3.20). The working-class poor had also been portrayed in this way by English artists like George Morland and Francis Wheatley, and one wonders whether Daumier knew of their work through prints.[26] The expressions on the faces of Daumier's family, however, show an earthy realism most characteristic of him. This distinctly pictorial treatment of prints – which had last been used for his great political lithographs like the *Rue Transnonain* massacre of 1834 (Fig. 1.1), until works like that were suppressed – was not carried on into Daumier's weekly cartoons for *Charivari*, for which he developed a more incisive graphic style. But

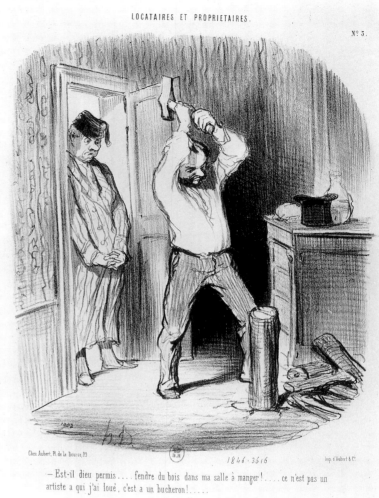

N.º 3.

Chez Aubert, Pl. de La Bourse, 29 imp. d'Aubert & C.ⁱᵉ

1846·3616

—Est-il dieu permis.....fendre du bois dans ma salle à manger!..... ce n'est pas un
artiste a qui j'ai loué, c'est a un bucheron!.....

3.22 Millet. *Woodcutter Swinging an Axe. c.*1847–
9. Black chalk, 29.3 × 21.2. Marseille, Musée
Grobart Labadie.

3.23 Daumier. *Est-il dieu permis . . .fendre du bois
dans ma salle à manger!* ('*In God's name . . . chopping
wood in my dining room!*') Lithograph, published in
Charivari 3 March 1847 (LD 1596).

if we do not find the inhabitants of his working-class world much in his cartoons
after this, we will find them wandering into his more private drawings.

Millet also treated general themes of poverty quite early in his career, but first
produced them in the style of his neo-rococo *manière fleurie* paintings. One of his
earliest drawings of rural figures is *The Old Woodcutter* (Fig. 3.21) of 1845–7.
Although this is a powerful image, it depends a good deal upon the art of the past
for its configuration – Brueghel for the archetypal made of the figure, and Titian
perhaps for the almost mannerist turn of the legs.[27] A similar swaying motion is
imparted to one of the first of many images Millet was to produce of woodcutters
working in the forest, either felling trees or digging rough ground with picks and
mattocks. The *Woodcutter Swinging an Axe* (Fig. 3.22), drawn before Millet's
departure from Paris, looks rather like a dancer in tights on stage (because he was
conceived out of Millet's imagination, nude), although he is swinging a hefty
blow. The firmness and fluency of the contours, drawn in black chalk, may still
express some debt to Daumier's highly developed (and at this epoch rapid)
lithographic drawing style, as shown for example in a *Charivari* print of 1847:
Est-il dieu permis . . .fendre du bois dans ma salle à manger! . . . (Fig. 3.23). This
hilarious image may be a sly comment on the political situation at the time –
maybe this badly behaved tenant, in the eyes of his bourgeois landlord, is a
subversive peasant in disguise! Be that as it may, the wiry vigour of the contours

37

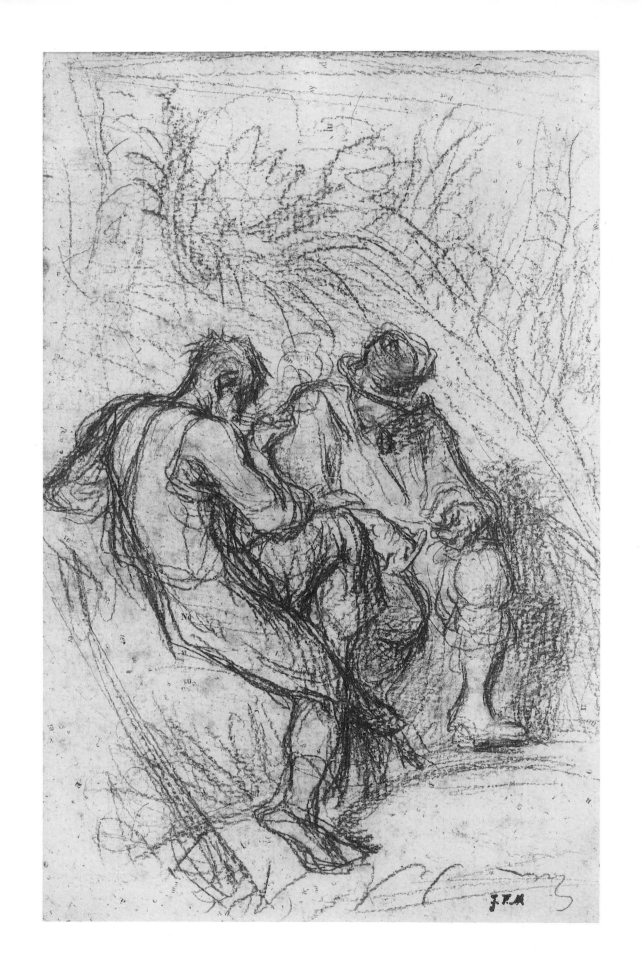

3.24 Millet. *Two Men in Conversation. c.*1848–50. Black chalk on wove paper, 31 × 20. Brooklyn Museum, New York. (Gift of the Estate of Mrs William F. Putnam.)

and the rich, velvety blacks of Daumier's print could surely have been a source of inspiration for a whole group of drawings of peasant labourers or field workers (their locations are indistinct) that Millet executed just before his departure from Paris and perhaps just after his arrival in Barbizon, that is, in the period *c.*1848–50. Taken together with a group of drawings of women drawing water and washing clothes (who will be discussed in Chapter 6), they form the core of his peasant iconography of the 1850s. I will include just one example of this group here, *Two Men in Conversation* (Fig. 3.24), a drawing which is now in Brooklyn Museum. The men may be road workers or peasants resting on a bank while one smokes his pipe. As will now often happen with Millet, the figures are not very particularised: we can see what type of people they are but we do not know them as individuals. What was the cause of the spiky, scratchy, disobliging urgency of this image, roughly scribbled in black chalk over lumpy paper? The relationship of the figures is one of casual intimacy with their environment. The suggestion seems to be that Millet has just discovered a new world – or rediscovered an old one – in which he is far more at home than he was in the city. And he now possesses sufficient armament as a draughtsman to be able to express it in the simplest notation.

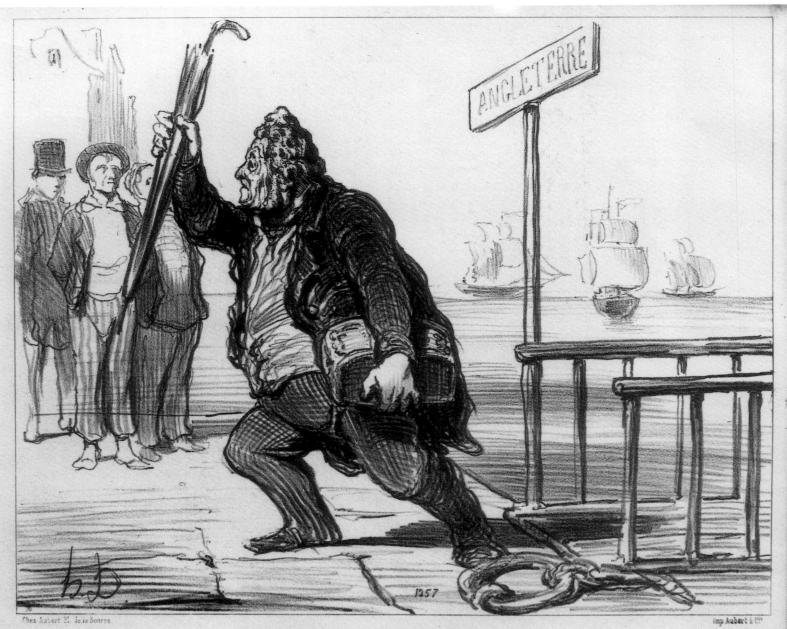

ANGLETERRE

Tout est perdu ! fors la caisse.......

4 Daumier: Lithographs and Drawings to 1850–1

DAUMIER'S PUBLISHED LITHOGRAPHS by no means furnish the complete explanation of his drawing style, because by the period in question he was using a highly developed formula resulting from continuous practice in this medium. That is not to suggest that his images were reached without a struggle, and without numerous corrections on the stone: I have shown elsewhere that the technique of lithography enabled Daumier to suppress all signs of labour and alterations from his final proofs.[1] Before we consider the significance of his few surviving drawings made specifically for lithographs, let us examine the impact the finished prints might have made on Daumier's public (or readers, we should call them, taking into account the captions).

Readers of *Charivari* required a message that could be understood instantly. The 1847 lithograph *Est-il dieu permis . . . fendre du bois dans ma salle à manger!*, discussed in the previous chapter for its graphic style (Fig. 3.23), holds the reader's eye first as a purely expressive image: the relationship between the two men's faces, one determined, one indigant, and the quite unexpected juxtaposition of the violent axe-swinging with what is evidently a middle-class abode. The type of room is conjured up with a laconic mastery of effect: a patterned wallpaper, which anyone who has stayed a night in an old Paris hotel can imagine; and a chest of drawers on which rests a decent top hat (deceptive sign of the lodger's 'class'!) and a carafe of water. The caption below – which almost certainly would not have been written by Daumier – is pure gloss on all this message already received, the caption writer simply inventing a line of dialogue as comic as the visual image. Or nearly as comic. The anonymous writer decides that the lodger is an artist (Daumier?) and that the landlord compares him to 'un bûcheron' – woodcutters being a potentially dangerous class of peasant.

With the advent of the 'February Revolution' in 1848 Daumier took his last opportunity to pillory the departing King Louis-Philippe with just such a concise armoury of expression. In the print *Tout est perdu! fors la caisse . . .* Louis-Philippe is shown arriving on the English coast (preposterously labelled *Angleterre*), cash-box under his arm (Fig. 4.1). The weight and balance of the fat king holding his umbrella aloft like a sword is as clearly rendered as the man swinging an axe in the other print. It has been remarked that Daumier was surprisingly kind to the old king, whom he had represented so viciously as the people's enemy in the 1830s. In a related print purporting to be a design for a medal with Louis-Philippe's head on it, to be struck by the Royal Mint, Daumier simply represents him as old and ineffectual, which he probably was at that time.[2] Very far from politically naive, Daumier was no doubt already aware of other conservative forces working against his socialist interests. The bogey of Louis-Napoléon was already apparent in prints like *An Alibi* (published on 9 June,

4.1 Daumier. *Tout est perdu! fors la caisse. . .* ('All is Lost! Save the Cash-box'). Lithograph, published in *Charivari*, 7 March 1848 (LD 1744).

4.2 Daumier. *Paquebot – Napoléonien*. Lithograph, published in *Charivari*, 7 December 1848 (LD 1754).

1848).[3] By the end of the year Daumier had drawn *Paquebot – Napoléonien* (Fig. 4.2), the obverse of Louis-Philippe's departure. Louis-Napoléon, whose beaked nose and moustache were to become the symbol of the Second Empire, arrives like a pygmy in an inverted tricorn hat, being towed ashore on the banks of the Seine by a bedraggled eagle.

It is not disputed that Daumier produced his finest lithographs when inspired by a good political target. The problem is to find the link between his popular (i.e. published) and his private imagery (his personal world as revealed in his drawings). There is always the danger of confusing his own views with the directions of his editors, especially when the captions were written by others. Much has been written about the frustrating effect of his labours on the lithographic stones. It has been pointed out that whereas his cartoons were generally funny his drawings never were (except when related to potential cartoons). It has even been suggested that there was no meaningful relationship between Daumier the cartoonist and Daumier the artist.[4] I think the reason for this misunderstanding lies in the inhibitions imposed upon Daumier the cartoonist by his editors, his public, and by censorship, at different periods. During the period until 1850–1 his situation was particularly ambiguous, because around 1848 political fortunes were changing so rapidly. The content of his lithographs series needs some investigation for the signs that lie beneath the most obvious comic mesages. His drawings too can be studied beyond the point of stylistic connoisseurship, for the reasons that might have brought them into being.

Immediately prior to the Revolution, the series *Locataires et propriétaires* (1846–8) reflected one of the most serious social problems of the day, an overcrowded Paris. *Les Bons Bourgeois*, another series very popular with the public for obvious reasons, are treated with sympathy as well as mockery for, as has already been observed, Daumier understood both their world and that of the working class. Workers appear very seldom in his lithographs, even in 1848, which makes the exceptions particularly interesting. 'He's smoked enough pipes to season his head!' is a rough translation of the caption to the print showing a worker seated on a wall of the Quais (Fig. 4.3).[5] Who is this monkey-faced labourer, enigmatically smoking, arms folded in silence, slippers dangling from idle feet? What is he waiting for? His pipe may *seem* to be seasoning his head, or alternatively his political colour and seasoned experience may be the cause of his expectant look.[6] The errand boy, to whom the impertinent comment is attributed, is even ruder about a bourgeois gentleman who appears in the pendent cartoon, *There's a special one who must be uneasy about his nose again this year . . . considering the outbreak of potato blight!* (Fig. 4.4).[7] The gentleman's nose may look like a potato, but that he is uneasy 'this year' is more significant. The errand boy acts like a Greek chorus, and his striking similarity to the street urchin who watches the most sinister of all Daumier's *saltimbanques* banging a drum, in a magnificent watercolour of the 1860s (to be discussed later)[8] forms a direct link between the artist's public and private imagery.

After the 'February Days', the outcome of the new democracy was uncertain for two months, and the organisation of the various socialist groups confused. Around April–May 1848 the editors of *Charivari* became alarmed about the working-class aspect of the revolution: for example the mass demonstrations initiated by the socialist clubs and the organised trades. Crowds gathered on the streets every night from early May onwards. The *élite* companies of the National Guard were dissolved, whilst new working-class recruits received arms.[9] In a lithograph published on 5 May, 1848, a simple peasant asks his local mayor, '. . . des communistes que qu'c'est ça?', and is told that they are people who wish Frenchmen to have money, work and land in common. The bumpkin opines that

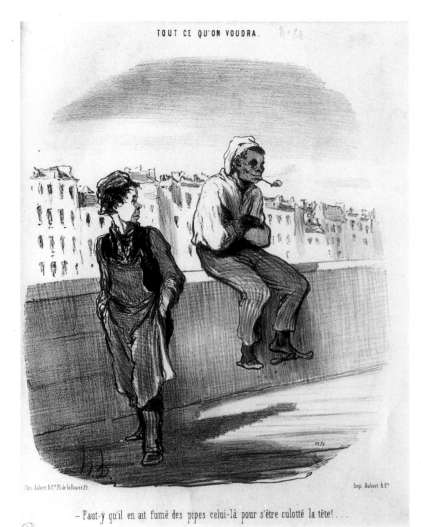

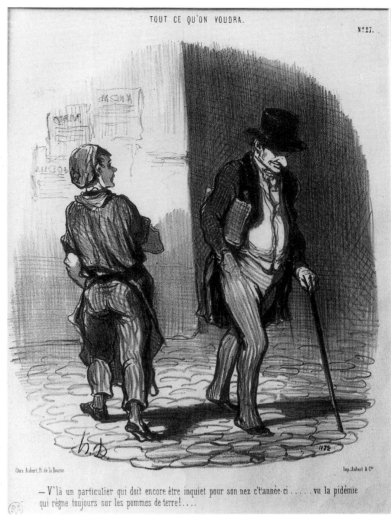

– Faut-y qu'il en ait fumé des pipes celui-là pour s'être culotté la tête! . . .

– V'là un particulier qui doit encore être inquiet pour son nez c't'année-ci vu la pidémie qui règne toujours sur les pommes de terre!

4.3 Daumier. *Faut-y qu'il en ait fumé des pipes celui-là pour s'être culotté la tête!* (*. . . he's smoked enough pipes to season his head*). Lithograph, published in *Charivari*, 23 November 1847 (LD 1670).

4.4 Daumier. *V'là un particulier qui doit encore . . .* (*There's a special one who must be uneasy . . .*). Lithograph, published in *Charivari*, 4 December 1847 (LD 1673).

they lack common sense.[10] The over-simplistic expression on the peasant's face, and the cynical expression of the patronising mayor, might have been acceptable to *Charivari*'s readers at that time, but the joke is rather a silly one and it is questionable whether Daumier had just such a text in mind when he drew this image. We shall never know. It is relevant, however, that this lithograph appeared just after the defeat of the Left in the National Elections (results were announced on 28 April), partly through the failure of the 'missionaries' sent out by the socialist clubs to tour the provinces.

When the workers protested against the dissolution of the National Work-shops, leading to the disastrous insurrection of 23 June, *Charivari*'s editors did not approve, and there are no Daumier lithographs on either subject. Nor were there any references to the workers having lost their freedom of assembly thereafter.

The two series of prints, *Les Divorceuses* and *Les Banqueteurs*, published later in the year, appear ostensibly to be humorous side issues. The local militia seem jolly and harmless, although the matter of banquets was a curious one: such gatherings were only considered safe when they did not involve the labouring classes.[11] As for *Les Divorceuses*, some commentators have expressed surprise at Daumier's male chauvinism in his representations of women. Nevertheless, when the woman speaker in the print *Citoyennes . . .* (Fig. 4.5) addresses the crowd with a magnificent gesture of exhortation, and the whole scene is rendered with a fine

43

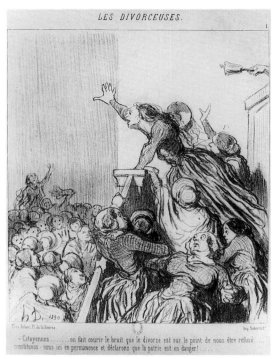

– Citoyennes........on fait courir le bruit que le divorce est sur le point de nous être refusé.....
constituons-nous ici en permanence et déclarons que la patrie est en danger!....

4.5 Daumier. *Citoyennes . . . (Les Divorceuses).*
Lithograph, published in *Charivari*, 4 August 1948
(LD 1769).

4.6 Daumier. *Deputy P.L. Parisis.* 1849.
Lithograph (unpublished), location unknown. (LD
1990).

baroque flow of line and tonal contrast, one may wonder why Daumier pulled out all the stops for this topic, unless it is meant to be taken as some larger metaphor for the loss of liberty.[12] Werner Hofmann, in the course of some interesting observations on the sometimes ambiguous relationship between Daumier's cartoons and their subtitles, has suggested that this particular print seems shallow 'once we are confronted with the ironic subtitle'.[13] I agree with his view that we should look back to the quality of the lithograph itself in this case, and notice its similarity in design to some of Daumier's great drawings of uprisings, like the Ashmolean *The Riot* (see Fig. 4.13).

Other clues to Daumier's political position may be found in the series *Les Représentants représentés*, a complete series of satirical portraits of the members of the constituent and legislative assemblies (not all the prints were published), which occupied Daumier for two years, from 24 November 1848 to 19 August 1850. Although the satire is relatively mild compared to his caricatures of Louis-Philippe's Deputies two decades previously, there are some interesting extremes between Daumier's likes and dislikes, evident in his varying treatment of individuals. In the print of *Le Comte de Falloux*, for example, the ultra-cleric who introduced a bill which delivered primary school teaching into the hands of the Church in June 1849, is represented as a priest both pious and sinister, 'en sa qualité de frère ignoratin' as the legend puts it.[14] His associate *P.L. Parisis*, Bishop of Arras and a Deputy, is represented holding a whip, and with huge insect-like eyes set in a head that floats like a bubble over his body; terrified children run away in the background (Fig. 4.6). According to Delteil only one proof was known, which belonged to Daumier's sculptor friend Geoffroy-Dechaume. The quality of the drawing is not particularly distinguished in the print, but there is an odd connection between the poses of the running children and a very fine independent drawing, in black chalk and wash, of a boy running (Fig. 4.7). The expression of terror on the boy's face in this drawing appears to have no explanation, unless it was originally connected with this minor caricature. In contrast to the other Deputies in the series, another unpublished print shows *Deputy Louis Blanc*, a committed labour leader and historian, with a friendly and intelligent expression on his big square face.[15]

Increasing press censorship must have inhibited many of Daumier's projects from about 1850 on, although the government could not do much about his invention of *Ratapoil*, as we shall see. His principal attacks on his enemies (from the vigour of the drawings one must assume they were his enemies personally, rather than targets produced by *Charivari*'s editors, though the extent of collusion is difficult to establish) appear in two innocent-sounding series of prints, *Tout ce qu'on voudra* (1847–51) and *Actualités* (1849–51). Dr Véron, the editor of the right-wing paper *Le Constitutionnel*, became a regular target for Daumier's wit. His myopic, piggy face, half smothered by his wing collar and cravat, became an almost obsessive symbol of corruption. Dr Véron and *Le Constitutionnel* were made into the same visual entity, the one symbolising the other: they were made to stand for ignorance, bigotry, complacency, self-indulgence and self-interest. (In point of fact, *Le Constitutionnel* simply supported the interests of the middle class.) Dr Véron is shown in states of debauchery – *Le Tentation du nouveau Saint Antoine*[16] – and, in 1852, as a kind of ringmaster of a circus of subjugated dogs, the dogs representing the common people.[17]

But what happened to Daumier's republican neighbours, the proletariat to the east and south-east of the Ile de St Louis? The poor were rarely allowed to appear on the pages of *Charivari* during the Second Empire. One exception is the print *Le spectacle est une chose bonne pour le peuple de Paris, il vient s'y délasser le soir des fatigues de journée*[18] – if, again, one can get around this patronising caption (Fig. 4.8). What a sad spectacle! Intrigued but not laughing, this silent crowd is presumably

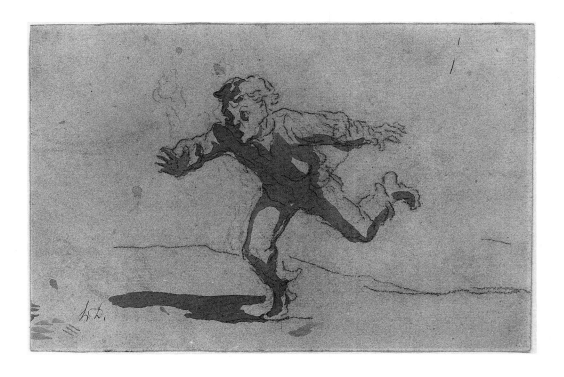

4.7 Daumier. *Boy Running.*? 1850s. Black chalk and wash, 15 × 23. Washington, D.C., National Gallery of Art (Rosenwald Collection).

4.8 Daumier. *Le spectacle est une chose bonne pour le peuple de Paris...* (*A spectacle is a good thing for the people of Paris...*) Lithograph, published in *Charivari*, 4 February 1849 (LD 1679).

watching a performance at a popular theatre. Or could it be a political meeting? At the beginning of the Second Republic Paris was full of socialist clubs in all districts, but only six survived 'violations' of new laws designed to suppress them, and they were finally proposed to be outlawed by the National Assembly on 20 March 1849. Daumier drew this lithograph for publication on 14 February.

During the years in which Louis-Napoleon worked his way into becoming President of the Republic and, finally, autonomous ruler of France, Daumier followed his footsteps in cartoons. In February 1850, a blindfolded Deputy trips over the stump of the Republic proclaimed on 24 February 1848 – it has been cut down.[19] In April Daumier drew one of his most powerful lithographs, *Un parricide*, showing Deputy Thiers approaching *La Presse*, personified as a slender goddess radiating light, with a huge club that he is about to swing at her head.[20] At the end of May universal suffrage was ended, and three million men were deprived of their votes. Louis-Napoléon stepped up his campaign against the Republicans by employing propaganda agents, a manoeuvre which Daumier exposed by one of his most brilliant inventions – his own propaganda 'agent', Ratapoil. This raffish *agent provocateur* was represented as a corrupted remnant of the old Napoleonic legend, a decrepit dandy turned thug, in top hat, tailcoat, and carrying a stick which is actually a club. *Ratapoil* appeared first as a statuette modelled in terracotta (Fig. 4.9).[21] Without being a specific libel of any one individual (the nose and moustache only faintly resembled Louis-Napoléon) its import was sufficiently clear to cause the liberal historian Michelet to say, upon discovering it in Daumier's studio, 'Ah! You have hit the enemy directly. There is the Bonapartist concept forever pilloried by you!'[22] Once born in three dimensions, this figure was used as the source of cartoon after cartoon, until the image became familiar to the memory to every reader of *Charivari*. It is true that Ratapoil's exploits are often so outrageous as to draw almost affectionate laughter from the viewer, as for a clown.[23] Nevertheless, Daumier does seem to have used this figure to issue warnings of the effects of Bonapartist propaganda. He associates him with the members of the 'Société de secours du dix décembre';[24] represents him with a claque of men (recruited from street thugs) drawn up to

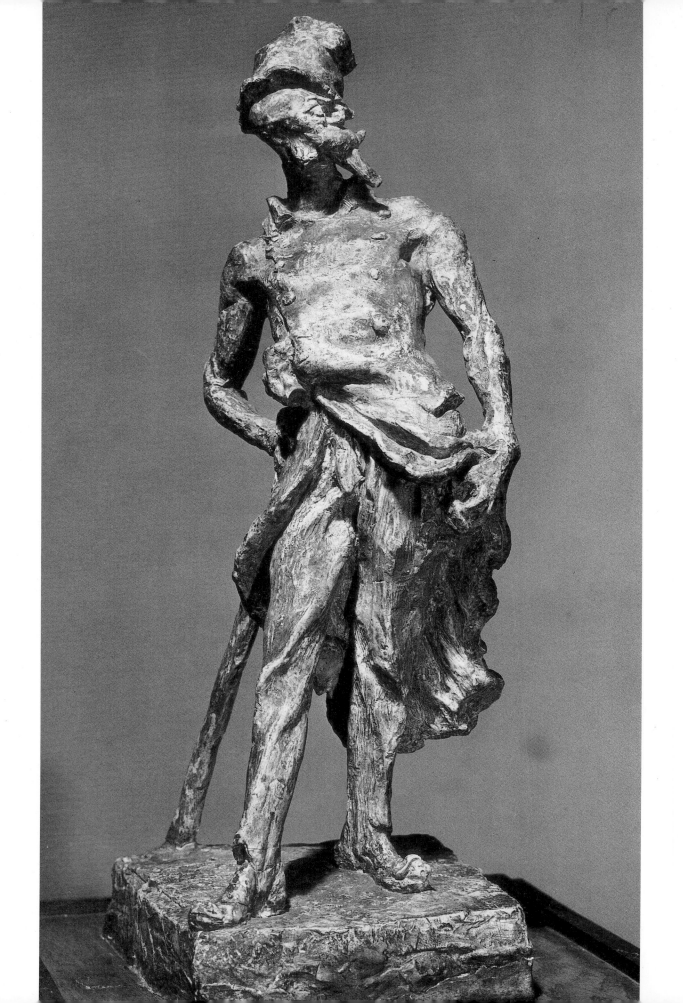

4.10 Daumier. *Un chemin dangereux*. Lithograph, published in *Charivari*, 20 August 1851. (LD 2139)

cheer the President's parade;[25] and trying to frighten the peasantry into voting for him, with threats about the effects of communism.[26] In August 1851 he drew *Un chemin dangereux* (Fig. 4.10), with Ratapoil, Dr Véron, Thiers, and the Deputy Montalambert sliding down a cliff face, away from a statue of the Republic. The sentiment of this is closely linked to another print showing Montalambert perched on the shoulders of a monk, attempting to extinguish the sun with his conical hat shaped like a candle snuffer (having already extinguished Liberty of the Press and Education, we are informed).[27] The approaching *coup d'état* of December was foreseen, with a direct lampoon on Louis-Napoléon himself, 'crossing the Rubicon' of the river Seine towards Parliament, just below the surface of the water so that all that could be seen was his tricorn hat. All to no avail. On the day of the *coup d'état* itself, 2 December, a print of Daumier's was published showing 'commerce' bursting in on two seedy characters playing cards by candlelight – one of them is Ratapoil – and saying 'What the hell, gentlemen, finish playing at this game . . . it's beginning to annoy me to have to pay the costs of the party!'[28] Daumier and his scriptwriter seem to have been at one here. But that was about all that Daumier was able to express against the regime. There were a few more jibes at Dr Véron as we have seen (he brought a libel case against *Charivari* in 1852), but otherwise the prints in the *Actualités* series concerned themselves thereafter with the harmless 'bon bourgeois' again. The workers appear just occasionally to frighten him, in the context of demolition to make way for the new Haussmann boulevards through Paris, but their situation is merely comic. The effective end of the Second Republic had been reached: over the next year Louis-Napoléon purged the Republican opposition, and at the end of 1852 he became Emperor.

Daumier's activities as a satirical cartoonist, commenting upon current affairs, must have taken up a large proportion of his energies during the years 1849–51. Only in the year 1848 had the number of lithographs produced for *Charivari* (approximately ninety) been significantly fewer than in previous years. But during the next three years he produced 155, 134 and 153 lithographs respectively, many of which were directly or indirectly political in content. These match the numbers he produced in the year immediately preceding the Revolution (141 in 1847) and in the year after the *coup d'état* (146 in 1852). The fact that a significant proportion of his best prints produced during the Second Republic did not get published in the journal suggests that his views may have been too exteme for his editors, at least for some of the time, or just inappropriate for whatever delicate political line they were treading then. There can be no doubt that he was an engaged commentator. In periods when his cartoons were dealing only with social comedy they often show signs of repetitiousness, implying boredom, but at this time this was seldom the case. It is the more surprising, then, that during this same period Daumier also attempted to launch himself on a serious career as an *artiste-peintre*. Certainly his exhibited works were few, and he was dilatory about fulfilling commissions, but when we consider the quantity of original drawings produced as well, some relating to paintings and some made as independent studies, it is clear that his decision was a serious one.

The subject matter he turned to in his own painting was from a different kind of 'Republic' than the political one treated in *Charivari* at this time. He seems to have been more concerned with a private 'Republic' of his own, a closed community perhaps, that lay at his front door on the Ile St Louis. Readers of *Charivari* might never have known that it existed. Dating the drawings made for himself (or rather for sale to his friends, for we are not yet fully into an era of 'art for art's sake') is of course a problem. There are a few fixable points, nevertheless, which can give us a clue to his developing style as a free draughtsman. Most of the drawings datable to the 1850s I shall discuss in Chapter 7 under the title

4.9 Daumier. *Ratapoil*. Plaster statuette from clay of 1850, height 43.18. Buffalo, N.Y., Albright Knox Art Gallery, Elisabeth H. Gates Fund 1954.

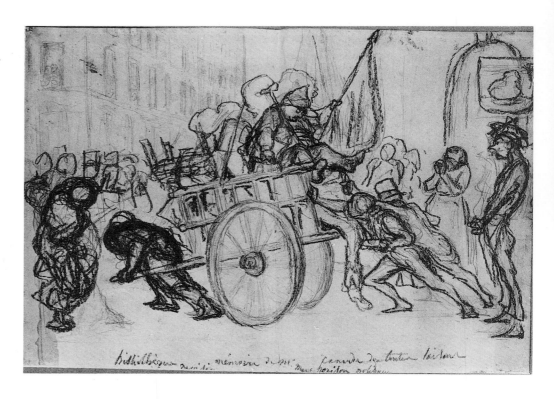

4.11 Daumier. *Grrrrand Déménagement du Constitutionnel ('Le Constitutionnel' Moving to New Premises)* 1846. Pencil and black chalk, 29.3 × 42.5. Private collection.

'Daumier's Republic', to distinguish it from the short-lived political one. In the meantime we should look at some of the 'fixable points' in this period of transition.

One firmly datable drawing is *Grrrrand Déménagement du Constitutionnel* (Fig. 4.11). This is a rare preparatory drawing for a large lithograph which appeared in *Charivari* on 8 June 1846, as a satire on that journal and its editor, Dr Véron (Fig. 4.12).[29] On the day before the publication of the lithograph *Charivari* had printed a humorous announcement that one of their most celebrated artists, M. Daumier, was going to produce a 'history painting' which, although a little grey in colour, would place him at the side of M. Ingres. The drawing shows not only signs of careful preparation, for example the pencilled perspective of the Montmartre tenement houses and the delineation of the handcart and figures, but also evidence of frequent corrections, as the accents are applied in black chalk on top of the underdrawing. Thus the menial figure pulling the cart seems to be pushed forward and downwards as Daumier's crayon presses on his back. The figure to the left in the drawing seems to be wound up like a corkscrew as the artist works out his basic movement, subsequently translated (in the lithograph) into an onlooker making an ironic gesture of farewell. All the essential features of his design are found in this drawing, from the *Serpent de Mer* lying limply beneath the fat proprietor (Véron) on top of the cart, to the pastry-cook from 'La Brioche Constitutionnelle' watching his customers depart for ever, his despair expressed by the S-bend concavities of his meagre body. There is a strong possibility that this drawing, which in its 'raw' creative state perhaps expresses the artist's feeling better than the finished image, was transferred directly on to the face of the stone and extensively reworked there. As always, all traces of struggle were removed before the stone was ready for printing.

The existence of that drawings omewhat belies the general belief that Daumier always drew his cartoons directly on to the stone. It also reveals the fact that his 'untreated' drawings, while fluent in imaginative invention, were far from graphically fluent in the sense of facility. As for all great draughtsmen, the full

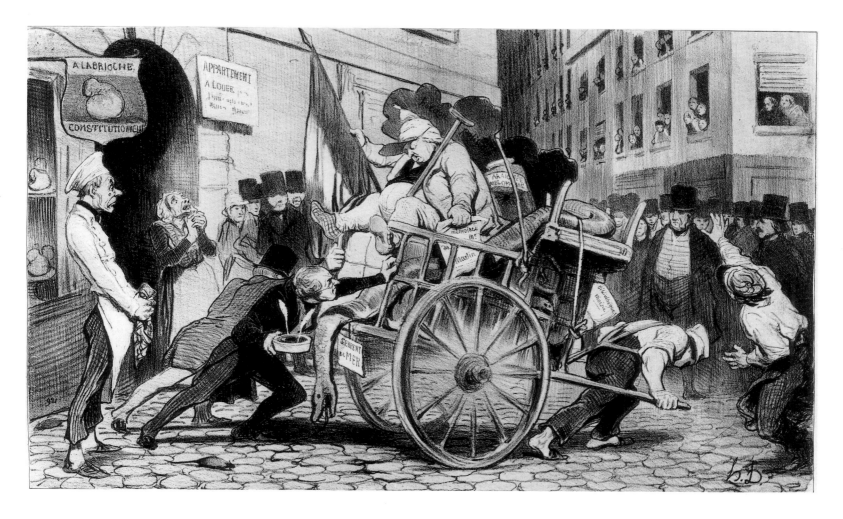

4.12 Daumier. *Grrrrand Déménagement du Constitutionnel* ('*Le Constitutionel*' *Moving to New Premises*). Lithograph, published in *Charivari*, 8 June 1846 (LD 1475).

realisation of an expressive image was a matter of continuous struggle. This is confirmed by the few other surviving compositional drawings made for lithographs: *Grand défilé de l'armée . . . pour entreprendre la fameuse expédition de Rome à l'intérieur* of 1850 is another example for which a vivid drawing exists;[30] and another much later one, again concerned with satirising a newspaper editor, is *L'Interrement de Girardin*, published in 1860.[31] It seems possible that the artist made many more such sketches for litographs, some of them mere doodles, and simply destroyed them once the stones were done.

When we turn to other drawings of this period *not* made for lithographs, then Daumier's struggle to fuse his inner, imaginative world with his outer, observed one begins to be revealed. The date of the project to illustrate Henry Martin's *Histoire de France* (which never came to fruition) is generally agreed to have been about 1849–50. Two of the three surviving drawings for it are clearly enough scenes of Revolution; the third, and most interesting, is less explicit. This is the drawing variously described as *L'Émeute* (*The Riot*), *Scene of Revolution*, or *The Destruction of Sodom* (Fig. 4.13). This extraordinary scene could be taken as a universal image of destruction, comparable in power, if not in scale, to Picasso's *Guernica*. The design is a turbulent vortex of lines, spinning anticlockwise from the outflung arm of the man at the upper window to the crashing masonry against a bright sky in the distance (is this the destruction of Sodom or the demolition of Paris?), down to the crowd of fleeing figures who surge towards us, both fighting each other and carrying their wounded, and up again to the bald-headed giants clambering up the terrace on the right. All the faces have manic expressions, as

4.13 Daumier. *L'Émeute* (*The Riot/Scene of Revolution/The Destruction of Sodom*). *c*.1848–50. Charcoal, grey and sepia washes, black chalk and gouache, 58 × 43. Oxford, Ashmolean Museum.

4.14 Daumier. *The Death of Archimedes. c*.1848–50. Brown and black charcoal, 42.6 × 38.9. Budapest, Museum of Fine Arts.

though they are in a state of frenzied claustrophobia. In the distance there seem to be fires burning. The fact that the figures are all nude, as in a Michelangelo *Last Judgement*, gives this picture an air of allegory rather than recorded history. The way the drawing has been built up by progressing through different media, starting with groping lines in charcoal and moving to black chalk, sepia wash and touches of white gouache in alternating layers, indicates how Daumier allowed his image to grow on the paper in stages as it became clearer in his mind. This mixture of techniques would become a common practice with Daumier in his drawings and watercolours worked up for sale. One of the most elaborate of these was the *Silenus* watercolour which he sent to the Salon in 1850 (see p. 72); such works are complete pictorial images, not studies *en route* to something else. Yet

the drawing called *L'Émeute* has an unfinished look, as though Daumier's nightmare, like some of the works of Goya, could never be resolved.

The Death of Archimedes (Fig. 4.14) is another 'dark' image which appears to have grown on the paper, and indeed to have been enlarged so that it now lies on three sheets of paper fitted together. This large drawing is executed in two kinds of charcoal, one brown and one black. It looks as though Daumier began by drawing the soldier in brown, and the head of Archimedes, and then extended the whole composition upwards and across to the left in this colour, adding two pieces of paper. Afterwards he reinforced some parts of the drawing in a heavier black, particularly the figure of Archimedes and the soldier's foreshortened foot. The distant vista of buildings and fallen bodies is rendered entirely in black charcoal. Thus, Daumier first imagined the physical action and then invented a setting for it. The cryptic signs in the foreground have been taken as a reference to the great mathematician of Syracuse, here about to be slaughtered by a Roman soldier who was angry at being rebuked by Archimedes for trampling on his diagrams in the sand. They probably represent two of Archimedes' theorems: the measurement of the area of a circle by the value of π, and the measurement of a parabola by its quadrature. (It is interesting that Daumier should know this.) The soldier is rendered nude on the Davidian model, and Archimedes' head resembles that of David's *Belisarius*, but there is nothing neo-classical in Daumier's conception of the incident. It seems rather to reflect a deep pessimism of mood, possibly related to the collapse of the Second Republic which was probably taking place at the time when he drew this.

A significant theme of Daumier's work in various mediums at this period is that of flight, or *Les Émigrants*. At least one of his two plaster reliefs of this motif is attributed to *c*.1848–50 (Fig. 4.15).[32] Jean Adhémar was probaly correct when he suggested a specific political reference here to the deportation of 4,000 republican refugees to Algeria by the end of 1848.[33] Several existing drawings are related to this theme, among which the most complete study is the one in black chalk, pen and wash from the Roger-Marx collection and now in the Louvre (Fig. 4.18). This straggling procession, in which all the figures are rendered nude, symbolises all refugees at any period in time. In the drawing, the head of the leading stretcher-bearer is drawn on a larger scale at the bottom of the sheet, with an expression like that of a character from some classical tragedy. But in the procession the figures are faceless, anonymous. The woman leading her child on the right, hand over her face, resembles a banished Eve (Fig. 4.16). The mother and child group Daumier drew several times separately, sometimes in relation to this theme and sometimes related more to his paintings of washerwomen on the

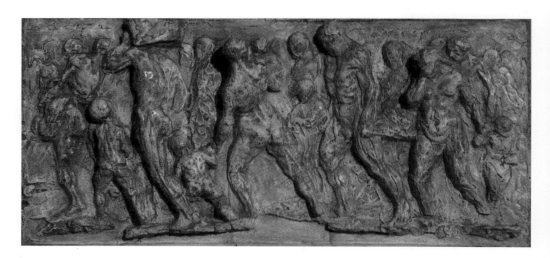

4.15 Daumier. *Les Émigrants. c.*1848–50. (Copy of original plaster relief from Geoffroy-Déchaume collection.) Plaster, 34.6 × 74. Private collection.

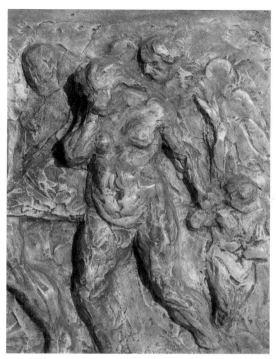

4.16　Daumier. Detail of Fig. 4.15.

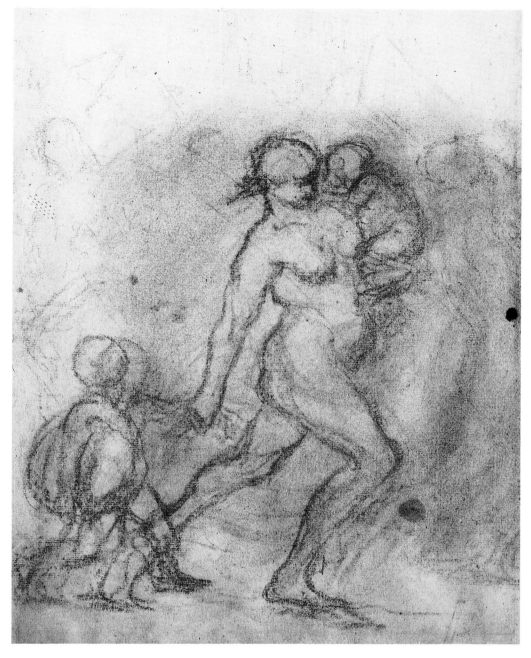

4.17　Daumier. *Mother and Two Children.*
*c.*1848–9. Black chalk over charcoal, 36 × 26.5.
Whitworth Art Gallery, University of Manchester.

banks of the Seine (see Chapter 7). In a drawing in the Whitworth Art Gallery (Fig. 4.17) she carries one child and leads another. This was begun in charcoal which has become badly rubbed – presumably from lying around in the studio and being handled as a working drawing – and the relief-like contours were redrawn in black chalk. The scratchy, searching style of such a drawing is like the one he did before his big lithograph (Fig. 4.11), and is thus another reminder of how Daumier really worked when pursuing his private researches alone in the studio.

A different style of drawing altogether, but datable to the same period as those discussed and also relating to the theme of flight, has acquired the given title *Une femme désespérée* (Fig. 4.19). It can be directly related to a small panel painting which shows a very similar young woman with hair and clothing blowing behind her in a wind, although the messages each composition transmits may be slightly

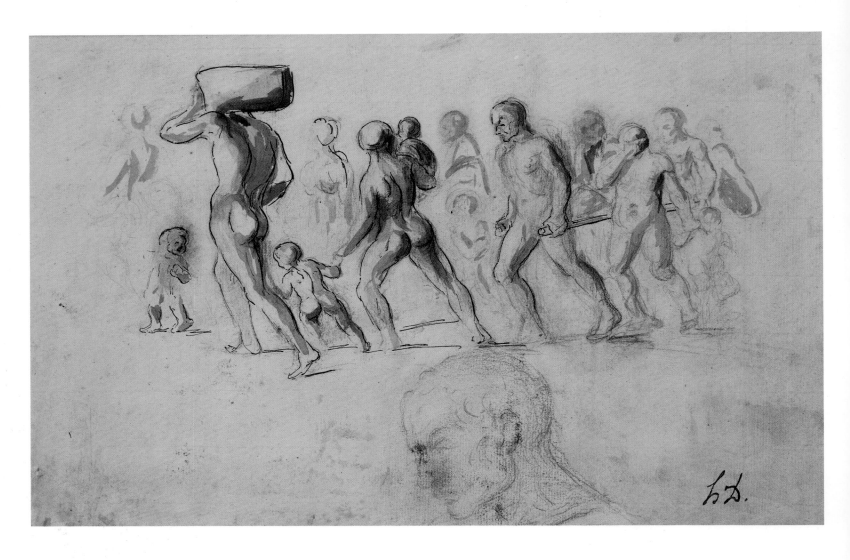

4.18 Daumier. Study for *Les Émigrants* relief. *c.*1848–50. Black chalk, pen and wash (head in black chalk and sanguine), 25 × 37. Paris, Louvre (Inv RF 36,801).

different. The 'despairing woman' in the drawing, tramping along some unspecified path, perhaps by a sea-shore, holds an object against her bosom, beneath her cloak, which is evidently a baby. This would place her, iconographically, with the class of *femmes abandonnées* that we have already noticed as treated by Millet (see Chapter 3, pp.33–5). She is drawn in charcoal on very coarsegrained paper that has been sized and painted with white gouache,[34] which gives it a texture rather like a canvas. The actual form of modelling here, by areas of tone rather than a sculptural conception, further suggests that this drawing was made with a painting in mind. The rather heavy transitions from light to dark conform to Daumier's early painting style, of about 1848–9.[35] The related painting (Fig. 4.20), which may be a year or two later,[36] shows the young woman leading her child by the hand, with hills indicated in the background. How this acquired the title *Course au bord de la mer* is hard to determine. *Un coup de vent* is more explicable, but both given titles are merely an indication of how wide of the mark such names can get when the owner (or dealer) has no idea what the subject signifies and invents one to facilitate a sale. Given the existence of several other paintings of refugees or fugitives by Daumier, and the context of the related drawing, there is little doubt that this painting too is concerned with flight. The image is as concise and self-contained as we have now come to expect of this artist in any medium. The anonymity of the people represented, taken together with the warmth of their physical relationships, places this last group of images as the

4.19 Daumier. *Une femme désespérée* (*A Woman Fleeing*). *c.*1849–50. Charcoal and white gouache, 38.8 × 27.5. Vienna, Albertina Graphische Sammlung.

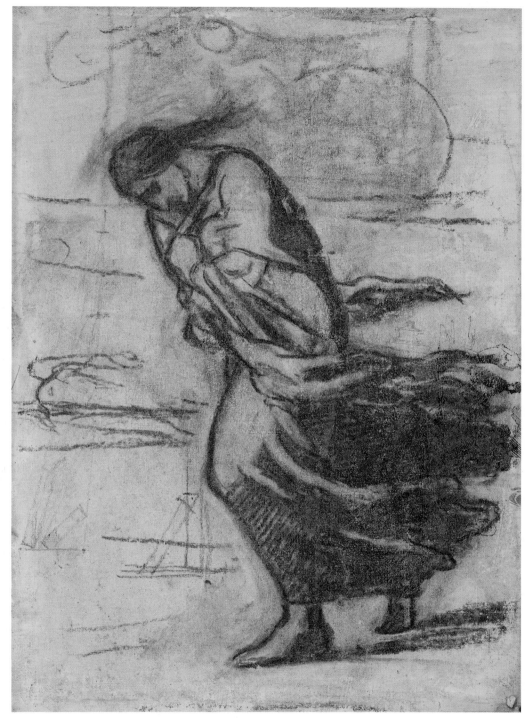

4.20 Daumier. *Course au bord de la mer* (*Woman and Child in a Gale*). *c.*1849–55. Oil on panel, 20.5 × 14. (London art market, 1965).

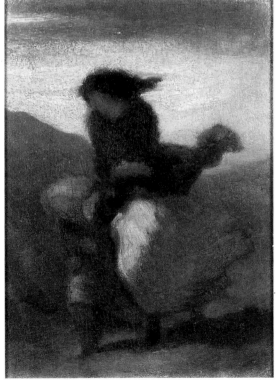

signifiers of Daumier's emotional and ideological position vis-à-vis the demise of the Second Republic, after he saw the promise of the February Days wiped out.

There is one codicil to that gloomy observation. In 1849 there was another reason for flight from Paris besides a political one. The outbreak of a severe cholera epidemic during the summer added to the general troubles. As a result of this, on August 9 Daumier accompanied his young wife to the small seaside resort

4.21 Daumier. *Croquis du jour*: ('*the fat deputy across the road . . .*') Lithograph, published in *Charivari*, 27 August 1849 (LD 1939).

of Langrune, not far from Caen, along with a family friend, Mme Muraire, and the latter's two children. Although the long journey of 237 kilometres took two days by diligence, and they needed a passport from the Prefecture of Police to pass between Paris and Caen, Daumier himself only acted as escort, starting back for Paris again on the next day, August 11. His six letters written to 'Didine' after his return are rare documents, since normally he would not write a communication of more than a sentence or two to anybody if he could help it. The letters reveal a touching degree of affection; they also reveal a deep personal disquiet at her absence.[37] His news is fairly laconic, however. He reassures her that the cholera epidemic is not getting worse in Paris at least; he visits her mother and her younger brothers, he dines with M. Muraire (who had also remained in Paris), and he is busy 'doing his [lithographic] stones'. For the rest, he buys her a month's subscription to a popular newspaper called *L'Estafette* so that she can keep up to date with events, and he mentions the news of the Revolution in Hungary, but says nothing about the political scene in Paris itself. However, we may glean a clearer picture of Daumier's own involvement with this, from the specific lithographic stones on which he was working.[38] In the three and a half weeks between his arrival back in Paris on Sunday August 12 and his departure for Langrune to fetch Didine back again on September 6, it seems that he completed about fifteen or sixteen stones. These almost certainly included the series of six *Souvenirs du Congrès de la Paix* (LD 1940–1945), which give a sardonic view of international politicians talking high-mindedly of pacifism, and the interpretations, both cynical and trivial, of their resolutions – an image of a female disciple of Richard Cobden fiercely attacking two scrapping dogs with her umbrella stays in one's mind. There were also four prints added to the series *Représentants représentés*, one of which was not published.[39] Other lithographs produced in these weeks included some for the series *Actualités*, with further sarcastic references to the ineffectiveness of the 'Congrès de la Paix', and an oddly subversive scene of workers seated on the quayside opposite the Legislative Assembly, making sneering remarks about 'the fat deputy across the road – we know him well', in *Croquis du jour* (Fig. 4.21).

In his letters to Didine, Daumier said he was counting the days to her return. When we juxtapose these letters with his lithographs, which show his sense of the political stresses in the capital during that hot August, and note the fact that he himself had no holiday, some sense of the forces that drove him may now be understood.

5 Private Imagery and Public Commissions: the Second Republic and the Salon

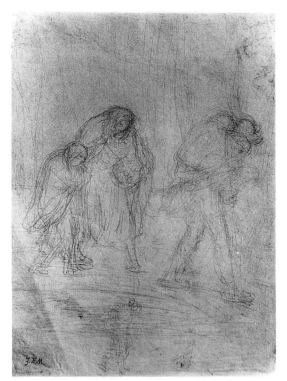

5.1 Millet. *Arrival at Barbizon. c.*1849–50. Drawing, probably pencil. Location unknown .

5.2 Daumier. . . . *des plaisirs de l'automne (. . .the pleasures of Autumn in the country.* Lithograph, published in *Charivari*, 29 November 1845 (LD 1416).

IN JUNE OF that same year, 1849, Millet had left Paris as his home for ever. Deliberately fleeing from the cholera, he had only intended to stay away for a few weeks. His own drawing called *Arrival at Barbizon*[1] appears to be a cathartic memory of the experience, as the two families, Millet's and Charles Jacque's arrived on foot, literally carrying their children and their provisions from where the diligence had dropped them on the Paris – Fontainebleau road (Fig. 5.1). Millet's drawing portrays himself and his family walking through a rainstorm, rendered by swirling lines expressing agitated movement. He is in the lead carrying two little girls on his shoulders, followed by his wife carrying a baby protected by her gown thrown over her head, and a little maidservant holding a bundle brings up the rear. This drawing could be taken as an autobiographical memoir, at the level of illustration: in this sense it is comparable to Daumier's lithograph *Ce qu'on appelle aller jouir à la campagne . . . des plaisirs de l'automne* of 1845 (Fig. 5.2).[2] A preliminary thumbnail sketch of the woman holding up her dress, at the bottom of Millet's drawing, is especially comparable to Daumier's figure. *Arrival at Barbizon* may also carry something of a more generalised, epic conception of refugees.

Closer comparisons between the two artists can be made when we look for images of the darkest side of human nature. Millet's equivalent of Daumier's *Archimedes* (Fig. 4.14) would be a drawing such as the so-called *Massacre of the Innocents* (Fig. 5.3). A Roman soldier, helmeted but nude, flings open a door upon a scene of massacre as violent as the study by Poussin (Fig. 2.10), but which also has a more orgiastic appearance, a sensual horror in the rendering of the woman bent over backwards, somewhere between the story of Bluebeard and Delacroix's version of *The Death of Sardanapalus*.[3] The man doing the stabbing seems to have half a dozen contours for every limb, rendered in jabbing strokes that look as though Millet was holding the crayon in his fist, empathetically stabbing the woman again and again. In the lower right-hand corner of the sheet is a curious fragmentary image of an open mouth with protruding teeth. Although this is a very small drawing, no more than a frenetically scribbled note for a composition, its conception does seem to reflect the kind of mental unease that we noticed in Daumier's more elaborate rendering of murder of Archimedes.

Violence, uncertainty, dispossession – neither Daumier nor Millet were immune to such images in their private, conceptual drawings. Daumier's drawing known as *Le Baiser* (Fig. 5.4), reasonably dated by Adhémar to *c.*1848–50, should be looked at closely in this context. Drawn in brown chalk on thick, almost parchment quality paper, the firm and heavy contours are similar in style to his *Archimedes*.[4] A nude man, faun-like with elongated thigh-bones and short forelegs, holds a nude woman by her voluptuous torso and embraces her with a

5.3 Millet. *Massacre of the Innocents*. 1848–50. Black chalk, 13.3 × 20.7. Paris, Louvre (GM 10,450).

degree of violence. Behind them a rocky forest landscape is perfunctorily indicated. (Alternative 'given' titles have been *Nymphe surprise* and *Adam et Eve*.) In some respects it anticipates the overt Rubenesque style of *Silenus* (which Daumier was to send to the Salon of 1850–1), but the sinister urgency of this particular image also gives a suggestion of rape. The heavily muscled shoulders and bald head of the man are reminiscent of the figures in *The Riot* (Fig. 4.13). There are, moreover, some curious iconographic sources of parallels to be found. The earliest of these is a very large painting in Marseilles Museum known as *La Peste de Marseille*, by Jean-François Detroy (1679–1752) (Fig. 5.5).[5] A group of two figures near the centre of this complex composition, comprising a convict seizing the semi-nude corpse of a woman plague victim, are remarkably close to the pose of Daumier's two figures, albeit in reverse. Detroy's painting is said to have been executed in 1722,[6] not long after the incident depicted had taken place, so that it is a very early example of a 'modern history' picture, although of course highly dramatised. The lurid, proto-romantic coloration, not altogether characteristic of Detroy who is better known as an eighteenth-century painter of 'boudoir pictures', in this case actually anticipates Géricault and Delacroix. It did not reach the museum of Daumier's native city until 1869,[7] but it was engraved at least three times before then (the last occasion in 1860), and I think that the balance of probability is that Daumier used an early engraving (in reverse) of this reasonably well known image as the source for his own fragmentary composition. If he knew the associations of the subject matter, that would account for the slightly

5.4 (right) Daumier. Le Baiser (The Kiss). c.1848–50. Brown chalk, 30 × 24. Paris, Louvre, Inv RF 4181.

5.5 Jean-François Detroy. Detail of painting La Peste de Marseille (1722). Marseilles', Musée des Beaux-Arts.

5.6 Cézanne. L'Enlèvement (The Rape). 1867. Oil on canvas, 90.5 × 117. The Provost and Fellows of King's College, Cambridge, on loan to the Fitzwilliam Museum, Cambridge.

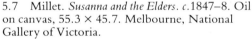

5.7 Millet. Susanna and the Elders. c.1847–8. Oil on canvas, 55.3 × 45.7. Melbourne, National Gallery of Victoria.

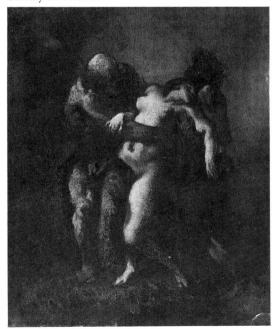

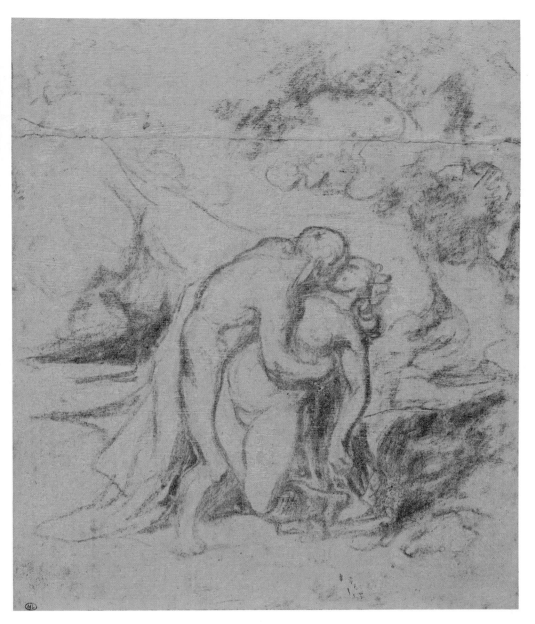

necrophiliac suggestion of his own drawing: his female figure looks submissive to the point of death, and in the Detroy painting the convict certainly displays a passionate interest in his corpse of Rubenesque proportions.

Figurative associations between the attitudes of love, rape and death are not confined to these two examples in the history of art. The pose of Daumier's man lifting the woman should also be compared to Cézanne's painting L'Enlèvement of 1867 (Fig. 5.6), a work which is a landmark in his early period. His figures, like Daumier's, move from left to right in the design, so that his source might also have been the engraving after Detroy.[8] This example of the interchangeability of imagery is compounded by another resemblance: the arm and head of the woman in Cézanne's painting appear to derive from a figure of Christ in an Entombment by Delacroix, of which Cézanne made a drawing.[9] Similar ambiguous associations between mourning and rape are found in a strange, coarsely handled oil sketch attributed to Millet known as Susanna and the Elders (Fig. 5.7). Here the naked woman, who appears to be at least fainting if not dead, is supported by two figures, who might be 'Elders', in an upright position reminiscent of the

5.8 Millet. *Study of Two Figures (Lovers)*. *c*.1846–7. Red chalk, 17.5 × 23.8.. Cambridge, Fitzwilliam Museum.

iconography of a *pietà*. Yet the painting plainly carries associations of rape as well, and the ambiguity of meaning is parallel to that in Daumier's drawing, *Le Baiser*. What this amounts to is that, at the 'melting pot' stage of the creative process (particularly in drawings), a given pose for the human body can exchange meanings very rapidly, the artist's intentionality being dependent on the current state of his psyche.

The dark side of Daumier's psyche in *Le Baiser* is clear enough, but the image is rendered with vigour and energy. There are several drawings by Millet of groups of nude figures which are superficially comparable to this, but they seem to express different states of mind. Millet seems to vacillate between a conception of ideal physical love, and guilt about that very situation. A good example of the first attitude is the sleeping lovers in the red chalk drawing, *Study of Two Figures* (Fig. 5.8). The woman slumps across the knees of her partner, her left arm hanging slackly in the *pietà* position, while his head hangs forward over her shoulder. Her torso is modelled strongly enough, but neither hands nor feet are completed. The sensuality revealed here is essentially passive, a pastoral daydream, without the drama of Daumier's group. This drawing belongs to a

5.9 Millet. *Susanna and the Elders (?)*. *c*.1846–8. Black chalk (size unknown). Paris, Coll. Claude Aubry.

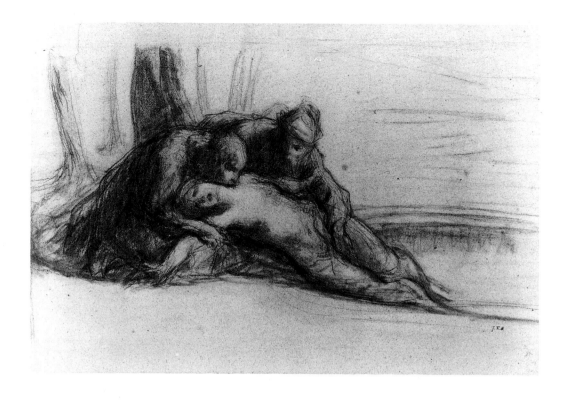

5.10 Millet. *Lovers*. *1848–50*. Black chalk on tan paper, 32.4 × 22. Chicago Art Institute.

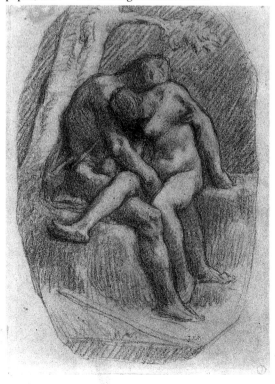

series of imaginary compositions, probably made at the same time as the studies of female nude models that he was making from about 1846–7 onwards while in Paris.[10] In another drawing, which is related to it in form and style, the subject has changed to a more dramatic configuration which has been called *Susanna and the Elders* (Fig. 5.9).[11] A rustic setting is indicated, and the woman's body appears to have been dragged from a pool on the right, in which she may have drowned. The sensuality with which the rescuers, if such they are, are regarding this nude body indicates the same ambiguous relationship between images of love, desire and death found in Daumier's *Le Baiser*.

Possibly one of Millet's last drawings of this type is *Lovers*, in Chicago Art Institute (Fig. 5.10). It has been dated *c*.1848–50, and the great clarity and firmness with which the forms are realised may indicate the latter year. Robert Herbert has suggested various sources for Millet's motif, including Veronese, Correggio and Tintoretto, and he sees it as rendered in the style of an antique or Renaissance relief (a gem or plaquette).[12] The modelling of the forms is certainly sculpturesque, and it is this quality, combined with the sensual, interlocked pose of the figures, that reminds one of Rodin's marble group, *Le Baiser*, executed some fifty years later. The self-absorbed privacy of Millet's image also suggests a kind of gloomy fatalism, which may partly explain its unexpected rapport with Rodin's *fin de siècle* sculpture. The irregular oval perimeter of Millet's drawing should also be noted: he frames his 'plaquette' as though it were carved on a rough piece of wood. His image is thus stabilised, as it were, at one remove from the flesh.

There are other, more erotic, drawings than these by Millet, some of an orgiastic nature, which may have been made with private clients in mind or, on the other hand, may be direct reflections of his own disturbance and anxiety, both in his private life and in so far as he was affected by the political upheavals of 1848–9. In either case, there is a certain lack of coherence in the works he was producing at this stage, which is in contrast to Daumier's clear distinctions between public and private imagery which were noted in Chaper 4.

When, on 14 March 1848, the Provisional Government announced a com-

petition for a painting of a figure representing the Republic, and for a medal commemorative of the Revolution, an entirely new kind of public imagery was hoped for. Six weeks later a very large number of painted sketches was placed on public exhibition – some 450. The entries were anonymous and identifiable only by signs, whose authors could be traced from a separate numbered list.[13] Daumier submitted one entry; Millet may have sent in two different sketches. Judging started on 10 May, 1848, by a 'committee of citizens', which included some of the most distinguished French painters, Decamps, Delacroix, Delaroche, Ingres, Jeanron and Meissonnier among them, as well as some writers and officials.[14] After several meetings, a revised list of twenty painted studies was accepted for enlargement for the second stage of the competition, at a fee of 500 francs each.[15] Daumier was placed eleventh on this list. The Barbizon painter Diaz was also in the closing rounds, and got put on a reserve list of five, to be called upon should any of the first twenty fail to deliver. Daumier, in fact, never delivered his enlarged version, not got paid. Millet was eliminated, but his name does occur on a supplementary list of thirty-four studies whose authors were to be recommended to the Minister for making copies of their figures symbolic of the Republic.

The whole process of the competition was incredibly cumbersome and bureaucratic, and the critics who reviewed the exhibition were not impressed. Daumier's painting, which now hangs in the Musée d'Orsay (Fig. 5.11), is plainly not a beginner's attempt,[16] but it does present a dark, even, matt surface which, I suspect, overlies a dark grey half-tone ground. The main tonal areas are broadly differentiated by arbitrary transitions from light to dark, and the contours of all the figures are reinforced by lines painted with a brush. The principal allegorical figure – seated, holding a tricolour, with two children suckling her breasts while a third reads a book at her feet – has a sculpturesque solidity and is reminiscent of Michelangelo's sibyls in her proportions. Yet in spite of the impasted highlights the heavy, brush-drawn contours make it look more like a 'draughtsman's painting', translated into a medium still somewhat alien to this artist.

A retrospective review of the competition, written by Champfleury later in the year, recalled:

> Nobody will forget that sad exhibition of Republics at the Ecole des Beaux Arts. There were Republics red, pink, green, and yellow, in marble, in stone, in ivory, sunburned, in breeches, scratched, scraped; Republics in floral patterns, in uniforms of the National Guard, in robes of silk, in robes of wool; Republics dressed in chains, dressed in attributes, dressed in nothing at all.[17]

But even citizen Thoré, whose word – wrote Champfleury – counted for something at that time, could not find the true Republic among them. Thoré, the republican writer, missed, lost among this coterie of odious paintings, one simple, serious and modest canvas. This was Daumier's *La République nourrit ses enfants et les instruit*.

> 'Ce jour-là, j'ai crié vive la République, car la République avait fait un grand peintre.
> 'Ce peintre, c'est Daumier!'[18]

Champfleury remained an admirer of Daumier for the rest of his life.

Marie-Claude Chaudonneret, in her recent book, *La Figure de la République: le concours de 1848*, calls Daumier's painting the sole 'chef d'oeuvre' of the competition. She stresses the stability and seriousness of Daumier's image, respecting the regulations of the 'official' programme. Concerning Daumier's 'sign', or rebus, which appears in the lower right-hand corner – a 'double goose-foot'

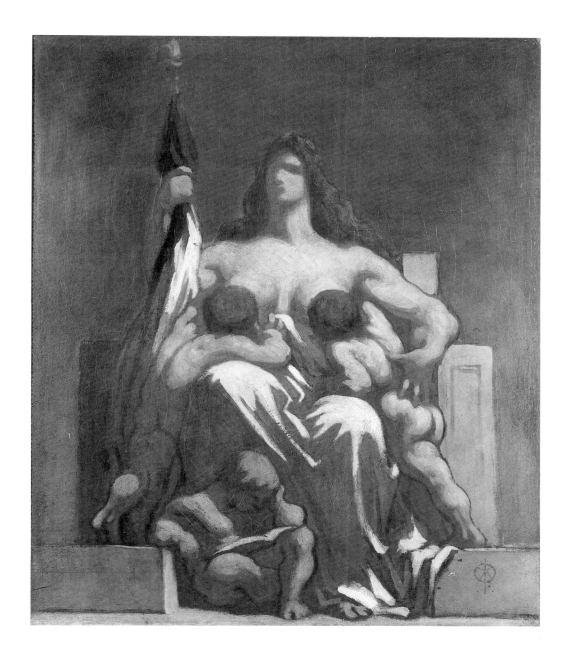

inscribed in a circle, and three points arranged in a triangle – Chaudonneret says these are signs used by the stone-cutters' guilds, and argues that Daumier could very well have seen this mark on a stone on a building and chosen it as his rebus for the competition. She further argues that Daumier was probably aware of its significance, and deliberately set out to produce an idealistic image of a mother figure for the young apprentices, who would become a symbol for universal brotherhood, crowned with laurels as sign of peace and immortality.[19] No documentation supports such an interpretation. Basically, Chaudonneret supports T.J. Clark's thesis that Daumier the lithographer remained at heart an artisan, a member of a group which lost its identity and culture with industrialisation.[20] The first victims of industrialisation, the artisans became 'the first proletariat', and the first to demonstrate in 1848. This is an intriguing argument, and it might account for some of the character differences which appear to have existed between Daumier and his recorded friends, all of whom were more literate and had more or less bourgeois educations – even Millet, though his literacy was

largely self-cultivated.[21] My own reservations about such a totalising interpretation are based on the actual appearance of Daumier's *oeuvre* as it develops through the two decades following 1848. It is true that an important group of his drawings, which will be discussed in Chapter 7, seem to reflect a particular sympathy with the working class; also that a republican historian like Michelet saw him as a natural champion of socialist democracy; nevertheless, Daumier's imagery in his paintings and drawings towards the 1860s and after will be seen to reflect a humanistic programme beyond entrenchment in any one social class.

Millet's entry, or possibly two entries, for the State competition were not successful, and so far only one of the sketches he submitted has recently been traced. This is the one described by Sensier as 'of Lacedaemonian simplicity . . . a noble figure of a woman, large and gentle, who, with a beehive and labouring tools at her side, offered, in one hand, cakes of honey, and in the other, held a palette and brushes. Millet had forgotten or suppressed the red cap, which he had replaced with ears of corn'.[22] A recent X-ray of his 1850–1 painting *The Wood Sawyers* (Fig. 6.12) now reveals that a sketch of *La République* lies beneath it. It clearly indicates the form of a bare-breasted woman, broad shouldered, with both arms stretched out symmetrically, and her left leg bent. It is not clear what she is holding in her hands, but ears of corn around her head may possibly be discerned, and she does, in general, appear to answer Sensier's description of 'a noble figure of a woman', and she may well have been rendered with 'lacedaemonian simplicity'.[23] She is, surely, rendered here as the goddess Ceres or, as Millet put it in a contemporary memorandum to Sensier, the Republic symbolised as Agriculture (see below).

There exists, besides, an oil sketch on panel called *Femme donnant à manger à ses enfants* (Fig. 5.12), which is strikingly similar to Daumier's *La République* in its iconographic derivation from the *carità* theme. The sturdy naked children, whom this woman feeds from a bowl, are like Daumier's, and the woman herself equally derives from Michelangelo's sibyls. The setting of both compositions is a shallow space with the figures set upon simple rectilinear blocks, as in a sculptured relief. The main difference is between the frontal, commanding pose of Daumier's figure and Millet's profile view, which makes his figure appear more human and less hieratic. I cannot see Millet's fluently executed oil sketch in Oran as merely imitating Daumier's conception;[24] on the contrary, the choice of a peasant or working-class woman of Michelangelesque proportions to symbolise the Republic, in both cases, seems to point strongly towards a conscious rapport between the ideas of the two artists. A photograph of a lost painting by Millet of *A Woman Breast-Feeding her Children* (Fig. 5.13), provides an even closer analogy to the motif used in Daumier's *La République*.[25] Executed in Millet's rather rough-handed style of 1846–7, it seems highly probable that some work in this earthy character was a direct inspiration to Daumier.[26]

Daumier did not like allegory much, although the figure of a helmeted woman who serves equally as *La République*, *La Liberté* and *La France* occurs often enough in his politically inspired lithographs. Millet, with his innately complicated mind, seems to have found allegory rather formidable. Worried about the 'complicated Republican symbol', he expressed himself on the subject in one of the first recorded documents addressed to Alfred Sensier, his future biographer. He charged Sensier with clarifying the question directly with the Fine Arts Administration, in the following memorandum:

Ask them to make the choice among the sketches submitted not to be too constricted, not confined to any one type. *The Republic* or *Liberty* is a subject which can be interpreted in many different ways and still be comprehensible to everybody; it would restrict breadth and imagination, if one was tied down by

5.12 Millet. *Femme donnant à manger à ses enfants*
(*Woman Feeding her Children*). 1848. Oil on panel,
32 × 23. Oran, Musée des Beaux-Arts.

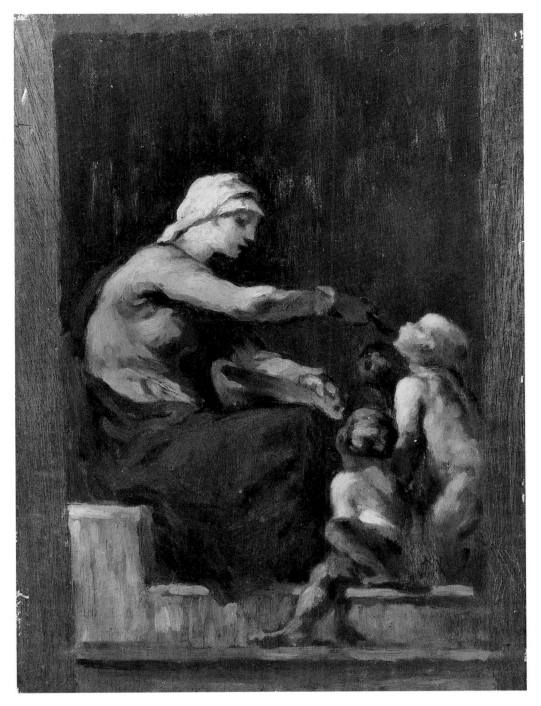

5.13 Millet. *Woman Breast-Feeding her Children*.
c.1846–7. Oil (size and location unknown).

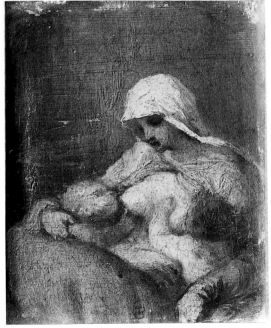

the choice of a single type. The symbol of *Liberty* contains within it all the
others and consequently must be variable according to its purpose: *Equality*,
Fraternity, *Law*, *Justice*, *Agriculture*, *Commerce*, *Science*, etc., [all] having their
principle in *Liberty*, and these diverse emblems, being protégées of hers, must
[all] be able to be placed in the exhibition rooms destined to deal with these
great questions.[27]

A wide interpretation indeed! His choice of *Agriculture* as a protégé of the
Republic helps to explain the iconography of his own designs. Two drawings,
inscribed respectively EGALITÉ and FRATERNITÉ, must relate directly to his thoughts
expressed above. The figure of *Egalité* (5.14) holds a small carpenter's level, of a

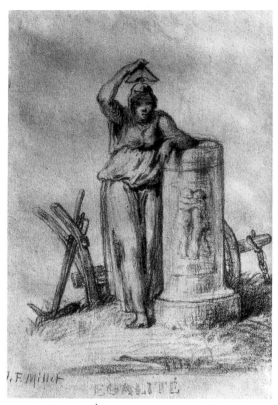

5.14 Millet. *L'Égalité*. 1848. Black chalk, 21.8 × 13.9. Reims, Musée des Beaux-Arts.

Facing page, top
5.16 Millet. *La Liberté*, or *La République* (with spear). 1848–9. Black Size and chalk. (location unknown.) (Size and location unknown.)
5.17 Daumier. *Dernier Conseil des ex ministres*. Lithograph, published in *Charivari*, 9 March 1848 (LD 1746).

5.15 Millet. *La Fraternité*. 1848. Black chalk, 21.7 × 17.7. Paris, Private collection.

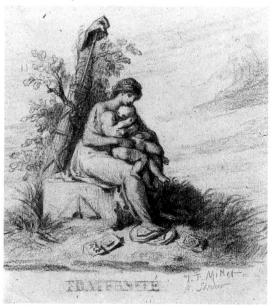

simple type that operates in the manner of scales, above her head with one hand. This device, associated with masonry, makes her a kind of working-class figure of 'Justice'. She leans against a heavy half-column or plinth on which two embracing cherubs are represented as in relief. They are a reference to 'Fraternity', and the primitive singe-wheel plough behind her represents 'Agriculture'. *Equality*, then, is represented in this allegory in classical garb but with strong peasant and proletarian associations. The combined references to Justice, Agriculture and Fraternity are awkwardly put together, and the central figure looks constrained, like a schoolgirl asked to enact a charade in class. The drawing itself is very tightly controlled. An exactly similar control is found in the other drawing, *La Fraternité* (5.15), in which the allegorical elements are reorganised. The carpenter's level now rests on the ground against the stone seat on which the woman sits; the cherubs, still embracing, are brought to life and sit on her knee; behind her a sheaf of bound rods grows into a tree on which hangs the Phrygian cap. Agricultural implements do not appear, but at her feet lie several heraldic shields in disarray. One foot partly covers a shield bearing the family device of Louis-Philippe (the three fleurs-de-lis are still clearly visible). In both drawings the setting is clearly rural, indicating with which aspect of the Republic Millet's sympathies lay.[28]

Such programmatic invention of *visibilia* for immaterial facts is true allegory, as C.S. Lewis defined it,[29] and quite unlike the *symbolism* of such drawings as the *Man Turning a Wheel*, in which we saw Millet begin with something of his own experience and turn it into a metaphor for things beyond the real. That other type of drawing, which seems to grow in a relatively intuitive way, through feeling, reappears in some other figures of *La République* (or *La Liberté*) which are far less anodyne than those we have just examined. One of these figures, which as likely as not represents Liberty, holding her Phrygian cap aloft on a staff (Fig. 5.16), resembles Daumier's personifications of *La France* in such 1848 lithographs as *Dernier Conseil des ex ministres* (Fig. 5.17). Millet's figure leans back against a tree, in a rural landscape strewn with corpses. In a variant of this design we find her striding through the night brandishing a sword, one foot on the chest of a prostrate king, and dragging behind her an old crone, whom she has seized by the hair (Fig. 5.18). The heavily blackened background is reminiscent of Daumier's dramatic chiaroscuro lithographs of *c.*1830–5, although Millet has added some colour here.[30] Iconographically, her direct antecedent must be the figure in Delacroix's famous painting of *Liberty Guiding the People*[31] but this particular Amazon has a dark ferocity of her own. This female is in absolute contrast to Daumier's liberating figure in his cartoon of March 1848, and it is most unlikely that she was drawn at the same period or, indeed, bears any relation to the Republican government's competition. This is a figure of violence and madness, apparently associated with the breakdown of order. A more finished version, in pastel, of *La République* holding a spear, combines elements of both the previous drawings (Fig. 5.19). This creature still has one foot firmly on the fallen king, but at the same time she holds out one arm in succour to the creatures in shadow on the right. The dismembered limbs under her other foot are gruesome enough, and, curiously, the same motif of a dismembered torso with raised elbow is to be found under the feet of a figure of *La République* painted by L.M.D. Guillaume, now in Bordeaux Museum (Fig. 5.20). This was the winning entry of another competition held by the municipality of Bordeaux, also in 1848. The two artists can hardly have known each other's work, and Géricault was probably a common source. Thus, while there is no positive documentary evidence that Millet's Republican convictions were as strong as Daumier's in 1848, it becomes evident what was in the air – after all, no one knew at that time how long the Second Republic was going to last.

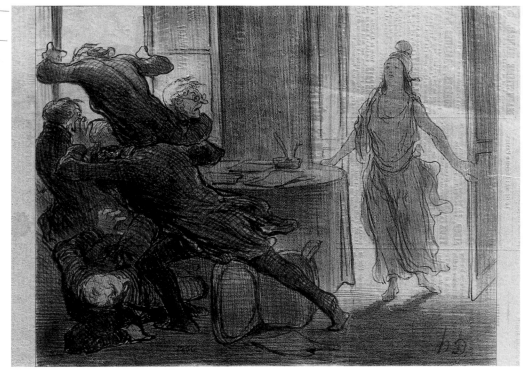

5.18 Millet. *La Liberté* or *La République* (with sword). 1848–9. Black chalk and coloured crayons, 41 × 31. (Location unknown).

5.19 Millet. *La Liberté*, or *La République*. 1848–9. Pastel on laid paper, 40 × 29. Coll. Muriel S. Butkin.

5.20 L.M.D. Guillaume. *La République*. 1848. Oil on canvas, 260 × 214. Bordeaux, Musée des Beaux-Arts.

Given the watershed nature of the years 1846–51, in so far as they affected the careers of both Daumier and Millet, some notice should be taken of the kinds of contribution that each beginning to make to the annual Salon exhibitions, before, during, and immediately after the brief life of the Second Republic. These contributions may be compared in tabulated form as follows:

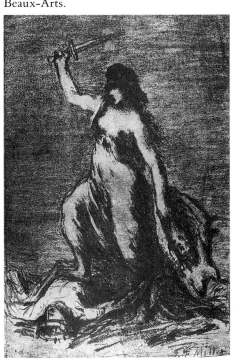

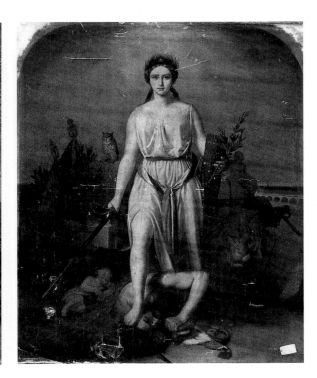

5.21 Millet. Study for the Head of *The Winnower*. 1848. Black chalk (?) (size and location unknown).

SALON	DAUMIER	MILLET (also exh. in 1840, 1843 & 1844)
1846	No paintings submitted	*St Jerome Tempted* (rejected)
1847	No paintings submitted	*Oedipus Cut Down from the Tree*[32]
1848	No paintings submitted	*The Winnower*[33]
		Captivity of the Jews in Babylon[34]
1849	*The Miller, his Son, and the Ass*[35] (one other painting submitted)	*Harvesters Resting* (withdrawn from the exhibition – bought by the State)[36] *Seated Shepherdess* (small sketch)[37]

5.22 Daumier. *Workmen in the Street. c.*1846–8. Oil on panel, 11.5 × 16.5. Cardiff, National Museum of Wales.

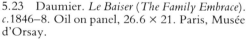

5.23 Daumier. *Le Baiser (The Family Embrace).* *c.*1846–8. Oil on panel, 26.6 × 21. Paris, Musée d'Orsay.

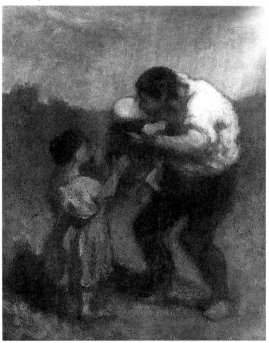

1850–1	*Two Nymphs Pursued by Satyrs*[38] *Harvesters Tying up Hay* (bought *Don Quixote and Sancho*[40] by the State)[39] *The Drunkenness of Silenus*[42] *The Sower*[41]

1850–1 *Two Nymphs Pursued by Satyrs*[38] *Harvesters Tying up Hay* (bought
 Don Quixote and Sancho[40] by the State)[39]
 The Drunkenness of Silenus[42] *The Sower*[41]

Millet had been professionally orientated towards selling oil paintings as early as 1840, when he began his career as a portrait painter and got his first work accepted at the Salon. Daumier entered this forum in 1849, with a subject from La Fontaine. At this date Millet had already exhibited his most important work in his new manner of peasant realism, *The Winnower.* The monumental forms, rich colouring, and thickly applied impasto of that work, in which the paint itself becomes a visual equivalent of the substance it depicts, excited the admiration of republican-minded critics. (They must have liked the subject, although they expressed their praise entirely in terms of style and technique.) Robert Herbert has corrctly pointed out that Courbet, too, must have partaken in this admiration of the *avant-garde*, for he seems to have adapted the pose of the figure for his picture of *The Stonebreakers* which he sent to the Salon in the following year.[43] Millet thus appears to have been more *en rapport* with Republican expression at the Salon than Daumier at this point, a position which he reinforced with *The Sower* at the Salon of 1850. Two powerful drawings related to *The Winnower* show a ruggedness of technique appropriate to the subject. A three-quarter-length figure study formerly in the Knowles collection[44] emphasises his muscular wrists and hands, and a large drawing of the Winnower's head in profile (Fig. 5.21) shows his jutting brow and beak-like nose, hatched and contoured like granite.[45] These features were more sublimated to an overall colouristic conception in the painting itself.

Daumier, as we have seen, had pursued his career up to now almost entirely as a professional 'artiste-lithographe' (whether this term really specified artisan status is always going to be in dispute), publicly recognised as a brilliantly gifted draughtsman, until he was encouraged by his Republican friends to venture further into painting for the State Competition in 1848. In so far as any of his paintings can be firmly dated prior to this year, the reasoning depends on stylistic grounds alone. There are, for example, a few small oil paintings on panels that are basically drawings made with a brush and then coloured: this quasi-graphic technique is made clear by an unfinished picture of two drunkards in a café, on paper laid down on board, in a Paris private collection.[46] Another such example, which has been carried a little further, is *Workmen in the Street* (Fig. 5.22), in which the craggy profile of the man carrying a shovel can be compared to that of Millet's *Winnower.* K.E. Maison has tried to date this very early indeed,[47] but I suspect that Daumier, getting on better and better with his friends among the Barbizon painters in the 1840s, was only just then beginning to try out what he could do, holding a brush instead of a crayon. The much thicker, heavily impasted style which evolved from this when he tried putting down paint as tone and colour, on top of his lines, is found in an early, small painting recently acquired by the Musée d'Orsay (Fig. 5.23), know as *Le Baiser*, which essentially shows a working-class man in shirtsleeves, embracing a baby, which has been handed up to him by a small girl. It is this kind of homely, private, and probably essentially non-commercial image which immediately preceded Daumier's essay at *La République.*

Following the year of the Competition, Daumier suddenly took to painting on a larger scale, even if he did not always finish what he started. *The Miller, his Son and the Ass* (Fig. 5.24) of 1849 will be discussed in terms of what La Fontaine meant to Daumier, in Chapter 9. In terms of style, one should just point out here the rich but subdued colour with which this group of Rubenesque girls is rendered, and the rather startling gesture of the girl who flings her arm out on the

5.24 Daumier. *The Miller, his Son, and the Ass.* 1849. Oil on canvas, 130 × 97. Burrell Collection, Glasgow Museums and Art Galleries.

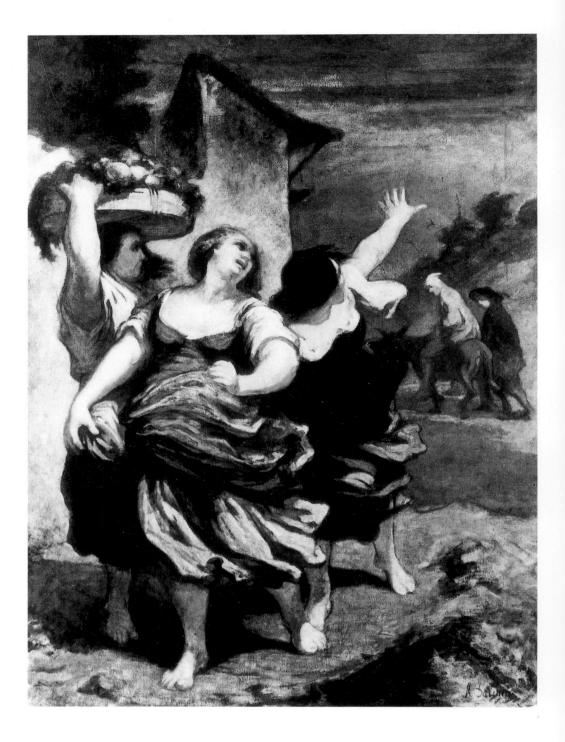

right. These figures are conceived sculpturally, and are reminiscent of Clodion's concentric terracotta groups of bacchantes, except that their physique is like a working-class version of such mythological ladies. *Two Nymphs Pursued by Satyrs* (Fig. 5.25) carries this baroque sensuality even further. Even though the cross-hatched strokes of broken colour in certain areas of the painting (reminiscent of Delacroix) were almost certainly added later in the 1850s, the basic design is entirely in keeping with Daumier's graphic linear rhythms of *c.* 1849–50. These are even better illustrated by his third Salon exhibit of 1850, *The Drunkenness of Silenus* (Fig. 5.26). This is fundamentally a drawing, notwithstanding its elaborately mixed media which make it look, at first, like a monochrome

70

5.25 Daumier. *Two Nymphs Pursued by Satyrs.* 1850 (with later additions). Oil on canvas, 128.2 × 96. Montreal, Museum of Fine Arts.

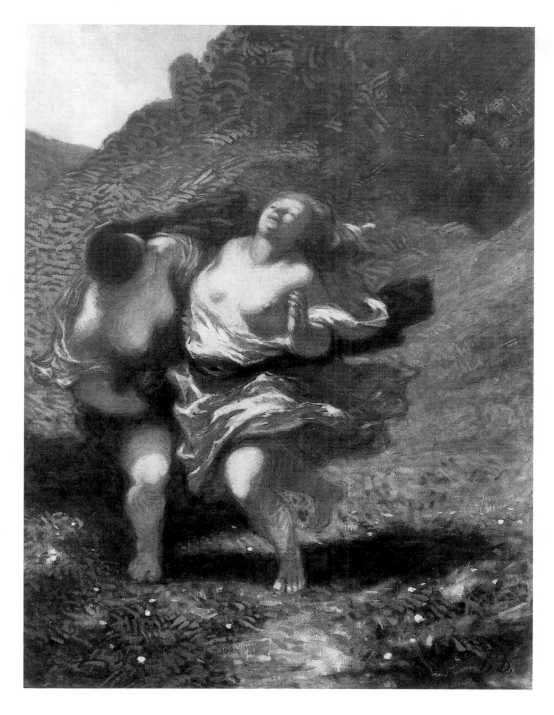

painting. Such an impression is enhanced by the size and tonal density of the work. The figures in the foreground group are heightened with white gouache over what is in effect a warm half-tone ground, which gives them again a sculptural look reminiscent of Clodion's terracotta figures. Daumier, however, was more than a latter-day rococo stylist. The composition owes much to Rubens prototypes, such as that master's *Dance of Villagers* in the Prado Museum, Madrid, and more particularly to the Rubens/Van Dyck *Triumph of Silenus* in the National Gallery, London.[48] It also contains remarkable formal inventions of Daumier's own. The woman moving away from us, behind Silenus with her arm outstretched, repeats exactly the gesture of the girl in *The Miller, his Son, and the Ass* (Fig. 5.24), except that Daumier has spun her completely round, as it were,

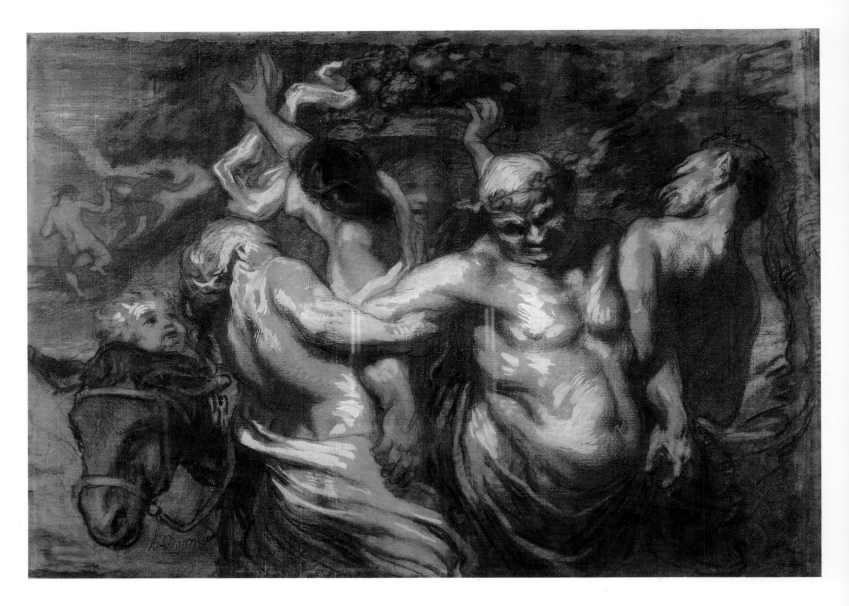

5.26 Daumier. *The Drunkenness of Silenus.*
*c.*1848–50. Drawing in charcoal, brown chalk,
sepia wash, and white gouache on orange tinted
paper, 43 × 61. Calais, Musée des Beaux-Arts.

and she flings out her right arm instead of her left while presenting her back to us.
If we could move into the picture and look at her from the front, she would now
bear a close resemblance to the figure of *Liberty* in Delacroix's *Liberty Guiding the
People* (see note 31). So why does Daumier present her moving away from us,
while Silenus (under constraint) attempts to advance? Is it a direct mockery of
the political events in 1849–50, as Louis-Napoléon steadily gained power and
began to squeeze out the Republicans in his government? There some elements of
caricature in the drawing. There is the resemblance of Silenus' face to Dr Véron,
editor of the pro-government newspaper, *Le Constitutionnel*, which we have
already noticed as an object of Daumier's satire in Chapter 4 (pp.48–9). Even the
comic couple in the background, sprinting off into the woods with ungainly haste,
might suggest the 'bon bourgeois' stripped naked, having an unseemly romp.

Thus, while Daumier's contributions to the Salon were ostensibly far less
plebeian in subject matter than Millet's, to his contemporaries their content may
well not have been so apolitical as it seems today. This was, it should be re-
membered, the same epoch in which Daumier created his composite character of
Ratapoil, whose mockery of Napoleon's regime was sufficiently serious for the
artist to have his home raided by the police.

72

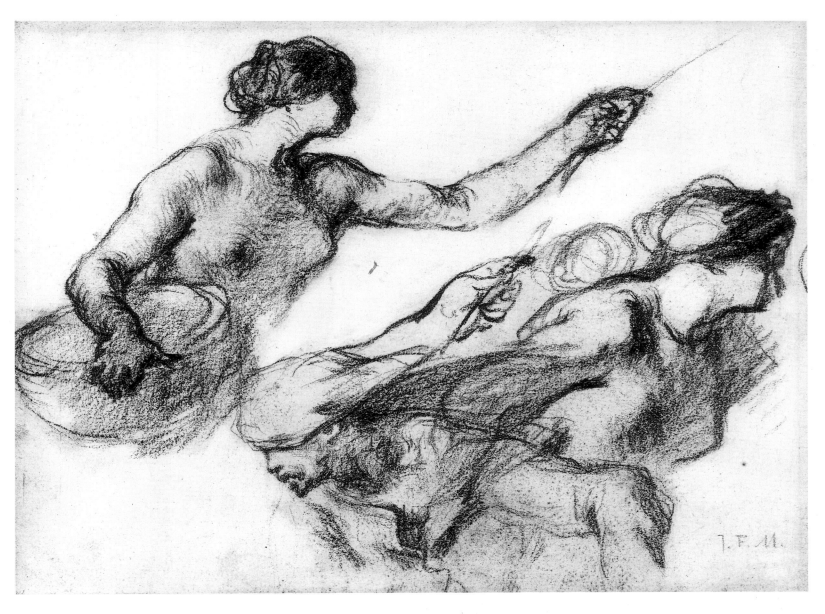

5.27 Millet. Sheet of studies for *The Return from the Fields* and other paintings. Black chalk, 21.2 × 29.2. Basle, Oeffentlichen Kunstsammlung, Kupferstichkabinett.

At the same time it would be a pity if these speculations on the symbolic content of Daumier's *Silenus* were allowed to obscure the formal qualities of the drawing itself. His touch, both firm and sensual when rendering the nude, creates simultaneous rhythms of surface contour, plastic form and spatial depth, not often to be equalled before Cézanne. There may even be some rapport with Millet's drawings of nudes done at this time. (Compare the intertwined bodies in *Silenus* with those in Millet's *Susanna and the Elders* (Fig. 5.9).) If Daumier visited Millet's Paris studio (and I believe, from the visual evidence alone, that he did) he must have seen studies made from female models there, including those of Mme Millet herself. An excellent example is the sheet of studies now in Basle (Fig. 5.27) which is datable *c.*1847.[49] The half-naked woman has the same hair-style, the same muscular neck, and similar enlargement of the deltoid and triceps muscles as in Daumier's retreating lady in *Silenus*.

Towards the end of Millet's regular production of drawings of nudes, which as far as one can tell was around 1851, an increasing realism in his treatment of them, closer to life than to art, becomes apparent. The drawing of a *Nude Bather Drying Herself* (Fig. 5.28) has an air of contemporary observation about it, and a lack of

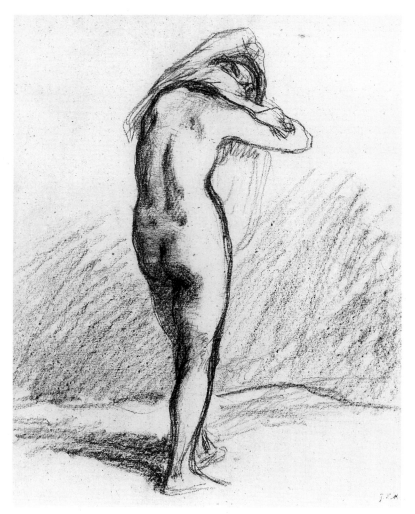

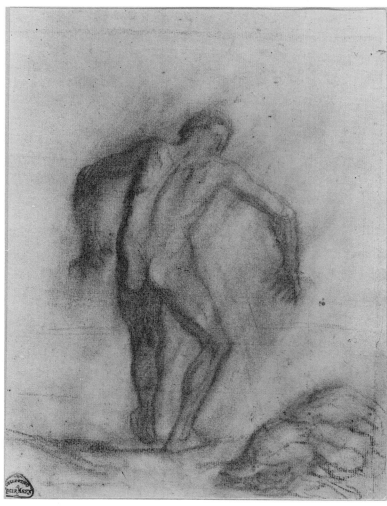

5.28 Millet. *Nude Bather Drying Herself.*
*c.*1848–50. Black chalk, 31.9 × 23.8. Paris, Louvre,
(RF 4163, GM 10,493).

5.29 Daumier. *A Man Entering the Water. c.*1849–
52. Charcoal (rubbed), 25.5 × 20. (Paris Art
Market, 1966.)

concern about any formula for posing the nude, that anticipates Degas (who will
be discussed in Chaper 11). The contours of this magnificently formed figure
have been repeatedly redrawn with just those variations of pressure that Delacroix
recommended for the true apprehension of volume. This naturalist trend in
Millet's drawings is matched in the few 'straight' drawings of nudes by Daumier
(as opposed to his 'Bathers' series of lithographs that were so much admired by
his contemporaries). Daumier's drawing of *A Man Entering the Water* (Fig. 5.29),
even in its present worn-down state, is a miracle of direct observation. The
tension as he cautiously extends one foot, and raises his elbows in anticipation of
splashing, is as full of masculine energy as Millet's women are of female grace. It
may be almost contemporary with Millet's drawings of nudes.

When the Assemblée Nationale passed a Statute on 17 July 1848, establishing a
credit of 200,000 francs for the encouragement of the Fine Arts, 'Citoyen
Daumier' was one of the many artists given commissions for paintings. On 15
September he received his first commission, for which he chose the subject *The
Magdalene in the Desert.* He only ever mangaged to produce on oil sketch for
this.[50] Other datable studies by Daumier for known paintings are equally
summary in treatment, at this stage in his painting career (see his charcoal
drawing for another State commission for a *St Sebastian,* which will be discussed

in Chapter 9). There is a marked difference in method here from Millet, who slowly compiled data in the form of drawings for paintings. It seems that when Daumier had an idea for a painting he began to work it out almost immediately on the canvas itself, so that his painting began simply as an extension of drawing.

When Millet received a State commission at approximately the same time as Daumier in 1848, he chose *Hagar and Ishmael* as his subject, and planned to paint it on a very large canvas, for which he made several preparatory drawings. his theme was exile – and it turned out to have significant personal overtones for him. But he abandoned his nearly completed canvas in 1849 and later obliterated it, fulfilling his commission with another, smaller picture of *Harvesters Resting*. *The Sower*, which he painted for the Salon the following year, gave him so much trouble again that he repeated it on a second canvas. His next figure composition for the Salon, *Ruth and Boaz*, or *The Harvesters*, took him at least two years to complete, and some thirty-nine drawings were made in connection with it.[51] In the process of adopting this painstaking methodology, Millet would henceforward make drawing *per se* the medium for his most personal formulation of ideas.

It is evident that Daumier was the more confident draughtsman of the two at the outset, in both his public and private productions. Whilst his private drawings (unlike his lithographs) do not work to a formula, there lies behind his style an assimilation of the baroque mode, deriving to some extent from the example of Delacroix, but with a distinct personal rhythm of his own. As Henry James expressed it: 'His thick, strong, manly touch stands, in every way, for so much knowledge . . . he is a draughtsman by race . . . '.[52]

Daumier now seems to be very far from the 'dreamer' that Courbet later accused him of being: his only crimes in this respect were indifference to official success, and comparative verbal silence. Whereas Millet's 'combat' was directly with officialdom, in seeking public success at the Salon, he also had a private combat within his own nature. Like Daumier, he drew constantly and with increasing fluency, but his paintings became more slowly executed. Concurrently with his painting and drawing he began to produce a stream of written words, mostly in correspondence directed towards Alfred Sensier, whom he appointed as his intermediary with the outside world. The details of modern everyday life, particularly concerning money matters, exasperated and confused him. He would suffer increasingly from migraines as he battled with his art and his worldly affairs together.

Daumier, meanwhile, was heard to grumble occasionally but drew and painted as he pleased, while he earned his modest (and grinding) living as a lithographer, and kept his melting pot of ideas casually on the boil.

PART III
Urban and Rural Imagery
*c.*1851–65

6 Millet's Peasant Imagery

Il faut pouvoir faire servir le trivial à l'expression du sublime c'est là la vrai force.

THE QUOTATION IS taken from a page reproduced in facsimile in *L'Autographe au Salon de 1864* (Fig. 6.1), a volume edited by Castagnery and published by *Figaro* in that year. This sentence, written in Millet's autograph hand above the sketch of a girl burning leaves, may be translated as follows: 'One must be able to make the trivial serve towards the expression of the sublime: that is where true strength lies.' To the left of this is inscribed *vide praevaricantes* ('behold the prevaricators'). The longer text at the side of this sheet of studies is extrapolated from Millet's letter to Sensier of 30 May 1863, in which he expounds on how he sees the countryside and the labourers who work in it. His particular context in this case is his painting of *The Man with the Hoe*, which was then hanging in the 1863 Salon.[1] This drama, Millet writes, is enveloped in the splendours of the countryside. It is not something of his invention, he claims, but a genuine '*cri de terre*'. He is defending himself against his critics. How he arrived at this position is the subject of this chapter.

By December 1851 the Second Republic had effectively come to an end. Millet had now been ensconced in Barbizon for two and a half years, and his political position had become somewhat ambiguous. All his friends in Paris were or had been Republicans – a position which stood for artistic as well as other freedoms – and while Millet was clearly not a political animal, he could hardly have been aligned with the conservative forces, urban and rural, who were helping Louis-Napoléon into power. And while he understood the peasants' way of life, indeed came from well-to-do, independent peasant stock himself, he was in no way blind to the narrow limitations in outlook of the peasant labourers and smallholders at Barbizon. We will find a certain ambivalence, therefore, or at least a plurality of meanings, in the ways in which his representations of them can be read.[2] Temperamentally, at least, as well as by upbringing, he seems to have been anxious not to be mistaken for a socialist – a position in which he was strongly backed up, if not actually directed, by Alfred Sensier.[3] Yet there is the incident of his being taken to visit Delacroix in his studio, and the latter's curious comment in his *Journal* (for 16 April 1853) about the 'pretentious' look of the peasants in Millet's pictures, as if Delacroix thinks that their sentiments are above their station. Millet evidently presented himself to Delacroix with a kind of

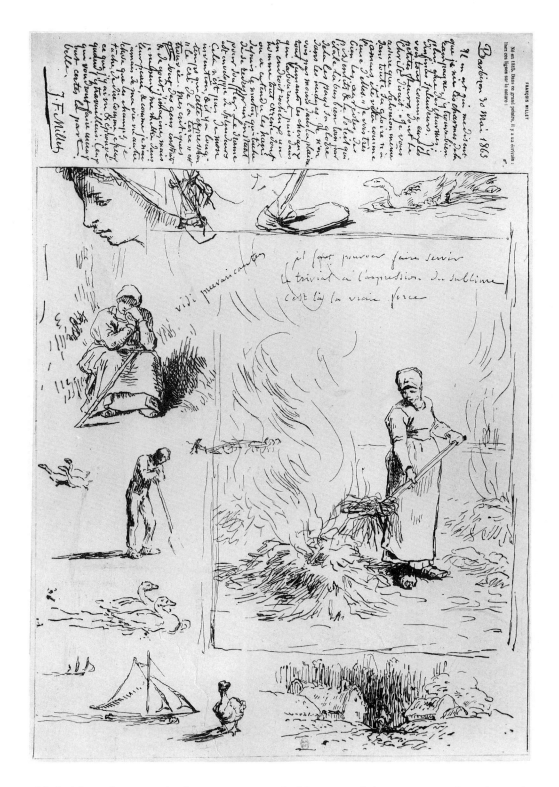

old-fashioned peasant's demeanour, probably out of shyness mixed with pride. Delacroix thus associated him with the 'constellation or crew of bearded artists who made the revolution of 1848', but he put him 'above their level' (presumably he meant in intellect and skill).

At the same time Daumier, who had become imbued with a deep and lasting hatred of Louis-Napoléon and everything that he stood for, was now obliged to keep his political views under cover, and would have to continue to do so for two

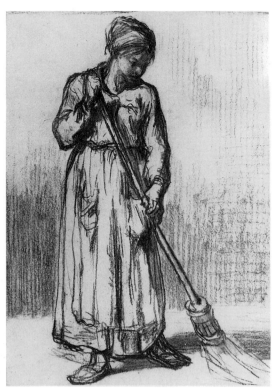

6.2 Millet. *La Balayeuse (Girl Sweeping)*. *c*.1849–52. Black chalk. (Size and location unknown).

decades. In the next chapter I will also look at the imager[...] private, urban back-yard environment, as it were, to see to [...] his representational intentions overlapped with those of Mil[...]

Millet's canon of rural imagery, as we have seen, began to be formed before he left Paris for Barbizon. The woodcutters, the harvesters, the sheep-shearers, the shepherdesses, the water carriers, the winnower and butter churners were first drawn in Paris; some of these remained in his repertoire for thirty years. *The Sower*, it has often been pointed out, has a more specific Normandy background, and relates perhaps to some of his earliest memories.[4] Certain indoor motifs, associated with cottage life rather than urban environment, could also have been conceived in Paris – the woman feeding soup to her child, the cooper making his barrel, and perhaps the little *Balayeuse* (her broom associated with the *Cris de Paris*) (Fig. 6.2).[5]

When Millet left Paris filled with intimations of exile and disaster in 1849, it is not surprising that allegorical depictions of the Republic disappeared from his *oeuvre*. Moreover, whatever his motives in moving away (more or less) from representations of sensuous nudes and other fanciful subjects, his arrival at Barbizon clinched his decision to develop a rural vocabulary with which to express his thoughts. His entire canon of images was mapped out within about three years of his arrival there. The forest workers; domestic cottage interiors; ploughing, digging, planting, and the whole gamut of harvesting activities – all these were established at that time. Even the first drawing of the *Gleaners* was done about 1852. By 1853 he was executing his first cycle of *The Four Seasons*, and he had produced a series of ten drawings which were engraved with the title *Les Travaux des champs*.[6] What followed during the next twenty years or so were variations on these themes developed into a specific discourse on rural life, which merits some discussion.

Another factor that modified Millet's rural vocabulary after his arrival in Barbizon, even while he was still engaged in finishing up quasi-pastoral commissions obtained for him by Sensier in Paris, was his increased awareness of the emotive power of landscape. After sending his paintings of *Harvesters Tying up Hay* and *The Sower* to the winter Salon of 1850–1, he wrote to Sensier on 15 January, 'J'ai bien grande envie, *si je vends mes tableaux* [my italics], de faire, cet hiver, quelques paysages d'après nature; quelque chose un peu feroce'.[7] He thought he would be able to do such things not badly, and had in mind a snow scene.[8]

Sensier's own schemes for promoting Millet's work, however, now had to be taken into account. The earliest letters between them had been exchanged in the winter of 1848–9. Sensier began their relationship as an admirer, an 'amateur' of art, but soon assumed the role of agent, most often acting as a go-between for both private collectors and professional dealers. His clientele was varied, at first. A Mr Roux, for example, was very partial to naughty pictures, and most anxious to have Millet complete a little painting of naked nymphs riding piggy-back on fauns, and beating them with sticks.[9] Sensier pressed Millet to finish this picture with the same urgency as his *Two Women Sewing*,[10] and a *Balayeuse*.[11] By 1851 we find Sensier admonishing him to look to what his potential clients want: he says he cannot afford not to, in his circumstances: 'It is essential to provide for the needs of the most prosaic and the most bourgeois [clients] in existence'.[12] That may sound like a deliberate exaggeration, a parody of practical advice, but in a later letter Sensier is more specific: 'Il faut, mon cher, en dehors de vos tableaux d'enfants et de baigneuses ou de mithologie [*sic*] que vous faites pour la vente, que vous mettiez à faire (si vous voulez être compris) des scènes rustiqes comme votre tableau du Ministère ou vos botteleurs'.[13] If Millet follows this advice, he says, he will have a commission every year.

78

6.3 Millet. *Female Nude Seated in a Wood.* c.1849–50. Black chalk, 16.5 × 18.4. London, Victoria and Albert Museum.

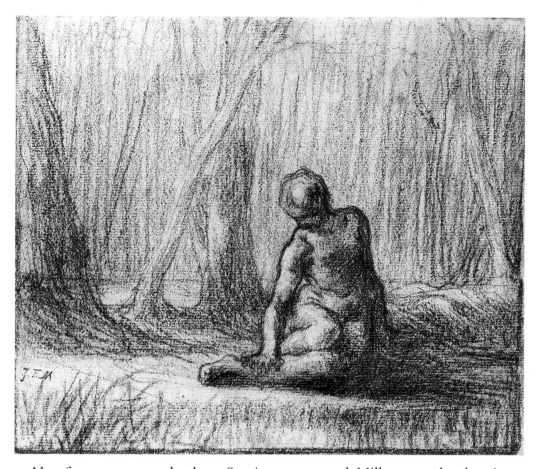

Also from a very early date, Sensier encouraged Millet to make drawings, separately, for sale. He had four 'amateurs' interested in this aspect of Millet's art in April 1850, and urged him to send 'a certain quantity as soon as possible' to Paris.[14] The following year he sold *La Balayeuse* for 50 francs (at this price it was presumably a drawing) to a friend of the collector Campredon, and another one – 'vous savez, la petite femme sortant des roseaux et montant ses fesses' – which may tentatively be identifiable with the drawing in charcoal now in the Kunsthalle, Bremen.[15] Campredon himself owned two paintings by Millet and no fewer than eighteen drawings, mostly in black chalk, by the time of the sale of his collection on 12–13 December 1856. His collection included several drawings of nudes, and one item, catalogued as '(204) Femme dans un bois – crayon noir' can very probably be identified, in my view, with a lyrical drawing of a nude seated in a wood, which is now in the Victoria & Albert Museum (Fig. 6.3). The significance of this promotion of Millet's drawings must not be overlooked: while Sensier may have seen it commercially, as a way of making quick sales to clients with modest incomes, he can hardly have missed Millet's extraordinary gifts as a graphic artist *per se* – indeed he tried to keep the best drawings for himself.

The question is bound to be raised, to what extent did Millet really follow Sensier's advice, and his requests? The obstinacy of Millet's character is well established, and it seems most unlikely that, given the quality of the works he produced, he carried out his orders as cynically as Sensier appeared to convey them. That Millet really did intend to produce an epic of rural imagery is proven by the evidence of the work itself. Sensier, as he increasingly became Millet's amanuensis, collected a group of twenty drawings in the early 1850s which he later entitled *L'Épopée des champs*.[16] The title of this series was his own, not Millet's, and the selection must have been his choice. The subjects almost entirely

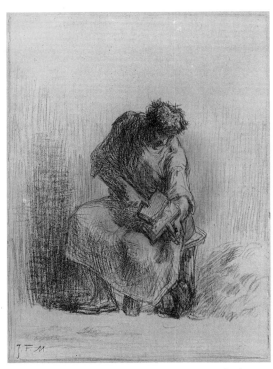

6.4 Millet. *The Wool Carder*. *c.*1846–8. Black chalk, 35.5 × 25.4. Burrell Collection, Glasgow Museums and Art Galleries.

6.6 Millet. *Two Women Resting by a River Bank*. *c.*1848–9. Black chalk on beige paper, 35.5 × 30. Plymouth City Art Gallery.

6.5 Millet. *Little Peasant Girl Seated under a Haystack*. 1851–2. Black chalk on beige paper, 33.5 × 26.5. Paris, Louvre (Inv. RF 4161).

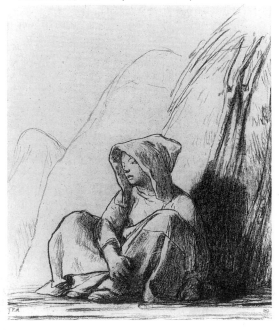

consist of field workers and farm workers employed by large farms, like the one at the bottom of the village street in Barbizon, which abutted on to the plain of the Brie. The drawings were mostly in black chalk (an exception, *Le Vanneur à la porte d'une grange*, in sanguine, was probably quite early in date), and doubtless displayed a freedom of invention which Sensier was smart enough to recognise, and which caused him to keep the drawings for himself.[17] At the same time, drawings of nudes certainly continued into 1851, and the quality of the one seated on a bank beneath the trees, in a wood which plainly evokes the forest of Fontainebleau (Fig. 6.3), suggests the possibility of an iconography very different to that which actually developed during the rest of the decade. One could not expect Millet to anticipate Renoir; this is, rather, an eighteenth-century image, of the type of Boucher, revived in realist terms. 'Pensez aussi aux dessins' wrote Sensier,[18] and again, 'I would be greatly relieved, when you come to Paris and bring your drawings with you, to be the *first* to see them' (his italics).[19] Yet the confident, free handling of these drawings was not equally to be found in Millet's oil paintings of the same period. To some extent the requirements of his clients may explain the rather laboured and dry surfaces of some of his oils in the 1850s. He was always being urged to finish, and retouch, when temperamentally he would probably rather have been creating new things. For the remainder of this chapter, therefore, we will examine critically some examples of Millet's best drawings concerned with rural imagery. It will be most apposite to conduct this discussion in terms of drawing styles, although meaning and content can never be wholly excluded if 'style' is to be truly understood.

The Wool Carder (Fig. 6.4) of *c.*1846–8 is an early attempt to make an iconic image from a rural pursuit. Robert Herbert has pointed out a specific source for this figure, namely a carving of one of the voussoirs of the north porch of the Royal Portal at Chartres. Gothic art, 'with its programmes of the months and the seasons symbolised by the rural trades . . . was the largest single corpus of peasant forms available to Millet', Herbert has observed.[20] There is plenty of evidence for Millet's interest in sculpture of earlier eras: visiting Clermont Ferrand in 1866, for example, he showed the greatest interest in some sixteenth-century sculpture he found in the Cathedral, and when buying sheets of *croquis* from Delacroix's studio sale in 1864 he included studies by the latter of sculpture and costumes from the Middle Ages.[21] *The Wool Carder* is executed in his relatively early drawing style with delicate cross-hatching which might derive from an engraving, although he is trying to obtain the effect of relief sculpture. This technique is also found in *The Stone Cutter* of *c.*1846 (Fig. 3.9), and the *Égalité* and *Fraternité* drawings of 1848 (Figs. 5.14 and 5.15). The simple, scrubby-haired figure might also be seen as relating to popular art – that is, a representation by an anonymous artist of a well-known activity in daily life, full of vitality.[22] The drawing has traces of a rectangular frame drawn round it, which suggests that he might have been intending such a subject for sale, even at this early date.

Very similar in carving effect, though rougher in execution, is *Two Women Resting by a River Bank* (Fig. 6.6). They are represented as water carriers, of some past epoch perhaps, although the river behind them is probably the Seine, on the northern outskirts of Paris. The figures are conceptually drawn – the standing woman with Grecian profile was begun nude – but they also form part of Millet's remembered observations. Their weighty forms inaugurate a series of drawings and paintings of women drawing water from the river and washing clothes in it. They will come to full fruition in the 1850s at Barbizon. Related to them in style (the firm hard outlines, the conceptual dignity of the figure, the carved relief-like effect of the shading) is *Little Peasant Girl Seated under a Haystack* (Fig. 6.5). The model here is probably his eldest daughter Marie, aged about six and therefore drawn at Barbizon. The haystacks behind her, with finger-like forks leaning

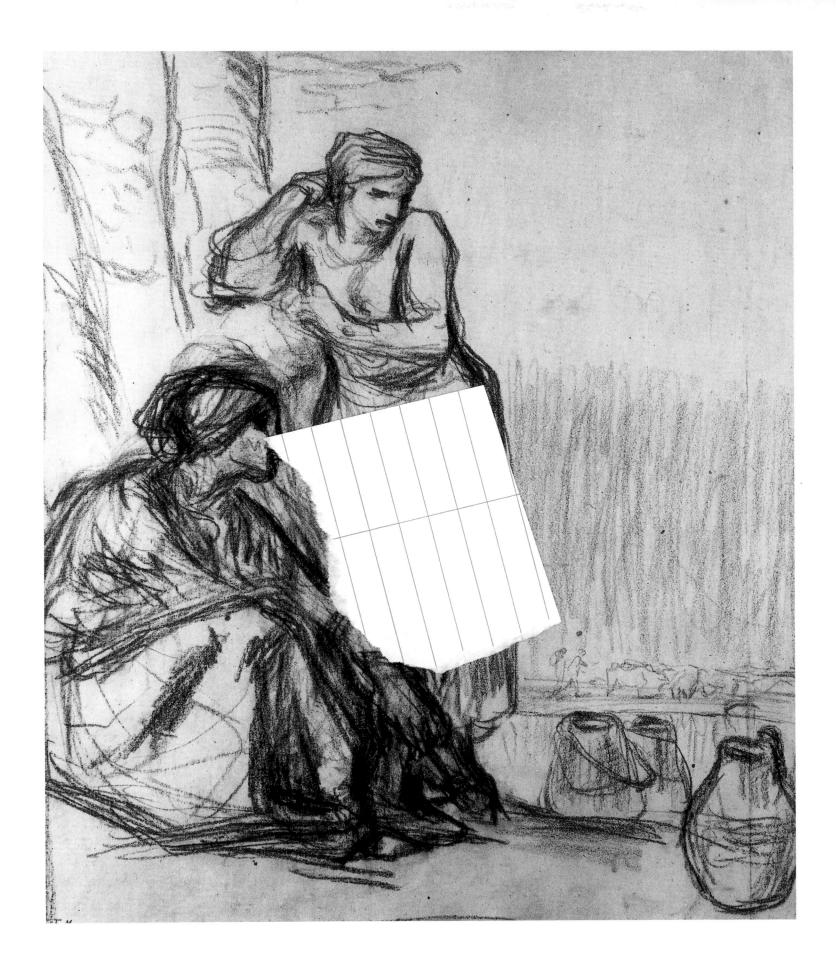

6.7 Millet. *Man Binding Sheaves* (study for *The Haymakers*). 1850. Black chalk, 15.3 × 13. Coll. Mr Daniel Lieberman.

6.9 Millet. *Two Girls Raking Hay.* 1850–1. Black chalk, 14 × 20. Coll. The Countess of Avon.

6.8 Millet (engr. Lavieille). *Man Binding Sheaves.* Woodcut, *c.*1852–3.

against them, are almost anthropomorphic in appearance. The little girl has an air of primitive innocence, under her Capuchin cloak. This innocence is, of course, consciously contrived, and seems likely to have an intentional reference back to Millet's own childhood, when he worked on a farm where 'l'exploitation familiale', as J-C. Chamboredon expresses it, was a happy condition.[23]

Millet's rural imagery did not entirely consist of sweet-faced country maids. In his various representations of physical labour, watching the body move under different types of stress, he began to develop a language which expressed these strains of work (as opposed to the language of dance). *Man Binding Sheaves* (Fig. 6.7) is a preliminary figure study for the painting *Les Botteleurs de foin* that accompanied *The Sower* to the Salon of 1850–1. On a small sheet of paper (cut from a larger one?) spiralling lines with abrupt turns like hooks create a two-dimensional equivalent of the man's physical problem: how to get a piece of straw wrapped around a springy, disintegrating mass of hay. The situation, which Millet was here envisaging in the abstract, is made clearer if we compare this study to a wood engraving, made from a block upon which Millet himself had drawn the lines of a more finished rendering of the same subject (Fig. 6.8). It was engraved by Adrien Lavieille[24] extremely skilfully, in that he has not only conveyed all the factual information now contained in the drawing, but also the spiralling gravitational forces that give the image its basic energy – forces which were unleashed in the first sketch.

Repeating elements of movement was another expedient Millet often used to convey the rhythms of physical labour. The very earliest drawings of the *Gleaners* introduced this repetition of movements in the stooping figures. More subtly, *Two Girls Raking Hay* in an autumnal field (Fig. 6.9) have sufficient rapport in their angular gestures (which, taken together, represent the beginning and end of the same movement) to create the illusion in the viewer's mind of the exact forces they are exerting upon the ground. The invention of linear analogies for different physical states devolved upon Millet's physical empathy for the actions he observed in his mind's eye. Concerning the thing observed, a sheet of three studies of a woman (Fig. 6.10) may or may not have been made from life. The

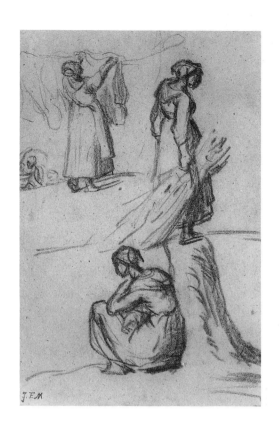

figure hanging up laundry could be Millet's wife, and the other two studies look like the same model. If that were the case, she could have posed briefly for the figure holding a bundle of faggots, in the middle of the page, but the elaborate drawing *Three Faggot Gatherers in a Wood* (Fig. 6.11), in which this same figure is prominent in the left foreground, can only be a compound of memory and invention. The point in common between the two images of this one figure is the angle of the shoulders, where the right shoulder is pulled down, and the right elbow is bunched up, by the effort of lifting the bundle of faggots. In the finished drawing this observation is translated into a forest drama, with heavy chiaroscuro and sheaves of lines angled in sympathy or in opposition to this point of tension. Notice also that the whole social mood of the drawing has changed, between the study which seems to have been made in a state of domestic contentment, and the finished picture-drawing where a proletariat belonging almost to the underworld is represented.

One of the most energetic images Millet ever invented was *The Wood Sawyers*, which culminates in an oil painting of about 1850–1 now in the Victoria and Albert Museum (Fig. 6.12).[25] In the foreground, two men are working a big cross-cut saw across a felled tree trunk on the ground, while behind them a third figure wields an axe. Two outstanding studies for the principal figures are known, in the Museums at Bayonne (Fig. 1.2) and Plymouth (Fig. 6.13) respectively. In both drawings one of the sawyers is repeated twice, so that we have a balletic image of three figures in relation to each other on the paper. The tree trunk is barely indicated, and the saw is represented not by any descriptive contour but by lines of force following the path of its movement. Robert Herbert

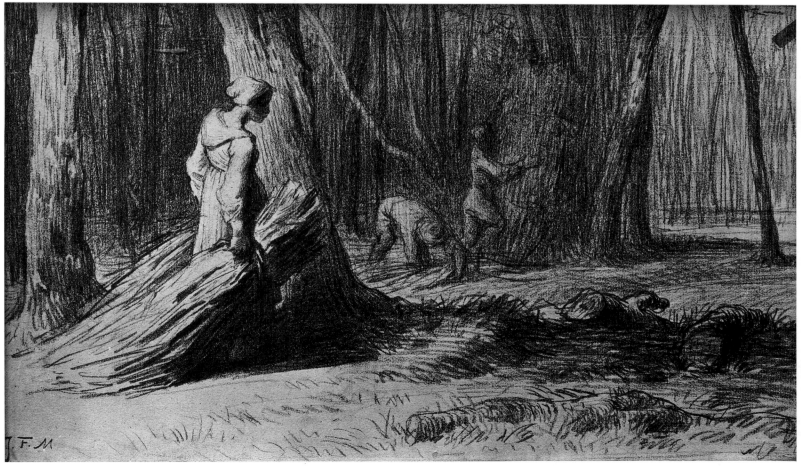

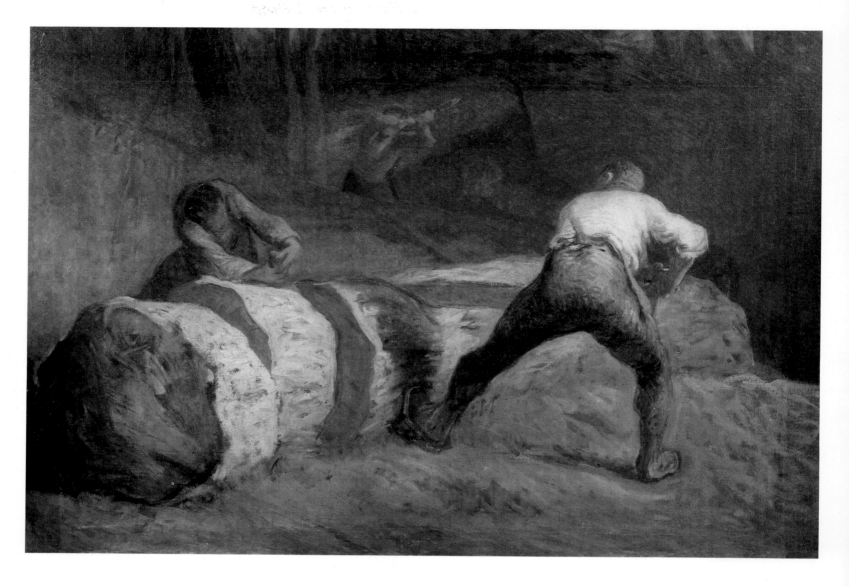

6.12 Millet. *The Wood Sawyers*. 1850–1. Oil on canvas, 57 × 81. London, Victoria and Albert Museum (Ionides Bequest).

Previous page:
6.10 Millet. *Three Figure Studies*. c.1850–1. Black chalk, 21.7 × 13.1. Oxford, Ashmolean Museum, P.M. Turner Bequest.

6.11 Millet. *Three Faggot Gatherers in a Wood (Bûcherons liant des fagots dans le fôret)* c.1850–1. Black chalk, 29 × 48. Present location unknown.

Facing page:
6.13 Millet. *The Wood Sawyers*. 1850–1. Black chalk, 31.8 × 46.7. Plymouth City Art Gallery.

6.14 Daumier. *Aspect de la Seine de Paris à Chatou*. Lithograph, published in *Charivari*, 19 July 1851 (LD 1716).

has already been quoted on the drawing in Bayonne, which he thinks was based on direct observation of unposed models.[26] One might also think of Daumier, for the way in which this imaginative equivalence of action was created. The whiplash curves of the bowed legs of the man in the Plymouth version, and the tensed back muscles of the man with outstretched arms, could find their analogies in a lithograph by Daumier, such as the fisherman casting his line in *Aspect de la Seine de Paris à Chatou* (Fig. 6.14). Even when printed on the rough newsprint of *Charivari*, the springing energy of Daumier's line comes across. At this time, 1851, the two artists are becoming very close in their drawing techniques, as well as in the virtuosity of their imaginative repertoires.

There is another aspect to Millet's choice of subject matter and his way of portraying it. If the forest workers with their axes, saws and machetes convey a sense of primitive energy, they can also be seen as representatives of an oppressed class of people with very limited rights. The more passive aspect of this condition is shown by Millet through his recurring images of *Bûcheronnes* – the women who carried home loads of gleaned brushwood on their backs. In an often quoted letter to Sensier, written in 1851, Millet effectively set out the philosophy to which he would adhere for the rest of his life. He confesses that it is the human condition which touches him most in art (this is again 'at the risk of passing for a socialist'!),

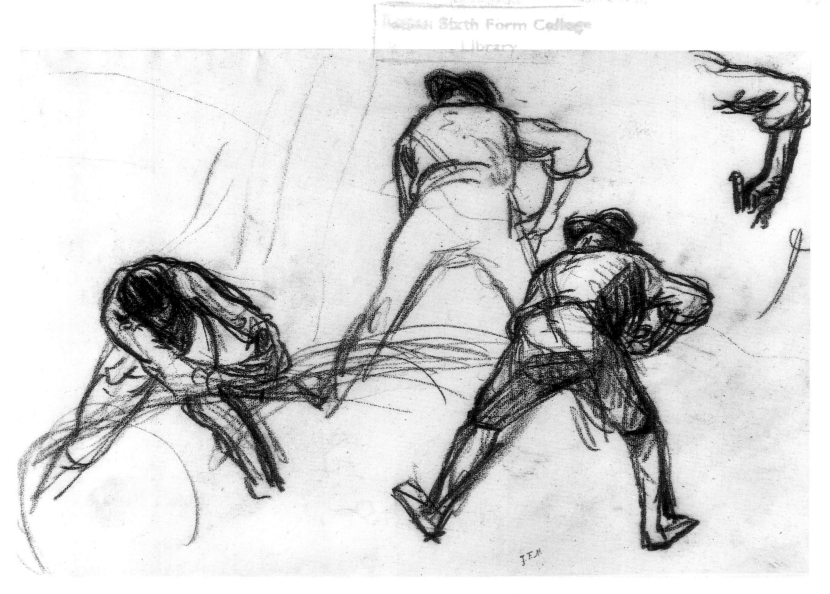

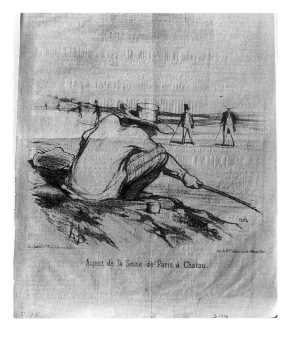

Aspect de la Seine de Paris à Chatou

and that it is not the happy side of life which appeals to him – indeed he has never seen it – but what he likes most is calm and silence, whether in the forest or the fields, and whether the latter be good tilled ground or not. No doubt he will be accused of being a sad dreamer. Having worked his way out of explaining to Sensier what he is going to paint (the ostensible reason for the letter) he continues:

> You are seated under the trees experiencing a feeling of well-being, all the tranquillity that one could enjoy, when you see emerge from a little footpath a poor female creature laden down with a bundle of faggots. The unexpected and always striking way in which this figure appears makes you involuntarily recall the sad human condition, and the fatigue of it. It gives you in fact an analogous impression to that which La Fontaine expressed in his Fable of The Woodcutter:
> 'What pleasure has he had since he came into the world?
> Is he not the poorest man in the whole globe?'[27]

This attitude of mind recalls Millet's first drawing of *The Old Woodcutter* (Fig. 3.21), as well as anticipating his great La Fontaine images of *Death and the Woodcutter* of 1859. The image of the 'poor creature' appears again in a group, the

85

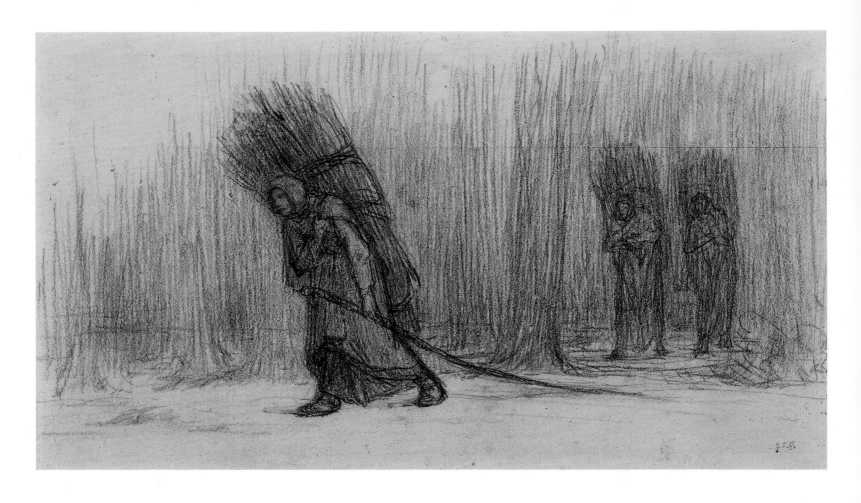

6.15 Millet. *Faggot Gatherers Emerging from a Wood. c.*1857–60. Black chalk, 28.9 × 46.9. Boston Museum of Fine Arts.

Faggot Carriers Emerging from a Wood (Fig. 6.15), in which the participants appear to be performing some kind of ritual. This drawing has a formal sophistication and refinement which suggests a later date in Millet's *oeuvre* although the subject plainly relates to the experience he described in 1851.[28] Vertical lines of black chalk are subtly graded in tone and strength to variously represent tree trunks, the forest in general, the figures of the three women, the brushwood on their backs and, through a kind of psychological osmosis, the emotion of sadness. We will find these same *bûcheronnes*, as they were called, in a painting which was in progress at the end of Millet's life, symbolising *Winter*. This whole group of forest workers relates to that class of peasant which Chamboredon has called 'L'épopée des humbles' (in opposition to Sensier's optimistic 'L'épopée des champs'),[29] a class to which, however he might try to deny its significance, Millet would consistently return to portraying as the alternative drama, as it were, in his rural imagery.

Echoes of the *Labours of the Months* schemata, first noticed in *The Wool Carder* (Fig. 6.4), recur frequently in the 1850s. The actual methods and implements used, in many of Millet's drawings of farm labourers, are themselves relics of earlier times.[30] This does raise the question of how much the rural pursuits that Millet represented really belonged to his own era, and how much his rural images are echoes of an historical past. Concerning the land itself, there are enough references to specific arable characteristics, both in his letters and in the annotations made on his landscape sketches drawn from nature, to make it clear that he surveyed what he saw with a knowledgeable eye – a farmer's eye. The same would have been true of the farm workers he drew. His attitude towards the

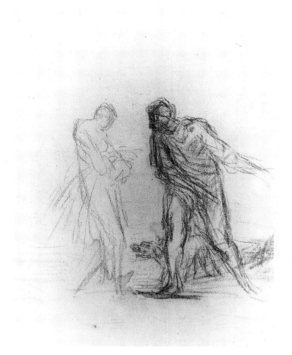

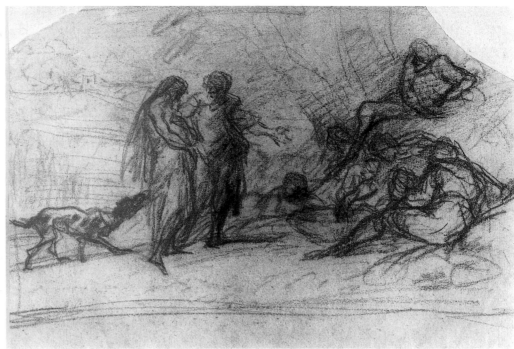

6.16. Millet. 'Première pensée' for *Ruth and Boaz*. *c*.1850–1. Sanguine, 26.2 × 18.9. Bayonne, Musée Bonnat (Inv. NI 1093 verso).

6.17 Millet. *Ruth and Boaz Approaching a Group of Harvesters*. *c*.1850–1. Black chalk, 26.5 × 38. Bayonne, Musée Bonnat (Inv. NI 1080 verso).

peasantry, then, must be distinguished as a matter of choice: he drew what he wished to observe. In the region around the Forest of Fontainebleau, rural society seems to have been a very closed system, not open to city dwellers making visits.[31] The local peasantry were suspicious, backward, and mostly had a low income because of the poor quality of land next to the forest. Millet, who was no fair-weather visitor but a year-round resident who cultivated his own small plot of land, was fully aware of the difficulty of dealing with the peasants in anything concerning money: he makes this clear in his letters to Sensier. This knowledge, however, was no hindrance to his becoming a kind of social historian of his local community in his art, and turning the local drama that he saw into one of larger human significance.

The painting of *The Harvesters*, exhibited at the Salon of 1853, had been first conceived as the biblical subject of *Ruth and Boaz*. The story of Ruth, a stranger received at harvest time, may have contained some autobiographical wish-fulfilment for Millet. The many drawings leading up to it (there are more than forty preliminary studies) show some significant shifts in style. For example, a drawing in sanguine, which has been called the 'première pensée' for this composition,[32] shows Boaz making a sweeping gesture of welcome to Ruth like an actor on stage (Fig. 6.16). The mannerist, balletic stance of the figures is repeated in another early sketch for the whole group, which has a Venetian flavour to it, like an outdoor figure composition by Titian or Giorgione (Fig. 6.17).[33] Such drawings predate the final version of the composition, which is much more realist in its treatment. The decisive change may be illustrated by a sheet of studies now in Brooklyn Museum (Fig. 6.19). A farmer wearing contemporary dress stands squarely on his two feet, giving Ruth a restrained gesture of welcome with open palm extended. (Note, however, the sketch on the right showing his conception nude.) Ruth becomes a farm girl with clogs, and the barking dog in the earlier study (symbol of hostility to strangers) becomes a study from life of a particular dog's head, sniffing suspiciously, nostrils wrinkled. Such figures were now in competition with Courbet: they could have stepped into the latter's *Burial at Ornans*. We should also notice the two other studies from life,

6.18 Millet. *Head of Boaz* (study for *Harvesters Resting*). *c*.1852–3. Black chalk, 12.7 × 18.1. Boston Museum of Fine Arts.

6.19 Millet. *Ruth and Boaz*, and other studies. Black chalk, 19.24 × 29.9. New York, Brooklyn Museum.

6.20 Millet. Sketch for *A Shepherd Directing Two Travellers*. *c*.1855–6. Black chalk, 22.5 × 28.8. London, British Museum.

6.21 Courbet. *The Meeting*. 1854. Oil on canvas, 129 × 149. Montpellier, Musée Fabre.

upside down on the same sheet, of a man putting on his jacket, a theme to be developed later as *The End of the Day*.[34] Once the new ambiance of Millet's composition was thus established, numerous other detailed studies were made. One of the finest is the study for the head of the farmer shown in the previous sheet (Fig. 6.18). Although drawn on quite a small piece of paper, the expression in this rugged head, with the white of his eyes glinting under the shadow of his hat like Géricault's painting of the *Vendéen*, is a masterpiece of imaginative invention. Whether such an image was 'true' or 'real', or not, is a question subordinate to Millet's intention, here, to express a biblical narrative disguised in forms that would look contemporary. (He dropped the title of *Ruth and Boaz*, and just called it *Harvesters Resting* instead.) He is creating a particular kind of rural myth closer to the classical structures of Poussin than the direct realism of Courbet, and it was this aspect that attracted the conservatively minded Sensier to him.[35]

Millet must have been increasingly conscious of Courbet's assault upon the art world of Paris, towards 1855. Whilst their personal relationships seem to have been distant, to say the least, there are oblique references to Courbet in certain of Millet's drawings. Two studies for a pastel of 1857, *Shepherd Directing Two Travellers*,[36] are closely related to the disposition of Courbet's painting *The Meeting*, which had hung at the Exposition Universelle in 1855 (Fig. 6.21). The pastel itself is quite far from Courbet's design in that it reverses the roles of the protagonists in this tripartite relationship: Millet makes a shepherd, not an artist, his dominant personality, with outstretched arm pointing the way, and the figure with proffered hat becomes not a respectful patron but a humble stranger to these parts. The pastel is a shade bland in its treatment, but the preliminary drawings in black chalk,[37] of which one is reproduced here, are not only much closer to Courbet's design but impart a more forceful psychological drama (Fig. 6.20). The man holding out his hat appears to be a parody of Courbet's M. Bruyas, and he

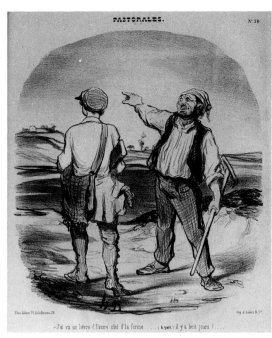

6.22 Daumier. *I saw a hare on the other side of the farm . . . [aside] eight days go!"* Lithograph, published in *Charivari*, 15 May 1846 (LD 1437).

6.24 Millet. Drawing for the etching *Going to Work*. 1863. Black chalk, 40 × 29. Algiers, Musée des Beaux-Arts.

6.23 Millet. *Man Leaning on his Spade*. c.1860. Black chalk, 32 × 22. Paris, Louvre, Inv. RF 245 (GM 10,364).

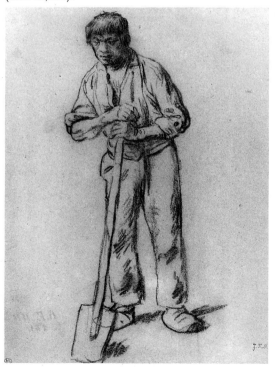

stands in supplication before a rather ferocious shepherd (who might be bellowing into his ear, as to a foreigner) and his even more ferocious dog. Curiously enough, there is an earlier lithograph by Daumier on the theme of 'the traveller lost', in which a shifty-eyed peasant derisively misdirects a hunter (a Parisian bourgeois) with the same gesture as Millet's shepherd (Fig. 6.22). Does Millet's drawing carry similar connotations, or is his shepherd to be read more as a spiritual guide?[38] While the readings of both Courbet's great canvas and Daumier's cartoon are unequivocal, Millet's image seems less certain in its intent, and the most disturbing of the three.

Millet's working process consisted of two stages: a very powerful inspirational drive when putting down a first notation, and then a high degree of self-criticism as he worked towards the final form. Moreover, such first notations could extend in several directions; key themes could be reopened for treatment a second or third time. A case in point is the drawing called *Going to Work*, in Algiers Museum (Fig. 6.24). This was the subject of two paintings of 1851–3, of the same design except for the landscape. This drawing was one of seven made in preparation for an etching which Millet executed in 1863.[39] Here the peasant and his wife walk rhythmically in step through the flat plain of the Brie. The weight of the water jar carried by the woman keeps her arm down stiffly to one side. In parallel to her stance, the man supports the big iron head of a digging tool in the crook of his left arm. The little village and orchard in the distance behind them might belong to an idyllic Impressionist landscape of the 1870s, except that to Millet this is strictly a working drawing for an image signifying labour. Impassively he draws an enlarged detail of the woman's features on the space reserved for sky to the left of her head, and another of her eyes and brow to the right of it. It is as though, whilst immersed in the artifice necessary to make art, he was actually unconscious of the art he was making in this drawing. It was near the date of the etching which evolved from this drawing that he wrote his statement: *Il faut pouvoir faire servir le trivial à l'expression du sublime, c'est là la vrai force.*

It is not feasible to make a catalogue here of the encyclopaedic range of rural labouring activities that Millet covered in his drawings and paintings of this period. The peasant types he represented could be divided into two social groups: the *bricoliers*, or smallholders, who owned perhaps 12–20 acres of land that they worked themselves; and the *manouvriers*, who could also own a small plot, probably less than an acre, and grow vegetables on it, but who had to become woodcutters in winter and hire themselves out to the big farmers in summer, as shepherds or general labourers.[40] Millet generally avoided making any overt moral or social comment when depicting them (other than the philosophical reactions already noted), and this has led to some varied readings of his intentions by later writers. It is generally agreed that the peasants he knew who lived on the immediate edge of the forest were poor, but he does not represent them in rags. He is more interested in their traditional activities as signifying some larger life cycle. The slaughter of a hog is a drama, to Millet; the gathering of the harvest is seen as a celebration; a man leaning on his hoe at the end of the day spells physical and mental exhaustion – but that, too, Millet claimed in his defence of his picture, is a drama. The extremes may be contrasted. A drawing of *A Man Leaning on his Spade* (Fig. 6.23) is one of a large group of drawings connected with men digging. All the images convey hard labour, and in a sense they culminate in the notorious painting *Man Leaning on his Hoe*, exhibited at the Salon of 1863. This drawing is not as grim as the figure in the painting to which it seems to relate,[41] but the weight, the simplicity of the lines, and the sense of the enormous leverage that he has been exerting with his long-handled spade (as opposed to the negative dead-weight of a hoe), gives this peasant a frightening presence in that the ordinary bourgeois will feel that he could not perform the labour that this one

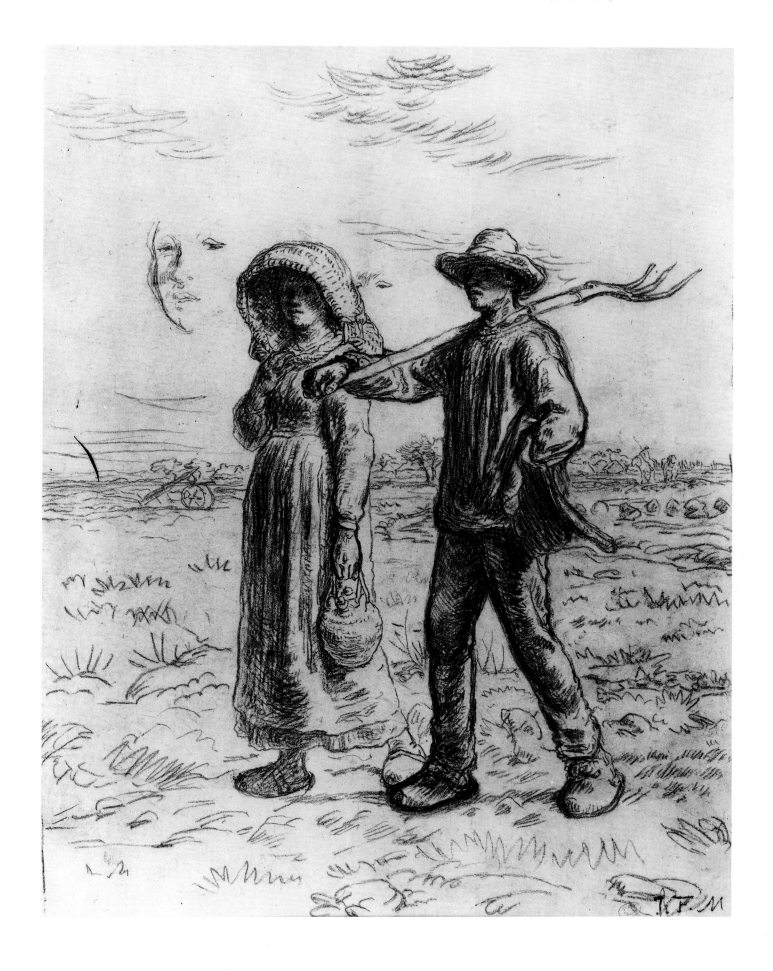

6.25 Millet. *Two Studies of a Peasant's Head.*
*c.*1860. Black chalk, 23.2 × 19. Paris, Louvre, Inv.
RF 257 (GM 10,489).

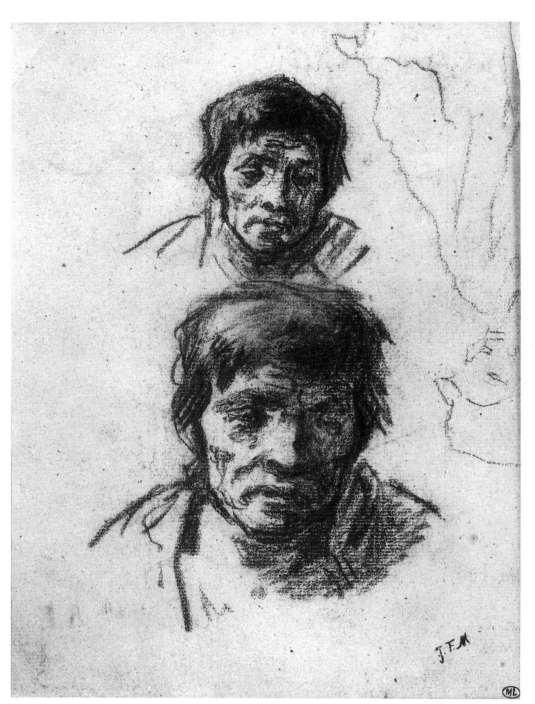

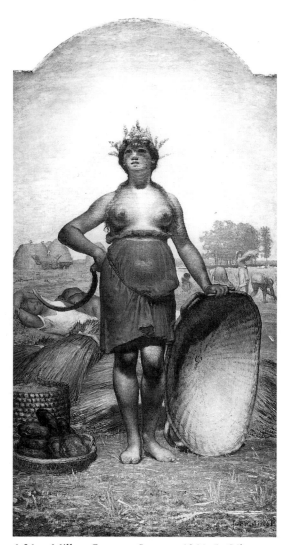

6.26. Millet. *Ceres,* or *Summer.* 1864–5. Oil on
canvas, 266 × 134. Bordeaux, Musée des Beaux-
Arts.

does. Among the several related drawings, a study of a single head exists that
must be for the painting of the *Man with a Hoe*,[42] but as studies of expression in
this context I prefer two studies of comparable size which may also be dated to
about 1860 (Fig. 6.25). It is a great mistake to believe (and therefore to think that
one perceives) that Millet's peasants' faces are devoid of expression. These two
heads are the full equivalents of Daumier's urban proletariat, as rendered in the
latter's drawings, paintings and lithographs.

By contrast, Millet's group of decorative canvases of *The Four Seasons*, painted
for the Paris residence of M. Thomas of Colmar during 1864–5, are optimistic
and brightly coloured. *Ceres,* or *Summer,* was conceived on a heroic scale (Fig.

6.27 Millet. *Two Figures*: study for *Ceres* or
Summer. 1864. Pencil, 27 × 18. New Haven, Conn.
Yale University Art Gallery, Everett v. Meeks,
B.A. 1901, Fund.

6.28 Millet. Figure study for *Ceres* or *Summer*.
1864. Black chalk, Coll. Claude Aubry.

6.26). The bright blue sky which fills the upper part of the canvas[43] contrasts with
the vivid red and orange skirt of the heavily overpainted central figure, who
might well be a resuscitation of one of Millet's entries for the allegory of *La
République* in the State Competition of 1848.[44] The background, with idealised
harvesters working in the fields, is as flat as a Puvis de Chavannes mural, only
more brightly coloured. The several surviving studies for these decorations are
much lighter in touch, in their drawing style, than the related paintings. An early
sketch for *Ceres* in pencil, now at Yale, shows two figures, one male and one
female, with joined hands (Fig. 6.27). (In another context, they will appear again
in the last chapter, as *Peasant Family*.) The woman holds a sickle, and the man the
handle of a plough, with an ox behind him. The vibrant pencil strokes might
almost be a throwback to his Paris *manière fleurie*, except that the intentions of his
contours are much clearer here, however loosely rendered.[45] The farm
implements are again an echo of 1848, in this case like those of his drawing
L'Égalité (Fig. 5.14). To the left of the young woman a lightly sketched nude may
be perceived, reclining on sheaves of corn, which recalls his early sensuous style.
In the painting this image is transformed into sleeping harvesters, of conventional
modesty. In a later sketch (Fig. 6.28) Millet decided to render his allegory of

93

Summer as a single female goddess. She is ⁞ ⁞orn and she has gained the attributes, besides her sick⁞ ⁞ huge straw sieve for winnowing and a basket of grain a⁞ ⁞expression is simple and dignified, and the background se⁞ ⁞he Brie. Did Millet signify a reversal of intent in this group ⁞ ⁞ssible for him to fuse the pagan classical tradition with me⁞nor⁞ ⁞can imagery? Would that even have seemed appropriate in 186⁞ ⁞. It might be supposed that Millet, who for the first time in his st⁞ ⁞was achieving a modicum of critical approval and financial succc⁞⁞, ⁞⁞ ⁞o express the epitome of his rural epic in its most optimistic aspect. If so, his optimism would not last for long. It is not correct to conclude from Millet's inconsistencies that in his rural attitudes he was 'more or less a liar'.[46] Nor can I allow that Millet's peasant imagery, when idealised like this, was produced in answer to the requirements of Sensier's fantasy.[47] We will shortly find him opening his eyes to new landscapes and places, and new harmonies of colour with which to portray his peasants, before his temporary optimism is overcome by his country's blighted history during and after the war of 1870.

7 Daumier's Republic

'Il faut être de son temps'[1]

WHEN DAUMIER SCRIBBLED these words above his signature in a presentation copy of Champfleury's *La Caricature moderne*, he was probably referring to the frame of mind of the caricaturist *per se*, rather than making a statement about his or any other artist's philosophy in general. Nevertheless, as his biographer Arsène Alexandre said, this maxim, so simple as to appear naive, is in fact quite justified in terms of his particular kind of wisdom, and one that few artists succeed in putting into practice. Daumier was deeply interested in the social and political structures of the society in which he lived. Some of his most direct comments on that society are made through his lithographs, the most forceful of which often did not require legends to be understood. Representations of that same society are found in some of his paintings and in some of his drawings, without the overt social comment.[2] A closer examination of his surviving drawings, however, reveals that many do not relate at all closely to the subjects of his lithographs: what he drew for himself spans a broader section of the social strata than the *bons bourgeois* who so often saw themselves reflected in the pages of *Charivari*. So varied are his wandering notations on paper that they could be seen as a kind of exploration of the basic clay of human existence.

A body of drawings more or less datable to the 1850s seems to be concerned with this 'basic clay', specifically as found in Daumier's local urban environment. The images they contain probably belong to a narrower catchment area than that required by his lithographs of the whole Parisian scene. The muddy shores of the Seine around the Ile St Louis, some bridges, some cliff-like silhouettes of housing along the *quais* of the Ile de la Cité and the Right Bank, intimations of markets northwards past Châtelet to Les Halles; this was the territory of those drawings I shall allocate to the category of 'Daumier's Republic'. Within these areas he could have found all the washerwomen, coal porters, meat carriers and blacksmiths, the butchers and bakers, the drinkers and smokers, the street entertainers and beggars, and the mothers with broods of children that he needed to populate his more private ruminations upon humanity. This kind of basic street population had frequently been explored before as material for popular art, most obviously perhaps in the many series of prints labelled *Les Cris de Paris*.[3]

In this chapter we shall consider what happened to Daumier's art after the political demise of the Second French Republic. That event coincided with the ending of Daumier's brief public career as an exhibitor at the Salon,[4] though why it should do so is not clear. It could hardly be because he 'went back' to working for *Charivari*, because he had never stopped producing lithographs during the critical years following the February Revolution. Indeed, the year 1851 marked a

7.1 Daumier. *Les Émigrants (Refugees)*. *c*.1849–52.
Plaster (toned), 28 × 66. Paris, Musée d'Orsay.

climax to his activities as a political commentator, when his opposition to Louis-Napoléon's *coup d'état* was unequivocal. The years that followed have been characterised by Osiakowski as years of 'Repression and Opposition' under press censorship, which tightened still further after 1858.[5] Would this have affected his separate activity of painting for the Salon? His painter friends all had an annual pattern of 'painting for the Salon', whether accepted or not. Moreover Courbet, Millet and Rousseau, all of whom were close enough to Daumier, were usually getting their works into the Salon, whether they were well received by the public or not. Another close friend, Corot, was now exhibiting at the Salon with ever-increasing success, although his naivety of character was apparently disliked by the Academicians of this era.[6] Daumier must have had other reasons for his procrastination. At this same period he was renewing his activities as a sculptor. His infamous plaster statuette made for his cartoon character of *Ratapoil*, with grisly countenance and spiralling rhythms like a hollow baroque genie, which exposed the sham aspirations of his enemy Louis-Napoléon at one stroke – much to the historian Michelet's delight – was created about 1850 (Fig. 4.9). At the same time or shortly afterwards he was working on a relief of a procession of emigrants or refugees which could have no popular appeal, and must only reflect his private despair (Fig. 7.1). Eye-witness accounts suggest that he produced nothing in accordance to any consistent plan. The only thing he *had* to finish to a deadline was his quota of lithographic stones for the week, to be taken to the printer. Anything less pressing more often than not remained in a state of creative chaos (no wonder he became so admired by twentieth-century modernists) – an outpouring of images constantly subject to modification and revision. Compare this oft-quoted description of his studio by the publisher Poulet-Malassis, who visited him on 14 January 1852:

Baudelaire takes me to Daumier's house on the Quai d'Anjou, near the Hôtel Lambert. We find him in his studio, very simple, the studio of an artist who has absolutely no reason to take account of outside visitors. One sees there only objects of utility or personal attachment. Two lithographs after Delacroix. Two after Préault, several medallions by David [d'Angers],[7] a landscape by an unknown.

He receives me like an old friend, for whom one does not have to jump to one's feet.

Daumier is pressed for time, he is finishing a lithograph for *Charivari*.

Baudelaire believes that he has already done this one. Daumier does not say no, [but] sufficiently full of originality as he is, he has no fear of repeating himself. There is on an easel the beginning of a painting of a Martyrdom.

[*P-M*] 'Will you have any paintings for the Salon?'

[*D*] 'I really don't know at all. I'm not counting on it'.

[*P-M*] 'You haven't much time to lose.'

[*D*] 'I start everything twenty-five times over. In the end I do it all in two days.'

This extraordinary off-handedness, which may have been to disguise shyness, seems to have slightly put out Poulet-Malassis. He makes an unflattering note about Daumier's features, 'devoid of fineness or nobility', and adds that his face is 'capable of the malleability of a comedian'. Then he glances round the studio again.

He also does sculpture. I see what looks like a great bacchanale, in wax, on the studio wall. Various *ébauches*.[8] A Magdalene, a Washerwoman dragging a little girl along the quayside, blown by a great wind – an *ébauche* so sad in feeling that one might say the huge bundle of linen stuck under her arm was en route for the pawn-shop.

There are many old canvases turned to the wall, to be taken up another time. That is all I saw . . . it is always [thus] as Baudelaire says, in the process of imaginative drawing.[9]

This short document is invaluable evidence in support of our previous speculations. Typical of eye-witnesses, Poulet-Moulassis' recall is a mixture of accurate and inaccurate information, depending upon the degree of visual interest he has in different things. But all the essential hints are there: Daumier getting bored with lithography and repeating an old design; the canvases, which all look like beginnings to this visitor's eye; the bas-relief which he thinks is in wax but might easily be one of the versions of the *Émigrants* relief in clay,[10] perhaps glazed over with some substance in preparation for casting; the Magdalene *ébauche* (identifiable as a study for a government commission);[11] and finally the more detailed description of *The Washerwoman* painting which has particularly moved him. It may not have been finished, but the feeling the artist wished to convey was evidently completely there, as indeed we may feel is the case today upon looking at one of the several extant versions of this picture (Fig. 7.3). The 'beginning of a Martyrdom' on the easel can definitely be identified with either the oil sketch or the *ébauche* of *The Martyrdom of St Sebastian* – another government commission which Daumier did finish but which disappeared from sight for many years, after he had received his final payment on 30 June 1852.[12] A preliminary drawing of the same subject will be discussed with his other religious illustrations in Chapter 9 (p.152 and Fig. 9.21).

The concluding quotation in this account, attributed to Baudelaire, that 'it is always thus in the process of imaginative drawing' seems to me significant. The confused mass of unfinished work in Daumier's studio was surely in that state because the imaginative vision can never be finite. Whatever chimeras came into his mind might be made concrete (to use Courbet's term) in paintforms, and they might dissolve again only to become something else. As one goes through the whole of Daumier's production it is often found that a given image with one associated meaning interchanges with another image, perhaps very similar in form but different in meaning. This occurs in drawings and sketches particularly, where meaning is most easily made ambiguous. Thus, for example, the bas-relief that Poulet-Malassis saw in the studio might have reminded him of the 'bacchanale' of the *Drunkenness of Silenus* gouache that Daumier had recently shown at the Salon (Fig. 5.26), whereas, had he looked more closely at this dark

brown clay relief, which was itself no more than a suggestive sketch, the slight resemblance of this swaying and straggling line of refugees to a bacchanale would have seemed a grim irony indeed (Fig. 7.1).[13]

The studio on the Quai d'Anjou had been visited by another writer a few years before Poulet-Malassis, at which time it gave a somewhat different impression. Around 1848 the journalist-poet Théodore de Banville had called upon Daumier to ask him for a drawing to be used for a new cover for the satirical journal *Le Corsaire*.[14] He found the artist sitting at a table in the middle of a big bare room, working at a lithographic stone. On the walls absolutely noting was hanging except a lithograph after Préault's *The Parias*.[15] His studio was purely functional. There was a square black stove of varnished sheet-iron and, against the walls, swollen cartons so overflowing with *drawings* (de Banville says) that they would never again be closed. (Could they have held lithographic proofs as well as drawings?) There is no mention of paintings.[16] This seems to confirm the general supposition that Daumier had done very little painting before 1848 and, if that were so, all the canvases that Poulet-Moulassis saw in January 1852 would have been begun in the space of about three years only.

Théodore de Banville concludes his account with a description of the disastrous state of Daumier's lithographic crayons, mostly broken stubs that had to be grasped at absurd angles in order to obtain a mark from them at all. (One is reminded of the stories of the elderly Turner sketching with blunt pencils – another instance of the romantic idea of creation best proceeding out of chaos.) All accounts of Daumier's studio have this factor of disorderly productivity in common: even a description of his last studio, in Valmondois, refers to 'pour ornament, des toiles ébauchées'.[17]

More than one commentator has remarked upon Daumier's handling of the paintbrush as if it were a drawing tool, especially in his earlier paintings (e.g., *La République* of 1848, *The Miller, his Son and the Ass* of 1849) in which the linear contours are vigorous enough but large toned areas tend to be flat and dull. It has already been noted that the *Silenus* picture sent to the Salon in 1850 was executed in mixed painting and drawing media. This 'graphic predominance', which characterises Daumier's first painting style, is found in his finest painting of the mid-1850s, *We Want Barabbas! . . .* (Fig. 7.2) now in Essen Museum. Using very large brushes as though they were outsize chalks, Daumier sketches in his rough and energetic crowd (they bear a family resemblance to his earliest paintings of workers discussed in Chapter 5) with immense confidence now. The baroque diagonal build-up of the composition, which is directly comparable to the schema he had already invented for an 1848 lithograph, *Citoyennes. . .* (Fig. 4.5), becomes suddenly stilled when one's eye reaches the figure of Christ, a frail silhouette representing God as Man, surrounded by a yellow-grey penumbra of light at the top of the picture. The crowd, as earthy as can be (where has one seen that bald-headed man holding up his son for a better view?) seems not so much hostile as uncomprehending of what all this is about. Like the *Citoyennes. . .*, the whole issue has become a big muddle, ironically 'recorded' by Daumier as if he could see it. The fact that this canvas is unfinished suggests that it was not a commission but a religious subject painted in personal terms, producing an image as unacceptable for public viewing as Millet's *Hagar and Ishmael* would have been.

We should now examine a selection of those drawings whose subject matter was drawn entirely from Daumier's immediate local environment. The theme of the washerwoman leading her child by the hand along the quayside, which caught the eye of Poulet-Malassis in 1852, is one that Daumier treated six times in oil paintings, and there are several related drawings. It probably interested him for

7.2 Daumier. *We Want Barabbas . . . (Ecce Homo)*. *c*.1852–7. Oil on canvas, 160 × 127. Essen, Museum Folkwang.

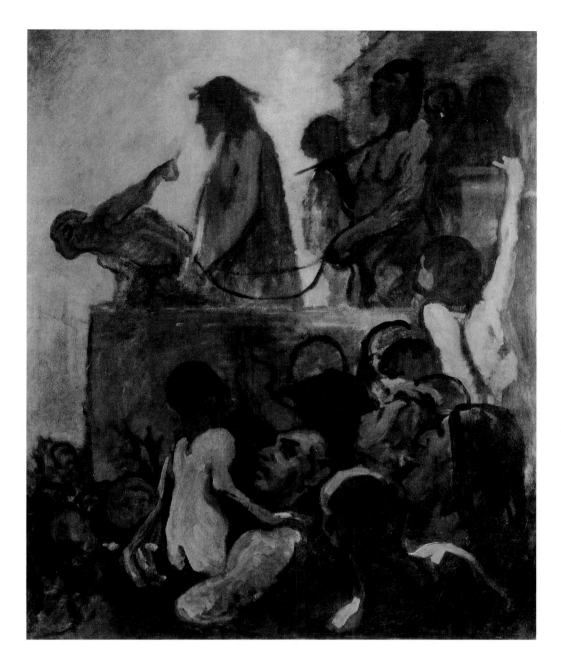

about ten years, between 1850 and 1860. The painting in the Burrell Collection, Glasgow (Fig. 7.3) is a rather sophisticated version of this theme, in which the woman bends her head down at a graceful angle against the wind and appears to float along the path beside the river wall.[18] These works have acquired various given titles, including *Le Fardeau (The Heavy Burden)* and *La Blanchisseuse (The Washerwoman)*, and the woman concerned belonged to that class whose occupation was to wash clothes on the banks of the river Seine below the Quais – a primitive task directly comparable to Millet's women doing their own washing in country streams – carrying their load up the steep steps to the street above after they had finished. A charcoal drawing in the Avnet Collection (Fig. 7.4) has just the same rhythmic flow as the figure in the painting, although in this case she is visualised from the back (Daumier has also mentally reversed the direction in which she walks). There are several other *croquis* extant of this sculpturally conceived group,[19] which became a kind of leitmotif in the imagery of what I am

7.3 Daumier. *Le Fardeau* (*The Washerwoman*). c.1855–60. Oil on canvas, 40 × 30. Burrell Collection, Glasgow Museums and Art Galleries.

7.4 Daumier. *Woman and Child Walking*. c.1850–5. Charcoal, 30.6 × 24.2. Mr and Mrs Lester Avnet, Great Neck, New York.

calling 'Daumier's Republic' – she and her child reappear a number of times in the street and in the market-place.

In the drawing known as *The Market*, in the Fogg Museum (Fig. 7.5), the child appears as naked as a cherub, now cheerfully holding its mother's hand while she carries her burden, changed from a bag of washing to a shopping basket. This drawing was made in successive stages. The first essay was in sanguine or red chalk with a slight greyish tinge to it, and then a light grey wash was applied for shadowed areas. The space to be enclosed by the design was marked clearly by the triangular shadow at the bottom left, reinforced by a thick horizontal mark in red chalk. Then the contours and internal structures of the three nearest figures were gone over again in black chalk, the figure on the left being almost entirely redrawn. The child remained nude, and the position of its legs was readjusted for the third or fourth time. With each redrawing the sculpturally conceived mass of

100

7.5 Daumier. *The Market. c.*1850–5. Brown and grey charcoal, black chalk, grey wash, and a touch of red chalk, 36.5 × 30. Cambridge, Mass., The Fogg Art Museum, Bequest of Grenville L. Winthrop.

7.6 Daumier. *Woman Guiding her Child* ('*The First Steps*'). *c.*1852–3. Charcoal (rubbed) on blue paper, 27.9 × 20. London, British Museum (Inv. 1925-11-14-3 verso).

the central figure became stronger. The contour of her forward-thrust hip was finally rendered by the unconventional technique of erasing the edge of the basket that presses against it. The positions of all the feet on the ground, in perspectival relation to each other, are marked by firm horizontal strokes in black, which double as shadows. Yet, for all this, the total image of the market-place remains incomplete; the bustling crowd is suggested, but not quite crystallised in its meaning. Some faint unease remains in the viewer's mind.[20]

Woman Guiding her Child (Fig. 7.6) and *Man Carrying a Bucket* (Fig. 7.7) are verso and recto respectively of the same sheet, both drawn in charcoal, the rubbed verso side having been drawn first. It relates to a group of paintings of bathers in

7.7 Daumier. *Man Carrying a Bucket*. Charcoal on blue paper, 27.9 × 20. London, British Museum (Inv. 1925–11–14–3 recto).

7.8 Daumier. *The Water Carrier. c.*1855–60. Oil on canvas, 26 × 16. Barnes Foundation, Merion.

the Seine, datable to the 1850s.[21] The figure holding the baby up by its arms, in the paintings, is usually a man up to his knees in water. It is hard to escape the conclusion that this drawing is some immediately recorded memory of a thing seen. Used or unused, the sheet was then turned over and a drawing produced which must be an imagined reconstruction of a man carrying a bucket of water. Daumier's chalk moves in empathy with the strain on the man's back muscles, twisted to the left, with arm stretched out to balance the weight of the bucket on the right. Iconographically, the theme is the ancient one of the Water Carrier, one of the oldest of the *Cris de Paris* recorded in numerous series of popular prints.[22] Daumier was not concerned with a popular image in this drawing, but he seems

102

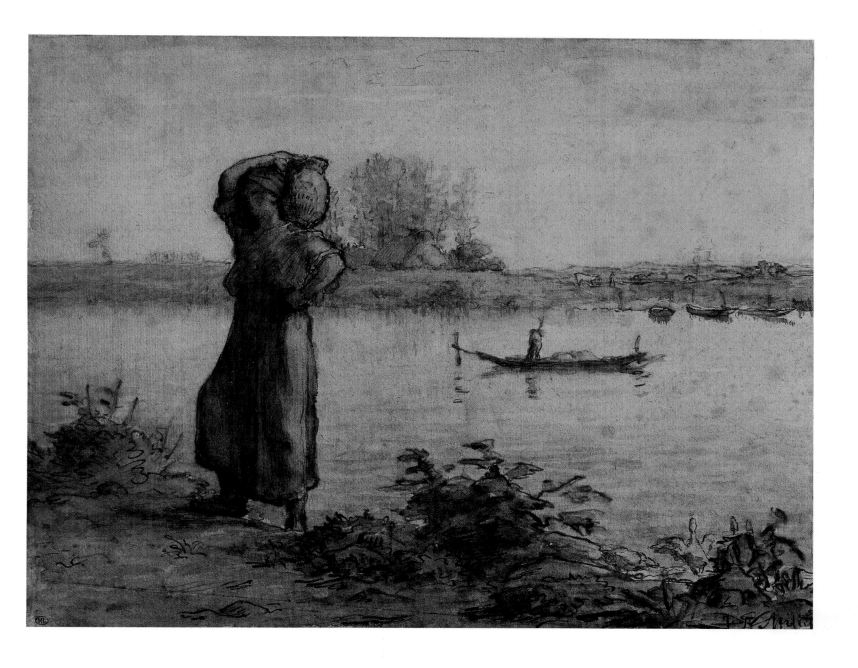

7.10 Millet. *Woman Water Carrier at the Edge of a River*. *c*.1855–60. Brown pen and water–colour, 27 × 34.5. Paris Louvre, Inv. RF 4650 (GM 10,384).

7.9 Daumier. *At the Water's Edge (Le Bain des jeunes filles)*. *c*.1849–53. Oil on panel, 33 × 24. Troyes, Museum of Modern art, Pierre Lévy Collection.

to have reverted to the sociological meaning of the Water Carrier in an oil painting which is formally related to it (Fig. 7.8).[23] The painting evokes the conditions of the original trade, as it might actually have felt to be the man carrying a heavy bucket of water as he entered a steep flight of steps in the dark mouth of an anonymous working-class dwelling. Daumier has combined his study of action with a Caravaggiesque evocation of the reality of mood and event.

There are a number of such studies sympathetic to mood and place. Another excellent example is the small panel from the Pierre Lévy Collection at Troyes known as *At the Water's Edge* (Fig. 7.9). Although still very dependent upon drawn contour lines to set the figures in space, this painting does have a golden atmospheric quality (caused, partly, by several layers of varnish and glazing colours), almost Corot-like in its simplicity, which makes a perfect setting for the young girl paddling in the shallows of the Seine under the city walls. She is obviously at one with the washerwomen working beside her, who are themselves

7.11 Daumier. *Four Children Playing. c.*1855–60. Brown ink and wash, 15.3 × 21.2 (sight). Detroit Institute of Arts.

7.12 Daumier. *Soins maternels. c.*1855–7. Brown and black chalk, 26 × 17.8. Bremen, Kunsthalle (1926.331 verso).

7.13 Daumier. *Woman Carrying a Child. c.*1855–7. Black chalk and pen, 26 × 17.8. Bremen, Kunsthalle (1926/331 recto).

7.14 Rembrandt. '*The Naughty Boy*'. *c.*1635. Pen and wash, 20.6 × 14.3. Berlin (West), Staatliche Museen-Dahlem.

strikingly in accord with Millet's drawings of women on the river banks on the outskirts of Paris, drawn at this same epoch or a little earlier (Fig. 7.10). The tall, slender figures have similar proportions, and both artists give the labouring classes a kind of balletic dignity. The colour in Daumier's painting enhances the lyricism of his chosen theme. There is a pervasive note of Antwerp blue, that begins in the sky, which is set off against orange-rose glazes on the flesh colours of the figures and a fine madder lake tint on the bathing girl's bodice. It is tempting to speculate that Daumier was learning as much about colour from Millet at this point as he had previously learned from the example of Delacroix.

Small children constantly appear in Daumier's local world. We can see them going to and from school, playing under the trees, and either holding their mother's hand or being carried by her. The virtues of 'the family' are, of course, commonplace in nineteenth-century French social mores – its inspiration in art lay in the ideas of middle-class *sensibilité*, best expressed in the previous century by Chardin and Greuze – but small children seem particularly ubiquitous in Daumier's drawings, as though he had them running under his feet. The drawing of *Four Children Playing* at Detroit (Fig. 7.11), drawn very firmly with a pen in brown ox-gall ink over some light lines in black chalk, is an example of his spontaneity in this vein. The round, doll-like faces of these little creatures border on caricature, but the observation of their attitudes and postures are what the French would call *très exacte*. Some local colours are added in pink and blue watercolour. On the reverse of this sheet is a part of a cut-down drawing of women and a child walking in an urban street.[24]

A family theme treated by both Daumier and Millet is politely known as *Soins maternels*.[25] Daumier's drawing of this title in Bremen Kunsthalle is a very rough sketch, now rubbed and faint, although it was drawn twice over using different chalks (Fig. 7.12). The vibrating contours are so lively that it is difficult to believe that it was not drawn directly from the model. The existence of a tracing from this drawing indicates that Daumier wished to carry his design further. On the recto of the same sheet is a drawing of a young woman carrying what looks like the same child (Fig. 7.13). This figure was very broadly adumbrated in black

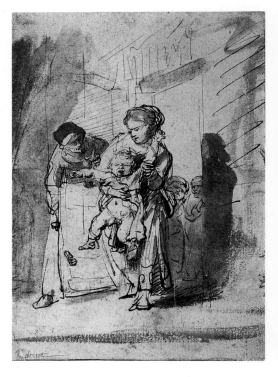

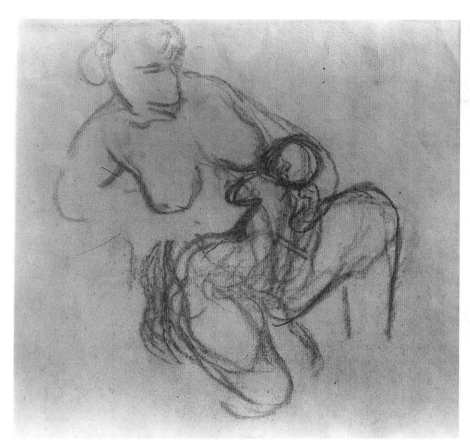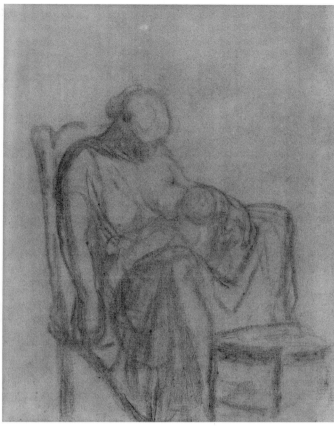

7.15 Daumier. *Woman Breast-Feeding her Child.*
*c.*1850–5. Charcoal, 28 × 28.8. (ex coll. Claude
Roger-Marx).

7.16 Daumier. *Détresse* (*Woman Feeding her Baby*).
*c.*1850–5. Black chalk, 36.5 × 28. Toronto, Art
Gallery of Ontario, Zacks Collection.

chalk (now rubbed) before he drew in a less full-skirted figure with a pen. At that
point the child's face looking over its mother's shoulder stole his attention, as it
now does ours. The analogies with Rembrandt's expressive drawings based upon
immediate observations of life around him are so compelling here that one
illustration may be permitted to make the point – the drawing known as '*The
Naughty Boy'* in the Dahlem Museum in Berlin (Fig. 7.14). This is just one of a
large group of such drawings that Rembrandt made in Amsterdam in the
mid-1630s,[26], all drawn in pen with incredibly spontaneous strokes that catch
both fleeting movements and fleeting facial expressions. Even if Daumier did not
know any of these in the original he certainly knew analogous Rembrandt
etchings.[27] Be that as it may, Daumier's own images are clearly created from his
own contemporary world – and a world very close to his home. From the same
environment, but perhaps made with a different purpose, are his drawings of
nursing mothers. One of these, formerly in the Roger-Marx collection, has an
almost brutal directness of treatment (Fig. 7.15). The urgency of the infant
suckling the mother's breast is expressed by contours drawn like iron bands cast
around and forms. The head of the mother remains almost featureless: one line
suffices for an eye, and single strokes define strong neck muscles and a heavy
jawbone. A related drawing, from the Zacks Collection, shows the same mother
almost asleep, with her head dropped forward (Fig. 7.16). Earlier I mentioned the
practice of sending babies out to wet-nurse with mothers (*nourrices*), who were
very low on the poverty scale (Chapter 3, p.35). The Zacks drawing acquired the
given title *Détresse* at some point, and it seems possible this drawing was intended
as a reference to that social situation. The definitive drawing in this group is the
one in the Louvre known a *La Soupe* (Fig. 7.17). The ferocious figure of the
woman with the baby on her lap might be Daumier's allegory of *La République*

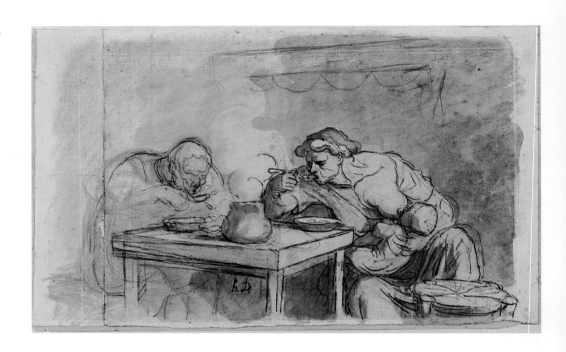

7.17 Daumier. *La Soupe*. *c*.1853–7. Black chalk, watercolour, pen and ink, 28 × 40. Paris, Louvre (Inv. RF 5188).

transformed into an illustration of contemporary life, though she still retains some associations with a Charity figure as well. The result is an image which has both monumental and violent aspects. The way she thrusts out her lips to the spoon, to feed herself while the baby feeds from her breast, has been interpreted as brutal realism, though when one looks at the drops of soup spilling from the spoon of the man on the left the scene could also be interpreted as comic. If so, it was not a kind of comedy calculated to entertain the bourgeoisie.

The technique of *La Soupe* suggests that it occupies an interim position in Daumier's development of finished watercolours done on commission or intended for sale (these mostly belong to the 1860s). It was begun in black chalk, and pictorial space was then further indicated by tonal washes in pink and grey. More linear accents were added in pen, a touch of red added to the woman's cap (affirming her identity with *La République*?) and a touch of blue to her dress. An additional piece of paper has been added to the left-hand margin, indicating that Daumier intended to develop his design further.[28] The interior setting with a huge fireplace might be either urban (the basement of a tall Paris apartment house) or rural (a farmhouse), but is more likely to be the former. The scallop shapes under the lintel of the fireplace are also found in a charcoal sketch, made for a watercolour in a private collection, known as *Chasseurs se chauffant*, in which three men and a dog sit before a roaring fire.[29] Their circumstances look more comfortable than the family in *La Soupe*, as though they might be country gamekeepers. A third and much stranger evocation of the hearth is a large, fragmented drawing of *A Boy Warming Himself by the Fire* (Figs 7.18 and 7.19). The central figure, drawn in black chalk, is actually superimposed over a number of erased drawings in charcoal. This naked gnome squats, like a sorcerer's apprentice, before a blaze that Daumier has indicated solely by tonal effects, that is, he has heavily erased a mass of charcoal shading until the paper has shown white again. A similar technique renders the effect of light on the boy's face, lit from below, and it is also used to suggest the head of a girl emerging from the shadows behind him. This mutilated sheet of paper, which has been folded in three and partly cut away, must have been hanging around in the studio for years before Daumier re-used it to produce this striking and yet somewhat sinister image. If the sheet is rotated 90 degrees anticlockwise, the remains of an earlier

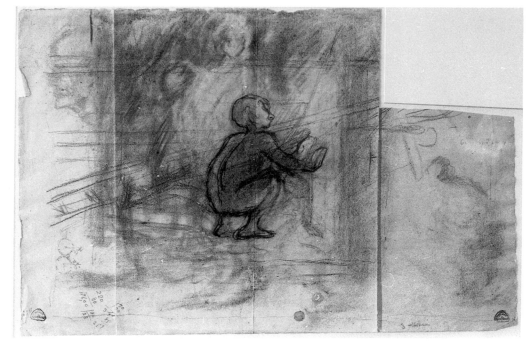

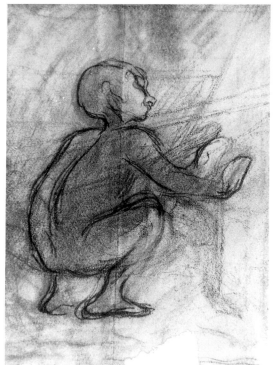

7.19 Daumier. De

7.20 Daumier. *I* *orge).*
*c.*1855–8. Black me pencil
and white goua re
(Donation Cl

study of a man climbing a ladder can be seen (compare Fig. 3.11). To the left of
the sheet, beyond the fold, is a man's head in profile, very like the one at the
bottom of the drawing of *Les Émigrants* (Fig. 4.15). These remains could go back
as far as 1848. Probably at a much later date he created a shadowy chaos out of
them, by stomping and smudging the charcoal to make the background against
which, for reasons unknown, this curious imp appears (Fig. 7.19). Whose hearth
is he at? Is he a refugee? He belongs to Daumier's private world.

'Daumier's Republic' included manual workers and skilled trades. Two
important groups among the latter were the *forgerons* or urban blacksmiths, and
the butchers.[30] A number of drawings of these which belong to the late 1850's
have a strength and confidence about them, as well as a slight suggestion of
menace, that reflects the character of the independent artisan which Daumier
evidently understood. Technically, many of these drawings were worked up
systematically in several stages, using preliminary sketches, towards an often
elaborately finished watercolour obviously intended for sale. (In this same era
Daumier began to produce his series of watercolours on the popular themes of
lawyers and of railway carriages, for both of which he had already become known
through his lithographs in *Charivari*.) A case in point concerning the artisans is the
subject of the *Man at a Forge* (Fig. 7.20). The significance of the forge worker in
urban Paris was mentioned in Chapter 3 (pp.33 and 211 note 17), in the context
of both Daumier and Millet. Daumier's drawing *Le Forgeron* in the Louvre was
preceded by at least two sketches in black chalk, in one of which (see Fig. 3.14)
the blacksmith's left hand is raised to pull the cord above his head that works the
bellows of the furnace. In the Louvre work he is performing the same action with
both hands. The dramatic tonal effect of glowing firelight is worked out in a
series of overlaid washes of grey. He began this drawing in black chalk, rubbing it
into the shadowy areas probably with his fingers, and followed with firmer
contours with a newly sharpened chalk. (On the second round the position of the
blacksmith's feet were raised about one inch on the paper.) Then the layers of
grey were applied, overlaid again with white gouache in places to make
corrections. The faintly indicated bust of a man wearing a hat, found in the

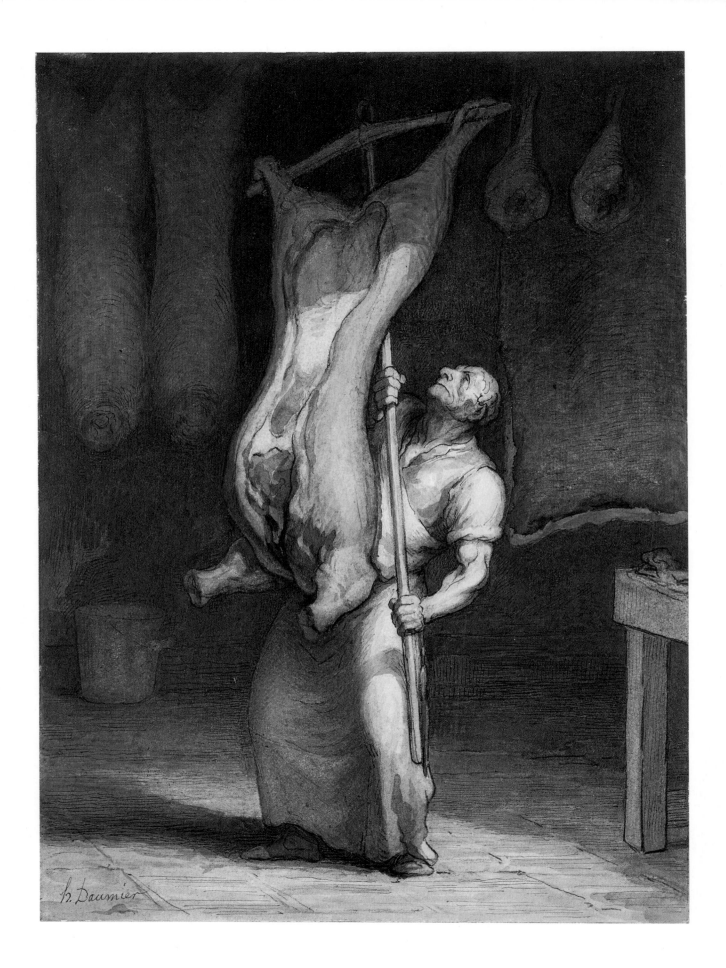

7.21 Daumier. *Butcher with a Carcass. c.*1856–8. Black chalk graphite, pen and black ink, grey and coloured washes, 33.3 × 24.2. Cambridge, Mass., The Fogg Art Museum.

7.22 (Diderot, Éd.). Illustration to *Encyclopédie, Plates,* Vol. II (1763). Boucher, Plate I. *Abattoir.*

7.23 Daumier. *Butcher with Meat Cleaver. c.*1856–8. Black chalks, guill pen and black ink, grey and coloured washes, white gouache, 27.3 × 22.3. Cambridge, Mass., The Fogg Art Museum.

middle of the flames, seems to be left over from some earlier stage of the design. The functional centre of this drawing becomes the blacksmith performing this single action, his face and shirt lit up in front of the surrounding darkness.[31] The rest of the drawing remains a kind of battlefield of unresolved ares, with only the anvil to the left, and the hammer leaning against it, firmly if roughly placed. In the final version of the drawing everything is resolved, with the blacksmith holding the bellows cord in one hand and his pincers over the fire with the other, and he is made into a dignified and commanding figure.[32] The Louvre drawing, however, catches the essence of the busy working man himself, neither demanding nor expecting an audience for his performance.

The drawings of butchers are closely comparable with those of the blacksmiths in style. *Butcher with a Carcass,* in the Fogg Museum (Fig. 7.21), is, however, more complex in technique than the final version of *Le Forgeron.* Contours are given further refinement in black ink, there are layers of transparent washes of colour, and a piece of paper has been let in to allow for a substantial alteration. At some stage in its execution Daumier evidently became dissatisfied with the upper portion. He retained the figure of the butcher, and seamed in a new piece of paper along a line which travels from left to right underneath the hanging carcasses in the left background until it meets the carcass on the pole, then follows the lower contour of this round its juxtaposition with the man's body, travels up and to the right across the top of his head, and then goes down again and out by the sack-like shape in the right background. The drawing was then refinished over this seam. In other words, Daumier wanted to completely redraw the carcass. There was noting new about carcasses of meat being made the subject of realist art,[33] but there is something about the relationship between the man and the carcass here which signifies more than simple reportage. That the shape of the butcher's pole forms a cross is perhaps too obvious to point out, yet it would be sacrilegious to suggest any association between the position of the carcass and that of a human figure in a crucifixion. There is some suggestion of cruelty in the rendition of this image, however, as though Daumier was remembering how the animal got there. The processes of an abattoir, as shown for example in the engraving in Diderot's *Encyclopédie* (Fig. 7.22) which combines several of these in a single scene, would hardly have been unkown to him, and as though to make the point clearer he made a companion drawing of a butcher cutting up a carcass.[34] When the version in the Fogg Museum, here identified as *Butcher with Meat Cleaver* (Fig. 7.23), was

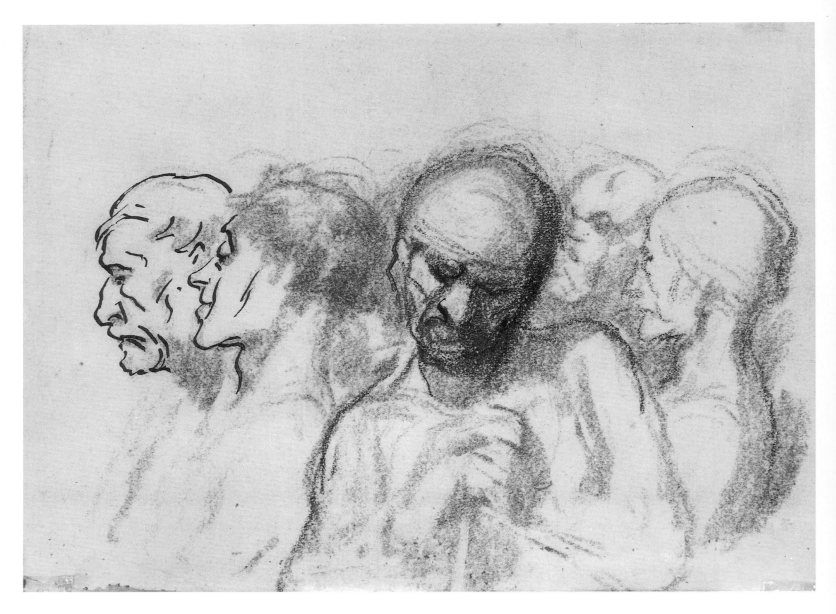

7.24 Daumier. *A Group of Heads. c.*1858–60. Charcoal, pen and black ink, 13 × 17.7. New York, Brooklyn Museum (Carl H. De Silver Fund).

exhibited once in London Lawrence Gowing was prompted to write: 'This butcher for instance – why does he hack so cruelly at the twisted meat? Are we on his side or the meat's?'[35] This second drawing is as delicately tinted with watercolour washes as the first, but intruded upon by a bright crimson spot on the section of cut bone. A further jarring note is added by a large blot of black ink in the background on the right, with expressionist effect.[36] Daumier's subtle combination of the material facts of the butcher's trade with other, less tangible, associations of the human psyche is quite striking in these drawings.[37]

Besides the workers and tradesmen, the poor are often the subjects of Daumier's drawings in the 1850s, and they are by no means represented as picturesque. The central figure in *A Group of Heads*, in Brooklyn Museum (Fig. 7.24), is that of an old beggar leaning on his staff – a person apparently known to Daumier because he can be recognised again in profile in another drawing, standing at the edge of a crowd.[38] His expression is so in accord with those of the other heads around him that this could represent a group of beggars. On the other hand, his headgear could indicate that he is a very old clown or *saltimbanque*.

Charcoal seems to have been Daumier's medium for exploring indeterminate

ideas at this epoch. *Man Leaning against a Wall (Personnage accroupie)* (Fig. 7.25) must surely be a beggar or vagrant of some kind. Daumier could not have invented such a figure – he must have seen and remembered him. This combination of shadows overlaid with a few incisive black lines gives the effect of the figure being carved out of the space on the paper – but only just so far, before the artist left him to sleep on.

A number of these working people, and others on the fringes of society that Daumier liked to draw, could find counterparts among the various strata of Millet's peasants, and occasionally their subjects overlap directly. *Woman Baking Bread* is one such, drawn by both artists at the same operation of putting her

7.26 Daumier. *Woman Baking Bread*. *c*.1855–60.
Black chalk heightened with white, 29.8 × 42.5.
Heemstede (Holland), Mr and Mrs Waals-Koenigs.

7.27 Millet. *Woman Baking Bread*. *c*.1855–60.
Black chalk, 37 × 30.5. Boston, Mass., the Misses
Aimée and Rosamund Lamb.

loaves into the oven at the end of a long pole (Figs. 7.26, 7.27). Daumier's study is almost entirely made with contour lines, while Millet's drawing, although its genesis did involve a tracing done entirely in line, is at a more advanced stage of realisation. What they have in common is an intense grasp of the physical action involved. The woman's balance, maintained by the positioning of her feet, the angle of her body, and the points where she grasps the pole (note Millet's separate study of *how* she grasps it), shows the grace of a tightrope walker in both drawings, although the simile may seem inappropriate in this social context. But perhaps even more important than social context, in this instance, was the concern of both Daumier and Millet with the action being performed by the subject – a subject in these cases unaware of the viewer's presence.[39] Their 'realism' was about the reality of being.

PART IV
Special Cases of Rapport

8 Landscape

NEITHER DAUMIER NOR Millet devoted much time to rendering landscape until the 1860s. This was quite late in their respective careers. In fact Daumier rarely drew landscapes without figures at any time, although all his contemporaries noted how well he could render an effect of outdoor light in his lithographs. Millet certainly observed his native Norman landscape closely, and reminiscences of it appear in paintings executed elsewhere. He made a number of drawings of specific spots when he revisited Normandy in 1854, but generally these studies were intended to provide him with information for pictures to be painted at Barbizon. Even when figures are not prominent in these, cottages, farm animals, farm implements and tilled fields are – that is, his landscapes of the 1850s were always concerned with human activities.

During Millet's transitional period spent in Paris, from 1845 to 1849, he tended to adhere to a conventional idyllic landscape in the French rococo tradition when painting small canvases to sell to private collectors. We also saw (pp.27ff.) that during that sojourn in Paris he could simultaneously represent a quite different aspect of urban, working-class genre much closer to the subjects that interested Daumier. Paradoxically, it is in some of *Daumier's* rural images in his lithographs of the 1840s that we find early evidence of a 'naturalist' eye, a kind of proto-impressionism such as we also being developed by his friends Daubigny and Rousseau in painting. A single example, the lithograph labelled *Regrets . . .* which was published in *Charivari* on 17 May 1840 (Fig. 8.1) will suffice to demonstrate this. The middle-aged man standing at the window in his nightcap provides the reason for the 'comic' caption and 'comic' physiognomy (pointed nose, drawn-out upper lip, toothless jaw) as he gazes at the young lady outside, but this merely provides the message necessary to amuse contemporary readers of *Charivari*. Many later commentators, especially in the twentieth century, have noted the superbly rendered suggestion of a summer landscape seen through the open window – an inspired impression of sunlight. There is no evidence that Millet, who had already finished his studies in Delaroche's studio by 1840, possessed at this date anything like the same degree of observation of natural landscape. An *esquisse* of *The Stoning of St Stephen* (*c*.1837–40),[1] for example, adheres to a strictly Poussiniste formula for a Roman background, and an exceptional oil sketch of the *Rocher du Câtel* near Gruchy, which probably dates to the early 1840s, is stylistically a romantic pastiche in the manner of Géricault, even though it represents a particular spot.[2]

8.1 Daumier. *Regrets . . .* Lithograph, published in *Charivari*, 17 May 1840 (LD 531).

Facing page:

8.3 Daumier. *Quand on fait ses foins, et qu'on veut surveiller de trop près ses faucheurs. (Making hay and keeping too close and eye on ones reapers)* Lithograph, published in *Charivari*, 2 April 1846 (LD 1436).

8.4 Millet. *Le Faucheur (The Haymaker).* Early 1850s. Black chalk, 61 × 43.2. Burrell Collection, Glasgow Museums and Art Galleries.

8.5 Daumier. *Un chapeau . . . deux chapeaux . . . les malheureux seraient-ils allés se suicider dans les blés! (One hat . . . two hats . . . the poor things must have gone to commit suicide in the hay!)* Lithograph, published in *Charivari*, 6 February 1847 (LD 1847).

8.2 Decamps. *Les Mendiants.* 1834. Lithograph, published in *L'Artiste*, and also (the state shown here) for the Galerie Durand-Ruel. Paris, Bibliothèque Nationale.

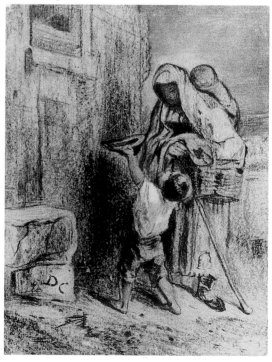

In this chapter I shall trace some of the origins of the concepts of landscape acquired by both artists, and then examine what landscape *per se* came to mean to each by the 1860s. This was the decade when landscape painting was being accorded a higher degree of importance throughout France, and young artists like Monet and Pissarro were looking at the works of the previous 'Barbizon generation' (Corot, Daubigny, Rousseau) with fresh eyes. I hope to show that neither Daumier nor Millet fits into any neat pattern of the 'evolution' of landscape, but that each made landscape imagery carry a special and singular meaning.

When, in 1835, L'Association Mensuelle was floundering financially and *La Caricature* was continually being threatened by libel suits,[3] the editor Philipon and the publisher Aubert launched in May a new monthly publication, *La Revue des peintres*, which was supposed to make the work of contemporary painters more easily available to the public, and to be a quality magazine which was not contentious politically.[4] Two lithographs, signed by Daumier, were registered for publication in this journal when it first appeared: *La Bonne Grand' Mère* (Fig. 3.20) and *Le Malade* (Fig. 3.19), on 14 March and 9 June respectively. The content of both has been discussed in Chapter 3, in a social context. They are mentioned again here to remind the reader that in 1835 Daumier was at a transitional stage in his view of landscape, relying partly on eighteenth-century models to provide settings for the situations he wished to convey. Jean Adhémar supposes that both these lithographs are translations of Daumier *watercolours*, the existence of which is traditional in the Daumier literature, although none of that date actually survives.[5] A possible case of an analogous technique might be found in the preparatory studies made by Decamps for his lithographs. These often combine a greasy black chalk with gouache and bistre wash: his drawing *Beggars outside a window* (Fig. 2.17) is one such, which was evidently used for his finely executed, deep-toned lithograph of 1834, *Les Mendiantes* (Fig. 8.2).[6] If Daumier's 'watercolours' were originally like those of Decamps, they would have been fairly monochromatic. The overall effect of lithographs of this kind – both those of Daumier and of Decamps – is like a landscape or genre picture in black and white. Decamps also made lithographs of the subjects of many of his paintings, for popular sale. Daumier, on the other hand, confined his first observations of landscapes to his lithographs for popular journals, *Charivari* in particular, in the 1830s and 1840s. *Regrets . . .* (Fig. 8.1) is only one of many hints in his landscape backgrounds that he had as good an *en plein air* eye as any of his contemporaries, although he relied on his superlatively retentive memory, rather than on notes made on the spot. His series of 'Pastorales' of 1845–6 and Les 'bons bourgeois' of 1846–9 make play upon the Parisian bourgeois' love of excursions into the countryside which lead them into comic predicaments or reactions due to their ingrained urbanism – and the landscapes are superbly drawn. The Parisians fall into the water looking for plants, tumble off mules or steep slopes, relax under trees accompanied by lizards, get attacked by farmyard animals, misbehave among fields of deep corn, and marvel uncomprehendingly at the activities of *plein air* landscape painters.[7] In several cases the configuration of these comic inventions is reflected later in drawings and watercolours which Daumier made in the 1860s, with far deeper meanings attached. To this point we shall return, but for the moment I would just like to take one example of a Daumier 'rural landscape' of the 1840s and compare it to Millet's treatment of a similar configuration – in this case the *faucheur* or mower – drawn perhaps a decade or so later. Daumier's man with the scythe in *Quand on fait ses foins . . .* (Fig. 8.3) is expertly rendered from the back as he sweeps his blade (grotesquely enlarged by a trick of linear perspective) under the feet of the leaping bourgeois into the standing corn. Beyond the two foreground figures a landscape of fields and sky is

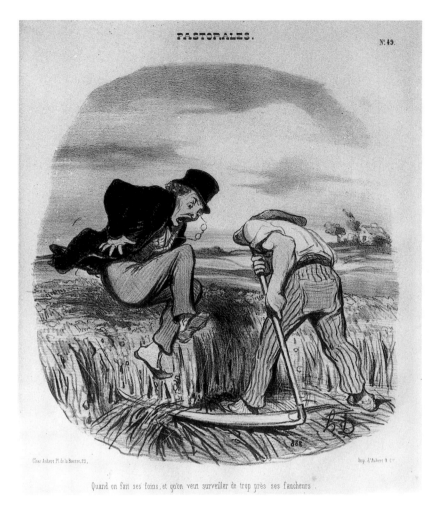

Quand on fait ses foins, et qu'on veut surveiller de trop près ses faucheurs.

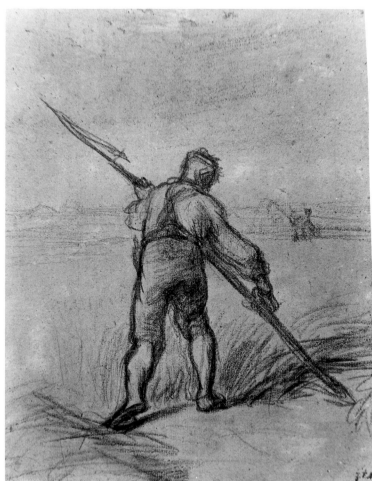

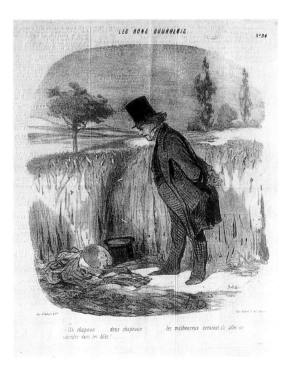

LES BONS BOURGEOIS.

—Un chapeau deux chapeaux les malheureux seraient ils allés se
suicider dans les blés!...

rendered with a sense of deep space not really called for by the cartoon itself. Millet's haymaker (Fig. 8.4) also stands in the foreground of a deep landscape space which is 'felt' atmospherically, although not rendered in as detailed a manner as Daumier's. Millet's figure is dressed in traditional rural garments that suggest an earlier epoch, and he swings his body against the weight of the huge shaft of the scythe with the formality of some slow, solemn ballet, imbued with dignity. The purposes of these works could hardly be more contrasting, but that should not blind us to the fact that the means by which the artists obtained their ends are not so dissimilar. In both cases the illusion of reality observed is achieved by various artifices – rhythmic patterns of lines that equate to the mower's movements, and a sense of space through tonal variations made by no more than the pressure of the artist's hand.

Thus during the 1840s Daumier's achievement as a landscape artist in black and white must be acknowledged, without the evidence of a single painting to push this conclusion further. No doubt the landscape drawings of many of the Barbizon group would have become available to Millet after he began to make acquaintance with them in 1847, but the point is that Daumier's drawings *as lithographs* were available to everybody and anybody who knew *Charivari* and the print-selling trade. As further evidence of his mastery of invented *plein air* tones (if such a paradox can be imagined), *Un chapeau . . . deux chapeaux . . .* is reproduced here as it appeared in its cheapest and most readily available form, with the newsprint showing through from the back (Fig. 8.5). The heavy summer sky, the pools of sunlight on the standing corn, the distant trees

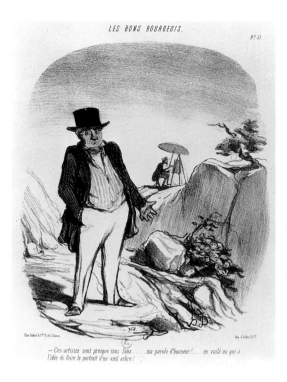

8.6 Daumier. *Ces artistes sont presque tous fous . . . (These artists are nearly all mad . . .) Lithograph*, published in *Charivari*, 15 April 1847 (LD 1527).

8.7 Daumier. *En contemplation.?* c.1860. Pen and wash, 18.5 × 26.5. Paris, Private coll.

shimmering in the heat, are all rendered as if in a painted landscape. Daumier, through his own personal friendships with the new landscapists, mush have been acutely aware of the difficulty of imparting meaning to paintings of nature without showing the presence of man. However, as a cartoonist, he could get round the difficulty by using irony: the 'revelation of nature' to the bourgeois here is one of human nature, but to today's observer the cartoon is also a revelation of natural landscape. Daumier addressed the problem – the bourgeois vis-à-vis the artist – more directly in 1847 with his cartoon, captioned 'These artists are nearly all mad: there's one who has conceived the idea of making a portrait of an old tree!'. The speaker stands in a rocky landscape wild enough for Don Quixote to roam in, and makes a despairing gesture towards the artist in the distance (Fig. 8.6). (But why is the bourgeois there himself?) By mocking the *plein air* artist's behaviour, Daumier could either have been revealing his own artistic orthodoxy or, more subtly, digging in a friendly manner at the naturalist school of French landscape which was already well established by 1847. This he continued to do as late as 1865: compare his famous print *Les Paysagistes: Le premier copie la nature, le second copie le premier*,[8] a comedy denoting mindlessness on the part of the copiers. Similarly, the very fact that the quasi-pastoral instincts of the 'bons bourgeois' in the 1840s tended to lead them into trouble, when out of their natural urban context, was used to suggest the *largeness* and potential hostility of rural France, whether wooded, mountainous, or of open plains. These aspects of the landscape were being explored in the same decade by Théodore Rousseau as an artist in the Romantic tradition, and they would soon be felt by Millet in his turn. (The fact that Corot's landscapes are seldom threatening, although he several times painted in the same locations as Rousseau, may be put down to his classical tendency towards order, to make a calm synthesis of all that he surveyed; but Corot's charcoal drawings of the 1850s and 1860s do make considerable concessions to the potential *drama* of natural effects.)[9]

Daumier contributed a number of small illustrations to the immensely popular series of quasi-sociological studies called *Les Français peints par eux-mêmes*, which was published in instalments between 1840 and 1842.[10] In terms of landscape, his

8.8 Daumier (attrib.). *Landscape with Figure.* *c.*1850–60. Oil on panel, 13.3 × 35.4. Present owner unknown. (Photo courtesy Messrs Agnews).

most significant contribution was perhaps his four wood-engraved vignettes for the piece entitled 'Le Bourgeois Campagnard',[11] a rather sympathetic analysis of the Parisians' passionate desire to escape to the country on Sundays, written by Frederic Soulié. The headpiece over the title shows a couple seated on a hilltop – he wearing a top hat, she holding a parasol – surveying with expressions of avid delight a wide valley landscape with cottages, winding road, and distant line of trees. Soulié writes that the *Parisian* bourgeois is the most enamoured of the countryside, to the point of fantasy – he dreams of it all the time. An original drawing by Daumier in pen and wash known as *En Contemplation* (Fig. 8.7), which from its handling appears to be later than the 1840s, almost exactly repeats the compositional arrangement of the woodcut, but in reverse. Here Daumier, the satirist, is completely absent. This portrayal of the bourgeois at recreation on a sunny afternoon is straight-forward: the two figures are in complete harmony with their surroundings, in a spirit which seems proto-Impressionist.

There is not a great deal of further evidence of Daumier's private reactions towards landscape before the 1860s, partly because so few early drawings are extant and partly because of the difficulty of attributing his oil sketches. Two apparently 'straight' drawings of landscape without figures, one drawn with a pen in the style of Rousseau and one in pen and wash in a kind of free baroque style for rendering trees, could conceivably have been done from memory in the 1850s.[12] More puzzling is a small painting on panel, measuring 5.25 × 14 inches, in which a single figure on a hillside under trees looks out over a panoramic landscape (Fig. 8.8). Although this painting is catalogued by neither Fuchs nor Maison, the same panoramic landscape, seen across a river, is found in the drawing *En Contemplation* (Fig. 8.7), and again in another landscape with a group of figures resting under the trees.[13] The conception is Daumieresque, and from the evidence of the photograph alone, together with the two analogous landscapes, I would accept this work as authentic.[14] Daumier's own associations with rural landscape appear to have been entirely recreational.

The meaning of the rural world to Millet, in terms of how he saw the peasants, has been discussed in Chapter 6. The landscape setting in which these peasants lived and worked seems to have had little or no symbolic reference for Millet

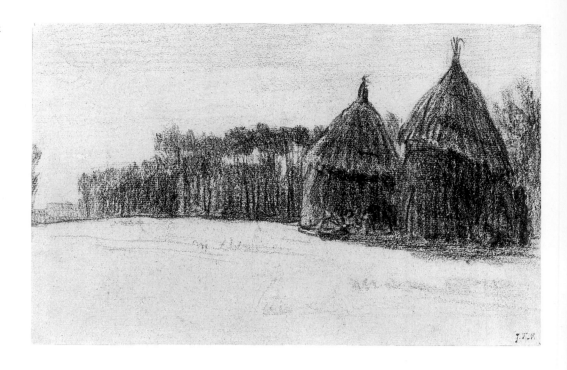

8.9 Millet. *Effet de soir, les meules*. 1847–9. Black chalk, 17.8 × 28.1. Stuttgart, Staatsgalerie, Graphische Sammlung.

before 1850. For example, in both the drawing and the painting for *La Délaissée* ('the abandoned one') (Figs. 3.15, 3.16), discussed in Chapter 3 for their social content, and which seem to belong to the Paris period, the forest setting is rendered as a kind of scenic property, not unlike Daumier's lithograph *Le Malade* (Fig. 3.19). In a similar way the landscape settings for Millet's more ambitious canvases, such as *Oedipus Taken Down from the Tree*, *Hagar and Ishmael*, and *The Sower* all use either closed-in scenic conventions or memories of Normandy. There may even be reason to suspect that the setting for his *Captivity of the Jews in Babylon*, sent to the Salon in 1848, may have been directly inspired by seeing a stage production of Verdi's *Nabucco* in Paris.[15]

The first sign of a change to direct observation of landscape appears in his painting *Le Repos de faneurs* (Musée d'Orsay) sent to the Salon of 1849, although it is painted in very dead colours and the representation of the haystack is less than convincing. However, the stretch of river with cows in the background is closely related to the background of his Paris period drawings (see Fig. 6.5), which were probably inspired by walks in the suburbs of St Ouen to the north of Paris. *Les Botteleurs de foin* (The Haybinders) (Musée d'Orsay), which Millet sent to the Salon of 1850–1, is set in a relatively more authentic-looking landscape, inspired apparently by the plain of the Brie, which abuts the forest of Fontainebleau in the distance.[16] The handling is heavy and rugged, still in his Paris style, but the dark, saturated colours have a certain atmospheric perspective. There is also a latent sensuality about this painting which seems related to some of Millet's preoccupations in Paris. The pair of haystacks suggests a pair of breasts in form, and the same configuration occurs in the background of *Les Móissonneurs* (Boston Museum) of 1851–3, where the haystacks are positively flesh-coloured. Similar pear-shaped haystacks are found in several of the drawings on the theme of *The Gleaners*, which Millet began at this same period.

Landscape drawings made directly from nature are exceedingly rare in Millet's work before 1854. One exception recently discovered is a landscape of the St Ouen region, looking across the river Seine to a flat meadow with cows grazing, and hills beyond.[17] It is drawn in black chalk with stomping, pencil and white chalk, with erasures. Compositionally it is reminiscent of Daubigny, but the

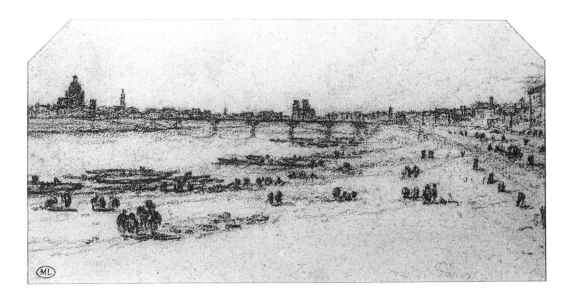

8.10 Georges Michel. *Paris from the Shores of the Seine.* c.1820–30. Black chalk on buff paper, 8.4 × 16. Paris, Louvre (RF 1758-18).

mixture of different drawing mediums to produce a painterly effect was used equally by Théodore Rousseau and other Barbizon artists at various times. There are two other black chalk drawings of open fields, without figures, in the Boymans Museum, Rotterdam, which may also predate the Barbizon period.[18] Another surprisingly early landscape drawing is the black chalk *Effet de soir, les meules*, now in Stuttgart (Fig. 8.9). This is a study for an oil painting of the Paris period,[19] so again we may assume that it was made in the St Ouen region. As Herbert has pointed out, however, it appears to be a more 'modern' drawing that prefigures Seurat in the remarkable tonal control of the black chalk by varying pressures, as it moves over the grey paper, leaving large areas almost blank. There are figures indicated under the thatched haystacks, but they do not emerge very prominently as subject matter. This use of the paper surface to stand for light may owe something to the style of Georges Michel (1763–1844), who was a very gifted topographer (comparable to the early style of Corot), and whose works Millet would have known by 1847 through the collection of his new friend, Alfred Sensier.[20] Michel did a great many topographical drawings of Paris and its environs at a time when a much greater area was open country than now. His preferred medium was black chalk, to which he sometimes added watercolour in broad tonal washes on his larger drawings. Two albums in the Louvre contain a group of smaller drawings. some in black chalk and some in graphite, on paper of different shades. The view of *Paris from the Shores of the Seine* (Fig. 8.10) which comes from one of these, shows how Michel could control the accents of his black chalk across the paper so that spaces between them give the effect of light.

When Millet arrived in Barbizon in 1849, an aspect of the local landscape that seems to have struck him immediately was the impenetrable forest wall (or so it appears from a distance) that rises up at the end of the village street furthest from the open plain. This natural break between forest and open ground, and the steep rise from the flat arable plains to the rocky wilderness above, probably had psychological significance as well. We have already noticed the woodcutters and faggot gatherers as a separate social class, on the fringe of civilised society. Much has been made of the differences in subject matter between Millet and his Barbizon neighbour Rousseau, with Millet preferring the human life on the plain and Rousseau the trees of the forest. Yet it is evident from some of Millet's early Barbizon drawings that he did explore the forest and was aware of its potential themes. The rocky skyline of *A Flock of Sheep Coming Down a Hillside* (Fig. 8.11) is likely to be somewhere near the Gorges d'Apremont, which is quite a way into

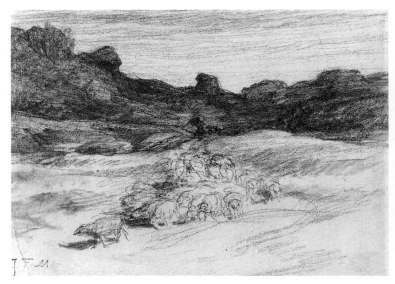

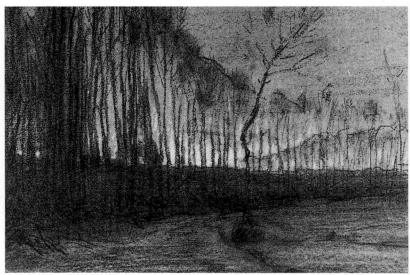

8.11 Millet. *Flock of Sheep Coming Down a Hillside. c.*1850. Black chalk and charcoal, 21.3 × 29.5. Christie's (New York) Sale, 24 February 1982 (33).

8.12 Millet. *Landscape Study at Barbizon. c.*1850–2. Black chalk on pinkish-brown paper. Size and present location unknown.

the forest and a subject already painted by Rousseau in the 1830s. Although a somewhat uncharacteristic drawing for Millet, it does relate to the directly observed style of his haystacks at St Ouen. Moreover, the shepherd merges into the shadows in the middle distance here just as the figures do in the earlier drawing. Millet also made a number of studies of groups of trees and the huge igneous rocks that lie all over the forest. However, many of these drawings are difficult to date and some may well belong to the 1860s rather than to his first period in Barbizon. In the 1850s he seems to have particularly liked screens of trees at dusk, looking out from the edge of the forest towards the plain. The *Landscape Study* (Fig. 8.12), known to me only through a reproduction in Bénédite, is a good example of this; another much thinner screen of trees, drawn with strokes of the chalk like fronds against a watery sky, is in the Cabinet des

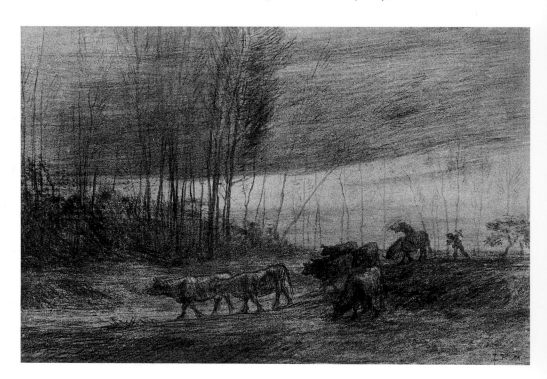

8.13 Millet. *Herdsman Driving His Cows Near the Hillock of the Biau Plantation.* 1852. Black chalk and charcoal on brown paper, 39 × 54. Paris, Private collection.

120

8.14 Millet. *La Porte aux vaches, par temps de neige.*
1853. Black chalk on beige paper, 28.2 × 22.5.
Paris, Louvre (RF 4159, Cat. 10,303).

Dessins in the Louvre.[21] Drawings such as these, possibly made on the spot,
would serve to give him information for compositions like *Herdsman Driving his
Cows near the Hillock of the Biau Plantation* (Fig. 8.13), which would have made a
saleable drawing by itself; in this instance the cattle and the light effect, being
reminiscent of Claude Lorraine's landscape studies, would have appealed to
connoisseur collectors.

 Millet's invented system of vertical and parallel hatchings to denote the denser
parts of the forest has been noticed in the context of the faggot gatherer scenes
(Chapter 6, p.86). Another striking use of this technique is found in the several
versions of his view of the *Porte aux Vaches*, a gate which marks the boundary
between the village and the forest. In the winter of 1853 Millet drew it in the
snow, when the tonal contrast between the white open foreground and the black
vertical wall of trees behind was intensified. The drawing in the Louvre illustrated
here (Fig. 8.14), which introduces a hunter and his dog into the scene, is related to

8.15 Théodore Rousseau. *Landscape of the Plains at Barbizon*. 1850s. Pencil on light grey-green toned paper, 17.1 × 29.3. London, British Museum.

8.16 Rousseau. *The Oak Trees*. early 1850s. Black chalk, 16.8 × 28.4. London, British Museum.

an oil painting in Philadelphia without the figures. The painting, which dates to the same year, is subtitled *Solitude*, and its image is bleaker but less threatening than this scene with the hunter. Millet returned to the subject in a very fine pastel of 1866–7 (now in Boston), again without the hunter and introducing soft, delicate colours which give a much more lyrical effect and take away the gloom of the forest.

Théodore Rousseau already had a permanent domicile in Barbizon a year or two before Millet arrived, although he kept on his Paris studio as well. Rousseau and Millet, as we have noted, became very close friends, and the almost pantheistic relationship between Rousseau and wild (uncultivated) nature may well have influenced Millet's own approach to it. But Millet was too independent an artist to allow himself much overlap with Rousseau's subject matter in his painting. (Put at the crudest level, it might have interfered with sales, at least in the 1850s.) It is significant, however, that on Rousseau's death in 1867 his biggest patron, Hartmann, had sufficient faith in Millet's understanding of his work to ask him to 'finish' certain canvases left in Rousseau's studio which had been begun on his commissions. It may be constructive therefore to compare some of their methods of landscape drawing at this point.

Théodore Rousseau's landscape drawings were highly developed by 1850, and he would vary his technical methods according to his purpose. Examination of any of his larger and mature canvases at close quarters will reveal that he depended on a very clear and precise structure of contours to delineate his trees and vegetation, before he applied full colour. His capacity for linear precision can be seen in his numerous studies in pen, in pencil and in black chalk. Two contrasting examples of such studies are illustrated here: *Landscape of the Plains at Barbizon* (Fig. 8.15) and *The Oak Trees* (Fig. 8.16), both in the British Museum. The former, in pencil, is purely linear except for some shaded-in silhouettes on the horizon, and could serve as the perfect structure for a painting. The latter, in black chalk, indicates almost all the shapes as relative tones only, seen *contre jour*. (Its design is not unlike that of his famous painting of *The Oaks* in the Musée d'Orsay, of 1852.) Both drawings probably date to the early 1850s. These are typical of his working studies. To understand Rousseau's romantic nature, however, it is necessary to examine a more ambitious work. Underneath his deliberate systems of picture construction, there burned a fierce sense of communion with the imponderable atmosphere of nature in the raw. *La Lande au genets* (Fig. 8.17), datable *c*.1860, conveys a strange feeling of stormy isolation,

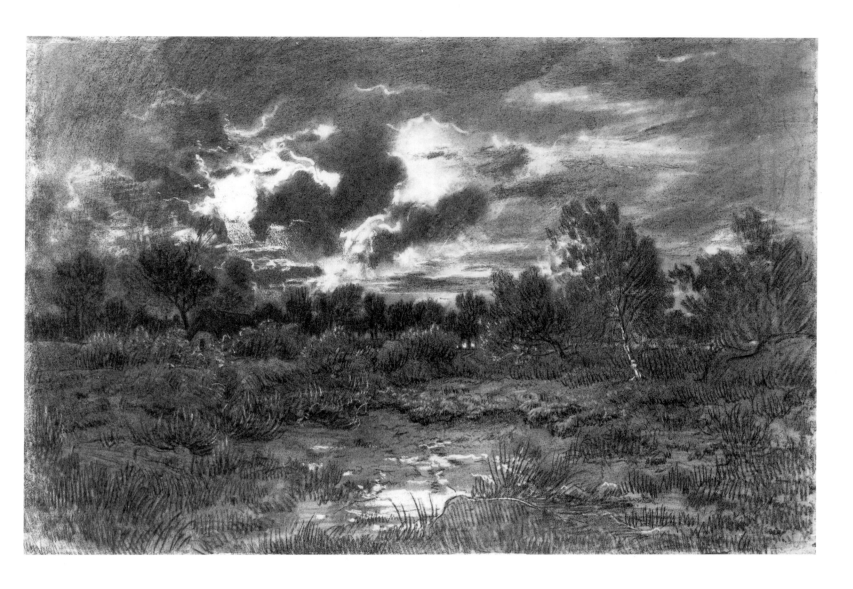

8.17 Rousseau. *La Lande au genets* (*Heath with Gorse Bushes*) c.1860. Charcoal and bistre wash, white and some coloured pastel on beige paper, 59.5 × 89. Montpellier, Musée Fabre (Alfred Bruyas Donation).

almost devoid of the presence of humanity, until one notices the small cottage or hut, hidden in the shadows under the trees on the left. This large-scale charcoal drawing on paper appears, perhaps, to be left unfinished,[22] in that only a few touches of yellow and green pastel are to be found, on the bushes with yellow flowers (gorse bushes), and the effect of strong chiaroscuro is achieved by the ground tone, made by bistre washes over beige paper, being left to show through the heavy strokes of charcoal and contrast with the shots of white light in the sky (where the sun should appear), and its reflections on the water in the foreground. Whether or not it is 'unfinished', in its present state it is a masterly piece of dramatised landscape drawing, perhaps deliberately left like this by Rousseau because he felt he had achieved what he desired. Such a work, certainly known to Millet, would surely have had some influence on the handling of his later landscapes (compare Fig. 10.11). Long before that, Rousseau's combination of a romantic temperament with an extremely systematic method of working may well have given Millet food for thought, and it may already have affected the type of studies that he made when he revisited his family home in Normandy in 1854.

Millet spent the summer of 1854 at Gruchy (after a brief visit the previous year

123

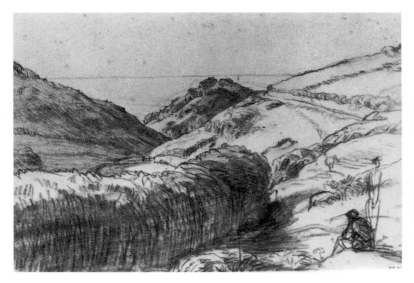

8.18 Millet. *Cliffs near Gréville, with le rocher du Câtel*. 1854. Black chalk. Size and present location unknown.

8.19 Millet. *The Seaweed Gatherers*. 1848 or 1854. Black and white chalks on grey paper. Size and present location unknown.

on the occasion of his mother's death) with Catherine Lemaire and their children. He returned to the rocks along the coast, the fields and hedgerows round the village, and the old stone well opposite the family house. His studies in black chalk and graphite appear to have been made rapidly, mostly on the sites.[23] *Cliffs near Gréville, with le rocher du Câtel* (Fig. 8.18) is plainly intended to provide him with accurate information about the contours of the land.[24] The standing schematic figure in the lower right-hand corner indicates the scale of the hedgerows (and hence the proportionate scale of the distant rock), and also shows that the viewer's eye level (established by the horizon line on the sea) is a good deal higher than that of the foreground figures. This drawing was later used for a pastel, which is now in the Philadelphia Museum of Art. By contrast, *The Seaweed Gatherers* (Fig. 8.19) was almost certainly not done on the spot. Moreau-Nélaton also dated this to 1854.[25] Millet's description of the local villagers, gathering seaweed from the rocks on the seashore to make fertiliser for their fields, and the precipitous paths up the cliffs by which it was carried on horseback, was written (but not used) for publication in about 1865, and Sensier paraphrased it later in his biography, accompanied by an illustration showing this drawing.[26] The whole scene is produced from a vivid childhood memory, which makes the dating of the drawing itself questionable. The linear style is far freer and more baroque than in the *rocher du Câtel* landscape. It is actually closer in style to Millet's invented figures of *La République* of 1848, and the somewhat grim setting of *The Seaweed Gatherers*, who seem to work with desperate energy, could well reflect his mood at that violent epoch.

The batch of Normandy drawings that Millet brought back to Barbizon – he made about 100 of them, apparently[27] – provided him with material for paintings and pastels for the next fifteen years. The next time he made a substantial number of studies there, in 1870–1, he was using a quite different drawing style at a quite different imaginative level, and this will be discussed in Chapter 10 in conjunction with Daumier. In between these two visits, he painted Gréville subjects from memory, as well as producing landscapes of Barbizon and of the Auvergne. *The End of the Village at Gruchy*, (Fig. 8.20) of which there are three versions painted in 1854–5, 1856 and 1866 respectively, is a prototype landscape of this kind, for which there is no equivalent in the work of any of his contemporaries. Although based on two drawings conveying factual information, this painting is no way a direct transcription of something 'seen' at one encounter (as in a landscape by Courbet or by Corot), notwithstanding the luminous and atmospheric colours in

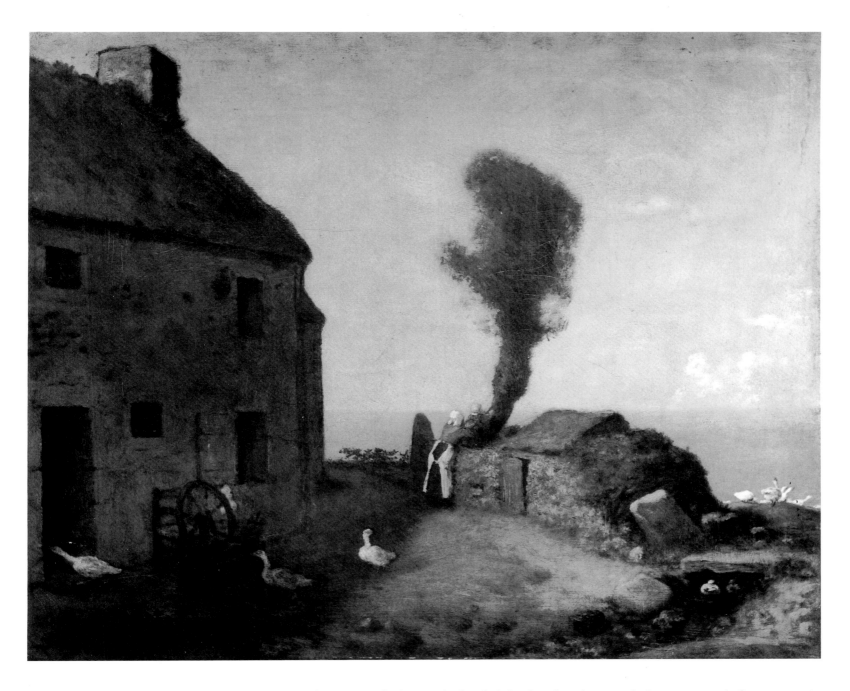

8.20 Millet. *The End of the Village at Gruchy*.
1854–5. Oil on canvas, 46 × 56. Otterlo,
Rijksmuseum Kroller-Müller.

the sea and sky and the bright local colours of the trees and figures. It is specifically symbolic of Millet's assocation with his birthplace. Every object in the picture is redolent with personal memories, from the geese in the foreground and on the cliff-edge to the mother who has lifted the child on to the wall, where it now stretches out its arms to the old pollarded elm tree, beyond which lies a distant sea that could extend to infinity. This child is Millet.[28]

In several of the settings for his figure paintings of rustic domesticity, such as *Peasant Woman Feeding her Children on the Doorstep (La Becquée)* (executed both as an oil and as a pastel, *c.*1860–2), and *Peasant Woman Returning from the Well* (*c.*1855–62), as well the religious subject of *Tobit's Parents (L'Attente)* (shown at the Salon of 1861) and the thinly disguised allegory of *The New-born Calf)* (Salon of 1864), Millet gave to the windows and doors of his houses heavy stone lintels reminiscent of the old buildings in Gruchy, as they can be seen to this day. He

8.21 Daumier. *Les Laveuses du Quai d'Anjou*
c.1857–60. Oil on canvas, 82 × 59. Lost,
presumably destroyed during World War II.

8.22 Photograph of flight of steps towards the
north end of the Quai d'Anjou, just beyond the
Pont Marie. (Photo: author.)

seems to have had a liking for enclosed areas such as farmyards and his own back
garden, as well as for the open fields. In such cases the format of his compositions
can bring him close to Daumier's treatment of urban spaces. Enclosed spaces
often cause problems in perspective when both near and distant figures are
included, and it may not be a coincidence that both Daumier and Millet
sometimes made notations of perspective construction when they were trying out
new designs of this kind, most often to do with the angles of walls to the picture
plane and the distance of given figures from the artist's eye. An account of some

126

8.23 Millet. *Lobster Fishermen at Night. c.*1857–60. Black chalk, 32.8 × 49.2. Paris, Louvre (RF 4104, GM.10, 467).

specific cases in point, relating to both artists, is given in Appendix 1 but the reader may prefer to ignore it.

Daumier's painting *Les Laveuses du Quai d'Anjou* (Fig. 8.21) is treated as a completely urban landscape which both epitomises his home environment (the house in which he lived is scarcely a hundred yards away from the top of the steps shown in the picture) and the local people of 'Daumier's Republic', who inhabited it. The size of the burdens that these women carry is probably authentic, though it is presented symbolically, like Millet's women carrying loads of faggots, and in this case the compositional schema, of one figure leaving the steps at the top while the other descends to begin her spell of labour, implies a kind of perpetual motion – an eternity, in fact. Nor is it in any doubt that this arrangement was very deliberately worked out in an unusual system of perspective,[29] designed to focus on the two figures and their relationship to the viewer, rather than to render the mere steepness of the steps in a realist manner 'because they were there'. My photograph of the actual steps (Fig. 8.22) shows what can be seen today – there are 37 steps on most of the staircases from the street down to the river on the Quai d'Anjou, and a figure at the top, seen from the bottom, appears in very sharp recession. Daumier's painting, it is argued, indicates what the viewer is intended to *know* about the people in the picture, and to do this the artist has given us two viewpoints at different eye levels, and a moveable telephoto lens with which to combine the image. Millet, too, used perspective constructions to enable him to manipulate the relative sizes of his figures, but they are not particularly complicated, and the evidence of his correspondence with Daumier in 1864 about finding a professional *perspecteur*, to help him with his ceiling painting for the Hôtel Thomas (see Chapter 1), suggests that Daumier probably knew more about it than he did.

Drawings of landscapes at dawn and dusk appear with increasing frequency in Millet's work during the late 1850s and 1860s. At first they were executed only in black chalk, as in *Lobster Fishermen at Night* (Fig. 8.23) and *Fields at Dusk* (Fig. 8.24); and then coloured chalks are more frequently added until by 1865 Millet had become a complete master of pastel.[30] *Lobster Fishermen at Night* is a very deliberately executed memory drawing of a scene off the coast of Normandy. Its

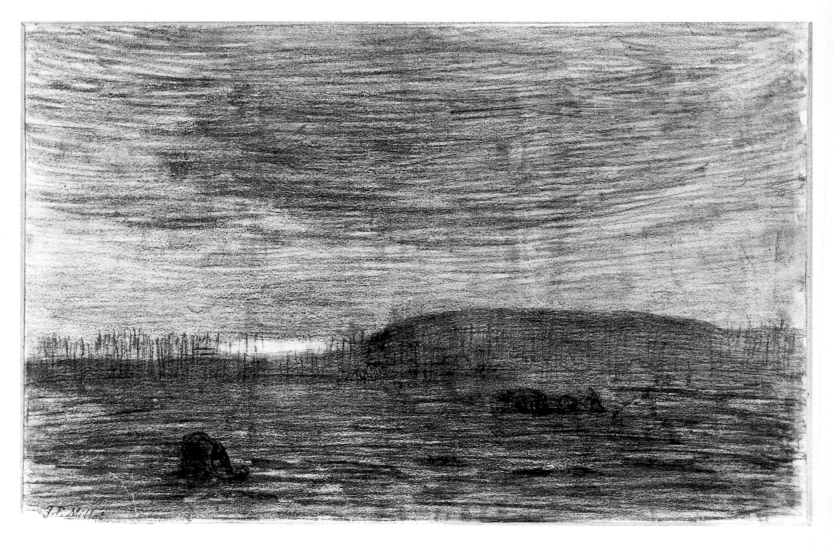

8.24 Millet. *Fields at Dusk (Crépuscule). c.*1860–5. Black chalk, 19.5 × 29.3. Paris, Louvre (RF 11,427, GM 10,814).

technique, which evokes the stillness and density of a night scene in calm waters, has often been admired for the artist's control of his crayon, which creates light and shadow by tones and simultaneously gives the equivalence of certain tangible phenomena, such as the water dripping off the oars and the agitated little snake of rope following the lobster pot as it is thrown into the sea. Here Millet shows himself a master of both visual memory and invention. The other drawing, *Fields at Dusk* (Fig. 8.24) looks more like direct observation on the plain of Barbizon, with a low hill arising like a whale's back out of a sea of dark ground, in the middle of which still darker figures carry on some mysterious work in semi-darkness. The only draughtsman who could emulate Millet in this mood, surprisingly, would be Daumier when drawing *Don Quixote*.

The increasing expressiveness of Millet's drawings in pen and ink at this period should also be noted. These have sometimes been considered as only preparatory studies, but although they are usually on a small scale they can often be regarded as works complete in themselves. *The Plain at Sunset* (Fig. 8.25) is like the setting of his famous symbolist landscape painting, *Winter with Crows*, but with nearly all its 'signs' removed: no crows, no plough, no harrow, no distant tower of Chailly – only two blobs that could be figures in the shadows, and scratches with a broad relief nib standing for furrows and tufts of grass. The setting sun is found at the centre of an explosion of lines which radiate out over a range of horizontal strokes across the dark sky. In such a drawing as this Millet seens to be doing

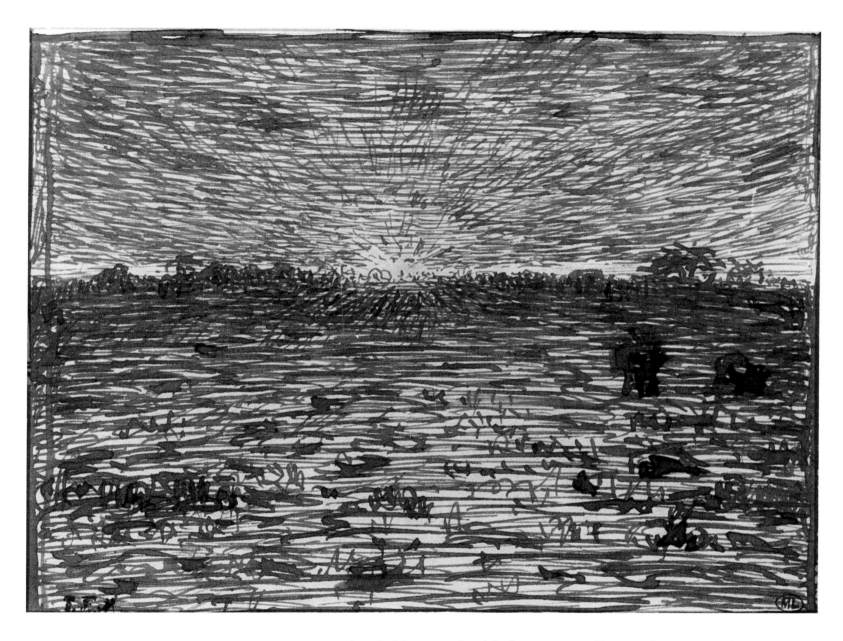

8.25 Millet. *The Plain at Sunset. c.*1865–70. Pen and brown ink, 20.6 × 19.5. Paris, Louvre (RF 11,385, GM 10,804).

more than 'taking notes': with the gestures of his pen he recreates his experience of a phenomenon of nature.

The subject of Millet's pastels is large enough for a separate, book-length study, and since in the present context this development has little to do with Daumier it will only be briefly touched upon. Within Millet's art considered as a whole, the pastels appear not only as an extension of his colouristic but also of his graphic skills. The same system of radiating lines from a focal point of light, for example, which is found in the pen drawings occurs also in pastels of landscapes with a setting sun or a rising moon. The *Sheepfold by Moonlight* in The Burrell Collection (Fig. 8.26) is a case in point where the startling colour effect of the near-full moon in white, Naples yellow and pink pastels shines out first as an impression of intense tonal contrast, but upon longer inspection our eye is drawn outwards from its radiating halo and then downwards by lines of black, slate blue and dark green across the shepherd waving his stick to the sheep moving mysteriously through the darkness into their pen. They move towards this central area of safety from the night as if drawn by lines of magnetic force. This fully-

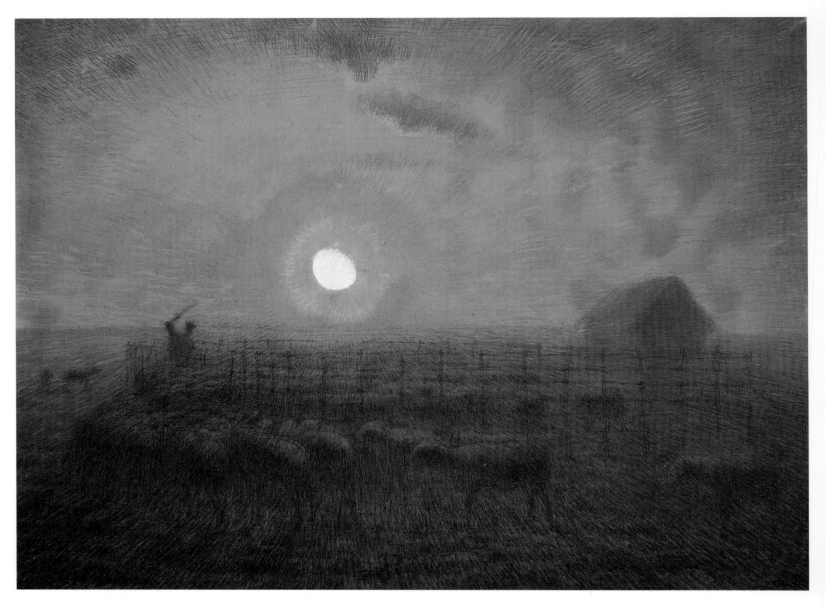

8.26 Millet. *The Sheepfold by Moonlight*. 1868. Pastel and charcoal, 72.1 × 95. The Burrell Collection, Glasgow Museums and Art Galleries.

fledged and very powerful pastel is but one of a large number that were acquired by Millet's patron, Emile Gavet, who commissioned quantities of them between 1865 and 1868.

Parallel with his development of this new skill in pastels, which initially began as a kind of embellishment to his drawings in black chalk or charcoal, Millet also increasingly used watercolour in the 1860s for his landscape studies. He particularly used watercolour to record the features of a new landscape to which he was exposed in the Allier and the Auvergne, when he made summer trips to Vichy for reasons of his wife's health, in 1866, 1867 and 1868.[31] Whereas the technique of pastel was associated with black chalk, Millet most often used watercolour in conjunction with pen drawings. As early as *c.*1856–8 we can find, in a finished work called *Hanging the Wash* (a theme showing his wife and children in their back garden at Barbizon, which he frequently drew), the linear structure outlined and hatched with thin pen lines and then local colours applied in small dabs the end of a pointed brush (Fig. 8.27). There is a no elaborate breaking down of colours into spectral components such as would be found later in the work of the Impressionists, but instead a quite arbitrary system of warm and cold tints in a

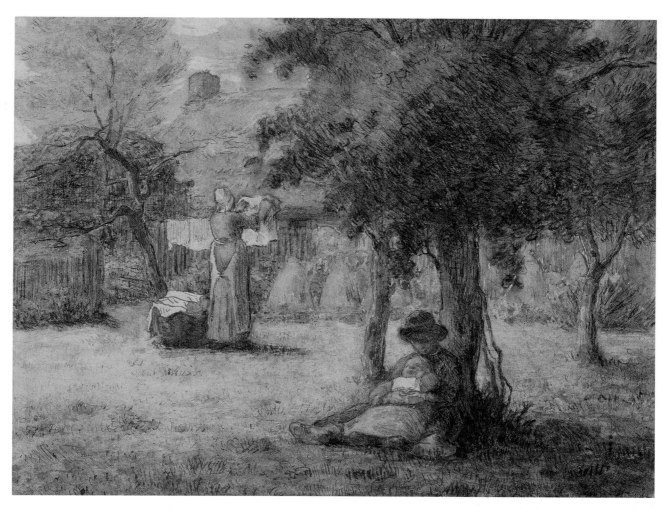

8.27 Millet. *Hanging the Wash. c.*1856–8.
Watercolour, gouache, pen and ink and black
chalk, 27.3 × 33.3. Sotheby's (New York) sale 24
February 1987 (418 A).

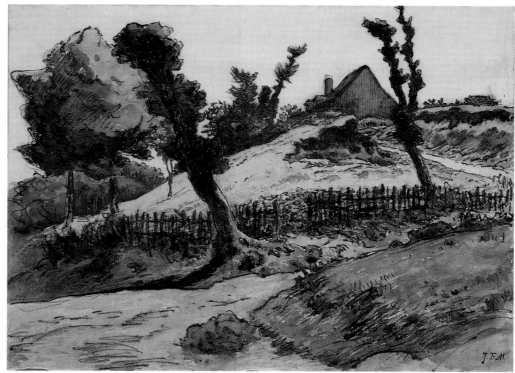

8.28 Millet. *Paysage d'Allier* (*Landscape in the
Allier*). (Road climbing to a hamlet, environs of
Cusset). *c.*1866–7. Pen and watercolour, 17.6 ×
26.1. Montpellier, Musée Fabre.

8.29 Millet. *Pâturage sur la montage, en Auvergne.*
1867–9. Oil on canvas, 79.3 × 97.9. Chicago Art
Institute (Potter Palmer Collection).

limited range – green, blue and violet; pink, yellow ochre and brown umber – are juxtaposed to give the equivalent of light and shade, aerial perspective and local colours. Such a drawing as this would have been saleable, but more often Millet used pen and watercolour for on-the-spot notations of corners of nature which he wished to recall for future use. He produced large numbers of these in small notebooks of varying sizes, during his visits to the Allier district around Vichy. *Paysage d'Allier* (Fig. 8.28) is an excellent example which combines traditional techniques, such as had been in use by landscape artists for at least a century, with a vivid and fresh eye for the local character of a particular place. It becomes clear by now that all the *places* that occur in Millet's landscape iconography do so as much for their autobiographical associations as for any 'picturesque' qualities in the conventional sense. In fact Millet was more interested in people than in the picturesque, and the associations of such landscape features here as the pollarded

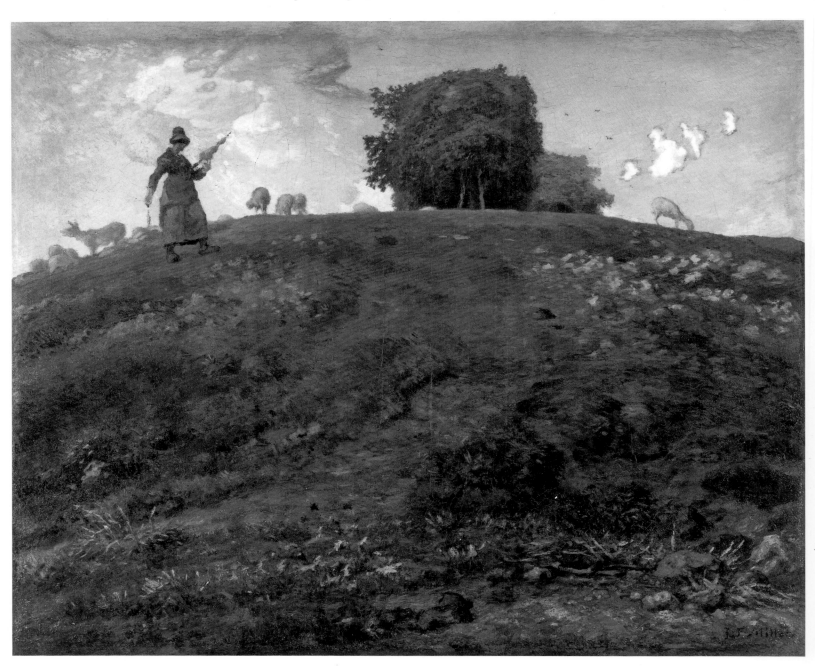

8.30 Millet. *An Auvergne Shepherdess Spinning.* *c.*1866. Black chalk and watercolour, 19 × 22.5. Sotheby's (London) sale 23–4 November 1983 (582 recto).

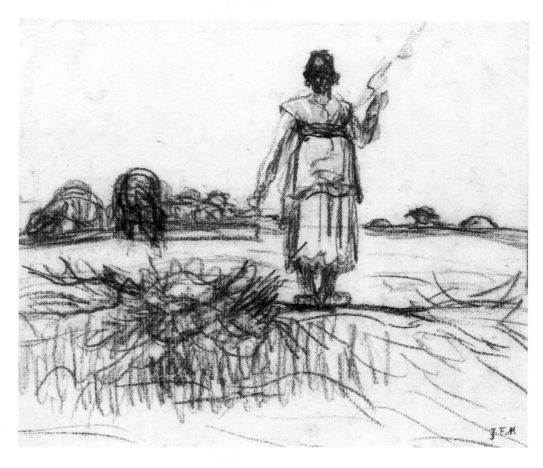

trees, a wooden fence, a winding path, and a steep cottage roof with a chimney stack are all to do with mankind. He liked the simple, guileless qualities of the Bourbonnais, whom he observed in this habitat.

This also applied to his experience of the country people in the Auvergne, although the landscape he saw there was different in character to the Allier. The spectacular effect of the mountains – an earlier generation would have called it sublime – from the Puy de Dôme to the Mont Dore seems to have remained with him, for he executed several pastels of this landscape, showing the awesome silhouette of the Puy de Dôme in the background, after his return to Barbizon. In 1866, after visiting a patron and friend of the artist, a lawyer called Chassaing, who lived at Clermont-Ferrand, the Millets spent eight days at a farmhouse called Diane, high upon a mountainside near Mont Dore. One of the finest syntheses of his experiences there may be seen in an oil painting in the Chicago Art Institute known as *Pâturage sur la montagne, en Auvergne* (Fig. 8.29). The actual site admittedly could have been an upland behind Cusset, near Vichy, but the spirit of the painting is that of the landscape around the farm at Diane. The farmhouse itself sits under a remarkable sugar-loaf hill, whose dominating presence can be felt as benign or threatening, to some extent depending on whether it is illuminated by sunlight or hidden beneath cloud cover. In the painting we are looking up a hillside which is reminiscent of this setting, from a low viewpoint. The little shepherdess near the top is an integral part of this environment, and the old-fashioned spindle on which she is spinning wool – which reminded the artist of the customs of the previous century – enhances the impression of her enduring permanence. This is not a sentimental throwback to the rococo vision of rusticity, but rather reflects the artist's direct experience of what was for him living history. The dominant position of the girl in the red jerkin is more than a compositional

133

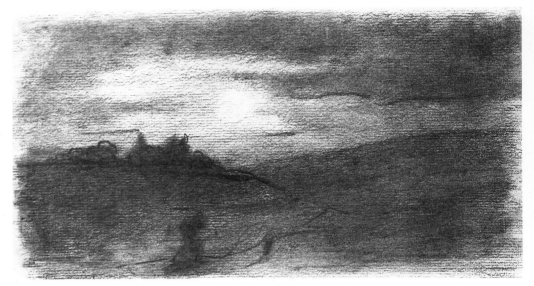

8.33 Daumier. 'Corot Reading', or *Le liseur*. *c*.1865–70. Pen and ink over black chalk, and watercolour, 31.5 × 24.5. New York, Metropolitan Museum.

8.31 Daumier. *Landscape by Moonlight (Paysage au clair de la lune)*. *c*.1860. Charcoal and stump, 20.9 × 30.2. Present collection unknown.

8.32 Daumier. *La Porteuse d'eau*. 1860s. Black chalk and wash, over charcoal, 6.8 × 7.6. Present collection unknown.

device to focus the landscape: her presence symbolises a confident balance with nature, unsullied and ideal. Millet's basic idea of the status of this figure may be discerned in a drawing related to the painting (Fig. 8.30), in black chalk heightened with watercolour, in which he has sketched her as a simple statuesque figure posing for him.[32] In sociological terms she could be seen as a kind of celebration of her class, comparable to Daumier's washerwomen on the staircases of the Seine.

Everything Millet did in landscape after his Auvergne visits can be classified as belonging to his 'late period', when landscape became his principal form of expression. In this he was of course also in tune with the developments of his own time, and the influence of his neighbour Théodore Rousseau should not be underemphasised. As it happened, in the same mid-decade that Millet was developing his pastels and making notes in watercolour, Daumier was also expanding the possibilities of the watercolour medium as a new art form. Although most of his uses for it were in figurative works, his relationship to 'impressionist' landscape in the 1860s should also be considered.

There is no equivalent in Daumier's work to Millet's pastels. Although rural landscape as subject was for Daumier a marginal activity, when the critic Roger Marx acquired a large quantity of sketches from Daumier's widow, being works left behind in his studio, at least three were pure landscape studies. Two of these have already been mentioned (p.117). A third, which may be later in date, is *Landscape by Moonlight* in charcoal and stump (Fig. 8.31). In treatment it is directly comparable to Millet's *crépuscule* or night landscape in black chalk (Fig. 8.24), except that the forms are more summary: an ideated rather than a particularised place.[33] Those three are Daumier's only known landscapes without figures. When one considers his landscapes *with* figures, however, the proto-Impressionist qualities of his late watercolour technique may be considered in conjunction with Millet's watercolours of the Allier. *La Porteuse d'eau* (Fig. 8.32) is a subject treated often enough by Millet, but it is here transformed by Daumier into a columnar figure of Gothic proportions (not dissimilar to Mme Millet hanging the wash in Millet's watercolour, or to his sketch of the Auvergnat shepherdess), placed in a sun-filled country lane. Other drawings of figures, reclining in landscape settings, use a similar combination of black chalk and watercolour. The best known Daumier watercolour of a figure in a landscape is the so-called 'Corot Reading' or *Le Liseur*, of which the final version is in the Metropolitan Museum of New York (Fig. 8.33). This drawing is the result of two preparatory studies, one of which is

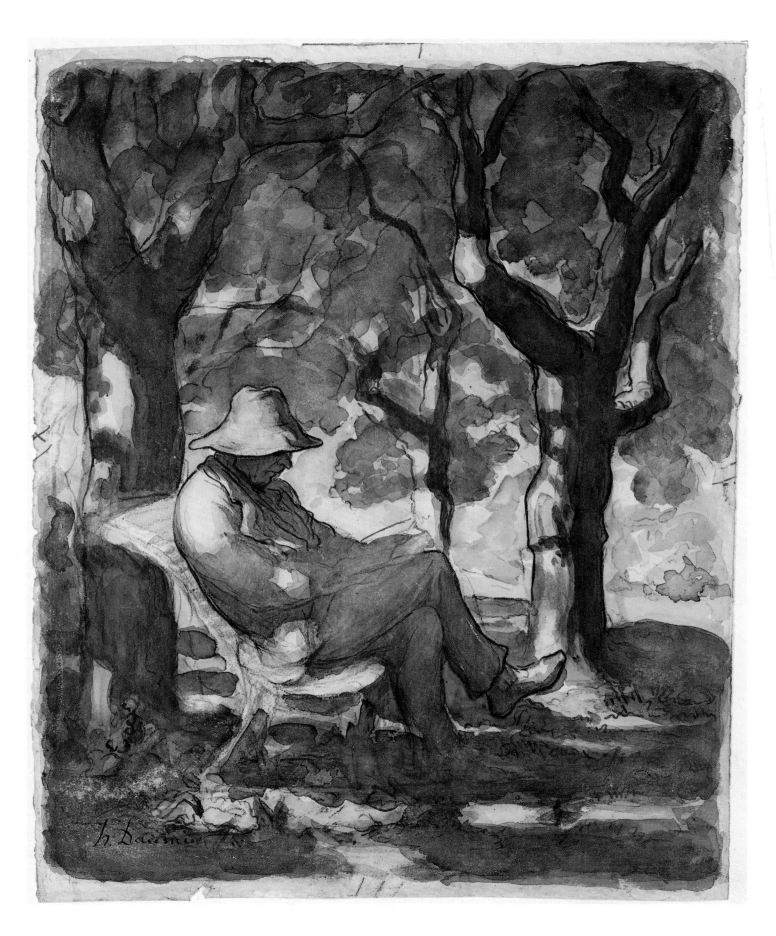

h. Daumier

on the verso of the sheet illustrated. Initially the relationship of a seated figure to two rather anthropomorphic tree trunks on either side was considered (each trunk has two arms). Then, a small study in pen and ink and yellow watercolour describes the dappled effect of sunlight coming down on the figure through leaves.[34] The final composition is turned to an upright format, and a wide variety of light effects is created by variegated watercolour patches, not in the full range of the spectrum, but mostly in shades of grey, with some in yellow ochre (the man's hat; between the trees), or a pinkish-brown (the tree trunks), with a few small spots of bright green. The basic linear rhythms are imparted with a broad-nibbed pen using black ink. The general effect, then, is that of a colour-tinted graphic design, as systematic as Millet's watercolours of the Allier but perhaps two stages further away from the original impression. So for Daumier the depiction of light remained a creation of the mind, based on memory. Pure landscape, in so far as he had much time to contemplate it, must have been for him a symbol of the purest mental recreation.

What would Daumier have made of the Auvergne? A lithograph in Nodier and Taylor's *Voyages Pittoresques*, called *Le Cantal*, from an original drawing by Sabatier and J. Taylor, could give us food for thought. An Auvergnat of 1830 rides up the bleakest of mountain roads on a mule, followed by another mule laden with baggage (Fig. 8.34). The landscape is composed of igneous rocks only. It is a landscape fit for Daumier's Don Quixote.

9 Illustrations to Literature

IT MUST BE stressed that neither Daumier nor Millet by temperament or practice were normally illustrators of other people's texts. Perhaps no artist likes to admit to being entirely an illustrator, but there is a sense in which we now think of Gustave Doré or Gavarni,[1] or even Carl Bodmer, as professional illustrators because their best work has survived in this mode. Daumier and Millet, on the other hand, although they occasionally got involved with various illustrative projects which might have provided auxiliary ways of earning money, are regarded today more for the kinds of personal imagery they developed through combining traditional narrative sources with their observed contemporary world. This power of unifying narrative traditions with contemporary concerns seems to be found particularly in both artists' late works.[2] Such a thesis will be tested in this chapter, in the context of illustration, and then developed in a more speculative manner in Chapter 10.[3]

Commissioned illustrations to texts must be distinguished from narrative paintings and drawings based on texts but produced independently, although the two modes of representation might sometimes be similar.

Most of the major romantic artists before Courbet used literary sources as the starting points for ambitious figure compositions: Ingres and Delacroix are the most obvious examples that come to mind, although the literary tastes of these two, and their methods of interpretation, were very different. A good deal of narrative painting was exhibited at the annual Salons in the nineteenth century, which relied upon the public's knowledge of literary sources, and this became an accepted form of popular genre. Such images were further disseminated through the graphic media. Delacroix himself produced a series of lithographs for a new French translation of Goethe's *Faust* in 1828, which was inspired by a theatrical performance seen in London. Furthermore his admiration for scenes evoked by the works of Dante, Shakespeare, Byron and Scott is well known. Whereas evidence of Delacroix's reading tastes is freely visible in his paintings and drawings, in the case of Millet, who was also very widely read, such direct evidence is relatively less frequent.

Daumier in his own time, of course, was regarded generally as a caricaturist rather than a painter, in spite of such perceptive critics as Baudelaire and Champfleury who ranked him high as a draughtsman, at least, along with Ingres and Delacroix. When he was working as an independent artist he chose to interpret literary texts very seldom. He admitted to Champfleury that he 'could not get on' with reading Aristophanes, when the book was proffered to him. On the other hand he became as fascinated by Cervantes' *Don Quixote* as any of his contemporaries, and also by the equally popular *Fables* of La Fontaine. In addition, he produced a very few drawings of scenes from Molière's *Le Malade*

"Some people regarded him with horror, others pitied him."—p. 35.

PÈRE GORIOT.

9.1 Daumier. *Le Père Goriot*. *c*.1843–6. Woodcut.

imaginaire. But classical mythology he treated only in a satirical manner, most often with references to contemporary dramatic performances. These effervescences in his drawings were spontaneous enough, but we have to deduce that he was never very keen on working for publishers.

His five woodcut illustrations to the novels of Balzac,[4] though sufficiently powerful, not to say ghoulish, do not suggest a devoted interest in the nineteenth-century novel. The attraction must have been the personality of the novelist himself with the breadth of his interests and the earthiness of his detailed knowledge of people's habits in all walks of life. Yet a sustained illustration of the characters created by Balzac would not have held Daumier's interest for long. The most penetrating of these woodcuts is the expressive figure of old *Père Goriot*, seated in profile with hands clasped as if patiently waiting for one of his daughters to notice him (Fig. 9.1). It is accompanied by the caption, 'Aux uns il faisait horreur, aux autres il faisait pitié.' The overlaying of deep human understanding by often dramatic and macabre plots is characteristic of Balzac's literary procedures: Daumier's visual procedures could not accommodate such narrative complexities. The large number of drawings he made of single, expressive heads suggests that he tended to see people's physiognomies as holistic reflections of themselves.[5] The physical appearance of Balzac himself may have intrigued Daumier – as it later did Rodin – and although there is no portrait of him, some other portrait drawings of the virtuoso sculptor Carrier-Belleuse executed about 1863 evoke a similar type of creative exuberance.[6] In fact, the physique of both the writer and the sculptor seems to resemble that of the fat/strong men at circuses, the 'senior saltimbanques' whom Daumier was so fond of portraying in his later years (see Chapter 11).

Earlier in his career, particularly during the 1840s, Daumier drew the designs for a number of woodcuts as illustrations for popular books, such as the *Némésis médicale Illustré* (1840),[7] and a number of *Physiologies* in 1841–2, as well for popular almanacs. A significant proportion of his early cartoons for *Charivari* were reproduced in woodcut form, particularly in the 1830s.[8] With a few exceptions, these woodcuts do not add very much to what we know about his drawing. He was also one of a group of cartoonists who took part in the mammoth project of illustrating the nine volumes of *Les Français peints par eux-mêmes* in 1840–2, but he contributed only a small number compared to the others – 25 woodcuts, most of which were vignettes for chapter headings. His landscape vignette for the article 'Le Bourgeois Campagnard' was the most exceptional of these (see Chapter 8, p.117). His gifted contemporaries, the cartoonists Gavarni, Grandville and Henri Monnier, contributed more often to this series, although the great bulk of the illustrations in the later volumes were done by the indefatigable Pauquet. By 1848 Daumier was positively resisting any commissions to make drawings for woodcuts, as testified by the well-known story of the young poet Théodore de Banville trying to get him to draw a new frontispiece for the avant-garde journal that he worked for, *Le Corsaire*. The point of the story, which may well have grown in the telling, is that Daumier professed to hate allegories: 'a journal is not a ship, and a Corsaire [Captain of a privateer] is not a writer!'. (However, he did make the drawing for the woodblock, to please his young friend) (Figs. 9.2 and 9.3).[9] We can only conclude from this that Daumier did not respond well to being told what to illustrate: he would create only such imagery as had significance for his own mythology, once he achieved some freedom to develop it.

It is perhaps surprising that Millet made very few illustrations at a similar stage in his career, or indeed at any time in the sense of commissioned works. Having been trained at the École des Beaux-Arts, it was perhaps against his principles (even at the point of starvation) to produce anything other than oil paintings or

9.2 Daumier. *Le Corsaire*. 1848. Pen and wash, 24.8 × 38.3. Location unknown.

9.3 Daumier. Sketch for *Le Corsaire*. 1848. Pen and Chinese ink, 22.5 × 36. Musée de Grenoble.

presentation drawings for sale. Two paintings of 1839 which illustrate the tales of Gresset, namely *Vert-Vert* (the parrot who scandalised the nuns of Nantes) and *Le Lutrin Vivant* (a tale of equal vulgarity) are exceptions in his subject matter. Perhaps more consciously than Daumier, he did not wish to be an illustrator.

In this chapter we will examine some exceptions to these adopted positions. Some were occasioned by economic necessity, some as a result of co-operation with patrons and friends, and others by sheer *joie d'ésprit*. In Millet's case the first significant illustration project in which he was involved required drawings of pioneers and Indians in the American wilderness. These were produced in 1851, by way of collaboration with his fellow-artist Carl Bodmer, who had accepted a commission for a series of lithographs to be published as loose sheets under the common title 'Annals of the United States. Illustrated. The Pioneers'.[10] Millet expressed his opinion of the publisher's requirements privately, in a letter to his friend Marolle (the following extract sums up his whole attitude towards illustration as a trade):

I am making drawings of savages, for a commission that an American traveller has given to Bodmer. I do not know if this affair will be successful, because there are set conditions which are a little out of my line. Firstly, the drawings in question must be very tightly finished, because they are for making prints [*pour la gravure*]. But that is not all: it is further required that they be in a style as polished as possible

Bodmer went to show them one, that I had finished as best I could in this style. I had the stupidity to believe, before the publisher had seen it, that I could sustain this struggle up to a certain paint . . . bah! when the publisher [Goupil] saw it, the expression on his face was not exactly that of satisfaction. He found the drawing good, but also, unfortunately, that it was a work of art, and this was above all what he wanted to avoid at all costs; this publication was aimed at the American market, and it was absolutely necessary that it be prettied up. I give myself a devil of a lot of trouble to do what I really cannot do. Bodmer will probably have to employ someone else . . . American people, you are very corrupted [*bien roué*] for your age![11]

In the event, Millet did go on to make five drawings for this collaborative series, for which he invented both the figures and their landscape settings. The

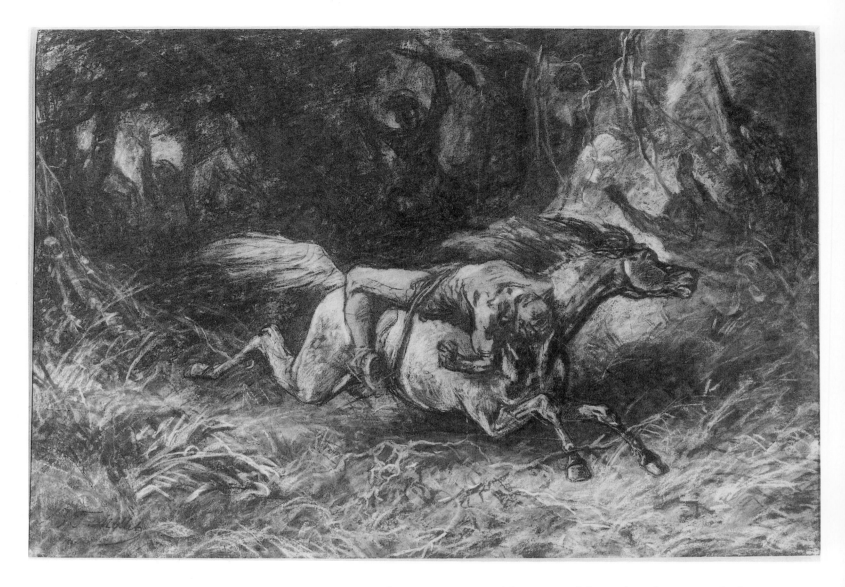

9.4 Millet. *Simon Butler, the American Mazeppa*.
1851. Black chalk heightened with white, 35.5 ×
53. Cherbourg, Musée Thomas Henry.

drawing style is vigorous, and in some of them densely textured; the sweetness
and neatness required by the publisher was imparted by Bodmer in the process of
transferring them on to the lithographic stones. *Simon Butler, the American
Mazeppa* (Fig. 9.4) is a good example of the expressiveness of Millet's conception.
The figure tied upside-down to the horse's back is in fact a direct borrowing
from the well-known oil painting *Mazeppa* by Horace Vernet of 1826 (Avignon
Museum), which Millet would have known, at least from engravings of famous
French Salon pictures. But even if the horse's gallop is of what we would now call
the pre-photographic era,[12] the agony of the supine figure is realised grimly
enough. The shadowy Indians behind the trees are inhabiting the thickets of the
forest of Fontainebleau – which, from Millet's point of view, was no doubt an
adequate substitute for the wilds of Kentucky, where this particular pioneer had
his adventure. The dense application of the black chalk, together with white
highlights on the grasses and the figure in the foreground, give this drawing a
pictorial look, which was presumably what was required. At least two of the
drawings in the series were to illustrate scenes from Fenimore Cooper's novel *The
Last of the Mohicans*; another, less finished drawing called *The Fortress* (Fig. 9.5)
has been connected with another of Fenimore Cooper's tales, *Lake Ontario*.[13] The
background screen of trees is again a motif familiar to Millet's local surroundings.

9.5　Millet. *The Fortress*. 1851. Black chalk, 35 ×
49.7. Budapest, Musée des Beaux-Arts.

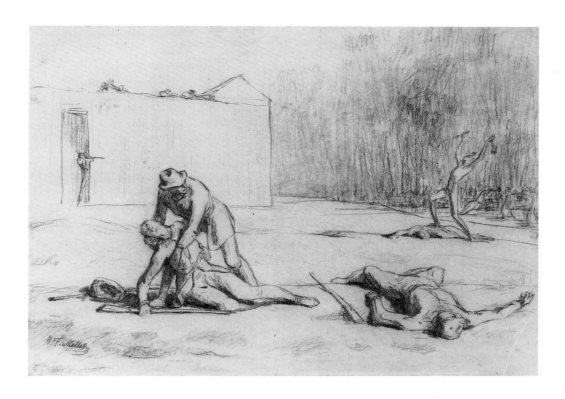

The action represented – a kind of factionalist warfare – would surely have
derived its *mise en scène* from the popular prints about the 'July Days' of the
Revolution of 1830, of which Millet (like Daumier) would be fully aware.[14]
However, Millet's anatomical rendering of the figures was probably achieved by
other means. If one looks closely at the configuration of the two limp figures in
the foreground of *The Fortress*, and compares their anatomy with that of the
supine figure in *Simon Butler*, it becomes apparent that Millet was setting up a lay
figure in his studio for some of the poses.

Millet evidently found it quite a struggle to produce such illustrations. But
when it came to the kinds of universal insight into the nature of mankind
perpetuated, as it were, through the great books – books sufficiently generally
known to have pushed their own images out into the verbal folklore of the people
– then, it will appear, both Daumier and Millet were on occasion willing to put
their best creative talents to the task of visualising such conceptions. The book in
which they shared the most interest in common was La Fontaine's *Fables*. Apart
from this, Daumier entered upon his own almost mystic communion with the
two central characters in Cervantes' *Don Quixote*, and Millet in his turn produced
some of his best narrative subjects, both in paintings and drawings, from the great
passages of the Bible. Their religious illustrations, many of the best of which
belong to the 1860s, will be discussed later in this chapter.

LA FONTAINE

Daumier and Millet had both admired La Fontaine from an early age, and
Adhémar claims that Daumier kept a copy of the *Fables* constantly with him.[15]
Similarly, Moreau-Nélaton notes that Millet's friend Marolle had given him La
Fontaine to read as early as 1839, and that he consequently strove to illustrate one
of the most witty tales, *Le Calendrier des vieillards*.[16] But this subject is of course
from the *Contes* of La Fontaine, not the *Fables*, and is thus a very different kettle of

141

9.6 J.B. Oudry (after). *The Miller, his Son, and the Ass*. 1755. Engraving.

fish.[17] With one early exception, all Millet's works inspired by the canon of the *Fables* belong to the 1850s and later. Daumier, on the other hand, had probably been brought up on La Fontaine by his poet father,[18] and by the time he had begun his career as a lithographer's apprentice with Belliard in 1825, on his rounds of print merchants and booksellers he would certainly have seen some of the many illustrated editions of La Fontaine's *Fables* which had appeared by then.[19] It is no surprise, therefore, to find him sending a painting of *The Miller, his Son, and the Ass* to the Salon in 1849, as a subject of his own choice. This painting, which was mentioned in Chapter 5 as part of Daumier's stylistic debut as a Salon artist (Fig. 5.24), is often described as using the scene of the fable merely as an excuse to paint the group of spirited young women in the foreground. This now seems to me to be an inadequate reading. Apart from the magnificently derisive gesture of the girl with oustretched arm (which, as I argued in Chapter 5, seems to contain political overtones about rejection of the past, or of the inadequate) the emphasis on a group of *three* figures is a fairly important part of the story illustrated. The story's point is the impossibility of pleasing everybody: after encountering their first, anonymous, critic, the miller and his son are insulted by three rich merchants; next by three girls who mock the millar as 'Grizzled Bishop Bones' for riding while his son walks, at which he gets very annoyed and tells them to be off; then 'a third three' come in view when both are riding on the ass and taunt them as 'uneducated boors!' for 'beating an ass to death'; and finally 'someone else' calls them 'a trio of donkeys' when men and beast are walking together.[20] The alleged motivation of the story, it will be recalled, was to give advice to a young man of the world about his future career: the opinion of three young ladies, then, would be of significance to him – why shouldn't he ride? On the other hand to be thought an 'uneducated boor' would be intolerable, and this aspect of derision from the sophisticated, in the fourth scene, is also conceived as coming from a group of young ladies in Oudry's interpretation (Fig. 9.6) of 1755, which Daumier is very likely to have known.[21] (There is even some degree of similarity between the landscape setting of his painting and that of Oudry's print.) Daumier's own representation of the three girls is indeed Rubenesque, as has often been remarked, but the reason for their painterly vitality may be a perfectly deliberate interpration of 'the ways of the world' as Daumier knew them. His rapport with La Fontaine is therefore considerable in this painting,[22] and brought out moreover with an earthy contemporaneity of touch, in the broad handling of the paint.

Another La Fontaine subject, on which I believe that Daumier was working at about the same time as this, was *The Thieves and the Ass*.[23] There exist two preparatory drawings, of which the larger follows the smaller, and an oil sketch on canvas which has been squared up to take the contours of perhaps yet another drawing, since its compositional arrangement does not exactly reflect that of the extant charcoal sketch (Figs. 9.7, 9.8). The charcoal drawing, which suggests a murderous struggle, has a vigorous muscularity of line reminiscent of the *Death of Archimedes* (Fig. 4.14), a drawing of equal violence and sinister import. The fable illustrated is a terse one, with a quite overt political reference in the second verse to the victimisation of 'a small province' by rival kings – 'Turkish, Hungarian or Transylvanian' being specified. As it happened, Daumier was writing to his wife (who was on holiday by the sea) in the summer of 1849 about an important piece of news: the end of the Austro-Hungarian war, when the Hungarian patriots were defeated after the arrival of Russian forces in support of the Austrians.[24] Not a very close parallel to a seventeenth-century fable? The coincidence of the dating of drawing and political event makes one wonder. Daumier was, after all, a political *cartoonist*. But this is no cartoon: it seems to be a statement about La Fontaine and his darkly ironic habits of thought. The painting, which may be later in date than

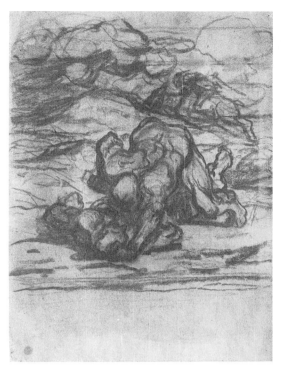

9.7 Daumier. *The Thieves and the Ass. c.*1849–50. Charcoal, 33 × 24.5. Paris, Louvre (Inv. RF 36,799).

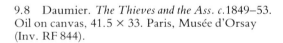

9.8 Daumier. *The Thieves and the Ass. c.*1849–53. Oil on canvas, 41.5 × 33. Paris, Musée d'Orsay (Inv. RF 844).

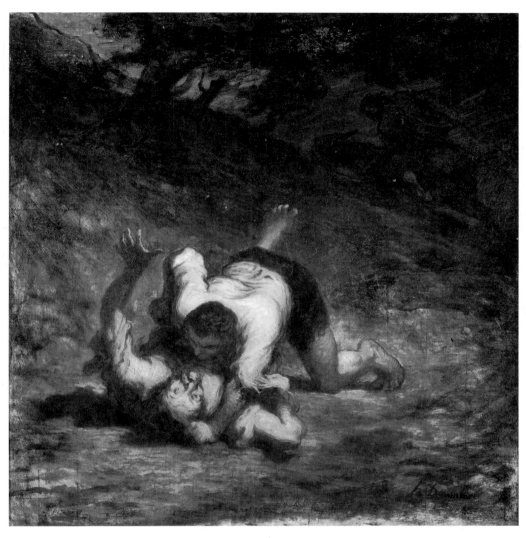

the drawings, seems relatively less subjective and topical, and more of a considered illustration to the tale in question, namely two men fighting on the ground, each searching for 'the better hold'. It was this aspect of the illustration which Daumier shamelessly used again for a lithograph of 1862, repeating the facial grimace of the upturned head (in the painting) exactly.[25]

Millet's earliest effort at illustrating the *Fables* treated a specially pastoral subject, the story of Tircis and Annette, wherein a youthful shepherd attempts to charm the fish in a stream on to his loved one's hooks by playing his flute to them. Millet painted this in his *manière fleurie* style, and exhibited it at his Le Havre exhibition in 1845, where it was sold to the Swiss Consul.[26] His next projected forays into La Fontaine territory were very different: in 1855 he took part in the discussions at Barbizon to launch a new edition of the *Fables*, to be jointly illustrated by seven artists. These discussions took place at Rousseau's house and, as recounted by Alfred Sensier and going by his lists of subjects, it looks as though Rousseau, Daumier and Millet were the prime movers.[27] There were two other Barbizon landscape painters named in the scheme – Diaz and Dupré – plus the sculptor Barye (a close mutual friend of them all). Delacroix was also listed with a range of subjects, but can hardly have been present, and somebody (probably Rousseau) was obviously going to be deputed to ask him. Millet, at this stage in his career, was bent on establishing his image as a peasant painter (not just

143

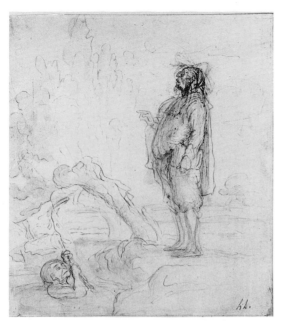

9.9 Daumier. *The Child and the Schoolmaster* (study). *c*.1856–7. Black chalk, with some pen and wash, 27.5 × 23. Location unknown.

9.10 Fressard. *L'Enfant et le maître d'école*. 1646. Engraving.

a painter of peasants), as we know, and Sensier describes his special 'aptitudes' at that time as for 'le rustique et le paysan'. His choice (or allotment? – we do not know how much wrangling went on during that convivial evening) of seven subjects included *Phoebus and Boreas*, *Death and the Woodcutter*, *The Shepherd and the Sea* (these three were all executed over the next several years); *The Thieves and the Ass* (surprisingly, because Daumier had already done this; Millet did nothing about it in fact, but suggested it again for another scheme in 1867); *The Forest and the Woodcutter*, *The Peasant from the Danube*, and *The Scythian Philosopher*, the last three subjects being left untouched. The subjects he did treat will be discussed shortly; for the moment it will simply be observed that the most significant fact to emerge from the choices made by these artists is that for once they *were* choices, not commissions. Perhaps that is why the scheme never came to anything. Sensier tells us that ensuing 'sad days, and the preoccupations of life' sent such drawings as were made back into the cartons reserved for times of more abundance.[28] What he really seems to have meant was that these artists were not right for such a competitive market! In addition to the numerous seventeenth- and eighteenth-century editions of the *Fables* mentioned earlier, about twenty more appeared by 1859, including a very popular one with 100 woodengravings by Gavarni and others (1851), another published by Fournier with illustrations by Grandville, which ran into four editions, and another in 1858 with illustrations after 40 drawings by Daumier's rival, Cham.[29] The rivals were all professional illustrators, and only Daumier could have competed with them. His friends, classified as artists, would seem (with hindsight) to have been doomed to express only their inner selves through the *Fables*.

None of this really proves who first thought of the scheme; it might equally have been suggested by their mutual friend the poet Martin Etcheverry, who was present at the Barbizon meeting, or, most likely, by Rousseau himself. Rousseau owned an eighteenth-century edition of the *Fables* illustrated by Fressard, in six volumes, with fine engraved headpieces to every fable.[30]

Turning to Daumier's 'distributed subjects', Sensier describes his 'speciality' as 'l'ironie et les moralités populaires'. It is evident that he spent much time and thought on *The Child and the Schoolmaster* (La Fontaine's title), and he produced a finished watercolour known as *The Scholar and the Pedant* (Fig. 9.13). There are two preliminary drawings, in which he explored the possibilities of his design. The second one (Fig. 9.9) indicates all the salient features of the finished work; the willow tree, the miserable expression of the child hanging on to a twig in the water, and the complete realisation of the schoolmaster's profile as he pontificates from the river bank. In the final watercolour a mountainous landscape is indicated in the distance, and if the composition is now compared with Fressard's engraving (Fig. 9.10) the inference is surely that he had been looking at Rousseau's book.[31] He turned the finished watercolour into a picture ready for private sale, more finely coloured than could possibly be needed as a model for an engraver, and La Fontaine's entire thought is beautifully recreated. The irony of this particular tale appears exactly suited to Daumier's own temperament, and the character of the schoolmaster is but an extension of Daumier's pillories of hypocritical lawyers and doctors. The schoolmaster's mental attitude is expressed by the whole attitude of his body, and the final touch of irony is added by his blue stockings: sign of a literary savant. Once more we may notice Daumier's subtle and spacious rendition of the landscape, with its finely balanced green and lilac tones. Although the arrangement of this design is 'lifted' from an older format, Daumier has transformed it through his powers of imagination.

Daumier also produced, possibly near the time of this project, two studies and a fine finished watercolour of *Death and the Two Doctors* (La Fontaine, V-12, *Les*

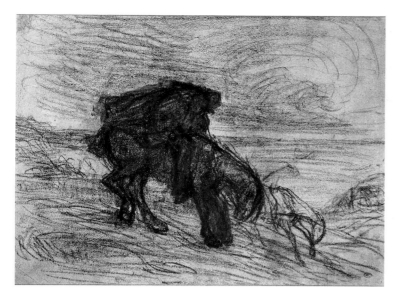
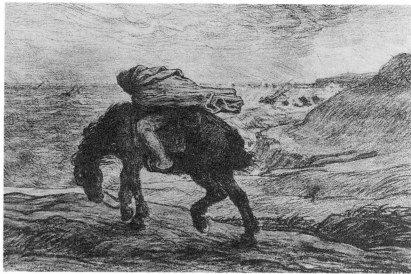

9.11 Millet. *Phoebus and Boreas* (study). *c*.1856–7. Black chalk, 20.6 × 27.9. Paris, Louvre (GM 10,471; RF 5797).

9.12 Millet. *Phoebus and Boreas*. *c*.1858. Pastel, 33 × 46. Location unknown.

Following pages:
9.13 Daumier. *The Child and the Schoolmaster*. *c*.1856–7. Pen and ink, watercolour and gouache, 29 × 23.8. Collection of Eugene Thaw.
9.14 Daumier. *Death and the Two Doctors*. *c*.1857–8. Black chalk, pen and wash, 32.5 × 53. Winterthur, Oskar Reinhart Collection.

Médecins) (Fig. 9.14).[32] He represented this fable as a kind of drama on stage. In his first scribbled idea, Death and the doctors seem to be dancing together; in the second, Death leans on his scythe and watches the doctors gesticulating. In the final version, reproduced here, the doctors are posed as though singing a duet together, while Death, visualised as a fine baroque skeleton, gathers the corpse under its arm and drags it bodily out of bed. Another, less finished, drawing of Daumier's, which carries the given title *Le Malade et la Mort* (quite reasonably, since Death is shown watching a sick person in bed), should probably be related to the fable *La Morte et le Malheureux*.[33] As neither of these last two fables figure in Daumier's list of assigned subjects, it may be assumed that the group project did not survive for long, but nevertheless served as a stimulus for more illustrations of the *Fables* with which Daumier felt a personal rapport.

The three subjects eventually executed by Millet from his assigned list all developed into more elaborate works than the project itself may have required. Like Daumier, Millet made preliminary drawings, and those made for *Phoebus and Boreas* are particularly striking. He envisaged the cloaked traveller on horseback on the cliffs at Gruchy with the turbulent waters of the English Channel below. A study in black chalk in the Louvre (Fig. 9.11) is executed with agitated, swirling lines indicating the wind, and the rider emerges from the paper as a heavy black silhouette, descending a steep slope. The force visible in this drawing signifies the artist's impression, drawn out of mind and memory together. A larger drawing in pastel (Fig. 9.12) indicates the cliffs of Gruchy more clearly (including a shipwreck in the distance) and reverses the direction of the traveller. I have not seen this in colour, but the drawing technique relates to his pastels as he took them up again in the late 1850s, and the inference is that this is a reworking of the theme for sale to a private client.[34] The old nag that Millet gives his traveller to ride bears some resemblance to Don Quixote's Rosinante, as rendered by Daumier on numerous occasions.

The same horseman, sketched on a minute scale, appears near the top right-hand corner of a sheet of studies for Millet's other La Fontaine subject begun at the same time: *Death and the Woodcutter* (Fig. 9.15).[35] To judge from another sheet of studies in the Louvre which includes this theme,[36] Millet was planning this composition at the same time as other rural subjects: in fact it lies right at the heart of his rural imagery, as we have already seen. Characteristically he renders this fable as being upon the dark edges of receivable human experience, a kind of

145

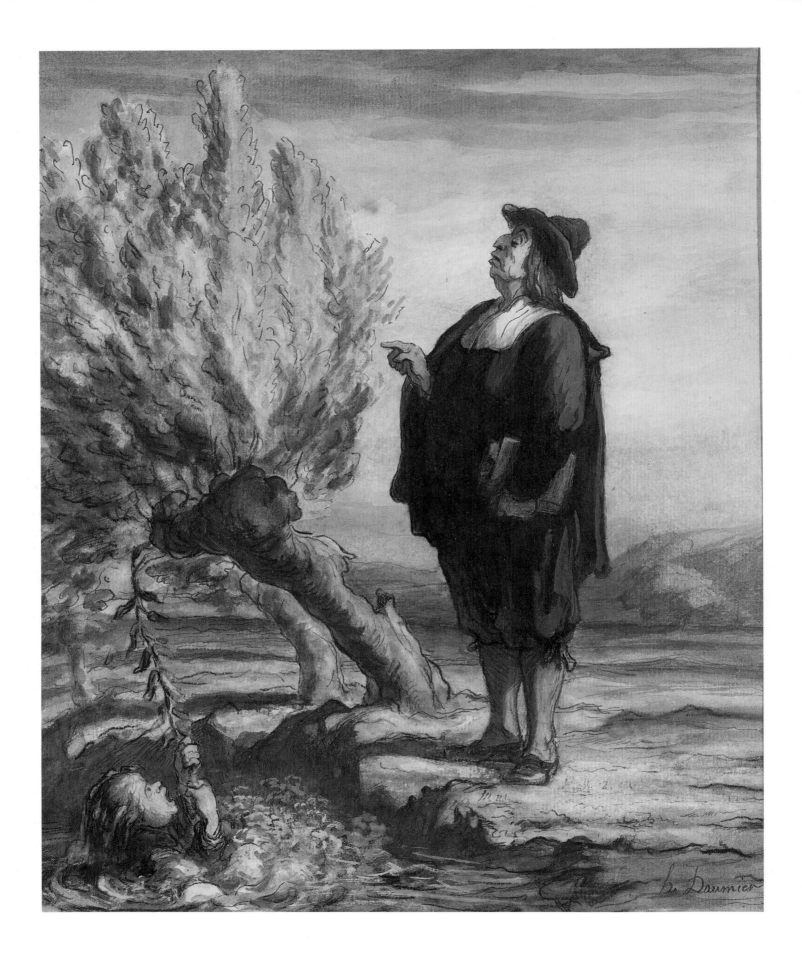

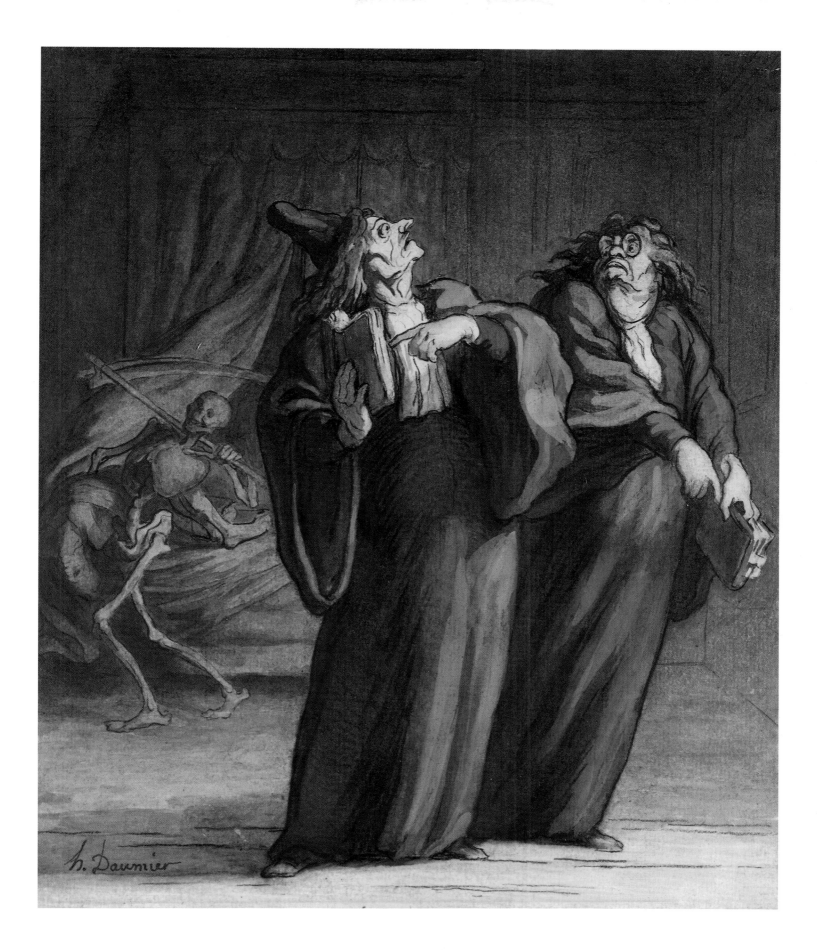

9.15 Millet. Sheet of studies with *Death and the Woodcutter*. *c*.1858. Black chalk, 22.7 × 28.2. Paris, Louvre (GM 10,310; RF 5706).

9.16 Millet. *Death and the Woodcutter*. *c*.1858. Black chalk, 30.9 × 41.3. (Galerie Fischer, Lucerne, 1967).

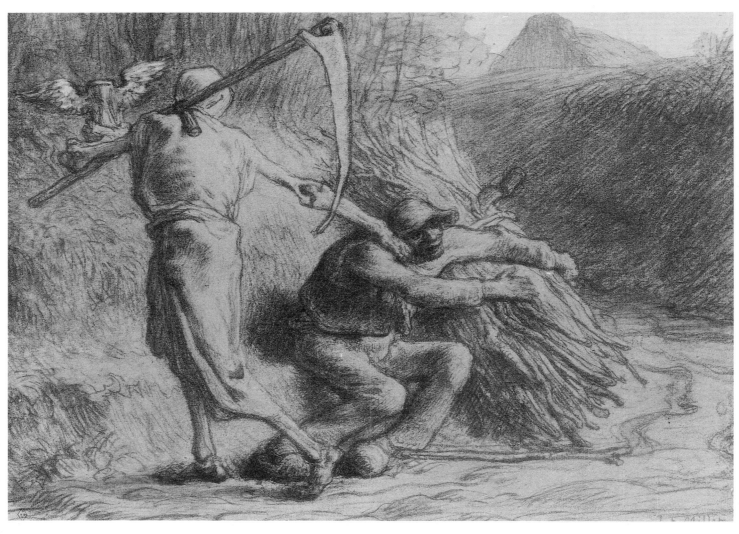

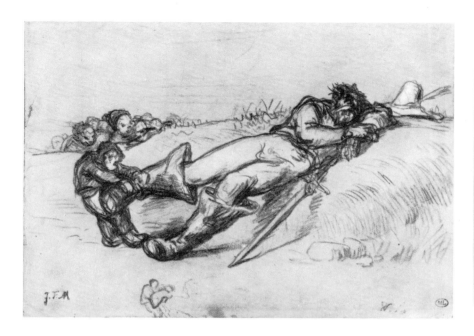

9.17 Millet. *Tom Thumb Pulling Off the Ogre's Boots*. 1857. Pencil, 13.3 × 18.9. Paris, Louvre (GM 10,615; RF 11,221).

9.18 Daumier. *The Cat Changed into a Woman*. late 1850s. Ink wash over crayon, 12 × 14. Location unknown.

desperate ballet played out in front of an impenetrable forest. The violence of the first imaginative sketches is also characteristic. In the finished drawing (Fig. 9.16) the action is slower and the symbolism heavier: Death carries a winged hourglass and a huge scythe (a very realistic one), and the expression on the woodcutter's face is a bit too overtly pathetic. Millet does not have the irony of Daumier in these illustrations, but interprets La Fontaine's wry text more as a tragic and inevitable drama, related to his perception of the conditions of the peasantry in his own day.[37]

The obverse side of Millet's solemn nature emerged occasionally in his illustrations to Perrault's tales, apparently made for his children.[38] The ogre in *Tom Thumb Pulling off the Ogre's Boots* (Fig. 9.17) is drawn in the same manner exactly as the sketches for La Fontaine's woodcutter, that is to say from memory of an environment overlaid with an imagined event. Only the text has lost its sting in the face of a children's story (or nearly so!). The spontaneous humour of such a drawing may be compared to a little Daumier watercolour of about the same size, illustrating one of La Fontaine's more lightly humorous fables, that of *The Cat Changed into a Woman* (Fig. 9.18). The wife with cat instincts, hunting mice in the middle of the night, might equally have been made to amuse a child.

The next group project for an edition of La Fontaine's *Fables* did not involve Daumier, and was more in the nature of a single private commission, handled by Sensier as agent for a Monsieur Carrier in 1866. This gentleman had been charged by one of his friends to obtain drawings for 'un Lafontaine de luxe'. Sensier wrote to ask Millet for some drawings for this, which were to be placed in a book, and therefore needed to be done in a very stable medium ('en matière très fixé') – no pastels, charcoal or chalks. Rousseau had also been approached (but he did not like the price), together with Diaz, Daubigny, Corot, Isabey, Barye and others, and thirteen subjects had already been chosen.[39] Millet wrote back with some enthusiasm, saying that he would be very happy to have some of these drawings to do (he was actually slightly confused about the subjects which had been 'chosen'), and that he would never have disdained such work at any other epoch in his life – but right now he was being terribly pressed to produce more pastels for M. Gavet, which were incidentally better paid, so there might be some delay. *However* (my italics), he is setting himself to note down on canvas some things

which it would interest him to do; and, if Sensier thought that it might be good for him to figure in this illustrative venture, and if he did not find himself too pressed, he would do two subjects: *The Oak and the Reed* and *The Shepherd and the Sea* if he was going to do any others, they might be *The Stag and his Reflection* and *The Oracle and the Impious Man*. The last choice Sensier might think strange, of little interest, but they should discuss it.[40] (In fact the last choice, when we consider that it involves a man clutching a live sparrow in his hand, which he may either squeeze to death or let go, may be seen as appealing to Millet's imaginative vocabulary.) Of course Sensier had to write again to explain what he meant about the subjects having been already taken, and Millet backed down, although later in the year he agreed to do *The Thieves and the Ass*.[41] Yet what is most significant about Millet's letter (here published for the first time) is the degree of commitment it reveals to the *idea* of La Fontaine's *Fables* as a legitimate vehicle for Millet's visual translations of his own view of mankind. He did, much later, produce a fine drawing of *The Shepherd and the Sea*, and the image of *The Oak and the Reed* turned into a painting, which will be discussed in Chapter 11.

CLASSICAL LITERATURE AND THE BIBLE

Millet's academic training as an artist involved his being given, while in the studio of Delaroche, classical and religious subjects upon which to invent *esquisses* for figure compositions. *The Stoning of St Stephen* and *The Raising of Lazarus* were two such early works. Subsequently, as was noted in Chapter 6, he submitted paintings of religious subjects to the annual Salons, either concurrently or alternately with paintings of peasants, up until the time he left Paris for Barbizon. His last major attempt at a traditional biblical narrative painting, left unfinished, was the *Hagar and Ishmael* with its autobiographical undertones of family abandonment and exile. A large drawing of *The Departure of the Prodigal Son* (Fig. 9.19) seems to echo this theme: it is interesting that Millet should choose 'the departure' as his subject, rather than the more popular subject of 'the return', and that there is no sign of a pendant drawing of the latter. In style this drawing appears to belong to the early Paris period of *c.*1846–7, judging by its grid-like system of cross-hatchings and rather stiff movements of the figures. Its naive awkwardness carries a strong feeling of conviction, however, and I suspect that this drawing, too, has autobiographical associations.

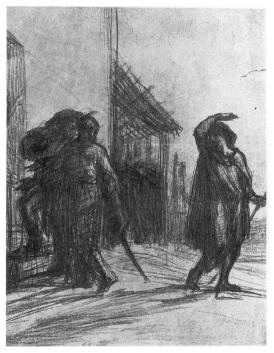

9.19 Millet. *The Departure of the Prodigal Son. c.*1846–7. Black chalk, 61 × 47. Location unknown.

After he moved to Barbizon, Millet's role as a biblical interpreter was transformed into an oblique, veiled, but still discernible pointing of analogies between his view of primitive peasant society and the figures in religious history. 'C'est biblique', Diaz is alleged to have said, on finding a painting of a woman sewing while she rocks a cradle, in progress on Millet's easel at Barbizon.[42] And when, very occasionally, Millet used biblical titles again in the late 1850s, such as the painting of *Tobit and his Wife Waiting for their Son (L'Attente)* which he sent to the Salon of 1861, their close connection with his peasant iconography is quite apparent. Among the several drawings made as studies for this moving work, a figure of *Tobit's Wife* (Fig. 9.20) shows an imaginative grasp of the psychology of the story combined with a vivid apprehension of the figures of peasants that he could see around him daily. The earthiness of such observation is certainly analogous with Daumier's way of seeing, although it is drawn from a different world of experience. The stiffness of the old woman's movements, conveyed here by Millet's peculiar linear phraseology of angular and hook-shaped lines, is emphasised by the sudden change of position of her left arm, as though she had just raised her hand to shade her eyes while we were watching (read: while Millet was thinking).

9.20 Millet. *Study of Tobit's Wife. c.*1859–61. Black chalk, 31.9 × 25.8. Paris, Louvre (GM 10,653 verso; RF 11,255 verso).

Classical literature was seldom used by Millet as a subject for direct illustration. One very curious exception is revealed by some correspondence concerning his friend and patron M. Chassaing, the solicitor from Clermont-Ferrand. Late in 1863 they were discussing a plan to illustrate the *Idylls* of Theocritus, for which Chassaing and a friend would support the cost of printing one specimen woodblock with a bearing on just one of the poems, by means of which it was hoped that a publisher could be 'seduced' into commissioning more. Millet became quite enthusiastic about this and wrote down descriptions of a suite of five designs, which he sent to Sensier for his opinion.[43] He had already begun to draw,

9.21 Millet. *Two Men Disputing a Woman* (subject from Theocritus). 1863. Black chalk, 28.5 × 19.2. Paris, Louvre (GM 10,470; RF 5877).

9.22 Daumier. *Matyrdom of St Sebastian*. c.1849. Charcoal, 38 × 18. New York, Metropolitan Museum.

9.23 Millet. *Christ at the Column*. c.1846–8. Black chalk, 32 × 13.5. Paris, Louvre (RF 31,765).

he wrote, the following for the first *Idyll*: 'Thyrsis and a goatherd seated near the grotto of Pan. Thyrsis is playing the syrinx and the other listens.' He then proceeded to describe in great detail three subjects which would be drawn as in relief, on a vase: a beautiful woman ('un chef d'oeuvre divin') being disputed over by two men; an old man fishing, under a rock, by the sea; and a child seated on a hedgerow, guarding a vineyard. The child is so busy baiting a trap for grasshoppers that he does not perceive two foxes, one stealing his dinner and the other eating the grapes. Finally there will be 'The Death of Daphnis' (the subject of the tune Thyrsis is playing on the syrinx), attended by Hermes, Venus, Priapus, goat-herds and shepherds. A most complicated programme! 'Five subjects in all', Millet wrote, 'and one could hardly do less than all five [for this particular idyll]'. In a second letter he admitted that five might be too many, but he had nearly finished the designs anyway. The drawing of *Two Men Disputing a Woman* in the Louvre is the only surviving record of this scheme which apparently was never realised (Fig. 9.21). Millet's line seem to wrap round her like a series of threads drawn over her soft curves, contrasting with the hard, muscular forms of the men. This imaginative flow matches Daumier's powers of invention.

It is, however, in their occasional drawings of narratives from the Bible, chosen and illustrated for their innate *drama*, that Daumier and Millet come closest together, partly because they were both liable to draw upon the art of the past for inspiration at such moments. I shall conclude this chapter by looking at a few outstanding examples of their respective achievements when working in this vein.

Daumier's State Commission of 1849, for which he produced a picture of *St Sebastian*, was noted in Chapter 5 (p.97). His initial conception for this was characteristically terse and decisive (Fig. 9.22). The heavy strokes of the charcoal stick produce a chiaroscuro effect of high baroque drama. The springy contours of St Sebastian's nearly nude body, poised like an athlete about to do a back somersault, have more vitality than anything he would achieve in the painting of this subject. This conception is a first visualisation of the essence of the story: Daumier draws his Saint looking up at cherubs in the sky, against a background as black and foreboding as that in the *Death of Archimedes* (Fig. 4.14).[44]

Millet's corollary to Daumier's *St Sebastian* (a figure which T.J. Clark has pointed out could be understood as a metaphor for the Second Republic)[45] might be taken to be his black chalk drawing of *Christ at the Column* (Fig. 9.23) which belongs stylistically to the period 1846–8. If it was drawn near the time of the Revolution it could also stand as an image of the people betrayed. The bony musculature of this elongated figure matches Millet's other drawings of that period of wild fawns and naked workers at the forge or manually turning huge geared wheels. As the face of Christ is not seen, because his hair hangs down over it, the image becomes a more anonymous one of human misery, powerful muscles rendered slack by captivity. This kind of expressive realism is also reminiscent of Spanish baroque art in a general way, a common source of inspiration which I believe that both artists shared at that time.

Certain scenes from biblical narrative seem to have been drawn for no other reason than they fascinated the artist who drew them. In Millet's case *The Good Samaritan* was one such – he had produced a kind of 'workers' version' of it in the painting of 1848 (Fig. 3.5), and in the early 1860s he produced two more drawings of this theme, put in a rural setting. One of these (Fig. 9.24) appears on the same sheet as a study for his etching *Going to Work*, and indeed the 'Samaritan' might be the same model as the farm worker carying a fork. The biblical overtones of Millet's rural world are once more confirmed. Particularly remarkable in this drawing is the active, springy line of the pen, which summons up in the viewer's mind both physical movement and an emotive contact between the two figures.

 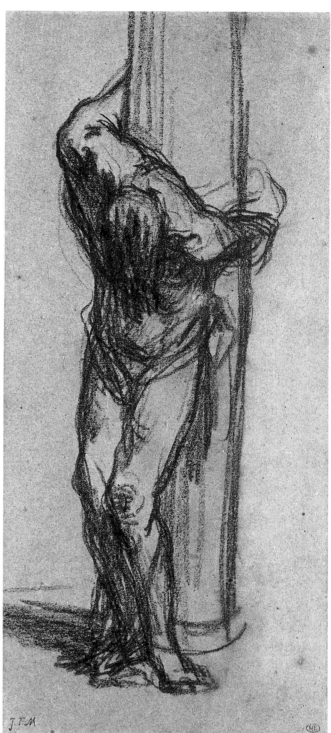

J.F.M.

Millet's drawing may be directly compared with Daumier's pen sketches of *The Prodigal Son* (Fig. 9.25), one of six sheets which have survived as a group of compositional studies of this subject, all in a late style which cannot be before the 1860s. When Daumier's line is compared to Millet's it is evident how differently their minds work. Millet seizes the passion of a real incident which he is capable of witnessing; Daumier might believe this too, but his more ovoid shapes and rhythmical system of self-generating loops produces a sculptural effect of forms being built up in his imagination, rather than a reflection of a thing seen. In Daumier's drawing the physical contiguity of the two bodies – one feels that they cannot be separated – in one homogeneous form expresses all the compassion felt by the father for his son. This was a kind of germinating drawing for the artist's idea, which he tried out again in several variants. Another sheet contains four studies showing the son in a more crouching position, and one with him being carried. In the most definitive of these, ink wash is applied to the lower left group, now visibly situated at the bottom of a flight of steps (Fig. 9.26). This scene must be outside the father's house. The last variant of the series (there is no evidence that Daumier got any further than this) transfers the viewer's position to inside the house, with the doorway surrounded by shadow as we look outside towards the figure of the father helping his son up the steps (Fig. 9.27). Daumier even tries shifting our position inside the door from slightly to one side to head-on to the approaching figures. This sequential mode of thought when at the invention stage of drawing is found in some of Millet's drawings as well, such as the sketch of Tobit's wife noticed earlier.

A group of three sheets of *croquis* by Millet, concerned with compositions for New Testament scenes, and now in the Louvre,[46] suggest an inspiration from Rembrandt's vivid realisations of these stories, which were very probably admired by Daumier as well.[47] Some of the biblical subjects Rembrandt drew most often – the Return of the Prodigal Son, Tobit, the Good Samaritan, Christ before Pilate, Christ disputing with the Doctors – were also treated by Daumier or Millet, or both. An edition of Rembrandt's etchings reproduced by photography, edited by Charles Blanc, appeared in 1853,[48] and the same author published his Rembrandt *Oeuvre Complet* in Paris in 1859. Rembrandt's etchings would, of course, have been more widely known than his drawings. In terms of illustration, his etchings very often have the same effect as expressive drawings, probably because they were so spontaneously drawn direct on to the etching plates with his etcher's needle.

The sheet of Millet studies illustrated here (Fig. 9.28) contains on the left side, two thumbnail sketches of the figure of the Woman taken in Adultery, and some explorations of her relationship to the figure of Christ; below these a fragment of a Lamentation; and, at the bottom, a compositional vignette of the Betrayal of Christ. On the right-hand side of the sheet are further studies of the figure of Christ and a compositional vignette, with chiaroscuro shading, of the whole scene of the Woman taken in Adultery; at the bottom are further notations of figures in the Betrayal. Thus we can see the artist juggling about with two quite separate scenes in his mind, and not necessarily sequentially at that. Yet the way in which each scene gets framed as he draws it suggests an orderly creative process. Another aspect of this sheet is the quality of Millet's *mise-en-page*, or, as Otto Benesch put it when writing of the drawings of Rembrandt, the way the different studies cover the page like a pattern.[49] This type of drawing was first developed consciously by Leonardo, later cultivated by both Rubens and Rembrandt, and it is found in French drawing particularly in the work of Watteau. To demonstrate this point a sheet of studies in pen and brown ink by Rubens is reproduced here of almost the same size as the Millet sheet, showing five variant poses for a *Thisbe* without further comment (Fig. 9.29). Following

9.24 Millet. Two sheets joined: studies for *Going to Work*, and *The Good Samaritan. c.* 1863. Pen, 29.2 × 13 overall. Paris, Louvre (GM 10,577; RF 11,191).

Facing page, below:
9.28 *(left)* Millet. Sheet of studies, with *Christ and the Woman Taken in Adultery*, *The Kiss of Judas*, and other studies. *c.*1863–5. Pen, 19.6 × 21. Paris, Louvre (GM 10,552; RF 5884).

9.29 *(right)* Rubens. Sheet of studies for a *Thisbe*. 1602–5. Pen and brown ink, 19.4 × 20.7. Paris, Louvre (Inv. 19,916).

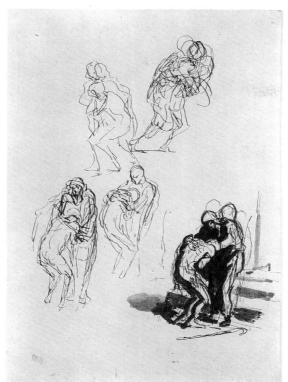

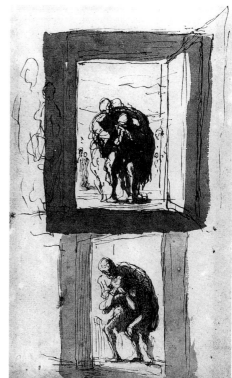

9.25 Daumier. Studies for *The Return of the Prodigal Son*. 1860s. Pen, 28.5 × 19.5. Paris, Private collection.

9.26 Daumier. Studies for *The Return of the Prodigal Son*. 1860s. Pen and wash, 20 × 14. Washington, National Gallery of Art (Rosenwald Collection).

9.27 Daumier. Studies for *The Return of the Prodigal Son*. 1860s. Pen and wash, 20.5 × 11.5. Cardiff, National Museum of Wales.

the path of Rubens, the great nineteenth-century artist who next springs to mind in this context of creative drawing is, of course, Delacroix.

In January 1864 Millet started becoming agitated in his letters to Sensier about the date of the Delacroix Studio Sale and the exhibition preceding it. There is no

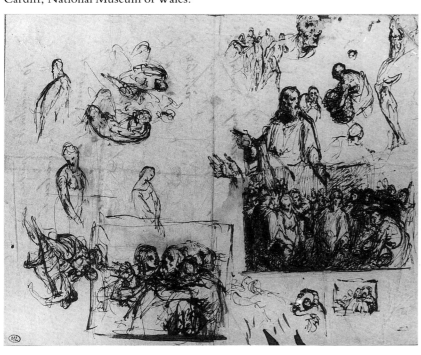

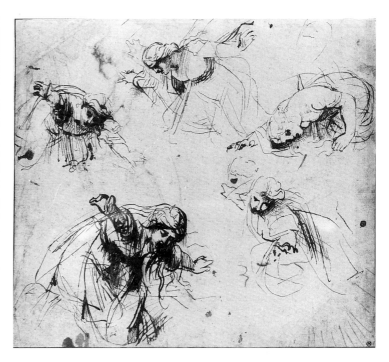

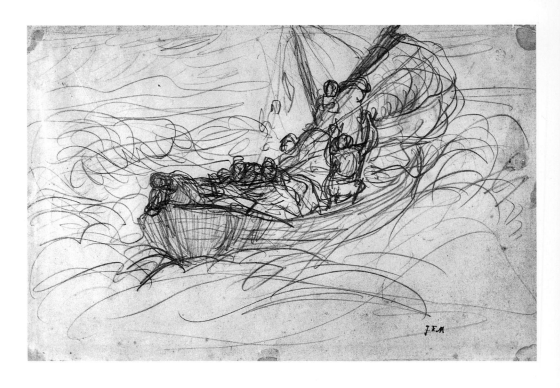

9.30 Millet. *Christ Sleeping on the Waves during a Storm*. 1864. Pencil, 19.9 × 30.5. Paris, Louvre (GM 10,715; RF 11.314).

record of his being present himself as a buyer, but on 16 February he did write 'Louise et moi partirons que demain matin [for Paris] à 6 heures . . . Rousseau ne viendra pas'.[50] It is also clear from subsequent letters that Sensier did a great deal of buying, for Millet as well as for other people, at the sale. A catalogue annotated by Burty indicates that Sensier bought a number of quite major drawings, including studies for the *Barque of Don Juan, The Death of Lara, Uqolino, Ovid among the Scythians*, and *L'Envie* (or *Le Triomphe de genie*, now in the Metropolitan Museum, New York).[51] Millet would certainly have known these, although it seems that he himself could only afford the less spectacular items. It is surprising to find, however, that he managed to obtain no less than 140 sheets of studies by Delacroix.[52] They were all groups of quite minor things – studies of drapery, *études d'après nature* unspecified, studies of architectural ornaments, and even six pencil and pen studies after Michelangelo – which Millet would have coveted as 'pure drawing'.[53] It would, of course, be useless to attempt to demonstrate any immediate 'influence' of these acquisitions – the rapport with Delacroix was already there. An exemplary comparison to demonstrate this natural affinity between the two draughtsmen, as well as their differences, would be Millet's *Christ Sleeping on the Waves during a Storm* (Fig. 9.30). of 1864, and Delacroix's study for his painting *Christ on the Lake of Nazareth* of 1853 (Fig. 9.31). In the Delacroix, every cursory line is descriptive of an area that is going to be painted, and the pattern of the waves expresses the agitation of the sea. In the Millet, every discrete line expresses agitation, with the exception of those on the still figure of Christ in the prow of the boat.[54] Millet's drawing is complete in itself, rather than a study for a painting: it is an illustration in which the line carries the message. Both these drawings are in pencil, and approximately of the same size. By comparison, Delacroix's hand moves with the delicacy of an Old Master, whereas Millet's has the ferocity of a modern one, appearing to relive the storm in his present feelings.

It would be too neat a conclusion to try to find another example of a Daumier drawing in such close accord as these (though if one just wanted a boat on the water, his earlier drawing of *Le Corsaire* (Fig. 9.2) could be cited). If any

156

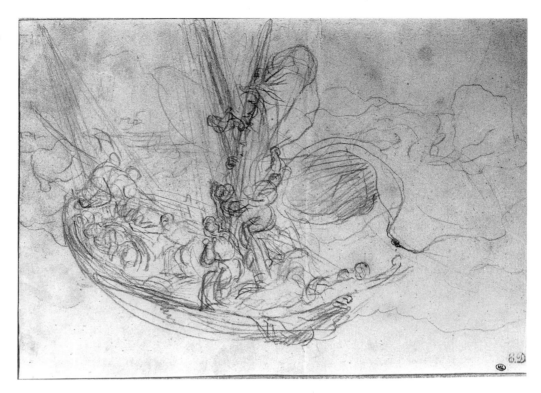

9.31 Delacroix. Study for *Christ on the Lake of Nazareth*. *c*.1853. Pencil, 22.5 × 34.9. Paris, Louvre (RF 9493).

conclusion is possible to this chapter, it would have to be that while the personal languages of Daumier and Millet were each too powerful and distinctive (this factor used to be called 'style') to lend themselves easily to narrative illustration in any system where they did not have exclusive control of what was expressed, nevertheless this resistant nineteenth-century tradition was not antithetical to them. The late works will demonstrate this again.

10 Personal Imagery in Late Works

IT HAS ALREADY been noted that there is no documentary evidence of contact between Daumier and Millet after December 1868 (Chapter 1, p.11). It may be that Millet was offended because the Daumiers who, although they would have been living in Paris at that time of year, did not make the short journey to Chailly for a Memorial Service for Théodore Rousseau, their close mutual friend who had died exactly a year before.[1] Or, it may simply be that these two artists had by now gone their separate ways. It is significant, however, that if one were asked to fix an approximate time for the beginning of their respective 'late styles', c.1868 would fit quite well in both cases. Millet, since his new experiences of landscape in the Allier and the Auvergne, had in a sense added the last ingredient to his repertoire of style. In Daumier's case, he had accumulated a small and discerning clientele of *amateurs* ready to buy his watercolours by the late 1860s, and it has been suggested that, when he finally gave up lithography after 1872, he went on producing paintings and watercolurs for these clients – at least there is evidence that he went on selling them.[2]

Notwithstanding their lack of personal communication, Daumier and Millet still show, in their late works, some similarities in their ways of thinking at the levels of both form and philosophical content. Their respective styles of expression were quite at variance both with those of their establishment contemporaries (with whom Millet, at least, was now ranked high), and with the painters of the new avant-garde (amongst whom Manet was already creating a considerable public stir). The subject matter of their late drawings and paintings is the same earthy, old-fashioned peasant or working class environment – not without an eye on the picturesque – that had always been their primary concern. As Robert Herbert rightly points out in his book on the French Impressionists, the images of leisure and entertainment that those young men produced towards the end of the 1860s would have been regarded by Millet (or Corot for that matter) with disdain.[3] Daumier was just as much a stroller of the streets as Manet, but he had absolutely no pretensions to being a *flâneur* in the dandyish pose of the latter. He made his comments on the new boulevards resulting from Haussmann's building programme, on the significance of the Exposition Universelle in 1867, and on other social developments in the pages of *Charivari* and *Le Boulevard*, but what he chose to paint for himself was quite different. In one sense the 'romantic' generation to which Daumier and Millet belonged might seem to have become alienated from contemporaneity, although their respective reactions to and comments upon the desperate events of 1870–1 can hardly be taken as signalling historical unawareness. Superficially their positions might appear to have been poles apart at that point, but this is something that needs more careful examination. In another, less personal, sense one could try arguing that their respective

languages of expression, as finally developed, had more in common with the sources of the Symbolist movement than with realistic observation of contemporary life. However, that could lead to nothing more than a dry exercise in academic hindsight. In strictly historical terms neither Daumier nor Millet can be related to any art 'movement' whatsoever after 1868, and even earlier than this neither should be tied down to such a bland category – as it had become by the 1860s – as the Realist movement. At this stage neither fits easily into any sequential, linear system of art chronology; their work needs to be considered synchronically. Before this attempt is begun through the examination of particular works, some further clarification must be made of their respective positions in the world of art dealers and patrons, and in the wider social context of France at the close of the Second Empire.

During and after the Franco-Prussian war Millet's affairs were very much involved with Durand-Ruel – who also dealt in the works of the young Impressionists – but Millet continued to work directly for a number of private clients as well, not least of whom was the wealthy industrialist from Münster, M. Frédéric Hartmann. This gentleman, who had been Rousseau's patron for many years, commissioned from Millet in 1868 a series of the *Four Seasons* as oil paintings, after he had seen some of the pastels of these subjects that Millet was already doing as part of a monumental contract with another collector, Émile Gavet.[4] This kind of commission was more important to him than selling through mixed group exhibitions in dealers' showrooms, although Durand-Ruel did begin to buy from him when they were introduced that same year[5]. Group exhibitions as such had not appealed to Millet since the middle of the 1860s, when he declined to exhibit at Martinet's gallery because it had grown too popular!.[6] Besides this he now held a distinguished position vis-à-vis the Salon, because he was made Chevalier of the Legion of Honour (due to the intervention of Théophile Silvestre) in 1868.[7] The following year the Museum of Marseilles bought a large painting from him, *La Bouille*, and Alfred Bruyas (Courbet's patron) asked him for something for the Museum of Montpellier.[8] In the spring of 1870 he was elected to serve on the Salon jury.

Daumier was so well known as a cartoonist, and he finished so few oil paintings in an acceptable manner for his time, that it would have been difficult to place him in any identifiable stylistic group even if he had wished it. Paul Durand-Ruel mentions in his *Mémoires*, however, that between 1865 and 1870 he was acquiring 'magnificent watercolours' by Daumier for his gallery at 1, rue de la Paix, along with paintings by Millet, Courbet, Diaz and Daubigny.[9] Durand-Ruel also refers to the dealer Brame as having an 'active part' in helping him get established, and indeed M. Brame figures prominently in Daumier's 'Fourth Account Book' as among the dealers who were acquiring his pictures – and more frequently his drawings – during the period 1864–8.[10] An interesting document drawn up by a kind of *ad hoc* committee of Rousseau's friends which met after his death – consisting of Daumier, Diaz, Charles Tillot (a former pupil of Rousseau's), Alfred Sensier and Théophile Silvestre – states that, after careful deliberation, Millet and the collector Hartmann also being consulted by letter, the dealers 'MM. Durand-Ruel et Brame' will be appointed as 'experts' at the sale of Rousseau's studio effects.[11] What this indicates is not only that Daumier had considerable influence over certain sections of the art world by this time, but that the nature of his authority was as a painter from *within* this circle of artists, who bore the respect of society even if their political views were, to differing degrees, radical. The title 'Barbizon group' would be too narrow and confining a term for this circle: they were simply artists independent of traditional classification. Such a position in society had been won, in the first instance, by Courbet in his personal campaign during the 1850s.

It follows that any artists of such independent repute might be expected to have reached equally independent political positions – no idle matter on the eve of the collapse of all the values of Napoleon's (so-called) *belle époque*. Early in 1870 Daumier was offered the cross of the Legion of Honour by a newly elected, more liberal government led by Émile Ollivier. He quietly refused it for obvious political and ethical reasons of his own – he could not accept honours from a society still subject to the values of the Emperor Louis-Napoléon, whom he had opposed since the beginning of his reign. A little later, in June, Courbet was also offered the Legion of Honour by the same Ollivier cabinet, on behalf of Napoleon. He refused it very publicly, making this refusal the occasion for a demonstration of hostility towards the Emperor. According to Albert Wolff, when Courbet found out that Daumier had also refused the honour he reproached Daumier for not protesting as loudly as he.[12] Daumier replied that he had done what he thought was right, and that it was no business of the public. Courbet is said to have shrugged his shoulders, saying 'On ne fera pas jamais rien de Daumier; c'est un rêveur.' Temperamentally Daumier was surely much closer to Millet in such a situation, although his course of action was different.[13]

Daumier remained in Paris after the outbreak of the Franco-Prussian war in July 1870, and stayed there during the siege of Paris and its aftermath, the Commune. His views of these tragic events were partly recorded in published lithographs which will be discussed shortly. He was therefore a 'real' member of the 'Committee of Artists', to which he was elected on 17 April 1871, during the Commune.[14] Just what this committee was able to achieve, in the light of the disputed evidence about Courbet's influence, or lack of it, on the Commune's decision to demolish the Vendôme Column, is not clear.[15] Be that as it may, the fact that Daumier chose to stay in Paris (he could have retreated to his cottage in Valmondois) is evidence enough of his commitment to the Commune's cause, whether he approved of their material actions or not.

Millet, like many other artists, had left the Paris region altogether at the outbreak of hostilities, taking refuge in Cherbourg. He simply regarded the war as a natural disaster, and regretted that he could not afford to go to England. He found the Cotentin area heavily defended against the Prussians, and wrote that it was impossible to draw out of doors, or he would be cut up or shot![16] He was informed of the peripatetic progress of the French government by letters from Sensier who, as a civil servant, followed it and wrote successively from Tours, Bordeaux and Versailles during the war and during the life of the Commune. Millet deplored the Commune, and those who wanted to stay on the barricades: 'Ce qu'ils nous dit sur *l'héroique défense de Paris* [*sic*], prouve que là comme partout ailleurs (à peu d'exceptions près) le patriotisme est tué. O que nous sommes devenus un pauvre peuple! . . .'[17] (In the depth of this feeling he may not have been so far from Daumier's position.) In the same letter he writes of a young man called Piton, who was engaged to his daughter, being in danger of arrest as a deserter from the French army (not an uncommon situation at that time). This young man, whom he regards as a nice boy, is a source of anxiety to him, notwithstanding some indignant evidence from Sensier that he had strong socialist convictions.[18] It was the artists of the Commune against when Millet really fulminated: '. . . quels miserables que tous ces gens là! Courbet est Président bien entendu'.[19] Later he referred to them as vandals and criminals: 'O les monstreux scélerats! Ce pauvre Delacroix, qui tenait tant à faire ses peintures dans les monuments publics! Que dirait-il?'[20]

These were doubtless fairly generally held sentiments at that time, just after the 'bloody week' of the fall of the Commune, and the accompanying destruction of many buildings and monuments during the fighting, but they also reflect Millet's particularly sensitive level of response.

160

Daumier began to publish lithographs on political subjects again in 1866, and from then until the collapse of Napoleon III's Empire in 1870 he showed himself to be aware of every nuance of political and ecclesiastical affairs, through mordant and succinct cartoons. He understood the meaning of the North German Union, led by Prussia, and he foresaw that Europe was on the brink of war. He did not believe in Napoleon's ability to keep the peace by precarious diplomacy – 'Europe', an allegorical female figure reminiscent of '*La Liberté*' in 1848, and now synonymous with 'Peace', was drawn balanced on a smoking bomb – and he saw the 1867 Exposition Universelle as an expedient to bring commerce to France while disguising her great military expenditure. In a cartoon, published on 14 February 1867, a personification of Mars is shown standing in front of the Exhibition entrance, on which a notice reads 'MARS n'entre pas ici'. The legend has Mars comment: 'Bah! Je ferai le grand tour!' (I'll do the Grand Tour then!). It cannot be established that Daumier wrote the captions for these images, or to what degree he was in consultation with his editor. We can only observe that Mars appeared again at the end of March 1867, talking to a man wearing a coat and muffler, saying, 'If you find spring very cold this year, you will perhaps find it very hot next year.' A simple thought but it seems sharp enough, with hindsight, considering the confrontation with Germany that was to follow. On 4 June, 1867, when the Exposition Universelle had just opened, Daumier drew a lithograph of two railway engines rushing towards each other on a single track, as a metaphor for this. And once more, as had happened in 1834 and 1851, some of Daumier's most pessimistic and sarcastic lithographs were suppressed by the censor. One such print, which is now extremely rare, shows Death, wearing a tricorne hat, driving a locomotive with a skull and crossbones on it, apparently a reference to the exhibits which showed progress in steam locomotives. The caption, *Madame déménage*, could be translated as 'Death gone mad', or alternatively, 'Death is on the move'.[21] All this suggests that Daumier was fully aware of the state France was in, and fully committed to preventing a disaster. He failed to do so, of course. When war was declared on Prussia on 14 July 1870, he waited until Napoleon's army lost the battle of Sedan and the Third Republic was declared before producing a lithograph celebrating the workers who were now going to defend Paris, which shows them marching past a statue inscribed *FRANCE*, and carries the legend 'Those who are about to die salute you!'.[22] During the siege of Paris that winter he produced a series of lithographs which were first published in *Charivari* and then collected into an *Album du Siège*, produced jointly with his colleague Cham.[23] Daumier's contributions include the ones captioned *L'Empire, c'est la paix* (an ironic reference to Napoleon's slogan of 1851), showing a cityscape in smoking ruins (Fig. 10.1);[24] *Moi, je suis ravitaillé . . . La reste m'est égal*, which is pure satire on a fat bourgeois sitting down to a good meal just before the German token occupation of Paris;[25] and *Ceci a tué cela*, which is a reproachful reference to the national referendum of 8 May 1870, when Napoleon had gained a vote of confidence from a majority of the people, largely due to the provincial vote (the Parisian majority had been against him).[26] These examples may help to show why, politically, Daumier threw in his lot with the rebels – the Paris Commune – against the Versailles government. What this meant to him at a personal level may be deduced first, from a look at a few of his lithographs produced during the siege, and during and after the Commune, and then at some of his drawings and paintings that may have been produced during the years under discussion.

L'Empire, c'est la paix! (Fig. 10.1), drawn during the early weeks of the siege of Paris, following upon Napoleon's defeat in northern France, represents an anonymous city of ruins whose forms repeat each other into the distance, like the pyramidal shapes of crumbling Mayan temples. The shadowy pile of stones in the

10.1 Daumier. *L'Empire, c'est la paix*! Lithograph, published in *Charivari*, 19 October 1870 (LD 3814).

161

10.2 Daumier. *Pauvre France!...le tronc est foudroyé, mais les racines tiennent bon!* Lithograph, published in *Charivari*, 1 February 1871 (LD 3843).

10.3 Millet. *The Carrefour de l'épine, Fontainebleau Forest.* 1866–7. Pastel, 48 × 62. Dijon, Musée Beaux-Arts (Collection Granville).

10.4 Millet. *The Sea from the Heights of Landemer.* 1866–70. Pastel, 48 × 61.5. Reims, Musée St Denis.

foreground forms a *repoussoir* for the viewer's eye, which is directed diagonally into the scene of desolation along the line of a broken piece of wood, which projects from the rubble like the barrel of a gun. Just beyond this, in the illuminated area, lies the dead body of a young woman, and beyond her a male corpse rendered like a primitive stick-figure. A spiral of black smoke projects forward from the background like a great baroque cloud, as full of foreboding as the one in Fragonard's famous academy reception piece *Coresus and Callirhoe*, which was probably still on display in the Louvre at this time. The movement across the spaces in this design is thus continuous and endless, as one's eye moves restlessly back and forth looking in vain for a centre of repose. The black rectangle of the empty doorway in the centre is quite unrewarding in this respect. Daumier's message in this lithograph is conveyed with extreme simplicity, even crudity, of means, and is thus immediate in its effect – an effect of hopelessness – and the art with which his modest symbols are put together is cleverly concealed.

More 'landscapes' of desolate wastes of rubble and nightmarish fields of laid-out cadavers followed in the ensuing months, all drawn with the same grim economy of means. Then, just after the siege was raised by the Germans and the armistice signed, with the French government still keeping to the safety of Bordeaux, Daumier drew his lithograph published on 1 February 1871, *Pauvre France! . . . le tronc est foudroyé, mais les racines tiennent bon!* (Fig. 10.2). This simple patriotic gesture took no account for the time being of the repressive measures taken by the government against the Republican elements in Paris. The shattered trunk of the tree, with a few leaves growing on its last remaining branch which signifies that its roots are still living, is blown by the winds of what looks like an electrical storm in the sky above. The landscape betrays no trace of human habitation: only a cliff-like space is implied behind it, that looks out on a dark grey sea of the consistency of a flat sheet of lead. The symbolism of the one living branch in an old tree was, of course, commonplace (remember that these images were meant to be understood by as many people as possible). It had fairly recently been the subject of a large pastel by Millet, *Le Carrefour de l'épine* (Fig. 10.3), drawn for his patron M. Gavet. The subject is a partly cleared area in the forest of Fontainebleau, with the fallen tree in the foreground pregnant with symbolism about the last years of life. The source of this image goes back to seventeenth-century Dutch landscape art, in this case filtered through the experience of the pantheistic imagery of Théodore Rousseau, to whom Millet was particularly close at this epoch. His manipulation of the strokes of black and coloured crayon to evoke different things in the spectator's mind – substances, texture, movement, even a sense of moisture – has been admirably analysed by Robert Herbert.[27] In the distance, emerging from the forest, are two of the faggot gatherers whose existence seems to have haunted Millet since his first arrival at Barbizon.

The sadness evoked by Millet's pastel of the dying tree carries no urgent message like that in Daumier's lithograph, although it offers no great celebration of the 'progress' demonstrated by the Exposition Universelle of 1867 either. Such an aloof, sublime form of contemplation is found again in a later pastel of *The Sea from the Heights of Landemer* (Fig. 10.4), executed while he was sitting out the war in Cherbourg during 1870–1. Since his visit to the Auvergne when he discovered new dimensions of space that seemed to reflect his spiritual condition, Millet had shown a penchant for high viewpoints giving on to the infinite expanse of the sea, as here. (The sea in Daumier's lithograph *Pauvre France!* has a similar existential effect.) As in his oil paintings of this late period, the colours are very pure and fresh, even though they are of limited variety; several bright blues and greens, heightened with white on buff paper, and warmer colours in the foreground with precisely drawn details of rocks and scrub.

Si les ouvriers se battent, comment veut-on que l'édifice se reconstruise?

10.5 Daumier. *And if the workers fight amongst themselves*.... Lithograph, on original page from *Charivari*, published 17 May 18722 (LD 3925).

10.6 Daumier. *Vous n'avez pas besoin de me rappeler les titres*...(*You have no need to remind me about the title deeds*...) Lithograph, published in *Charivari*, 1 November 1871 (LD 3888).

— Vous n'avez pas besoin de me rappeler ses titres, je les ai tous les jours sous les yeux.

Before considering more examples of Millet's work at this period, we should finally clarify Daumier's position within the Commune, when he was effectively cut off from all communication with his friends in the outside world. The rebels closed the gates of Paris between 28 March and 25 May 1871, and formed their own government to run the city from the Hôtel de Ville.[28] *Charivari*, which had briefly returned to normal circulation in France on 6 March after 'un blocus de cinq mois', as it reminded its readers, suspended publication between 21 April and 12 June, evidently badly shaken by events. Daumier, as has been noted, took some part in the Paris Arts Commission, headed by Courbet, and he produced no more lithographs until 12 July. When *Charivari* recommenced, it published a series of lithographs by Cham, 'Les Folies de la Commune', but Daumier did not contribute to this. His few specific comments on the workers' struggle – which was what the Commune was all about – suggest that as far as fighting was concerned, he was a pacifist.[29] His principal themes during the war had been death and starvation and ruins. After the armistice he devoted a number of prints to ridiculing the 'theatre of Bordeaux', i.e. the French Assembly held there under the leadership of Thiers. He remained ferociously anti-clerical: after the token occupation of Paris by the German army was over, Daumier produced a lithograph showing a procession of Catholic priests in shovel hats marching in while the Prussians marched out. The caption was 'One invasion replaces the other'.[30] The peasant and the urban worker, amalgamated into a single, proletarian figure in the last lithographs, wearing rumpled trousers, waistcoat, and a kerchief on his head, and usually carrying a spade, appears as a bewildered dupe of the events that have taken place. One peasant regards his roofless farmhouse, saying 'So this is what I voted "yes" for'.[31] Daumier must have been fully aware of the weaknesses inherent in the endless debates in the workers' clubs and committees in Paris during the Commune and the dangers of factional struggle. A lithograph produced in May 1872, with the caption *And if the workers fight amongst themselves, how can they hope to reconstruct society*? (Fig. 10.5),[32] seems like a retrospective comment on the previous year. Daumier was better at drawing first-fights than military engagements, and the raw vigour of this punch-up in a mason's yard is characteristic of his late lithographic style.

In fact, Daumier's late lithographic style has a distinct coincidence with his late style in drawing generally. A vigorous but wandering line with few straight directions and little pretensions to rendering volumes, it snatches the viewer's eye, as it were, into action with it. When, in the autumn of 1871, he produced a spectre of Robert Macaire, who quickly acquired a club and a Napoleonic moustache which merged into another spectre, that of Ratapoil, he confronted his new creation directly with another, that of the worker-peasant.[33] And now Ratapoil is not quite on top of the situation. A man with a spade, apparently about to dig into the foundations of a new world, holds out his arm and says to the surprised, top-hatted Ratapoil, 'You have no need to remind me about the title deeds, I have them under under my eyes every day' – pointing to the ruins of his house (Fig. 10.6). The lines that describe this simple encounter vibrate and interlock. These are among the last lithographs that Daumier drew. I am not at all sure that they are his last drawings *per se*, however, nor that his sight deteriorated so suddenly as his biographers imply. He had, after all, no longer any need to support himself by cartoons at this point in his career. They appear to be, rather, the last statements that he chose to make about public life. What he chose is significant. In July 1872 the cleric in the shovel hat, who now needs a crutch to support him, commiserates with an equally decrepit Ratapoil (Fig. 10.7). They are no longer in any real space – just silhouettes on a misty horizon. Finally, an unpublished lithograph, traditionally supposed to be Daumier's last, shows a vituperative crowd advancing on the doors of the trial of Marshall Bazaine.[34]

Et ces deux laids débris se désolaient entre eux.

YVES & BARRET Sc

CONSEIL DE GUERRE

LES TÉMOINS.

10.7 Daumier. *Et ces deux laids débris se désolaient entre eux*. Lithograph, published in *Charivari*, 3 July 1872 (LD 3935).

10.8 Daumier. *Les Témoins*. Lithograph, unpublished. Reproduced from A. Alexandre, *Daumier* (1888), with inscription *Actualités* (1873).

They are represented as vengeful skeletons of victims of the war, not only soldiers but also a woman leading her child by the hand, strangely reminiscent of the pair that Daumier had drawn shopping in the market-place (Fig. 10.8).

There are no such direct interpretations of contemporary events to be found in the work of Millet. Nevertheless, if we allow ourselves to think of landscape as a new mode of symbolic communication in his late work, certain *rapports* with Daumier's position begin to appear. The beautiful but strangely pessimistic image of the *Carrefour de l'épine* pastel (Fig. 10.3) sums up a number of his associations with the forest of Fontainebleau, one of the three landscape locations most personal to him. His associations with the mountainous area of the Auvergne were of a different order, as noted in Chapter 8 (pp.133–4). The comforting inviolability of his Auvergne shepherdesses on their steep hillsides, surrounded by equally intrepid sheep and goats, is perhaps used as a symbol of maternal balance found in nature, under such primitive conditions. They are also 'comforting' because, being a manifestation of old and unchanged traditions, they seem far away from the troubled and menacing facts of modern life, of which Millet, being no fool, was certainly materially aware. Yet the precipitous gorge which yawns to the left and behind the seated shepherdess in the pastel illustrated here (Fig. 10.9) does, after all, present some symbol of danger, even if she seems unaware of it. Indeed such a juxtaposition is slightly surreal, dreamlike, in its menacing suggestion.[35] There is a similarity here in mood with the pastel of *The Sea from the*

10.9 Millet. *Pâturage Auvergnat. c.*1867–8. Pastel on grey wove paper, 47 × 56.2. Helen Clay Frick Foundation, Pittsburgh, Pa.

Heights of Landemer (Fig. 10.4), where the viewer is also placed on a vertiginous height, and in the sharply hatched, hard forms of the exposed rocks in the middle distance. Since Millet reported from Cherbourg that it was dangerous to be seen drawing outside, while the Franco-Prussian war was in progress, the probability is that this pastel was executed the following summer, in 1871.

A painting that Millet exhibited at the Salon of 1870, *Novembre*, was surely an outstandingly bleak and pessimistic image, although it was much admired by Alfred Sensier in his Salon review.[36] Bought by the Belgian collector De Knyff, and unfortunately destroyed in World War II, it was the largest landscape painted by Millet (92 × 140 cm).[37] Its subject was a bleak and wintry landscape like *The Harrow* (*L'Hiver aux Corbeaux*) of 1862, but with a rising hillside at the top of which a figure is seen in silhouette. A small drawing for it in black chalk (Fig.

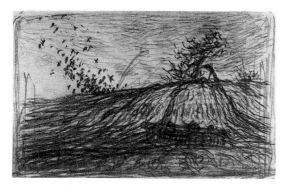

10.10 Millet. Composition study for *Novembre*. *c*.1869–70. Black chalk, 13.3 × 20.25. Paris, Louvre, Inv. RF 5776 (GM 10,438).

10.11 Millet. *Le Coup de vent. c*.1871–3. Oil on canvas, 90 × 117. Cardiff, National Museum of Wales.

10.12 Millet. Study for *Le Coup de vent. c*.1870–1. Black chalk, 19.9 × 30.4. Paris, Louvre, Inv. RF 11,302 (GM 10,697).

10.10) sums up the whole idea of this picture in a graphic shorthand. The furrows of the ploughed field, the abandoned harrow, the slanting lines of crosses on the left signifying birds, and similar crosses on the right signifying bare tree branches: all these are clear, and the only thing the viewer needs to be told, I think, is that the black, angular figure beneath the tree is a farmer shooting at the crows. Now if we compare this small but quite complete sketch with a Daumier lithograph like *Vous n'avez pas besoin de me rappeler les titres . . .* (Fig. 10.6), it should be seen that although the 'handwriting' is different, the drawing language is the same in their late styles. Everything is expressed, mood and message equally, by the character of the lines that scuttle across the page like interconnecting waves of energy. Nobody could pretend that the message is not intended to disturb, in either case.

More overtly symbolic in content is Millet's painting known as *Le Coup de vent* (Fig. 10.11). The painting was given this title when it appeared in Millet's studio sale after his death in 1975,[38] but its subject is plainly La Fontaine's Fable, *The Oak and the Reed*. The oak is represented at the moment of being torn out by the roots by a great gale of wind, while reeds are blown flat against the water of a pond in the foreground. This very authentic-looking landscape must be a hillside above Gruchy. In the distance, seen against a Rousseauesque evening sky glinting with fiery gold, are the roofs of a village, and between us and them a shepherd urges his flock of sheep down a slope, hurrying them out of danger. The topicality of this image of the uprooted oak, if it was produced in the winter of 1871, is directly comparable to Daumier's use of the broken oak tree image in *Pauvre France!* (Fig. 10.2), and it is perfectly possible that Millet had a similar association in mind, subjacent to his literary theme. In a preliminary drawing for this painting (Fig. 10.12) the essence of the subject is condensed to linear expression, the lines themselves seeming to be swept and scattered across the paper by a gale, some in long and some in jagged strokes. The shepherd of the painting can hardly be seen in the drawing, although the sheep can, because his form is merged with loose tree branches by lines reminiscent of flying rope.

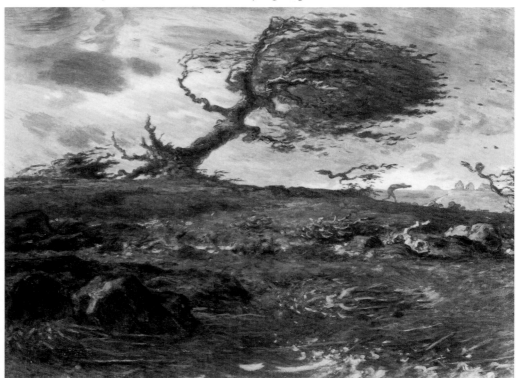

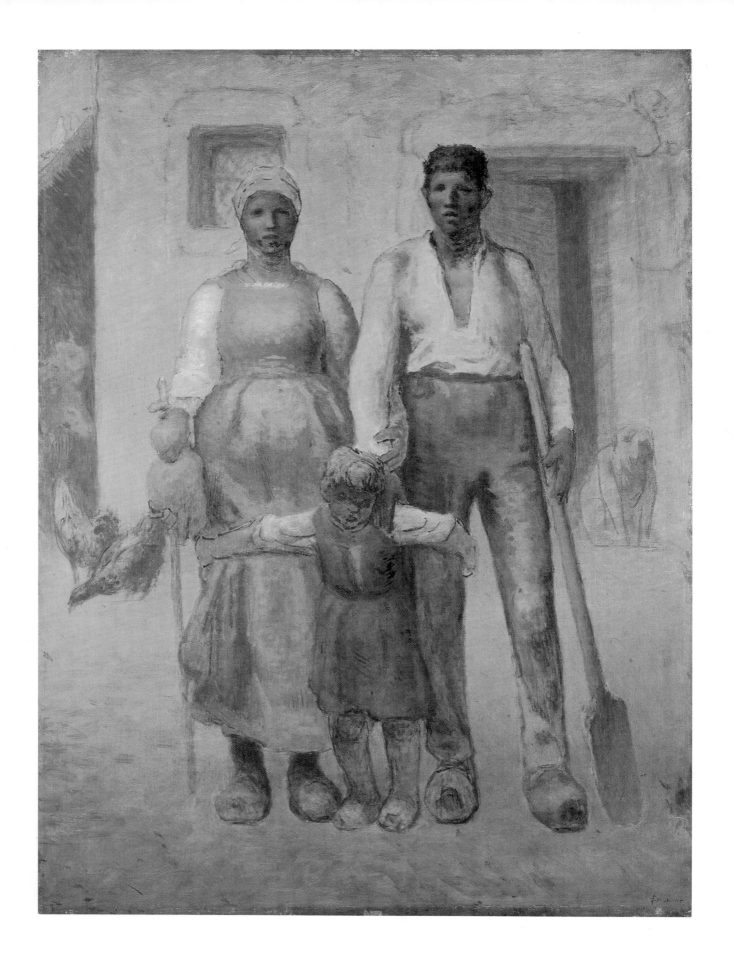

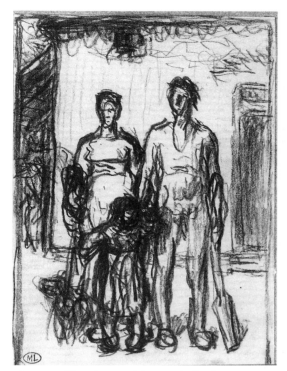

10.14 Millet. Composition study for *Peasant Family*. *c.*1870–1. Black chalk, 12.7 × 8.4. Paris, Louvre, Inv. RF 5817 (GM 10, 460).

10.13 Millet. *Peasant Family*. 1871–2. Oil on canvas, 111 × 80.5. Cardiff, National Museum of Wales.

Such landscapes are plainly intimations of disaster, and there is a dichotomy between such imagery and many of Millet's late pictures of peasants, which convey not so much nostalgia as a stoical capacity for survival in an unstable world. One of these, *Peasant Family* (Fig. 10.13), is almost a propaganda piece for the latter point of view. It is an unfinished canvas, with a pseudo-iconic image of a Norman peasant family standing in front of a stone farmhouse, with door and windows exactly like the cottages in Millet's birthplace in Gruchy. Herbert thinks that this canvas, begun in 1870 or 1871, might be an act of homage to his sister, Émilie, and her husband, who both died of typhoid at Gruchy in 1866. He traces the evolution of the design from a graceful drawing related to one of the studies for *Summer* (see Fig. 6.27) to what he correctly calls the 'chunky primitivism' of the present picture.[39] The sense of an incised sculptural mass, conveyed by the contours in this canvas, comes from their uncompromisingly angular forms: the woman's face and the man's left clog, for example, are each rendered as multi-faceted prisms, seen head-on, like cut diamonds. They are, in fact, drawn on the canvas as very clear and self-sufficient lines, some probably in black chalk and others in black paint. The whole painting, at this interim stage of its execution, is basically a drawing filled out with tones for modelling and some local colours applied on top. This same combination of drawing and painting systems will be found in Daumier's canvases quite often. In a little composition drawing for this subject (Fig. 10.14) the contour lines are less definitive but there is more linear movement, giving an effect as though Millet were chipping away at a piece of wood with a pocket knife. Adjectives like 'sharp', 'hooked', and 'blunt' come to mind to describe these lines, and this may have been exactly how Millet felt about his peasant ancestry.[40] (Compare Daumier's man leaning on a spade in Fig. 10.6 – his lines have more flow, but they also employ some sharp turns and hook-shapes to convey the message.) Again this painting was conceived at a time when the French social system, as Millet heard and read about it in Cherbourg, was being threatened at its very roots by current events in 1870.

How should we now define Daumier's later works, the ones done in his studio for his private patrons, outside his work for the journals? There is a generally agreed 'late drawing style' of his that can be recognised by its almost excessive freedom of touch (E.H. Gombrich once described Daumier's drawing process as pulling images out of 'clouds of lines' analogous to clay under a modellet's hand,[41] and a corollary can be found in the free linearity of the brush strokes of his last paintings. However, definitions of that kind are not very useful unless they can be linked to some causal state in the artist's mind. Why, for example, should Daumier's paintings begin to resemble Fragonard's after 1869? Is the opening of the La Caze Gallery of eighteenth-century French paintings at the Louvre in that year sufficient explanation? It is true that Fragonard's style of doing things, in both drawing and painting and in his zest for life, may have come to stand for a certain hedonistic amorality in many people's minds, but if so why should Daumier respond to this at that time? Does it correspond with Daumier's subjects? The answer must be no, except in the case of his images of *saltimbanques* or travelling players at fairgrounds and street corners, whose associations are with a past age of joyous entertainment, repeated now in a shabbier, if still appealing, fantasy.[42] The great ' parades' of clowns on platforms outside the Paris theatres in which they performed, signalled especially by Pierrot beating on his drum, had taken place in the seventeenth and eighteenth centuries, and they just survived through the eras of the Revolution, First Empire and the Restoration. By 1828, however, in the words of Victor Fournel, the great clowns had 'stolen away', and what was left were popular street spectacles of a much more transient nature.[43] It

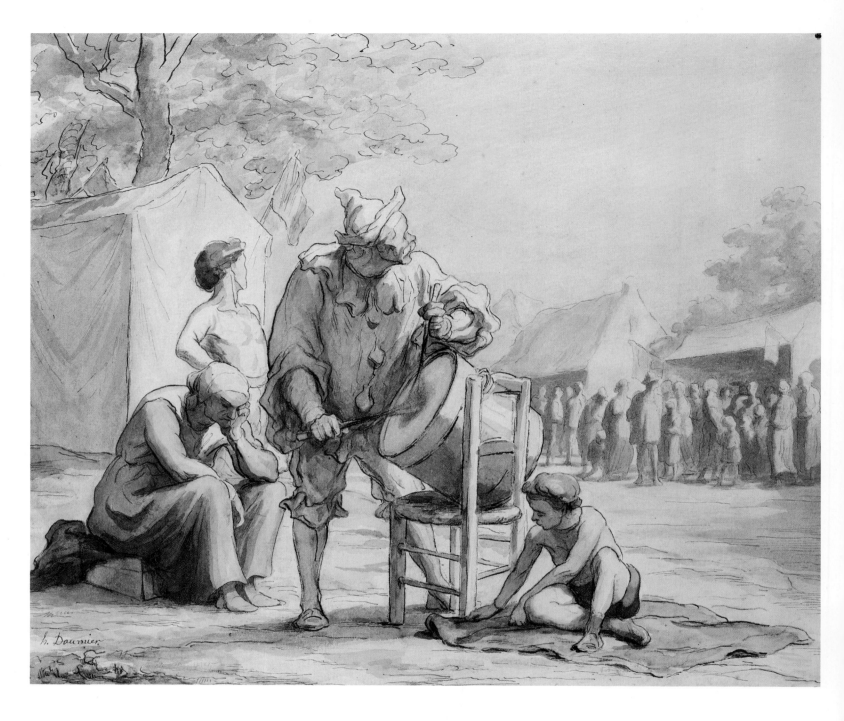

10.15 Daumier. *Les Saltimbanques. c.*1865–9. Pen and watercolour, 33 × 40. London, Victoria and Albert Museum.

is quite clear that Daumier based his drawings and paintings of such subjects on the lowest and poorest class of clowns, these being the ones who survived into the 1850s and 1860s.[44] Consider his watercolour *Les Saltimbanques* (Fig. 10.15). A family of these mountebanks are waiting by their tent on the perimeter of a fairground in the country. The father, dressed as Pierrot, beats his drum which is balanced precariously on a chair, trying to attract the attention of a crowd over by the stalls of the fair. The people in the crowd, comfortably dressed in smocks and other country clothes, seem to be chatting to each other and ignoring him. The elder son, an acrobat, also watches the crowd, but his younger brother seated on the mat is indifferent. Behind them sits the mother, her head in one hand, looking weary and resigned. This is a family of travelling performers whose accoutre-

170

ments and props had not changed for at·least half a century, to Daumier's certain knowledge. Compare the same outdoor act, recorded by Duplessi-Bertaux in his etching published in 1814, with the same chair and drum in one corner and the family act introduced by Pierrot (Fig. 10.16),[45] and consider the difference in the crowd that he portrays. These are soldiers and bourgeois citizens of the First Empire, provincial perhaps, but they are well to do, they watch with interest and they give money. Daumier knew full well the economic conditions of the *saltimbanques* he was drawing, and how in the 1850s they were moved on and harried by the police as vagrants, potentially dangerous to law and order.[46] Stylistically his watercolour should belong to the 1860s, in which case its message is nostalgic but also slightly ironic – these peasants over by the fairground stalls do not show any awareness of or need for the artist-performer.

Quite different, apparently, is the message of *Saltimbanques Leaving Town* (Fig. 10.17), where the artist-performers have literally packed their bags and are leaving the city, the near-naked boy on the left carrying a very small cash box. In the background, under the dark and cavernous walls of the city street, Daumier began to draw a faceless crowd in white chalk, then stopped. A real problem is posed here by the dating of this drawing, if its meaning is to be properly interpreted. K.E. Maison puts a painting with roughly similar subject matter as '*c*. 1847–50(?)', and both T.J. Clark and Paula Hayes Harper seem to go along with this for the date of the watercolour.[47] Yet apart from the convenient link with Daumier's 'refugees' theme of that epoch, I see no reason to place it so early. Its tragic import could equally look to the future, rather than the past, in terms of Daumier's own career as a public entertainer. That is to say, his reputation as a *caricaturist* was long since established, but was it, in the end, based on the type of entertainment he really wanted to put across? Perhaps the act he wanted to perform was at a 'higher', or simply more thoughtful level, *qua* artist. If so, this drawing, if it belongs to the 1860s, would now represent a 'true' record of people struggling to live on the fringe of society (and on the fringe of an economic boom, at that), and it would in a sense be the equivalent of Millet's drawings of marginal rural workers (see Fig. 6.24).

171

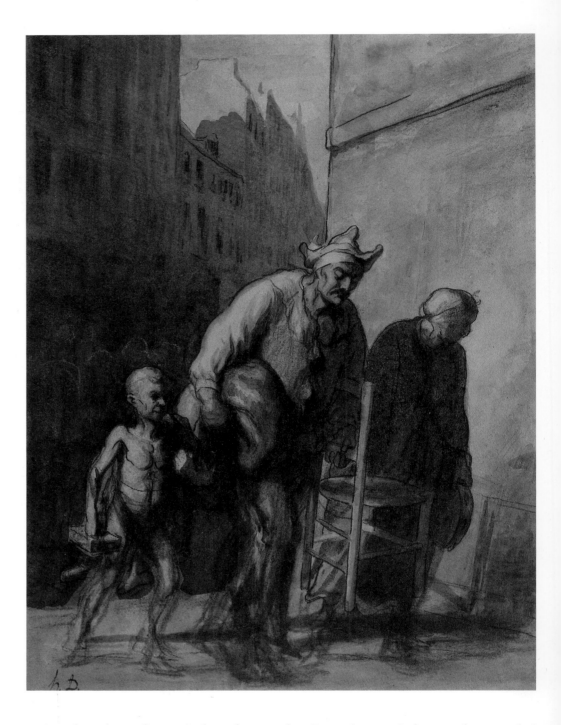

10.17 Daumier. *Saltimbanques Leaving Town.*
*c.*1865–9. Charcoal, black, white, and red chalks
and watercolour, 36.5 × 27.1. Hartford, Conn.,
Wadsworth Atheneum. The Ella Gallup Sumner
and Mary Catlin Sumner Collection.

Another class of marginal performer that Daumier not infrequently recorded
was the street musician, a perennial sight in big cities. He drew violinists,
hurdy-gurdy players and singers, people who seem to be associated with the
saltimbanques without being of their family. *The Street Violinist* (Fig. 10.18) is an
image of loneliness as much as it is about playing the fiddle. The sadness of the
man's expression dominates, although the shape and tension of the violin sloping
down towards us are marvellously realised. Could Daumier have worked this up
into any more elaborate and finished design? I do not know of any such. This
sketch looks more like the trace of a compulsion to record something
immediately seen, experienced and remembered. Once put down, the cathartic
record is done. Or so it would seem. Such an image, however, also rests upon a

172

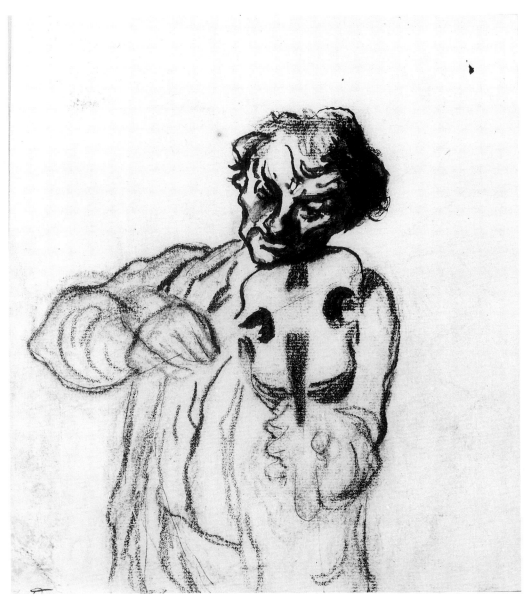

10.18 Daumier. *The Street Violinist. c.*1869–72. Charcoal, pen and brown wash, 21 × 17.9. (?) Coll. Señor Ernesto Blohm Venezuela.

10.19 F.r.Ingouf. *Charles Minart.* Early eighteenth-century. Engraving. Paris, Bibliothèque Nationale.

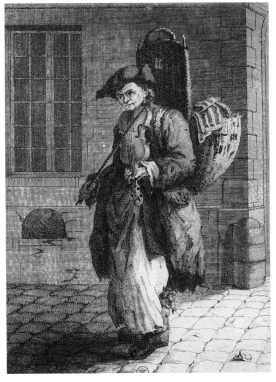

huge collective repertoire of such street singers. Popular art in France had abounded in such images since the eighteenth century, and they are included in the various collections of '*Cris de Paris*' that had proliferated by the time of the Restoration.[48] One such print, not one of the 'Cris' but of the same genre, is the record of an apparently well-known street singer and song seller called Charles Minart, in an eighteeth-century engraving (Fig. 10.19). He is represented in rags and tatters, playing at the corner of a cobbled Paris street, and he is as self-absorbed and trance-like in his expression as the character in Daumier's drawing. Even Daumier's most spontaneously produced sketches, then, by virtue of being drawn from memory, may also be the result of a collective memory of the past which he was somehow able to share.

The *saltimbanques*, then fast disappearing from the streets and the fairgrounds of the city, were part of this popular heritage which Daumier utilised all his life. He had used the image of a 'parade' of *saltimbanques* in a lithograph for *Charivari* as early as 1839,[49] and it goes on recurring in scribbles and sketches until his very last drawing style. He also represented them in some quite highly finished

173

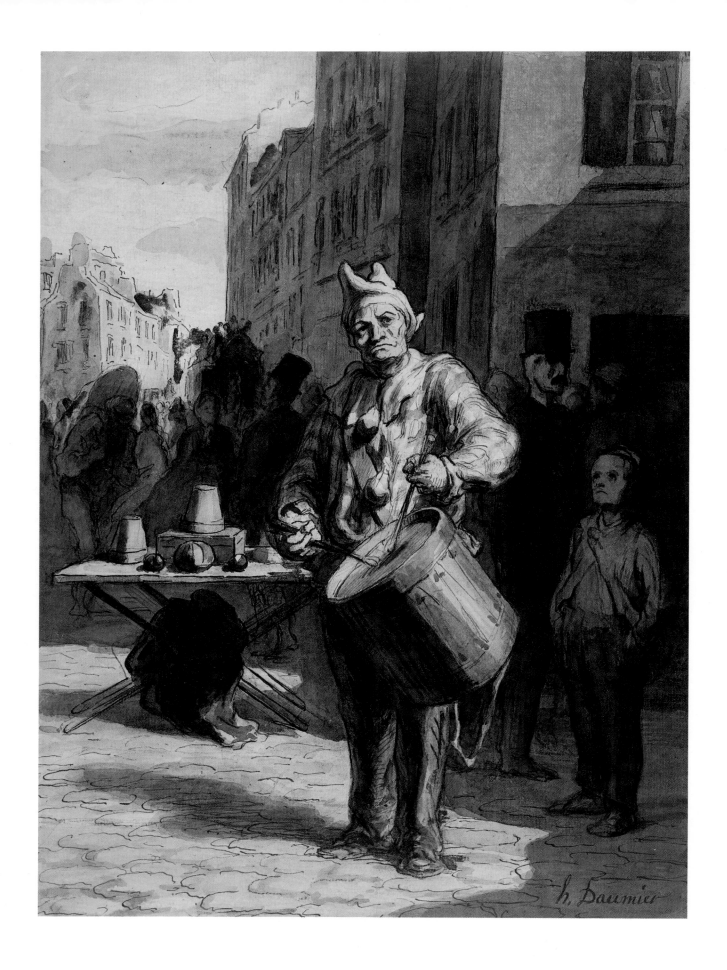

h. Daumier

10.20 Daumier. *Mountebank Playing a Drum*.
c.1865–9. Black chalk, pen watercolour and
gouache, 35.5 × 25.5. London, British Museum.

watercolours, produced for amateur collectors of the kind mentioned at the beginning of this chapter, which should date to the end of the 1860s. One of the finest examples of these is *Mountebank Playing a Drum*, from the de Hauke Collection and now in the British Museum (Fig. 10.20). Here the *saltimbanque* is drumming up a crowd prior to his performance as a *escamoteur* or juggler and sleight-of-hand artist. The traditional props of this trade are on the table behind him: notice the red, white and blue balls and the upturned cups which he will place over them. The performance was counted as another of the *Cris de Paris*, as recorded in Carle Vernet's prints of 1815.[50] But notice most of all the expression of Daumier's mountebank. He stands with his back to a retreating crowd and stares straight at us, the viewers. For whom is he really banging this drum? In the deep shadow to the right (as deep as that in *Saltimbanques Leaving Town*) a top-hatted bourgeois passes by, ignoring him. Also in the shadow is the street urchin, whom we noticed in Chapter 4 (Fig. 4.4), making dark remarks about the bourgeois in 1847, on the eve of a Revolution. Daumier's types do not change but here the context has. The urchin seems intrigued by what the drummer is doing and, it is possible to infer, by what he might portend. I believe this finely executed but grim image was produced on the eve of the Franco-Prussian War, and that the state of things which it projects – including the retreating coach full of revellers disappearing round the corner – is not intended to be an optimistic one for any of the classes (including the street porter with his pannier on the left) who mingle on this Paris street. But it has none of the blunt political commentary of his lithographs. Instead the viewer is allowed to be seduced by the beautiful decorative tints – bright blues and reds, patches of pale yellow and pink – in the area where the drummer stands in full sunlight, and to marvel at the controlled mixture of black crayon lines, pen and layers of grey watercolour washes that make up this design. This technical virtuosity is Daumier's equivalent of Millet's acquired mastery of pastel during the same period. Daumier's later techniques are in fact more traditional than Millet's, and no stylistic comparison is possible between them at this time. In fact, they contrast. What continues to distinguish them from their contemporaries, however, is the nature of their motivation. Daumier's *Mountebank Playing a Drum* may have been executed to please a connoisseur of style, but its content was also intended to arrest his attention.

Millet's commission for his last series of paintings of *The Seasons*, from Frédéric Hartmann, was mentioned at the beginning of this chapter. He did not really get going on this commission until after the Franco-Prussian war, but he managed to finish *Spring* (Paris, Louvre) in 1873, *Summer* (Boston Museum of Fine Arts) and *Autumn* (Metropolitan Museum, New York) for his client in 1874, the year before his death. The subject of *Winter* did not get completed, but Hartmann got hold of the canvas anyway, and it eventually found its way into the great modern collection of Henri Rouart,[51] where it acquired the title *Les Bûcheronnes* (Fig. 10.21). I use the phrase 'great modern collection' in a sense relative to the period when it was collected. Perusal of the catalogues reveals that from the 1870s the major Realists, to the avant-garde collector, were equated with the rise of Impressionism – rightly or wrongly – and that equally prominent in the former category were Daumier and Millet. Most significant is the fact that 'unfinished' works like Millet's *Les Bûcheronnes* were considered eminently collectable. It is reproduced here as the most compelling of his series of the *Seasons*, at least to modernist or even postmodernist eyes, possibly because in this state it strips the narrative element of the scene down to its raw essentials. The broad flat areas of dark colouring (the forest is a murky black) are relieved only by a splash of light pink on the second figure's skirt.[52] The expression of slow, painful movement by thick, heavy contours, and the blank faces, seems to foreshadow twentieth-

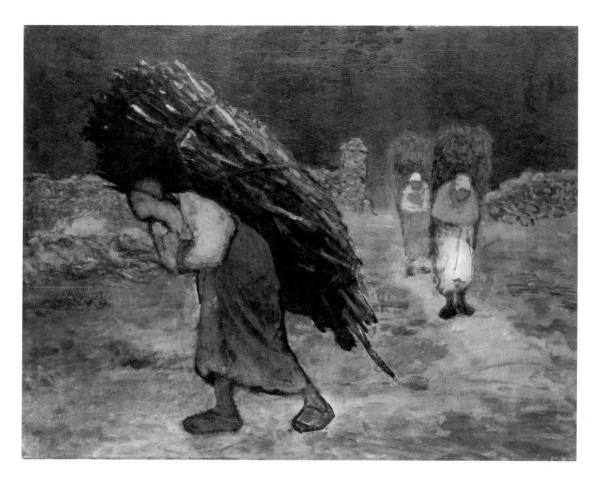

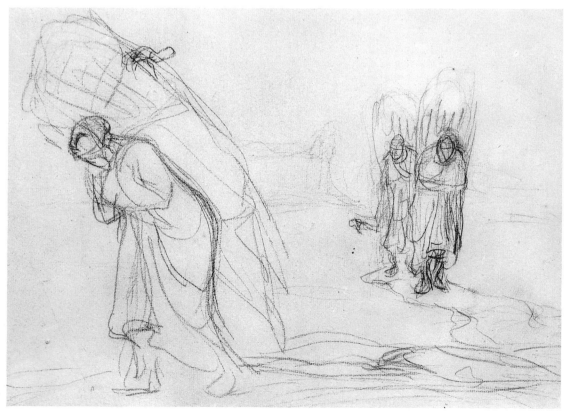

10.21 Millet. *Les Bûcheronnes (The Faggot Gatherers)*. 1868–74. Oil on canvas, 78.7 × 97.8. Cardiff, National Museum of Wales.

10.22 Millet. Composition study for *Les Bûcheronnes. c.*1868–70. Black chalk, 30 × 42. Paris, Private collection.

century expressionist art. These women are ghostly apparitions of Millet's twenty-year obsession with the most primitive of forest trades: no text is needed now to explain their symbolic emergence from the dark. This kind of reductivism is the counterpart, in style and expression, of Daumier's images of Don Quixote in his late period, many of which are also faceless. A composition study for *Les Bûcheronnes* (Fig. 10.22) summons up the image with even more brutal immediacy. The three figures are joined up by continuous flowing lines which are as expressive as they are descriptive (like the drawings which Edvard Munch would produce in the 1890s). The impact of this drawing is strongest when looked at in conjunction with the painting, for which it isolates a single, linear element.

 Millet's habit of drawing on canvases with his brush, in his late works, has been mentioned more than once. He also drew contours on some canvases using a pen. His purpose seems to have been not merely to define the areas within which to place his colours, but also to initiate what he would surely have called the *force* of his first idea. (Like Daumier, he was always quite prepared to paint through and across such contours at a later stage in the picture.) That he should finally settle on line as the best means of conveying the strengh of his idea, and this notwithstanding a highly developed sense of colour by the end of his career, is of some significance to understanding his art. Line is used to structure, and in some instances even to destructure, his last works. The last example I shall discuss here is *Hunting Birds with Torches at Night* (Fig. 10.23). It is perhaps the darkest of all Millet's images of pessimism. A most appropriate place to see it (as I did for the first time) is in the basement storage room of Philadelphia Museum, by tungsten light, for the most dramatic effect of its flame-coloured yellows against the deepest chiaroscuro. This brilliantly conceived picture is an imaginary reconstruction of a memory that Millet had had since his childhood in Normandy, when such events still took place. ' . . . we used to go with torches, and the birds [wild

10.23 Millet. *Hunting Birds with Torches at Night* 1874. Oil on canvas, 73.5 × 92.5. Philadelphia Museum of Art.

10.24 (Diderot, ed.) *Encyclopédie, Plates*, Vol. III (1763), *Chasses*, Plate XIV, Une chasse de nuit. Engraving.

177

10.25 Millet. Study for *Hunting Birds with Torches at Night*. 1874. Bistre wash, 9 × 13.7. Paris, Louvre, Inv. RF 11,304 (GM 10,700).

pigeons], blinded by the light, could be killed by the hundred with clubs', he told a visitor to his studio.[53] There are a number of preliminary drawings and *croquis* for this subject, one of which, a bistre wash drawing in the Louvre, is illustrated here (Fig. 10.25). Executed with what seems to be a reed pen, these spiky lines build up a pattern of strokes like those of a Chinese calligrapher. Each line acts upon the next to produce an effect of restless agitation. This pattern is repeated and enlarged in the flickering yellow lines in the painting, transforming the scenario of leaping men and scrabbling children on the ground into a frenetic nightmare of mankind's capacity for mass slaughter.

To get the whole picture of Millet's art, some balance has to be struck between imagery such as this and the heroic simplicity of works like the *Peasant Family* (Fig. 10.13). He might have achieved more paintings in the latter vein had he lived to accomplish his commission, given in 1874, to produce murals of the Life of Ste Geneviève for the Panthéon.[54] However, his health declined rapidly, and after several months of illness, and just a few days after the terrible noise of a deer being killed by hunters on the property next door to his had upset him,[55] he died in the village of Barbizon on 20 January 1875.

10.26 Daumier. *The Connoisseur. c.*1860–5. Black chalk, pen, wash, watercolour and gouache, 44 × 35. New York, Metropolitan Museum.

Although Daumier suffered the tragedy of going slowly blind at the end of his life, his last years were relatively more peaceful than Millet's. After the defeat of the Commune he retired entirely from the public eye, even refusing a renewed offer of an official decoration towards the end of his life, though he did not refuse a State pension. In the 1870s his 'fine art patrons' were the connoisseurs who had discovered him in the 1860s, and although this following was probably never

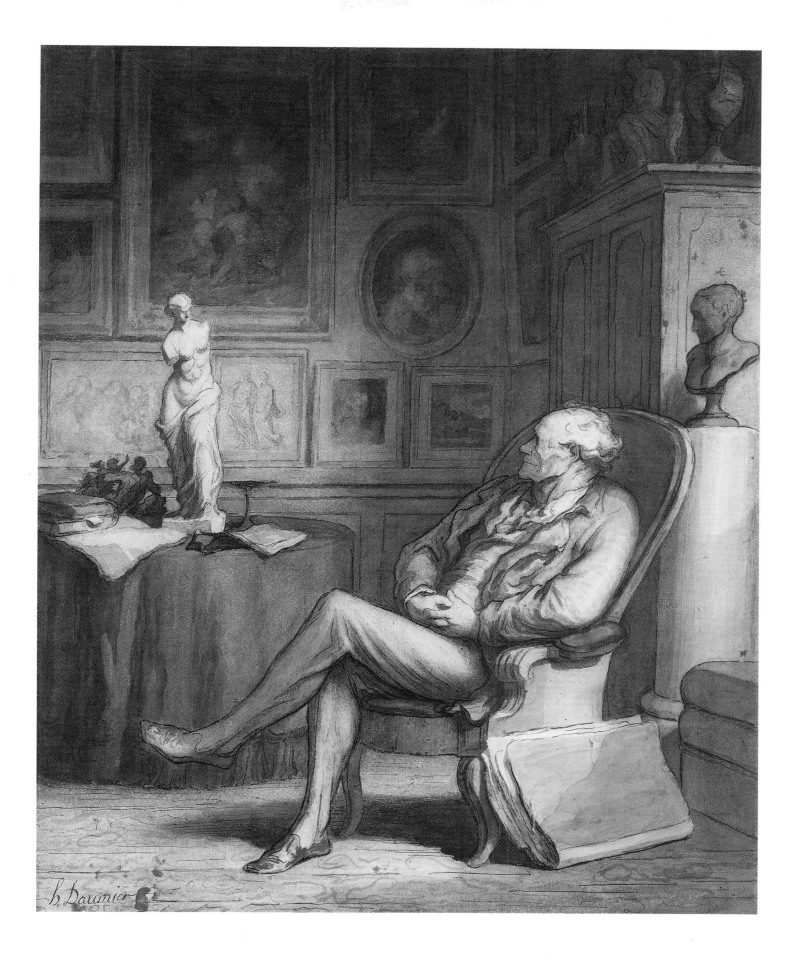

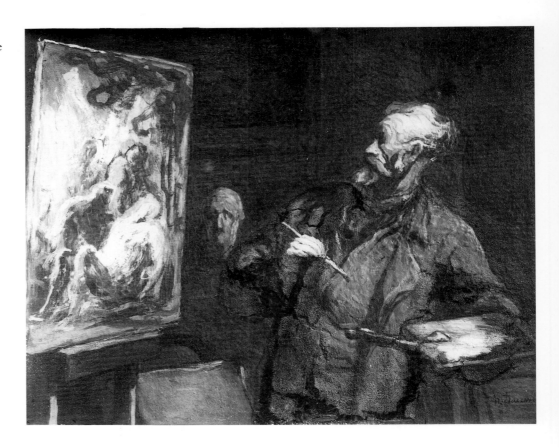

10.27 Daumier. *The Artist*, or *Mise en tombeau*. *c*.1868–70. Oil on panel, 26 × 34. Reims, Musée de Beaux-Arts.

large, he was well enough esteemed for a group of them to join with some leading republicans (who were interested in Daumier from other motives) in persuading Durand-Ruel to risk setting up a Retrospective Exhibition, which was held at his gallery in the rue le Peletier in the spring of 1878. This contained 94 oils, 139 watercolours and drawings, the two reliefs of *Les Émigrants*, the 34 coloured clay busts of Parliamentary Deputies of 1831–2, and five separately framed lithographs, four of which were from the Association Mensuelle series of 1834.[56] In addition, there were twenty-five other frames for holding lithographs, the contents of which were changed twice a week. The emphasis of the show, therefore, was on Daumier as artist-painter rather than as artist-lithographer: the thrust of it was to immortalise Daumier for his art rather than his politics. However, as Michel Melot has dryly remarked, 'the public did not recognise this immediately'.[57] Durand-Ruel recorded that the exhibition was 'not a success with the public',[58] meaning that there were not many visitors. Champfleury, in his Preface to the Catalogue, reminded everyone of what was now held to be a highly creditable political past (in this age of the Third Republic), and how dangerous his commentaries really had been to his opponents, although he was so mild and quiet a person that the police would not have recognised him had he spent a night in a police station. The last remark was pure rhetoric, of course, and the reference was to the 1830s not the 1870s. His old political enemy, Thiers, was present at the opening and congratulated him on his drawings of lawyers – certainly the most popular of his subjects at that time. These, however, and even the finely ironic drawings of the connoisseurs themselves, such as the collector with a skull-like head, who contemplates a replica of the Venus de Milo in a room hung with shadowy drawings and paintings invented by Daumier himself (Fig. 10.26), are not strictly within the context of this book. The real point of Daumier's *invention* is the paradoxical character of the artist in a changing society, and how Daumier

10.28 Daumier. *Don Quichotte au clair de la lune.* *c.*1868–70. Charcoal and stump, 19.5 × 26.5. (ex Robert von Hirsch Collection, Basle).

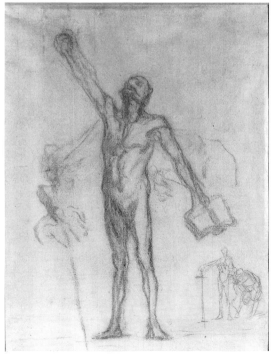

10.29 Daumier. *Don Quixote Declaiming before his Sword. c.*1868–72. Charcoal (rubbed), 38.5 × 27. Sotheby's (New York) 16 May 1985.

perceived himself in this role which he also perceived for the artist in general. The best of his vehicles for conveying this perception, in the end, was the character of Don Quixote.

Don Quixote's physiognomy, as imagined by Daumier, bears a strong resemblance to that of the genre of 'artists' whom he represented at work in their studios. A small panel painting, heavily worked, of an artist before his easel (Fig. 10.27) serves to illustrate this physiognomy of a man with a long face and pointed beard, which occurs with only minor variations in a number of such representations in Daumier's *oeuvre*. The artist holds his brush like a lance and his palette like a shield,[59] as he faces up to his canvas, on which is a very rough *ébauche* of an entombment. In the space between the two, further back into the picture, there is either a plaster bust or a death mask, also long-faced. Here, surely, is 'the knight of the woebegone expression'.

The wide circulation, in France, of Cervantes' *Don Quixote* as a popular classic with frequent illustrated editions from the seventeenth century onwards, was only surpassed by the *Fables* of La Fontaine.[60] 'Don Quixotisme' developed into a cult in the Romantic era, among writers and artists alike. It appealed not only to specialist illustrators like Gustave Doré, but also served as inspiration to a number of artists who used the idea as a starting point for more or less freely invented compositions of their own. In the eighteenth century, illustrations to *Don Quixote* tended to reflect the manners of the time in France, rather than the deep irony of Cervantes' view of seventeenth-century Spain. Fragonard made about thirty chalk drawings, of great vivacity, of incidents in the book, and Jean Seznec is correct in seeing him as 'the authentic precursor' of Daumier in this context.[61] Don Quixote was made the subject of paintings by Delacroix, Decamps and Corot (who inserted his figure into a misty landscape) among others. Daumier made paintings and drawings of Don Quixote over twenty years or more, starting with the picture he sent to the Salon of 1850.[62] Sometimes he did illustrate specific scenes in the novel, such as *Don Quixote and the Dead Mule*, and *Don Quixote Turning Somersaults* (because of his mad love for Dulcinea). The more gross incidents in Cervantes' rambling plot do not seem to have deterred Daumier at all: he particularly relished the scenes of Sancho squatting to relieve himself, which he drew several times. Conversely, the stark discovery of the dead mule, which had belonged to the distraught lover Cardénio, is rendered as a moment of high drama. Most often, however, Daumier's preferred image is simply the silhouettes of Don Quixote and Sancho riding in line ahead, signifying their roles as a pair of inseparable and complementary opposites, through desert-like plains or barren mountains.[63]

Don Quichotte au clair de la lune (Fig. 10.28) is a drawing in black chalk which exploits the whiteness of the paper as a source of light in the same way that Millet did in his drawing of *Lobster Fishermen at Night* (Fig. 8.23), and which induces the same feeling of stillness and quiet. Daumier has rubbed his chalk over the whole surface to create a film of darkness, which the moon shines through, casting its romantic light against the wiry silhouette of Don Quixote as he stands on his vigil. A darker shadowed lump behind him turns out to be, not a rock or a dead mule, but Sancho sleeping. In *Don Quixote Declaiming before his Sword* (Fig. 10.29) Daumier renders him in the nude, as though literally baring his naked soul. Such an image might be read as nearly grotesque, but the knight's body is not distorted: it may be emaciated by his asceticism but it is vigorous and muscular, and much more than merely comic. His supplicatory gesture seems reminiscent of some saintly hermit in the wilderness – which is exactly what Don Quixote wanted to be. The sword itself seems to flutter in the air, like some baroque device, and Don Quixote's other outstretched arm scarcely seems to feel the weight of the heavy book in his hand. All this is deliberately contrived. The

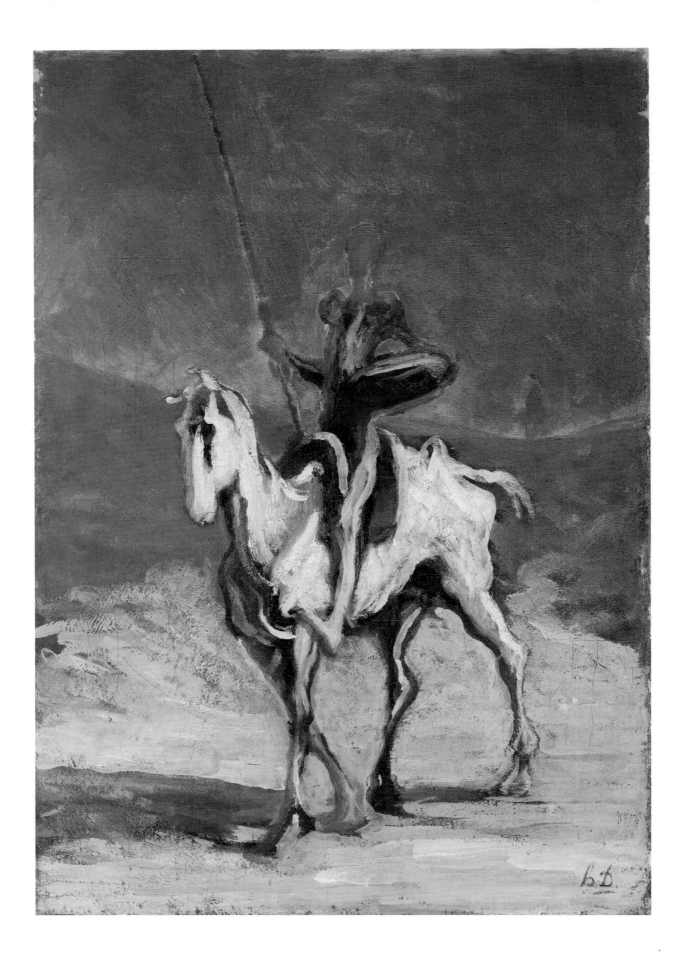

10.30　Daumier. *Don Quixote on Horseback*. *c*.1868–70. Oil on canvas, 51 × 33. Munich, Bayerische Staatsgemäldesammlungen.

10.31　Daumier. *Don Quixote Descending a Hill*. *c*.1866–8. Pen and brown ink, 27.4 × 19. Present location unknown. (Photo by Sotheby's.)

vignette at the bottom corner, in which Sancho appears in his role of squire, is like a supplementary note for the narrative which is about to unfold.

Don Quixote Descending a Hill (Fig. 10.31) is a study for a painting, which will include Sancho Panza, showing them riding down into an extensive plain. This is one of three nearly identical drawings in pen and brown ink, in which the cursive strokes are the epitome of Daumier's late drawing style. In a way it evokes Delacroix; in a way it is comparable to Millet's pen drawings, but the 'handwriting' is exclusively Daumier's. These sets of lines operate entirely upon the surface of the paper and interact according to their own laws of dynamics: the drawing seems to generate its own internal energy and equilibrium. The fact that Daumier drew this three times – and we cannot tell in what order because each version is nearly the same in its manner of rendition – suggests that the exercise itself, in this case, had taken over from the message. In each case Don Quixote is arrested in mid-action, like a butterfly upon the page.

Don Quixote, then, is an instrument upon with Daumier can play many variations. Since we left Millet's final imagery with his unfinished painting of the three *Bûcheronnes* (Fig. 10.21), a not unreasonable comparison with that work might be Daumier's equally late painting of *Don Quixote on Horseback* (Fig. 10.30) of *c*.1868–70. This is essentially a drawing done with the brush on canvas in full colour of high intensity. As with Millet's generalised images of the faggot carriers, Daumier's rider is also devoid of facial features. His silhouette and his bearing convey all that is needed. This relatively small canvas contains as completely realised a conception of an idea of nature of pure painting, perhaps, as Daumier would ever make. His method of realising it was by pure drawing, in paint.

Epilogue

11 The Heritage of Pissarro, Degas, Cézanne, Seurat and Van Gogh

THE OBJECT OF this final chapter is to show the direct relationship of the drawing languages of Daumier and Millet to certain of the major draughtsmen in France who came after them. This discussion will necessarily take note of the reception of their works by critics, collectors and the general public in the 1870s, 1880s and 1890s, but these matters are not my main theme: when we look at the *kinds* of interest taken in these artists by Pissarro or Degas, for example, it will be apparent that they were not likely to be swayed by popular or fashionable opinion of the posthumous status of Daumier or Millet in those decades. The only thing that could affect the independent judgements of such creative artists as these would be the availability of Daumier and Millet's original drawings at different times, and this factor was subject to market pressures, which were affected by social, economic and political change. In Daumier's case, his fame as a draughtsman was continually promulgated throughout the availability of his lithographs. Regarding Millet's work, there was some discrepancy between his evaluation by collectors and his evaluation by contemporary artists in the years immediately following his death; in the eyes of the former he may be said to have suffered a temporary eclipse. A balanced view of Daumier and Millet's respective art productions as a whole was not achieved much before the late 1880s.

For the discerning artist or collector (sometimes this could be the same person) the public exhibition of approximately half of Émile Gavet's collection of Millet's pastels in April 1875, and Millet's studio sale which took place in May of the same year, followed by the sale of the whole Gavet collection of his drawings and pastels in June, were events of great significance. However, the Millet Retrospective Exhibition held at the École des Beaux-Arts in 1887 probably had a more widespread effect on more artists, some of whom were doubtless seeing his drawings for the first time. Even Camille Pissarro, who had certainly known Millet's work since the 1855 Exposition Universelle, and who began to produce some paintings of French peasant subjects himself from the early 1860s, did not make his most serious pronouncements upon Millet's *drawings* until he had visited the 1887 exhibition. Another major sale organised for Millet's widow in 1894 further increased the respect in which his drawings were held by other artists (not least by Degas).[1]

The retrospective exhibition of Daumier's work in all media, held in 1878 at Durand-Ruel's (one year before his death), did not have any immediate effect on his reputation outside the framework of his existing patrons and friends, as we have already noticed. His lithographs, on the other hand, had *always* been

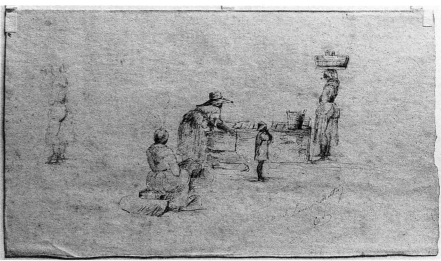

11.1 Pissarro. *The New Road to Caracas. c.*1852–4. Black pen and pencil, 26.8 × 35.7. Caracas, Museo de Bellas Artes (Inv. 59.64).

11.2 Pissarro. *Women Bringing Clothing to Wash. c.*1852–4. Sepia pen and wash, 17.7 × 30. Caracas, Museo de Bellas Artes (Inv. 59.71A).

11.3 Pissarro. *Edge of the Forest. c.*1853–4. Pencil and watercolour, 37.6 × 54.9. Caracas, Banco Central de Venezuela.

11.4 Pissarro. *Card Players in Galipan.* 1854. Pencil, 25.4 × 29. Caracas, Banco Central de Venezuela.

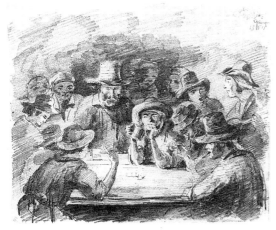

regarded with admiration by artists of all persuasions and, moreover, they were admired as drawings in themselves. The hierarchies of art production in terms of the fine art market, nowadays so fashionable a subject among art historians, did not, I suspect, carry any great weight with French avant-garde artists of that era. For this reason, then, Daumier's draughtsmanship was more widely appreciated than Millet's in the 1870s. Millet's 'eclipse' took place along with Rousseau, Courbet and other painters of his generation, at least according to Durand-Ruel, who organised a big exhibition of the 'School of 1830' in the summer of 1878.[2] This partly explains why Pissarro had so little to say about Millet in this decade.

It is now widely recognised that Pissarro was already a very accomplished and original draughtsman before he came to Paris from Venezuela in 1855 to further his career in France. He had begun to paint in the island of St Thomas, in the Danish Antilles, where he was discovered by the landscape painter Fritz Melbye in 1852, and he subsequently spent two very productive years in Caracas, working in the company of this artist. Pissarro's early topographical drawings bear no relation to Millet's drawing style, other than showing a capacity to convey atmospheric space by broken contours and varied pressures of line when working *en plein air*. A drawing of *The New Road to Caracas*, for example, is more like an early Corot in its combination of precise detail with clear spatial organisation (Fig. 11.1). His interest in peasant subject matter already extended to washerwomen working out of doors, and he recognised the village pump as the centre of social intercourse (Fig. 11.2).[3] In Caracas, its environs and the surrounding mountains he made many drawings of primitive farming communities and exotic forest trees and plants. He also became, quite early on, a virtuoso in watercolour brush drawing for landscape notations (Fig. 11.3). Finally, there are a few precocious drawings of indoor scenes, some in sepia wash and some with elaborate pencil shading, that record different aspects of Caracas society with the liveliness of a Gavarni (Fig. 11.4).[4] The situation vis-à-vis Daumier and Millet, then, is that Pissarro was already an accomplished artist when he first became aware of their work.[5]

Pissarro's landscape drawings of the 1860s in France relate, stylistically, most patently to the studies of Corot, Rousseau and Daubigny. It is only when he gets into drawing figures in movement that Millet is more firmly brought to mind, and then it is as much because of his peasant subject matter as from any similarities in style. Signs of a direct awareness of Millet's drawings in Pissarro's works do not occur, in fact, before about 1875. In his small study of a woman

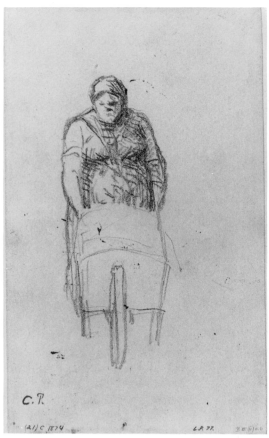

11.5 Pissarro. *Study of a Female Peasant Pushing a Wheelbarrow*. *c*.1875. Black chalk, 19.6 × 11.3. Oxford, Ashmolean Museum (from Pissarro Sketchbook VI, 85A recto).

pushing a wheelbarrow, for example, Brettell and Lloyd have noted the 'short splashing lines' used for modelling this figure as cognisant of line systems found in Millet's drawings and etchings (Fig. 11.5).[6] On another page in this sketchbook are some studies of female nudes, in black chalk (Fig. 11.6), which the same authors try to relate to Cézanne's bathers, but which seem to me to be closer to Millet's drawings of nudes, though whether Pissarro could have seen any in private collections is open to question. At this same date Pissarro was making considerable progress with his landscapes in pastel, and examples such as *The Pond at Montfoucault, Autumn* (Ashmolean Museum) may well owe much to Millet's techniques with this medium. The coincidence of such drawings being made in 1875, the year of Millet's studio sale, suggests that Pissarro may have looked in there.

On 6 December 1873, Théodore Duret, an influential critic and friend of the Impressionists, wrote to Pissarro of a landscape of his which he possessed that 'pour le sentiment et la puissance, ce paysage avec animaux est aussi beau qu'un Millet'.[7] In this same letter he urged Pissarro to follow 'votre voie de la nature rustique'. He told him bluntly that he did not have the decorative sentiment of Sisley nor the fantastic eye of Monet, but that he did have a profound and intimate feeling for nature, and a 'puissance de pinceau', which made any picture by him something absolutely firmly realised. He had better, therefore, not think of Monet or of Sisley, but pursue rusticity.[8] Such advice surely echoes the theories of *le vrai force* of Millet himself! Pissarro replied humbly, saying that he lacked models at his disposition, and that not every picture could be made in front of nature, that is to say outdoors, but he would try to follow his advice. As we pursue Pissarro's own recorded references to Millet, however, it transpires that the connection between them that many critics made was not entirely to his liking, notwithstanding his declared respect for 'le grand Millet'. The first of these recorded references is in a letter he wrote to Duret on 12 March 1882. He refers to an article by Philippe Burty, on the seventh Impressionist show, which he does not like. Burty says his figures recall the style of Millet, and Pissarro responds – 'They throw Millet at my head, but Millet was biblical! For a Hebrew he [Burty] seems to me to be very little with it, this is curious!'.[9] Through the 1880s he makes several references to Millet in his letters to his son Lucien, including the fact that he has framed three 'original prints' of wood engravings drawn by him and engraved by his brother.[10] In May 1887 he finds it demeaning that this 'Great Millet', who has made such heartrending interpretations of the life of the old peasantry, could have made such indignant protestations against the Commune and the communards (in 1871), and that letters to the press in this connection should now be republished.[11] In this context Pissarro's political sympathies were much closer to Daumier's, obviously, and he immediately objected to Millet's conservative opinions being dragged out to show that he was on the side of the bourgeoisie. Millet's refusal to be aligned with socialism he found merely funny – 'more and more indignant protestations from the great artist! . . . for a long time now I have been struck by the unconscious innocence of such men of the élite'.

Only two weeks after writing this came the famous letter to Lucien, 'Je suis allé à l'exposition Millet', which was partly quoted in the opening chapter of this book. He went, he says, with Amélie [Isaacson] yesterday . . . a dense crowd. He met a local painter from Eragny, Hyacinthe Pozier, who waxed fulsome to the point of tears ('we thought he'd had a death in his family') about Millet's *Angelus*:

This painting, one of his less good ones for which a price of 500,000 francs has recently been turned down, had a moral effect upon the gross spirits who crowded round it; they were overwhelmed by it! I am telling you this word for word. This gives one a sad idea of humanity. Idiot sentimentality[12] which

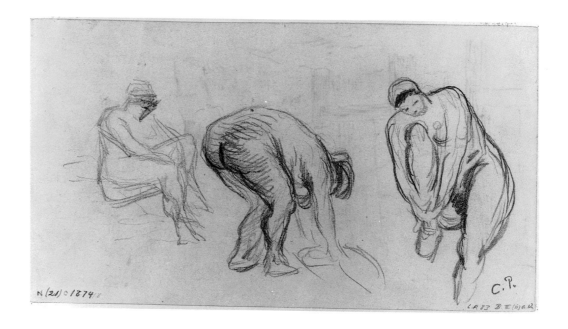

11.6 Pissarro. *Three Studies of Female Nudes.*
*c.*1875. Black chalk and pencil, 11.3 × 19.4.
Oxford, Ashmolean Museum (from Pissarro
Sketchbook VI, 85G recto).

reminds me of what worked for the painter Greuze in the eighteenth century: *la Lecture de la Bible; la cruche cassée.* These people only see the petty side of art; they do not see that the drawings, certain drawings of Millet, are a hundred times better than his paintings which have become old fashioned. [The paintings] do not have the thunder and lightning of the admirable Delacroix's at Saint-Sulpice! What brutes! This is distressing![13]

This was of course a highly emotional and subjective reaction to the herd instinct of the 'gallery crowd' of the 1880s, but Pissarro's estimate of Millet's drawings is more significant than his dislike of the religiosity of *The Angelus.* There were 120 drawings and pastels in this exhibition. Later, Pissarro said, he discussed the exhibition with the poet Astruc, who agreed with him that Millet's painting was out of date, and that he 'existed' by drawing (compare his estimate of Daumier, below), tarnished, however, by sentimentality. Yet in other letters Pissarro continues to list Millet with the 'great artists' from David to Puvis de Chavannes, and one is bound to suspect – based upon the evidence of Pissarro's own work – that his fulminations in 1887 were caused by Millet's type of admirer rather than by his work at source. I have quoted Pissarro at length here because the roughness and severity of his expression emphasises that the language of drawing was a hot issue for him in the 1880s, and a serious one for the avant-garde in general.

Another insight into the causes of this heat is found in Pissarro's letter to his son, Georges, written on 17 December 1889. He complained, 'What is astonishing, is that as for my peasants which they say come from Millet, one is always haunted by this, *it is too entire a sensation* for them to be able to see it, there are only superficial people who confuse black with white'.[14] These lines were written in the context of a panegyric for Hokusai, whom Pissarro much admired, and are to be taken as 'an interesting adjustment' on the part of Pissarro to the comparison of his works with those of Millet.[15] Quite simply, Pissarro wished to be regarded as more up to date. This reservation on his part would apply, not merely on grounds of some abstract 'advance' in formalistic terms – the magnificent solidity and balance of the girl carrying a bucket on the large sheet in Cardiff (Fig. 11.7) is equal to Millet's treatment of such a figure – but also in the emancipated way in which he perceives his peasants. These cheerful, innocent

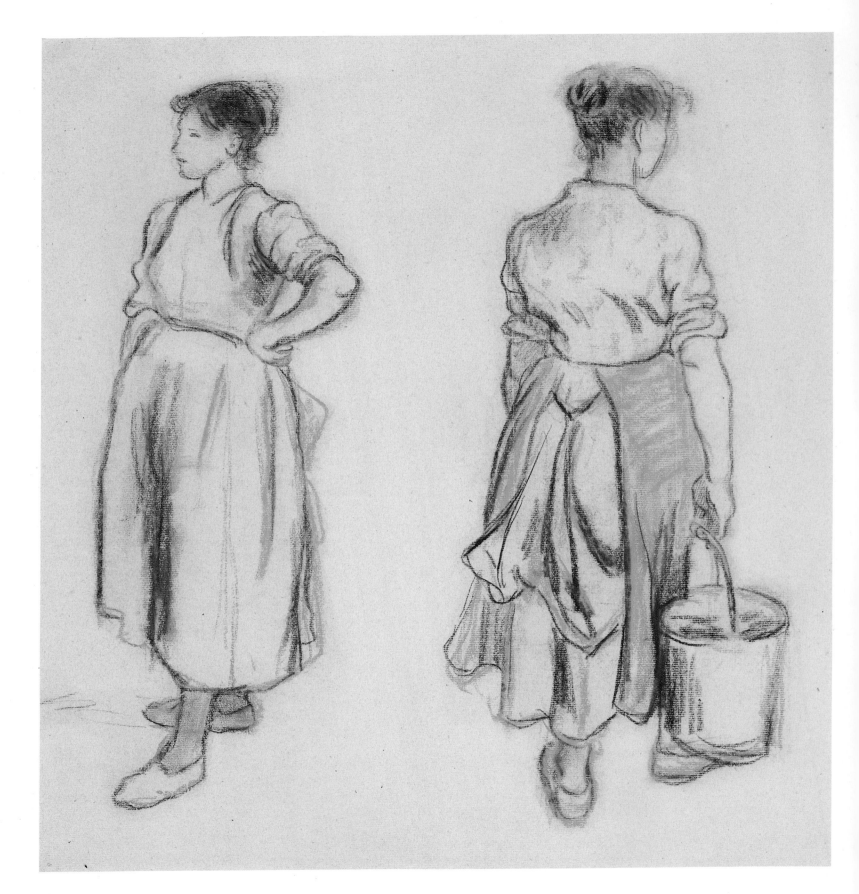

farm girls could almost be propaganda for the kind of free, agrarian system of decentralised economies that Pissarro subscribed to in his anarchist beliefs.

As for Daumier, Pissarro had absolutely no reservations about his quality as an artist, and her drew no distinctions between his different modes of work either. Around April 1876 Pissarro wrote a letter to his friend Murer, who was about to address his first attempt at art criticism in an article on the second Impressionist group exhibition, giving him the following preliminary advice: 'In fact in principle, *we do not wish to be considered a School*; we admire Delacroix, Courbet, Daumier and all those who have real guts, and our whole preoccupation is with nature, *plein air*, and the different impressions which we experience. We repudiate all factitious theories.'[16] Pissarro does not record having seen the 1878 Daumier exhibition, but in a letter to Lucien written in May 1888 it is clear that he was familiar with all the media with which Daumier worked: '. . . you must think of profiting from the best season [of the year] for drawing and painting, you understand that [oil] painting, watercolour, etc., etc., very much help the draughtsman, see how Daumier preoccupied himself with these, moreover there is the same feeling in all his drawings. It gives a great freedom and speed.'[17] The context of these remarks almost certainly relates to another exhibition of Daumier's work which had opened in Paris a month earlier – he wrote to Lucien on 28 April that he would very much like to see the exhibition of *la Caricature*, 'the Daumiers above all; he had the sensation, that one', but doubted if he could make it. The passage quoted above, however, strongly suggests that he did manage to see it.[18]

Another valuable piece of evidence about just how Pissaro regarded Daumier's drawing is found in his letters to Lucien written early in 1884, when he was arranging to send to his son, then in England, ten lithographs by Daumier which he could *copy* as a means of instruction – 'my beautiful Daumiers which you can draw' – and he enjoined him to pay close attention to the way they were *constructed* (his italics). 'The handling of the arms, the legs and the feet is as admirable as any of the great masters, yet these are *caricatures*! Remark the cravats, the necks, the trousers, the folds so well drawn . . . the shoes are remarkable, and the hands!'[19] Camille Pissarro wrote this to his son, but two years later he might have been saying as much to his new 'pupil', van Gogh – or van Gogh might have been saying it to him. The same letter to Lucien continues:

> I bought in Rouen Champfleury's *Histoire de la Caricature*, a valuable book with illustrations of Daumiers. Daumier's whole history is traced there. One understands well, perusing this book, that Daumier was the man of his drawings [*Daumier était l'homme de ses dessins*], a man of conviction, a true republican. One feels moreover in his drawings the sense of a great artist who presses on to a single goal but who does not cease, however, to be profoundly artistic, in the manner in which even without inscriptions, without explanations, his drawings remain beatiful.[20]

The dichotomy of Pissarro's basis for aesthetic judgements could not be made clearer than in these consecutive statements. As a socialist, Pissarro respected Daumier deeply and recognised, correctly, that his republican convictions were the very foundation of his art – the form of his best drawings was the form of his most serious messages. At the same time Pissarro perceived a *separate* quality in Daumier's drawings which he calls 'profoundly artistic', by which he seems to have meant that the 'beauty' of Daumier's drawings can be seen as a thing apart. Such a judgement would be music to the ears of a 'bourgeois' connoisseur, but I do not think Pissarro quite intended that the one quality could be perceived and enjoyed without the presence of the other, the 'single goal' which drove Daumier on.

Pissarro's perceptions of Daumier and Millet in a sense also speak for the Impressionists, whose ambitions he shared in the 1860s and 1870s, and whose diverging paths he understood so well from the 1880s onwards. If we now look at some of these divergencies, it will be with the intention not so much to demonstrate new critical perceptions as to try to find the residual traces, as it were, of the types of drawing language which Daumier and Millet created, as they appear in exemplary drawings by a new generation of artists with discourses of their own.

Degas owned at one time the astonishing total of some 1,800 lithographs by Daumier.[21] It is perhaps less astonishing when one considers that he had probably cut many of them out of the pages of *Charivari* as they appeared, and that he was an avid collector of prints anyway, not least those by Gavarni, who might be considered Daumier's greatest rival, but we are left in no doubt of his admiration of the quality of Daumier's drawing. In so far as he rated him, together with Ingres and Delacroix, as one of the three greatest nineteenth-century draughtsmen, one might suppose that Baudelaire's challenging statement, first published in his *Salon of 1845*, had been read by Degas or come to his ears.[22] Degas went after not only the popular prints such as could be found in the 1860s, but also the rarer editions of the great political prints of the 1830s, which became especially sought after when Daumier's political involvements were 'reinstated' during the Third Republic.[23] Given Degas' own obsessions with print techniques, he would have been as interested in Daumier's technique in the medium of lithography as he was in his drawings. His collection also included five smallish original drawings and the unfinished painted *Don Quixote Reading* (now in the National Museum of Wales, Cardiff).[24]

Degas' interest in Daumier was shared by his friend Duranty, the art critic, whose articles on the latter were published during his 1878 exhibition at Durand-Ruel's.[25] Duranty's detailed description of the print *The Legislative Belly* could even have inspired Pissarro's later injunctions to his son (see above, p.189) – compare Duranty's 'Il faut regarder ces faces élargies ou allongés, angouleuses ou arrondies . . . les *manies* des mains, des cous . . . ces écartements de l'habit autour des poitrines étroites ou fortes; ces gilets qui plissent . . .',[26] etc., with Pissarro's text. Theodore Reff has correctly pointed out that a number of Daumier's subjects for his lithographs of *les moeurs* – the café, the café-concert, the ballet (very occasionally), the theatre (more often), the art exhibition (like all cartoonists!) and the boulevard – are parallel to Degas' subjects of modern life,[27] as indeed they are to Manet's. How early could Degas have seen original Daumier drawings and paintings? He was friendly with the dealers Brame and Durand-Ruel, and his old schoolfriend Henri Rouart, whose collection of Daumiers has already been noted, possessed at least two of his paintings by 1878 which he lent to the Retrospective exhibition: *The Water Carrier* (Fig 7.8)[28] and *Print Collectors*.[29] Watercolours are harder to trace, except that we know from his own account that Durand-Ruel stocked them. It is reasonable to conclude that the year 1878 was the crucial one for Degas' discovery of Daumier's activities other than printmaking.

The second of Duret's articles on Daumier's exhibition had this to say about the nature of his art:

> With the exception of a few canvases, one could say that the whole of his *oeuvre* is, in essence, drawing, painted or coloured. On occasion strong black lines form the contours of his images; traces of pen or charcoal lines fuse with the monochrome washes or with the watercolour tints. The colourist, which Daumier is to a remarkable extent, emerges out of the draughtsman. It is with

black and white chalks that the brightness of light and the depths of shadow are most movingly expressed. If he then becomes preoccupied with the beauty of certain tones, the saturated colour proceeds no less from, first of all, the broad masses and the half-tones that the black and white base succeeds in recapitulating and affirming . . . great stretches of charcoal or of wash drawing, great displays of the same tone, reddish-brown and blonde, grey-blue, blue-black or white, call across to one another. Paintings, drawings, lithographs form an ensemble, one and indivisible.[30]

Although rhetorically expressed, these observations are very just, and there is every reason to suppose that Degas would have been in accord with them.

It is, I shall argue, the *processes* of drawing, such as those evoked by Duranty in the passage quoted, that are most important to Degas' assimilation of the lessons of Daumier, rather than mere iconographical transfers of subject matter. These processes should not be tied down to instances of specific resemblance. It is the willingness to switch, freely, from one medium to another, or to combine several, and even to switch levels of seriousness in different expressions of the same image, that link the creative processes of these two artists in a more general way. 'Paintings, drawings, lithographs form an ensemble, one and indivisible' is the real link. It would not be at all unfair to imagine Daumier saying 'nothing is less spontaneous than my art', although it might spoil the Daumier myth for some.

Michael Pantazzi has recently cited Daumier's late painting *Crispin and Scapin* (Fig. 11.9), which was in Durand-Ruel's 1878 exhibition and was subsequently acquired by Henri Rouart, as a good source of inspiration for Degas' pastel *The Chorus* (Fig. 11.8), now identified as a scene from the opera *Don Giovanni*.[31] The link, at first sight, may seem tenuous: they are both realistic illustrations of comedies taking place on stage, but the 'dramatic lighting from below', which illuminates the lower chins of the people on stage in the Degas and gives a rather lurid effect, is found more often in Daumier's many lithographs of stage subjects. (Toulouse Lautrec later utilised this same effect in his drawings and lithographs of night-club entertainers.) It is more significant, in this context, that the Degas pastel is in fact drawn over a monotype, i.e. a printed image of his whole design which was originally drawn in black and white. This factor does indeed created some link between the colouristic techniques of Degas and Daumier, although Daumier used watercolour over black chalk rather than pastel over monotype.

A more unexpected rapport, in both subject matter and style, is the very curious drawing by Daumier of a naked boy warming himself by the fire (see (Fig. 7.18), which has an intimate, almost secretive air that could be compared in imagintive force to Degas' two strange monontypes known as *Women by a Fireplace* (Fig. 11.10) and *The Fireside*, both of about 1876–7 and recently exhibited together.[32] In each case the figures emerge out of a murky, indeterminate background space like apparitions, summoned up with a few incisive contours. In more general terms, Daumier's whole mode of detached observation when making drawings of his private experience, as discussed in Chapter 7 on 'Daumier's Republic', was akin to Degas.

In the Degas retrospective exhibition of 1988–9 were some late unfinished paintings which reminded the cataloguers, as well as the present writer, of Daumier's brushwork, and also some large charcoal drawings in which the use of this medium for large exploratory statements seemed similar to Daumier. I am not sure how fortuitous this resemblance is – perhaps it demonstrates no more than the way in which artists who are 'men of their drawings' think out their pictorial problems. Both Degas and Daumier showed a penchant for producing large *ébauches* on canvas, late in their careers, which repeated earlier subjects in large synthetic designs. Degas' huge canvas, *Nude Woman Drying Herself*

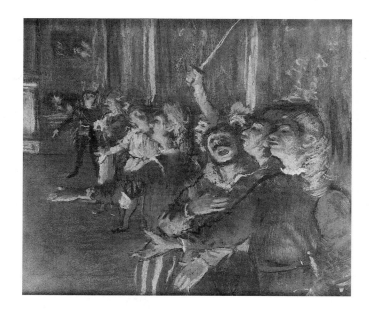

11.8 Degas. *The Chorus. c.*1876–7. Pastel over monotype, 27 × 31. Paris, Musée d'Orsay.

11.9 Daumier. *Crispin and Scapin (Scapin and Silvestre). c.*1860–5. Oil on canvas, 60.5 × 82. Paris, Musée d'Orsay.

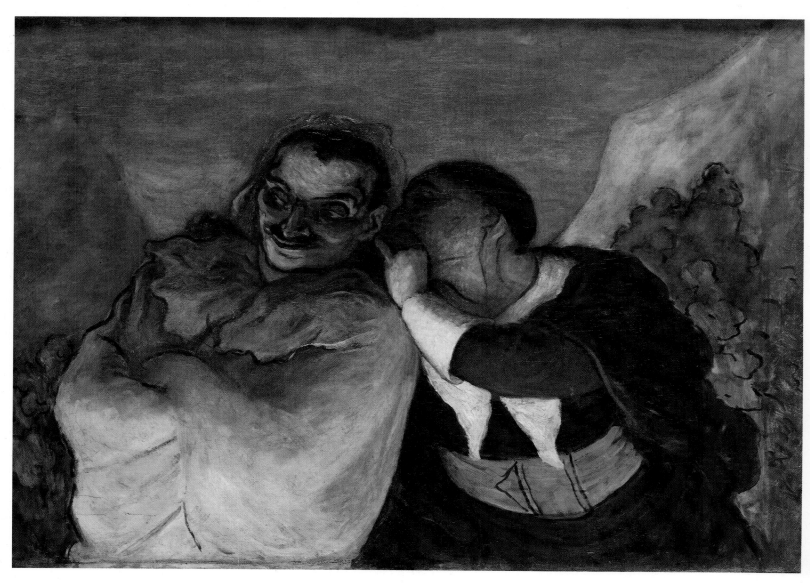

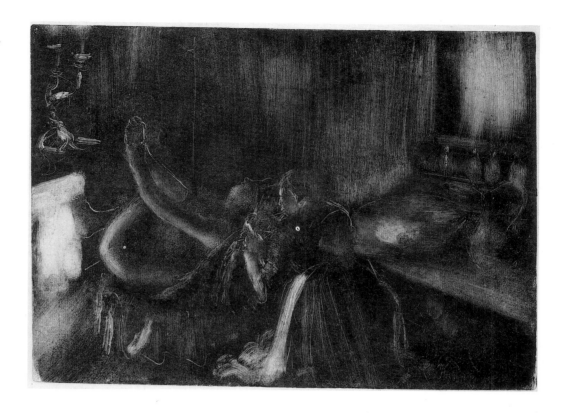

11.10 Degas. *Women by a Fireplace. c.*1876–7. Monotype in black ink, 27.7 × 37.8. Washington, D.C., National Gallery of Art, Collection of Mr and Mrs Paul Mellon.

11.11 Degas. *Dancers on the Stage. c.*1898. Charcoal and pastel on tracing paper, 56.8 × 60.3. Private collection.

(Brooklyn Museum, New York), which is drawn, with the tones scumbled in, in brownish monochrome with a brush soaked in turpentine, so that drips have run down the surface of the canvas, has an exact parallel in technique in Daumier's late picture of *Don Quixote and Sancho Panza* (Courtauld Institute Galleries, London). In both cases the drawing with the brush conveys the whole content, at the point at which each canvas was left. Late *ébauches* by Millet have similar characteristics, though the handling is not so violent.

As with brush drawing, so with Degas' late works in charcoal. The large scale of some of these may be attributed to the exigencies of his failing eyesight, but their extremely summary technique, showing complete disregard for 'finish', denotes a draughtsman composing for himself, without regard for the requirements of connoisseurs. In a drawing like *Dancers on the Stage* (Fig. 11.11) of *c.*1898, in charcoal and pastel on tracing paper, space, form and light are indicated with great economy of means, by changing pressure to adjust the weight of lines, and finger smudging. Features are not indicated; the body movements of the dancers interact, but they are unaware of the spectator. The group in the distance are an 'anonymous crowd' such as we found in Daumier's market scenes (compare Fig. 7.5).

Degas also admired Millet, though probably for different reasons. His interest in the medium of pastel strikes an immediate link, and it has been suggested that the exhibition and sale of Gavet's collection of Millet's pastels even stimulated Degas to make a 'sudden shift' in this direction.[33] Philippe Burty, reviewing the 1877 Impressionists' exhibition, noted that Degas had essentially abandoned oil for distemper and pastel. By 1879, he wrote in another review, collectors were fighting over the works that Degas came to refer to as his 'articles'. In a letter to Rouart, datable to this year, Degas wrote: ' . . . Pas de temps de faire des essais un peu sérieux. Toujours des articles à confectionner. Le dernier est un éventail en camaieu pour Mr. Beugniet. Je ne pense qu'à la gravure et n'en fais pas'.[34] The inference is that *printmaking*, in the many techniques of which his researches at this

11.12 Millet. *Two Studies of a Female Nude.*
*c.*1846–8. Black chalk on beige paper, 24.3 × 15.7.
Paris, Louvre (Inv. RF 4513, Cat. 10,492).

11.13 Degas. *Studies of Nude Men. c.*1860. Pencil,
38.7 × 26.5. Williamstown, Mass., Sterling and
Francine Clark Art Institute.

period amounted to an obsession, was what he now considered 'serious work', but that (like Millet) he had to do things in other media to sell.

By the mid-1870s pastel was beginning to be considered more durable than oil paint, in the sense of retaining the colours without darkening, and Degas' use of this medium was a part of his general concern with technique and process as a scientific aspect of realism, besides being a conscious attempt to revitalise an older technique. The relative brightness of Millet's pastels compared to his oil paintings is quite startling at the present day – even when the latter have been cleaned and restored to their original richness of colour – and this must have struck Degas, as well as other members of the Impressionist circle, when they saw them in 1875. A general break-up of the old hierarchies of 'high' and 'low' art media was now taking place among the artists of the avant-garde, which no doubt also suited their new class of customers with modest incomes. Degas' use of the term 'articles' to describe his works for sale is thus significant. Be that as it may, we should now investigate a possible 'dialogue' between Degas and Millet in the basic language of drawing, which is the central concern of this book.

In the studio sale of Degas' collections there appeared an early Millet drawing in black chalk, *Two Studies of a Female Nude*, possibly for a figure of Eve picking the forbidden apple (Fig. 11.12).[35] It is not certain when or where he acquired this, but the most probable time is the later 1890s. The remarkable rapport between the fine, painterly contours of Millet's figures – contours which could be used as object lessons to illustrate Delacroix's classic description of drawing quoted in Chapter 2 – and those in Degas' own early pencil drawing of *Studies of Nude Men* (Fig. 11.13), itself executed in about 1860,[36] makes nonsense of the standard art-historical use of the term 'influence'. Degas could only have bought this drawing because he understood it, and it reminded him of his own *joie de vivre* as a youth.[37]

Another characteristic these two artists had in common was a habit of beginning an idea with the most lively, freely created notations, based on observation or memory or both, which might or might not be developed later, through further studies, into complete realisation of given themes. Compare, for example, two studies of nudes, drawn far apart in time and even with quite different art markets in view. Millet's half-length bust, probably drawn from a model intimately known to him (Fig. 11.14), was used for a little oil painting called *Une nymphe entraînée par les amours*, itself painted for private sale in 1851 to some collector with mildly erotic tastes.[38] Degas' drawing of a *Nude Dancer with Upraised Arms* (Fig. 11.15) led to a further study for an unfinished pastel of dancers, destined for the market of the 1890s. Gary Tinterow comments on Degas' fascination with the articulation of his model's joints at shoulder, elbow and wrist, and the sense of continuous movement in the pose.[39] Degas' eroticism seems sublimated into this movement. Robert Herbert has commented on the singular contrast, in the Millet drawing, between the nymph's open display of her superb bosom and the expression on her face, in which he sees 'a sort of tragic consciousness of love'.[40] That may be a just observation, but my point in putting these two drawings side by side is to show that, despite such different motives, the descriptive language – the grasp of the articulation, the sensuous precision with which the contours are felt and modified by the black chalk, even the gentle stomping on critical shadowed areas of the flesh – is very similar in both. Far from being academic, these life studies are the most disciplined expressions of strong emotions. I conclude from this, as from the observations on Daumier made earlier, that the degree of freedom and experimentation in Degas' work in the 1880s and after was encouraged, in no small part, by his discovery of the drawings of Daumier and Millet.

194

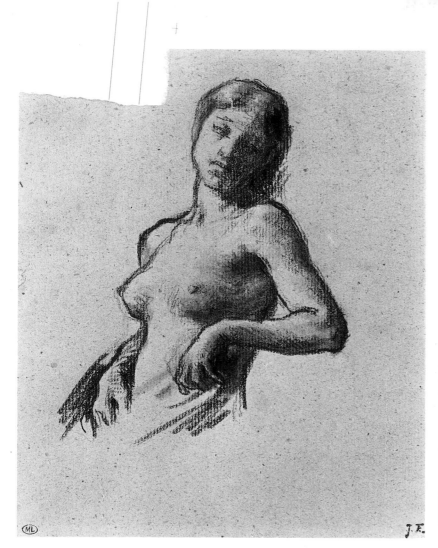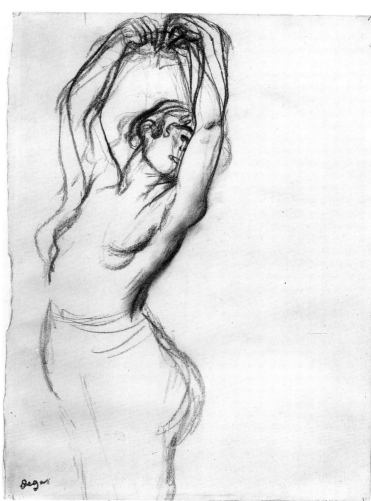

11.14 Millet. Study for *Une nymphe entraînée par les amours*. *c*.1851. Black chalk, 19.9 × 16.4. Paris, Louvre (Inv. RF 4183, Cat. 10,295).

11.15 Degas. *Nude Dancer with Upraised Arms*. *c*.1890. Black chalk on buff paper, 32.7 × 23.6. Copenhagen, Statens Museum for Kunst.

It might be thought at first that Cézanne owed less to Daumier and Millet than his Impressionist contemporaries did. It is true that he did not produce images celebrating rural life much before the 1870s, and even then, such works as *La Vie de champs*,[41] *Les Moissoneurs*[42] and *Les Faucheurs*[43] are relatively marginal to his obsession with the more middle-class *Déjeuner sur l'herbe* theme, which was followed by pure landscapes and separate studies of bathers. In the case of urban landscape, his pictures reflecting a Zola-like realism during the short period *c*.1869–72, executed in a style reminiscent of Manet, are even rarer.[44] His invented compositions of 'modern life' subjects in the 1860s are another story, however, closely tied to the development of his drawings.

The tremendous vigour and vitality of Cézanne's drawings in the 1860s, so unlike the norm expected of students' work at that time, gave rise to the conventional response that he 'could not draw'. Rather than enter into an historical discussion of this now well-worn and, effectively, dead controversy, I would like to suggest that one perhaps unexpected source of this vigour might be Daumier's lithographs. The strength and directness of Daumier's handling of his lithographic crayon we have already observed; the later lithographs would have been those most accessible to Cézanne. The connection is obscured, however, by the fact that Cézanne seldom referred to Daumier, nor did he copy any of his work. (His prolific activities as a copyist included some modern masters such as Delacroix, Barye and Millet, but to a much larger extent he made drawings after drawings, paintings and sculpture by the Old Masters.) The clue to the connec-

11.16 Cézanne. *Male Nude* (after Signorelli).
c.1866–9. Pencil, 18 × 24. Basel, Kunstmuseum.

11.17 Cézanne. Page of studies, after Veronese's
*Marriage Feast at Cana. c.*1866–9. Black chalk, 17.7
× 22.8. Basle, Kunstmuseum.

11.18 Cézanne. *The Robbers and the Ass. c.*1869–
70. Oil on canvas, 41 × 55. Milan, Civica Galleria
d'Arte Moderna – Raccolta Grassi.

tion lies, I think, in the manner in which Cézanne dr[...]
him, was an extension of his studies of the whole vo[...]
only worked from live models with great difficulty after leaving the Académie
Suisse,[45] existing images in other works – regardless of the medium in which they
were executed – served him in a sense as substitute models. His drawn copies
were nearly always fragmentary, and in no way slavish imitations: they were
studies of forms which he redeveloped in his own distinctive system. The *Male
Nude* (Fig. 11.16), for example, taken from a drawing of *Two Standing Men* by
Luca Signorelli (1440–1525) in the Cabinet des Dessins in the Louvre,[46] does not
reproduce the style of the Renaissance master at all – instead it summarises the
basic directional thrusts created by the stance of the figure, in a simple system of
lines and hatching created by Cézanne himself. Compare it to Daumier's labourer
confronting Ratapoil by the ruins of France (Fig. 10.6), and we discover a modern
drawing, not remote like high art but something that could be a living model,
taking from Signorelli only his poise and balance.

Cézanne's invented compositions for such subjects as brothels, doctors'
dissecting rooms, and his own rather lurid versions of *fêtes champêtres* in the 1860s,
tended to stray rapidly into fantasy. The closest he got to drawing an ordinary
social scene, like people eating at a table, might be found in the drawing of a
seated man with a hood hanging down his back (at first sight it looks like a pair of
braces) which turns out to be copied from Veronese's *Marriage Feast at Cana* in the
Louvre (Fig. 11.17).[47] His black chalk sketches of details of heads and hands from
that painting are firm and clear, and vigorously realistic. Quite often, Cézanne's
paintings of this period have been assumed to be violent, even mocking,
emulations of Manet's *peinture claire* (what he called his *couillarde* manner) –
thickly impasted surfaces of creamy paint with abrupt tonal transitions – though it
has also been noticed that Daumier could paint in the same way. Cézanne's *The
Robbers and the Ass* (Fig. 11.18) is a good case in point. Lawrence Gowing has
perceived in it an element of 'jocular baroque' which he thinks is directly due to
Daumier.[48] The story, from Apuleius, has an element of coarse, satirical humour
about it, which is at the same time subtly ironic: its analogy in feeling to
Cervantes cannot be overlooked, and the absurd little white donkey which
presents its posterior to the viewer is close to Daumier's renditions of Sancho
Panza's mule. The problem, however, in developing such a Daumier – Cézanne
discourse would be to show what opportunity the latter could have had to see
original paintings and drawings by the older master. Any arguments in favour of
his having such opportunity would devolve upon the enthusiasms of mutual
friends, such as the collector Henri Rouart who owned paintings by both.

Of course, baroque does not have to be jocular. We noticed in an earlier chapter
a community of feeling in a group of images of rape which included Daumier's
drawing *Le Baiser* and Cézanne's painting *L'Enlèvement* (Figs. 5.4 and 5.6).
Among a small group of superb early drawings by Cézanne chosen for the 1988
exhibition were two portrait heads of his friend the painter Achille Emperaire.[49]
Lawrence Gowing has described the one reproduced here (Fig. 11.19) as
'Cézanne's most spectacular drawing and successful essay in baroque
portraiture'.[50] It is drawn in charcoal, and is close to the same size as Daumier's
portrait of the sculptor Carrier-Belleuse, also in charcoal (Fig. 11.20). The sadness
of Emperaire's expression is combined with a strength and elegance of character
comparable to Van Dyck's portraits of Charles I. The rhythmical vibrations of the
principal contours are knit together by a simple system of cross-hatched shading
into a firm, sculptural mass. A similar welding of baroque curvilinearity with
simple, heavy shading is found in Daumier's portrait of Carrier-Belleuse, a
flamboyant virtuoso in his time, whose vanity is conveyed here with a rather
tragic clarity of which the caricaturist was specially capable.[51] A number of other

11.19　Cézanne. *Portrait of Achille Emperaire.*
*c.*1867–70. Charcoal, 49 × 31. Paris, Louvre.

11.20　Daumier. *Portrait of Carrier-Belleuse.* 1863.
Charcoal, 43 × 28.5. Paris, Petit Palais.

11.21　Cézanne. Study after the *Venus de Milo.*
*c.*1883–6. Pencil, 27 × 23. Bremen, Kunsthalle
(Inv. 68/374).

drawings by Cézanne from this period show a similar power of what I might call raw synthesis, and it is incredible to think, with hindsight, that he was at one time considered inept.

This is not the place to launch into a lengthy discussion of how Cézanne's particular systems of drawing developed throughout his career. His seemingly academic practice of repeating past images was transformed by the extraordinary power of his imagination, itself stimulated by the conflict between his determined efforts to see objectively and the emotional impact his received sensations made upon his sensibility. For example, Chappuis has catalogued nine drawings after the Venus de Milo in the Louvre, in two groups made *c.*1872–3 and in the mid-1880s respectively.[52] The one reproduced here is from the latter group, and it can be deduced that it was drawn from the plaster cast in the Trocadero Museum of casts, rather than from the original marble, because of its near eye-level angle of vision (Fig. 11.21). Although his source is not a live model, the sensuous urgency of Cézanne's drawing is in some ways comparable to the two busts by Millet and Degas discussed earlier (Figs. 11.14 and 11.15). His lines, being in pencil, are a little harder and sharper than theirs, but such features as his constant

197

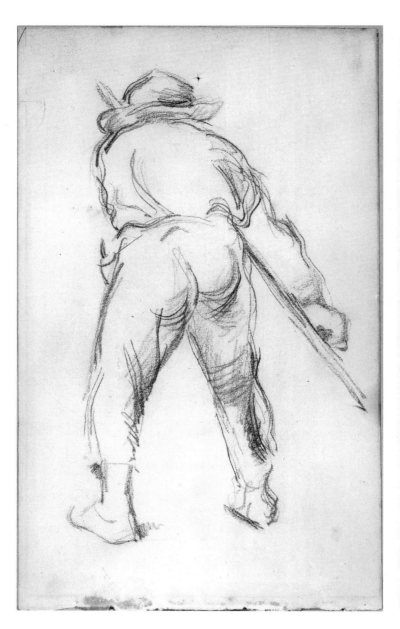

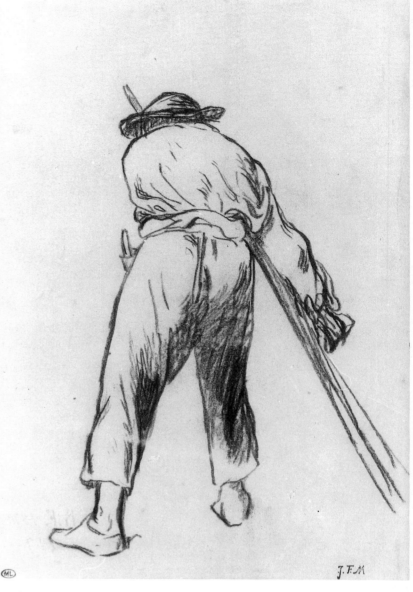

11.22 Cézanne. Study after a Millet drawing: *The Reaper*. Pencil, 21.6 × 12.7. New York, Coll. Mrs Enid A. Haupt.

11.23 Millet. *The Reaper*. c.1852. Black chalk, 28.3 × 10.1. Paris, Louvre (Inv. RF 247, Cat.10,484).

adjustments to the contours while the drawing grew, and a sense of searching for the planes and directions of movements through strokes akin to touching, are in the same vein of drawing process. A very surprising Cézanne drawing to find is his copy after Millet's figure of a man wielding a scythe (Fig. 11.22). This is clearly not made after the well-known woodcut in the series engraved by Lavieille,[53] but appears to be after an original drawing of a mower by Millet in the Cabinet des Dessins in the Louvre, which acquired it from his studio sale in 1875 (Fig. 11.23).[54] While Cézanne's main contours echo Millet's very closely, he has considerably speeded up the rhythms which express the movement of the figure, and shifted his weight more from the right leg to the left. Not only has he doubled and tripled a line's position where Millet had only modified the same line by adjustments of pressure, but he has made many of the curves rounder and more interacting upon each other. He has, in effect, turned Millet's slow classical rhythms into a neobaroque ballet. Why Cézanne should have done this, late in his career, can only be explained in self-referential terms. The connection with

11.24 Seurat. *Peasant Gathering Plants*. c.1881–2. Black chalk, 31.4 × 23.8. London, British Museum.

11.25 Seaurat. *Fort de la Halle* (*Market Porter*). c.1882–3. Black chalk, 31.5 × 25. Paris, Private collection.

Millet here is surely not so much through image as subject, as through image as language: for some reason of his own, Cézanne needed the movements of Millet's mower – and he took them.

Comparable image/style 'dialogues' can be found between Seurat and Millet, and with Daumier too. Since, however, Seurat's debts as a black and white draughtsman to both these artists are well known, I shall only remind the reader briefly of some connections that can be made. In the case of Millet, it is the technical control he achieved with black chalk that plainly influenced Seurat's technique on the one hand, and the romantic atmosphere of his twilight scenes that influenced some of Seurat's choices of subject on the other. Exploitation of the paper's whiteness, as it is allowed to emerge from beneath varying densities of black shading, as a sign for light equivalence, is found in the drawings of both artists. An excellent example of this is found in Seurat's black chalk drawing, *Peasant Gathering Plants* (Fig. 11.24).[55] It may be usefully compared to several Millet drawings of the late 1850s and early 1860s, when he was investigating just this feeling of light at dusk – or light when there is hardly any light. The scenes of dusk illustrated in Chapter 8 may be consulted, perhaps best of all the *Lobster Fishermen at Night* (Fig. 8.23). Seurat has similarly used his black chalk to express two different things: single, nervous lines to define such fragile things as individual stalks held in the man's hand, and at the same time, by constant and rhythmical repetition of surface marks, a gathering darkness of tones on the foreground and on the man's silhouette. The end result – and here the language of drawing reveals its ulterior meaning – is to make the darkness itself tangible and to evoke a situation between seeing and knowing, when the sense of sound (perhaps the leaves rustling) would tell us as much as the sense of sight. Ostensibly an objective drawing, its whole ambiance is romantic.

As well as his drawings of field labourers, so reminiscent of Millet's, Seurat in the early 1880s drew city streets and industrial suburbs, with figures passing mysteriously and ananymously through them, as in the night. It is here that his urban subject matter is often close to Daumier's, although no expressions can be seen on the people's faces. R.H. Herbert has argued that this was due to a particular conscious horror that the young Seurat may have had of the effects of the industrial revolution upon city dwellers, denying their individualities.[56] Certainly there is little romanticism present in Seurat's drawings of railways and docks, other than in a residual, Zola-like sense of dark drama. What is most reminiscent of Daumier in Seurat's urban drawings is the powerful characterisation of certain figures by their silhouettes – the *flâneur* under the street lamp, or the market porter, for example (Fig. 11.25). This *Fort de la Halle* is like a resurrected ghost, still as an Egyptian funerary stele, of Daumier's street workers of the 1850s (cf. Figs. 7.7, 7.8).

If subject was important to Seurat, it was overwhelming to Vincent van Gogh. In his voluminous letters to his brother Theo, and to other artists, he never stopped writing about what he was painting and drawing and what he wanted to express. When Vincent finally decided to become an artist in 1880, the number of drawings he produced in the next five years greatly exceeded the number of his paintings. Even when his paintings did become steadily more prolific, over the last five years of his life, he never stopped developing his drawing style, which became as it were the very basis of his particular visual language. A number of commentators have noticed that in his letters themselves, drawings frequently appear interspersed with the text – sometimes, even, the text appears to be

11.26 Van Gogh. *The Diggers* (after Millet). 1880.
Pencil, charcoal and red chalk, 37 × 62. Otterlo,
Rijksmuseum Kroller-Muller (Inv. 958–28).

written round the drawings of pictures and projects that he is engaged upon.
Subject and method were thus inextricably intertwined, for him. Understand-
ably, when he was not discussing his own art he was writing about other artists
and, particularly in his early letters, he lists their names in droves, as though
continually calling up some Last Judgement Day for artists. Of interest in our
present context is that among the older artists Millet and Daumier are two of the
most frequently mentioned in these heavenly roll-calls, along with Rembrandt,
Delacroix, Corot, Jules Breton and the Dutch artist Jozef Israels. The reasons for
his constant references to Millet and Daumier respectively differ slightly.

Van Gogh's first reference to Millet is in a letter to Theo written from London
in January 1874, when he was a schoolteacher there. He expresses unqualified
praise for Millet's '*Angelus*', a picture of which he bought an engraved
reproduction in 1876 and copied in a drawing of 1880. When working at his
uncle's gallery in Paris he reported going to see the Millet Studio Sale at the Hôtel
Drouot in 1875.[57] Thereafter his enthusiasm for realist artists who produced rural
and urban images of the common people became quite omnivorous for a while,
and not particularly discriminating, although Millet was always present among
those who, as he put it, 'may become the source of new thoughts.[58] In October
1880 he made a large copy, in pencil and charcoal, of Millet's etching *The Diggers*
(Fig. 11.26) from a photograph.[59] He used very heavy pressure with the pencil,
and the charcoal for toning; there are also streaks of red chalk in the sky, which
perhaps is an attempt to convey a sense of colour, as for an evening sky. The
effect is a very spacious vision of a landscape, stretching out beyond these two
lonely figures working so vigorously: they might signify the brothers Van Gogh
themselves.

Daumier enters into Vincent's correspondence in 1881, in the context of his
ambition at that time to become an illustrator of papers and books – he admires
'those studies from life, sometimes of startling realism, which have been drawn so
masterfully by Gavarni, Henri Monnier, Daumier . . . '.[60] Writing to Theo again
from the Hague the following year, he remembers having been 'very much
impressed . . . by a drawing by Daumier, an old man under the chestnut trees in
the Champs Elysées (an illustration to Balzac) . . . something so strong and manly
in Daumier's conception'.[61] There are several more references to Daumier and
Gavarni in the Hague letters to Theo, admiring their realism but placing them on

11.27 Van Gogh. *Peasants Working in the Fields.* 1888. Reed pen and ink, 26 × 34.5. Amsterdam, Rijksmuseum Vincent Van Gogh (Inv. F1090).

a lower plane than artists like Millet, Breton and Israels, because the latter have more 'noble and serious' sentiments. However, when Theo tells him about Daumier's portraits of the deputies, and pictures like *The Third Class Railway Carriage* and *Le Révolution (sic)*, he writes 'in my imagination Daumier becomes more important because of it'.[62] It sounds as though Theo had seen the 1878 Daumier exhibition, or works from it at Durand Ruel's, and accepted Daumier's new elevation among the dealers to that of '*artiste-peintre*'. Vincent keeps asking Theo to tell him more about Daumier, and by the end of 1882 he is collecting Daumier prints. Thereafter his references to Daumier are fairly continuous through his remaining career: he asks Theo to buy him Daumier lithographs to decorate his studio at Arles in 1888, and the basis of his admiration seems to have been what he regarded as his absolute realism, which he equates with a kind of moral quality, parallel to contemporary realist literature. Thus, writing again to Theo from Arles about his studio and the environment, he says, 'Its surroundings, the public garden, the night cafés and the grocer's, are not Millet, but instead they are Daumier, absolute Zola'.[63]

Millet was, for van Gogh, both a father figure and a saint. He loved Millet's identification with the peasants (this had now become a legend, which he accepted uncritically, lock, stock and barrel). He also admired Millet's humility. When struggling hard to fight his way out of Nuenen to launch his own career as an original artist, he wrote to Theo, ' . . . I always think of what Millet said, '*Je ne veux point supprimer la souffrance*, car souvant c'est elle qui fait s'exprimer le plus energiquement les artistes . . .'. At this time Sensier's biography of Millet, with its heavily slanted picture of the bibical peasant painter and his heroic sentiments, was now available. In this same letter, Vincent continues, ' . . . when reading Sensier I was struck by his saying [something to the effect that] *puisque j'y vais en sabots, je m'en tirerai* [because I go there in clogs, I shall be able to manage]. That's what Millet did . . . and I repeat, Millet is *father Millet* . . . a guide and counsellor . . . '.[64] There is much more in the same vein.

11.28 Daumier (after). *Physiologie du Buveur – les quatre ages*. 1862. Woodcut by G. Maurond, published in *Le Monde illustré*, 25 October 1862, etc.

As Van Gogh became increasingly confident in himself as an artist (we are not concerned here with his biographical details), it becomes evident from the letters that while his admiration for Millet's imagery never lessened, he came to regard his techniques as out of date,[65] lacking in colour if not in drawing. Also he began to realise that the content of Millet's pictures referred to a bygone era.[66] By the time he reached Arles in 1888, Vincent was experimenting with and inventing a wide range of drawing techniques, especially with a reed pen, which he used with a kind of Japanese concentration on virtuoso stroke-making. But the object of his researches was still the same as Millet's had been: to find new notational systems that would serve him to 'read back' his drawings as paintings. A drawing like *Peasants Working in the Fields* (Fig. 11.27) is a direct descendant of Millet's pen drawings of landscapes (cf. Fig. 8.25), combined with his studies of peasants bending to various tasks, except that in Van Gogh's case the peasants seem to be modernised in dress, and also to be working as a co-operative group, under the guidance of overseers.[67] And much as he admired Millet's drawings, when he came to make his extraordinary series of twenty-one copies after Millet at St Rémy in 1889, he made them as oil paintings. Some of his sources were engravings (*Les Travaux des champs*), and others drawings – for example, Theo sent him a photograph of Millet's pastel '*The First Steps*' in October 1889, a photograph in black and white which he squared up and produced from it the remarkably colourful painting now in the Metropolitan Museum, New York. 'Doing Millet's drawings in painting' was a deliberately conceived project: '. . . it seems to me that painting from these drawings of Millet's is much more *translating them into another tongue* than copying them', he wrote.[68]

If Millet, then, remained a 'guide and counsellor', the lessons from Daumier must have been harder for Vincent to absorb. It is interesting that when he did choose a Daumier print to copy at St Rémy, it was one with an overt moralistic content. The woodcut after Daumier's design, *Physiologie du buveur – les quatre ages* (Fig. 11.28), was first published in *Le Monde illustré* in 1862, and appeared again in 1865 and 1868.[69] Van Gogh began to copy it, in oils, in January 1890 (Fig.

202

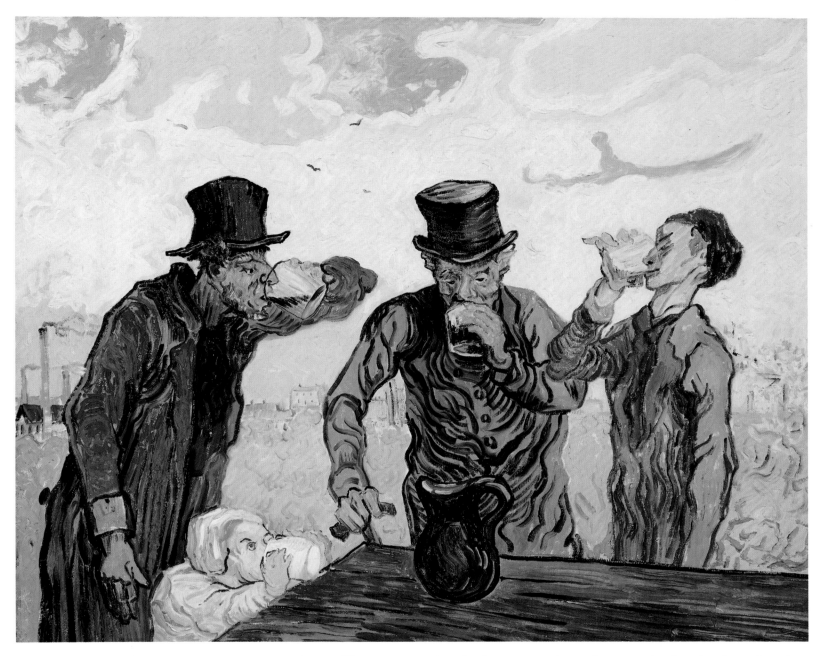

11.29 Van Gogh. *The Topers* (after Daumier). 1890. Oil on canvas, 60 × 73. Chicago Art Institute.

11.29).[70] In two very brief references to this in letters to his brother he referred to it as 'Men Drinking', and made no comment on its supposed allegorical content (like Daumier himself, Vincent was not keen on allegories!). He said he found it very difficult – in fact, we can see that he invented a landscape background for the scene, which he made the outskirts of an industrial town. In this painting, he has revitalised a second-hand image (engraved *after* Daumier) into an idea of his own of what Daumier stood for as an artist. Even if some of Van Gogh's social philosophy may now seem as homespun as his religion, his early insight into Daumier as having 'a passion which can be compared to the white heat of iron'[71] was not far off the truth.

It is appropriate that Vincent Van Gogh, perhaps the most inventive artist of an exceptional generation of inventors in the linguistics of drawing, should so clearly acknowledge his debt to the two draughtsmen who have been the cause and *raison d'être* of the exposition in this book.

APPENDIX 1 *The Use of Perspective Constructions by Daumier and Millet*

MILLET NOT INFREQUENTLY used a construction known as an *échelle fuyante* to establish the scale of figures in landscapes.[1] A sheet of drawings in Boston Musem of Fine Arts (Fig. A.1) uses this construction to establish the scale of a woman drawing water for a cow by a well, in relation to the farm building to the left of them and also to a notional figure standing in the doorway. The artist's eye level and the vanishing point are indicated to the right of the well. More subtle is the tiny sketch to the upper right, which B.A.R. Carter thinks may be based upon a 'distance point construction' to try out different eye distances between the artist and the subject represented in the larger drawing, which would affect the character of his perspective.[2] In the lower right sketch on the same sheet, Carter thinks that the lines reaching out to the left are searching for a vanishing point for the converging lines of a building whose front is only at a slight angle to the picture plane. The artist's problems do not appear to have been resolved on this sheet, but we may deduce that he was trying out a scheme for incorporating the well from his native Gruchy into a Barbizon farmyard. The fact that these constructions are drawn over an earlier sketch of the *Porte aux Vaches* indicates that Millet picked up this sheet again after he returned to Barbizon from Normandy.[3]

A rare perspective drawing by Daumier treats a problem of enclosed space in a more unusual manner (Fig. A.2).[4] It is a study for his painting *Les Laveuses du Quai d'Anjou* (Fig. 8.21).[5] He seems to have deliberately employed several vanishing points and two eye levels in 'vertical axis perspective'. In order to conceive this peculiar spatial relationship between the two washerwomen on the steps leading down to the river, B.A.R. Carter has suggested that there might actually have been two flights of steps facing each other and that Daumier himself moved up and down the other flight (mentally at least) to change his eye level for perceiving each figure. Carter is convinced that Daumier has *not* simply tilted the picture plane to follow the direction of his gaze, since this would have made his verticals convergent. After a close analysis of the design on Daumier's canvas (which happens to be a root–2 rectangle i.e., the rectangle which folded in half makes two reciprocal rectangles), and comparing the way that it is represented in the upper part of his drawing with the 'box interior' shown in the lower part, Carter concludes that an axial construction can be seen there. That is to say, there are two horizon lines, one above the other, with central vanishing points on a vertical line which bisects the canvas. (These are drawn in the 'box interior' sketch.) The lower horizon line, it would appear, is intended to coincide with the square of the short side of the canvas, measured from the top. In the painting this line would be about the level of the approaching woman's right hip. A second, higher, vanishing point is found on the same vertical axis, not quite as high as the

Fig. A.1. Millet. Sheet of perspective studies, including *Woman Drawing Water for a Cow. c.*1853–4. Black chalk on blue-grey paper, 30 × 31.8. Boston Museum of Fine Arts (Inv. 61.624).

Fig. A.2. Daumier. Perspective study for *Les Laveuses du Quai d'Anjou*. Black chalk, 18 × 12. Private collection.

corresponding square of the short side would be, measured from the bottom. In the painting this line would be at about the level of the third step from the top of the flight. (Its position is deduced from the convergence of the orthogonals of the edge of the parapet on the left and the top of the railings on the right.) In order to reconcile these separate vanishing points Daumier appears to have 'splayed' the wall on the left outwards, in plan. (Carter thinks he did not like the very steep angles of the wall that the lower vanishing point would have given.) As a result of this splaying, the horizontal lines of the wall in the painting no longer converge to a central vanishing point, but to a new vanishing point further to the right, under the arch of the bridge, on the lower horizon line. This is yet another instance of axial perspective that Daumier's 'perspective box' suggests he had in mind: dotted lines lead to the third vanishing point.[6]

With this painting in mind I checked the height and steepness of some of the flights of steps that lead down from the street level of the Quai d'Anjou to the quai itself. They do indeed occur in pairs at various points along the quai between the bridges (the bridge in the distance in Daumier's picture is the Pont Marie), but not in a relationship that could make Daumier's visual source susceptible to literal transcription. His perspective construction, in other words, is an imaginative one. Moreover, on those flights that go down to the lower level nearer the water there

are 37 steps, whereas in Daumier's painting there are only 24, which suggests that the viewer might be conceived as part of the way up the stairs, meeting the washerwoman coming down. Such stairs down to the water existed on the Ile St Louis from at least the middle of the eighteenth century[7]: one flight was directly in front of Daumier's house. The flight illustrated in my photograph (Fig. 8.22) is not necessarily that in Daumier's picture, but it indicates the character of the site. The iron railings are unchanged today.

The design of Daumier's *Les Laveuses* is so subtle that Carter suspects he did it with the help of a professional *perspecteur*, since, as he puts it, 'painters of that age no longer had a very thorough grasp of perspective geometry versus natural perspective (geometrical optics) and were demonstrably not up to *sotto in su*'.[8] We noticed a link between Millet and Daumier in this respect (Chapter 1, p.10) when Millet was so anxious to find out the address of Daumier's *perspecteur* in 1864, who was 'donné comme très habile', when he was engaged upon his illusionist ceiling for the Hôtel Thomas commission. Daumier's notional *perspecteur* for *Les Laveuses* would certainly have been familiar with the general principles of design such as the harmonic divisions of rectangles, even if Daumier was not.[9] One wonders how many other perspective sketches by Daumier may have been lost or destroyed.[10] What is interesting about both the urban and rural landscapes of Daumier and Millet is that they should use such traditional, academic devices as perspective constructions and yet at the same time be capable of such imaginative designs to express the feeling of their subjects. There is nothing 'impressionistic' about their art in this: the deliberation with which they developed their pictorial designs seems more in tune with the classicising, Renaissance spirit of Degas and Seurat (see the Chapter 11).

APPENDIX 2 *The 1855 Scheme to Illustrate La Fontaine's Fables*

THE DISTRIBUTION OF La Fontaine's *Fables* to be illustrated by the seven artists listed in the 1855 scheme is described by Alfred Sensier in *Souvenirs sur Th. Rousseau*, Paris, 1872, pp.230–2. Since this book is not readily available in some parts of the world, the gist of his information is given here.

Each artist in the group was allowed his speciality, for creating according to his aptitudes. The list includes Delacroix who, one is given to understand, was to be approached (there is no evidence that he was at any meetings). The following list is a summary of Sensier's material, rearranged for greater clarity:

Barye (sculptor) ('les lions et tous les animaux sauvages'):
Les Animaux malades de la peste VII–1
Le Lion devenu vieux III–14
Le Corbeau et le Renard II–1
– these were to be painted.

Daumier ('l'ironie et les moralités populaires')
Le Villagois et son Seigneur [*sic*] IV–4
– actual title is *Le Jardinier et son Seigneur*
Le Cygne et le Cuisinier III–12
L'Ecolier et le Pédant I–19
(= *L'Enfant et le Mâitre d'École*) executed
L'Astrologue (*qui se laisse tomber dans un puits*) II–13
Le Savatier et le Financier VIII–2
L'Huître et les Plaideurs IX–9
L'Ivrogne et sa Femme III–7

Diaz ('le caprice coloré et les folies d'Espagne')
L'Homme entre deux âges et ses deux maîtresses I–17
La Jeune Veuve VI–21
Les Devineresses VII–15
La Vieille et les deux servantes V–6

Jules Dupré ('les fermes et les pacages [pasture lands]')
La Grenouille et le Boeuf I–3
Le Cerf se voyant dans l'eau VI–9
Le Charretier embourbé VI–1
– these subjects were 'réservés' for Dupré: perhaps he was not present.

Millet ('le rustique et le paysan')
Phoebus et Borée executed VI–3
Le Laboureur et ses enfants V–9
L'Alouette et ses petits [avec le Maître d'un champ] IV–22
L'Ane et les deux voleurs [*sic*] I–13
– Millet expressed an interest in this subject much later, in 1867. (Daumier, however, had already treated it in two drawings and a painting of about 1852, and he would repeat it again in a lithograph of 1862.)
La Mort et le Bûcheron executed I–16
– this subject turned into the painting he submitted to the Salon in 1859; there are drawings related to it.
Le Berger et la mer executed IV–2
La Forêt et le bûcheron XII–16
Le Paysan du Danube XI–7
Le Philosophe Scythe XII–20

Rousseau ('les solitudes, les forêts et les marécages')
Les Grenouilles qui demandent un roi III–4
Le Coche et la Mouche VII–9
La Mort et le Mourant VIII–1
Le Chêne et le Roseau executed[1] I–22
Les Lapins[2] X–14
Le Loup et l'Agneau I–10
La Cigale et la Fourmi[3] I–1

In addition to the above, they were going to ask Delacroix for the following five subjects:

Delacroix ('le mythologie, l'héroique et le fabuleux')
Les Compagnons d'Ulysse XII–1
Le Dragon à plusieurs têtes et le Dragon à plusieurs queues I–12
Simonide préservé des Dieux I–14
Le Songe d'un Habitant de Mogul XI–4
Jupiter et les tonnerres VII–20

NOTES

The following abbreviations have been used in the notes:

Adhémar, *Daumier* for Jean Adhémar, *Daumier*, Paris, 1954

Maison for K.E. Maison, D *Honoré Daumier Catalogue Raisonné*, Vol. I (Paintings), Vol. II (Watercolours and Drawings), London, 1968

Moreau-Nélaton for Étienne Moreau-Nélaton, *Millet raconté par lui-même* (3 Vols), Paris, 1921

Sensier, *La Vie* for Alfred Sensier, *La Vie et l' œuvre de J.-F. Millet*, Paris, 1881

other than these the short title system has been used.

1 LINKS BETWEEN DAUMIER AND MILLET

1. Nothwithstanding his final retirement to the little village of Valmondois, within walking distance of Auvers-sur-Oise, important for its associations with Daubigny, Camille Pissarro, Cézanne and eventually Van Gogh.

2. As reported by Edmond Duranty in his articles on Daumier in the *Gazette des Beaux-Arts* (1878) Part I, p.436.

3. It may also be inferred that he used non-greasy chalks for his initial designs. See B. Laughton, 'Daumier's Drawings for Lithographs', *Master Drawings*, 22(1), 1984, pp.56–63.

4. K.E. Maison, the most recent cataloguer of the drawings, lists 826 items, differing from Fuchs in a number of attributions. Only a very few more genuine drawings have come to light since 1968. When one compares this figure with the more than 4,000 lithographs produced over a period of forty years, as catalogued by Loys Delteil, and the 950 woodcuts reproduced in Eugene Bouvy's volumes, it becomes obvious that an enormous number of Daumier's drawings must have been lost or destroyed during his lifetime, because unless they were made specifically for sale he simply did not value them.

5. A significant detail is that Daumier's name appears as *H. Daumier lithographe* (not as *peintre*) among the lists of names signing a petition of protest against the harshness of the Salon Jury in 1840. See *Dossier du Salon de 1840* (Archives du Louvre), and also the article by William Hauptman, 'Juries, Protests and Counter Exhibitions before 1850', *Art Bulletin*, 67, March 1985, pp.95–109. But Daumier's name is 'writ large' on the first draft page of the 'suite des signatures', before they were put into order by

6. These two were neighbours of Daumier's in 1847, living at 17 Quai d'Anjou, the Hôtel Pimodan. All commentators on this period have noted the literary gatherings that took place at the Hôtel Pimodan, which included Théodore de Banville, Champfleury, and Balzac, and some distinguished *amateurs*, as well as artists. Delacroix himself was a visitor. The relative grandeur of the Hôtel Pimodan would have been in contrast to the earthy squalor of Daumier's own studio down the street.

7. Thomas Couture (1815–79), who had been a fellow pupil of Millet's in the studio of Delaroche, was generous enough to heap praise upon the latter's *St Jerome Tempted* which was refused from the Salon of 1846, but Couture's own subsequent rise was so meteoric that little further contact with his more reticent friend could have been expected.

8. *Manière fleurie* was a term invented by Millet's first biographer, Alfred Sensier, to describe a kind of neo-rococo painting style of brushwork which he frequently employed in the mid-1840s.

9. Champfleury, *Histoire de la Caricature Moderne*, Paris, 1865, p.177 of 3rd edition, 1884.

10. See B. Laughton, 'A Group of Millet Drawings of the Female Nude', *Master Drawings*, 17(1), 1979, pp.44–50.

11. See B. Laughton, 'Millet's *St Jerome Tempted* and *Oedipus taken down from the Tree*', *Bulletin of the National Gallery of Canada*, 24, 1974, pp.2–12; and 'Millet's *Hagar and Ishmael*', *Burlington Magazine*, 121, Nov. 1979, pp.705–11.

12. For example the review by Ernest Filloneau of the annual exhibition of the 'Cercle de l'Union Artistique' at the rue de Choiseul in 1864, in which he 'found a considerable difference between the drawings and paintings of Millet', the heaviness and ugliness he found in the latter being absent in the drawings which nevertheless retained his exquisite sentiment for his rural figures. *(Moniteur des Arts*, 15 March 1864). It transpired that he had seen the drawings at Alfred Sensier's house, not in the gallery, which was showing two paintings only, *Woman Carrying Buckets of Water* and *Shepherd Herding his Flock by Moonlight*.

13. C. Pissarro, *Letters à Lucien*, ed. J. Rewald, Paris 1950, p.149. See below, Chapter 11 p.000, for a fuller account of this incident.

14. R.L. Herbert, 'Millet Revisited', *Burlington Magazine*, 104, July 1962, p.301 ff.

15. *'Drawing'*: 'the trace left by a tool along a surface particularly for the purpose of preparing a representation or pattern' (*Oxford Companion to Art*, 1970).

The mediums we find most commonly entering this definition are chalks and crayons (usually but not necessarily of one colour in the same drawing), charcoal, pen, pencil, and varieties of metal point. Under the last heading I would include etchings drawn by the hand of an original artist, although these are commonly included under the heading of 'graphics'. Equally I shall consider Daumier lithographs as drawings, because he himself drew the final images in lithographic crayons and they were printed unaltered. A further broadening of the definition must include watercolours and diluted inks, whether applied in patches of colour or tone on a linear framework, or used directly to define large contours by means of a brush. The incorporation of various drawing mediums in the construction of *oil paintings* by both Daumier and Millet seems to me to be a significant reflection of their manners of thinking.

But I am not satisfied with a definition of drawing that uses merely technical parameters. Obviously the Italian term *disegno* as used from the High Renaissance onwards carried more philosphical connotations, to do both with the conception of original designs and with the expression of phenomena as perceived in a certain way: specifically a linear way. It is this quality of expression in line that carries still further connotations of expressive *gesture* (conscious or unconscious) that in 'original' artists leaves traces of a personality ('the trace left by a tool').

16. This awareness is best expressed in Delacroix's own words. See the introduction to Raymond Chappuis' *The Drawings of Cézanne* Geneva, 1973, p.29, n.16, where he quotes Delacroix's letter to Peisse (15 July 1849) concerning drawing, as untranslatable without losing its character. With great temerity I would freely render it thus:

> 'However, if you are a colourist you will succeed in making clear through a simple mark (on the paper) that I have a relief, a thickness, a body. How do you succeed in this? By not resting equally on all parts of the contour, by making it very flowing, almost interrupted at certain places, by defining it in other places with the help of a second mark,

and if necessary, a third or else by means of a heavier line, thickened, which must take care not to be an iron wire, because everywhere I have seen a relief . . . there is no opacity in the contour which indicates it; neither the light which breaks off at the contour, nor the shadow which slides over it have any graspable stopping-point.'

The French text runs:

Pourtant, si vous êtes coloriste vous viendrez à bout avec le simple trait à faire comprendre que j'ai un relief, une épaisseur, un corps. Comment en viendrez-vous à bout? En n'arrêtant pas également partout ce contour, en le faisant très délié, presque interrompu en certains endroits, en l'accusant en d'autres endroits au moye d'un second trait et, s'il le faut, d'un troisième ou encore au moyen d'un trait élargi, engraissé, qui se garder a bien d'être un fil de fer, car partout ou j'ai vu un relief . . . il n'y a pas d'opacité au contour qui l'indique; ni la lumière qui frappe le contour, ni l'ombre qui glisse dessus n'ont de point d'arrêt saisissable'. *Correspondence Générale de Eugène Delacroix*, ed. André Joubain, Paris Plon. 1938, Vol. II, p.388.

17. See W. McAllister Johnson, *French Lithography: The Restoration Salons 1817–1824*, Agnes Etherington Art Centre, Kingston, Canada, 1977, p.7 and *passim*.

18. Two 'Quittances de loger' preserved among the Millet papers at the Bibliothèque Nationale (Moreau-Nélaton Bequest, Snr boîte 6) prove that Millet rented these premises from 29 June 1849 to 1 April 1854 inclusive. An annotation by Moreau-Nélaton on a letter of 1853 indicates that this was a room on the third floor.

19. A page is reproduced in part in T.H. Bartett, 'Barbizon and Jean-François Millet', *Scribner's Magazine*, May 1890, p.550. The year can be deduced from Daumier's age as inscribed: 44. Unfortunately the present owner of some of Ganne's hotel registers, Mme Gauthier, has found no further reference to Daumier.

20. Frequently published, e.g. in Raymond Escholier, *Daumier*, Paris, 1923, p.72. In the same publication it is evident from a letter from Daumier to Rousseau (p.71) that the Daumiers had become accustomed to staying at their friends' houses in Barbizon by this date, which would explain the absence of further entries in the register of the Hôtel Ganne.

21. Adhémar, *Daumier*, p.46.

22. Some 600 letters and notes by Millet are preserved in the Cabinet des Dessins in the Musée du Louvre, most of them being written to Sensier. Only a proportion of these are published in Sensier's and Moreau-Nélaton's books (see Bibliography). Transcripts of an almost equal number of letters from Sensier to Millet, mostly unpublished, are in the same location. I am extremely grateful to M. Maurice Serullaz, formerly Chief Curator of the Cabinet des Dessins, to Mlle Rosaline Bacou, his successor, and to Mlle Françoise Viatte, now Chief Curator of the Département des Arts Graphiques, for permission to consult these.

23. They were staying with Théodore Rousseau. A letter from Daumier to Rousseau dated 12 September 1861, announcing their imminent arival at Barbizon, proves that they stayed for several days. See Y. Zolatov, 'Lettres des peintres français du XIXe siècle dans les archives sovietiques', *Revue de la civilisation mondiale*, 2 1959.

24. Agreement with his new landlord, a Mons. Z. Demussy, was signed on that date (see J. Cherpin, *Daumier et la Sculpture*, Paris, 1979, p.198.) His final *pied-à-terre* address in Paris, however, was in the Boulevard de Clichy. Again Sensier knew this.

25. On 2 January 1855, Millet wrote to Sensier saying he was astonished that Jean had not been to see him, and asking him to enquire of Jean's concierge if he had been seen around as usual.

26. The French text of this letter, as transcribed in the Cabinet des Dessins, is as follows: 'Vous savez combien l'état de Madame Jean était lamentable: santé, moral et affairs! Madame Daumier est allée à Asnières et y a fait *un coup d'état* [my italics]. Elle a dit à Jean nombre des tristes verités, lui certifiant que sa peinture ne se vendrait jamais, que son genre de vie n'aboutirait que'à la ruine et à la mort de sa femme. Mais, comme il réfugiait dans les approbations que vous, Rousseau, Daumier et moi semblions lui donner, elle lui a dit (sans m'en demander conseil, bien entendu) que nous pensions tous de même à son sujet, et que son seul salut était de reprendre la sculpture.'

'Jugez de l'effarement de Jean. Il est resté trois jours sans dire un seul mot; puis, le quatrième, il est arrivé chez Daumier en disant qu'il était décidé *à tout même à la sculpture.* Daumier l'a immediatement envoyé au sculpteur ornamantiste de l'Opéra, où, depuis huit jours, il travaille.'

27. This is a free translation combined from the original letter in the Cabinet des Dessins (Louvre), and its transcription by Moreau-Nélaton in the Cabinet des Estampes (Bibliothèque Nationale). The slightly odd phraseology of the French may have been due to Millet's own state of mind at the time of writing it.

28. Moreau-Nélaton, II, p.165. He does add, however, that Jean-Baptiste was an artist without a pressing sense of vocation, that he was in constant debt, and that he quickly returned to his life of expedients.

29. Ibid. p.163, and Sensier's letter to Millet dated 4 June 1864.

30. Julia Cartwright, *J.-F. Millet: His Life and Letters*, London, 1896 (2nd edn, 1902, p.158).

31. Alfred Sensier, *Souvenirs sur Théodore Rousseau*, Paris, 1872.

32. When, after Rousseau's death in December 1867, Sensier visited Mme Rousseau in hospital, he found her completely dotty, talking about her husband as if he was alive at Barbizon, and about 'poor Daumier who has died so quickly after a paralysis, and his unhappy wife who has gone mad and is going to be sent to Charenton . . .'.

33. Delicate, because of Mme Rousseau's condition. She did go to Charenton, and died soon after, in February 1869.

2 DRAUGHTSMANSHIP IN FRANCE, c.1800–50

1. Arlette Serullaz, in *The Age of Neo-classicism*, London, Arts Council of Great Britain, 1972, Cat. entry no. 62.

2. It was one of five such detailed studies, covering among them all the figures in the final composition. Three of these are in the Musée Bonnat, Bayonne, and the other two in the Musée des Beaux-Arts, Angers, all of a scale with each other. The whole composition had already been broadly determined in a finished drawing in pen and ink (Musée Wicar, Lille) which precedes the five drawings and was modified for the final composition.

3. See Julius S. Held, *Rubens: Selected Drawings*, London, 1959, p.98.

4. See, for example, the enormous number of working drawings left in Ingres' atelier at his death, which he donated to his native city of Montauban. There are some 4,000 of them, of which the largest group consists of studies for compositions. Cf. Exh. *Ingres Drawings from the Musée Ingres at Montauban . . .*, London, Arts council 1979, and bioliography in Daniel Ternois, *Les Dessins d'Ingres au Musée de Montauban*: Les Portraits, Inventaire général des Dessins des Musées de Province III, Paars 1959

5. Michael Jaffé, *Cent Dessins Français du Fitzwilliam Museum*, Heim Gallery, Paris, 1976, p.52.

6. Ingres had witnessed the execution of David's *Madame Récamier*. The connection can be made by comparing the position of the feet in the two drawings on this sheet. In the top drawing, Ingres has crossed the model's right leg over her left, as in David's pose for the portrait. In the bottom drawing Ingres changes this, putting her left foot over her right calf, creating a more provocative twist in her whole position, which he adopted for his *Grande Odalisque*.

7. By Lorenz Eitner, in 'Géricault's Wounded Cuirassier', *Burlington Magazine*, 96, Aug. 1954, p.237 ff.

8. The inscription at the top, partially cut, reads *[cuir]assier le Empire/leur de la garde 2e Empire*, and *1814*.

9. The combination of watercolour, pencil and pen was a traditional French procedure when making precise composition studies for pictures. David made neatly executed sketches of his large figure compositions in this way. Géricault, however, is here employing the same media to give an impression of *plein-air*.

10. Meaning, in such a case, 'to the pumps!' in the sense of 'Fire! Fire!' Ten days before the publication of Daumier's *Water Carrier*, *Charivari* had published a print by him with the caption *Traquenards Politiques*, which showed people setting political gin-traps (LD 206, 8 & 10 March 1835).

11. It's then, the great revue,
When in the Elysian fields
At the midnight hour
Umpteen Caesars die! . . .

(Sedlitz, German poet)

12. The composition of the lithograph is reminiscent of Gros' painting *Napoleon on the Battlefield of Eylau* (1808), although Raffet has substituted a line of charging ghost-cuirassiers for Gros' dead and dying troops in the foreground.

13. 1863 was the year when Giocomelli's *Raffet Oeuvre Catalogue* was published. Since Giocomelli was the first owner of Daumier's drawing, Adhémar assumes that he commissioned it (*Daumier*, note to Plate 136).

14. So popular did Decamps become that in the 1855 Paris Exposition Universelle he was one of four French artists given especially large representation by the official organisers (the other three were Ingres, Delacroix and the battle painter Horace Vernet). For further discussion of the significance of this, see Patricia Mainardi, *Art and Politics in the Second Empire*, New Haven and London 1987, p.49 ff.

15. For example, there is a lithograph by Jeanron in *La Caricature*, no. 68 (proof in Bibl. Nat.) entitled *Il meurt d'inanition pour avoir vécu trop longtemps d'ésperance*, which shows a young man in a top hat, rifle on the ground, looking down upon a cornucopia which hangs over a wall like a dead snake, labelled 'Révolution de Juillet'. It spews documents headed 'Loi', 'Liberté de la Presse', 'Egalité devant le loi', etc., all of which look very limp. Another Jeanron lithograph shows a worker, stripped to the waist and chained by the ankle and wrist, staring up at a sky crossed by departing swallows, representing hope.

16. The history of the images of *Les Cris de Paris* goes back at least to the fifteenth century, and is a subject for study in itself. Edmé Bouchardon was the author of a particularly famous series of sixty drawings, done in a realistic manner, called *Etudes prises dans le bas peuple, ou les Cris de Paris*, which the Comte de Caylus had engraved, and which were published in five sets issued between 1737 and 1743. Some of these plates were even touched up and re-used to illustrate certain articles in the quasi-sociological series of volumes, *Les Français peints par eux-mêmes*, 9 vols, Paris (Curmer), 1840–2.

17. In the right background the defeated Bourbon king, Louis X, is expiring, by implication as the result of an encounter with 'the press' – here represented as a printer in working clothes, dominating the foreground. In the left background the new king, Louis-Philippe, appears, in bourgeois dress and brandishing his umbrella menacingly, urged on by a lawyer but restrained – barely – by a politician. In view of this very clear reading of events, I strongly suspect that Daumier composed this design upon the stone to be 'read' from left to right, so that we must now read it from right to left in the inversed print.

18. 'Je ne partage pas toutes les idées ni toutes les tendances de cet excellent Jeanron, mais c'est un brave coeur qui a la passion de son art et qui en possède à fond l'histoire.' This text was quoted by Millet in his letter to Sensier dated 14 March 1865 ('J'ai reçu tantôt une lettre de Siméon Luce datée de Marseille . . .'). Published in Moreau-Nélaton, II, p.171.

19. I should emphasise that this chapter is not intended to be an encyclopaedic guide to French nineteenth-century drawing. If that had been the case, many other artists of quality would have required illustration, for example Guérin, Girodet, Gérard and Gros after David; Chassériau and Flandrin after Ingres; Isabey and Lami alongside Charlet and Decamps; Riesener after Delacroix; etc., etc . . . All that is attempted here is a broad overview of Daumier and Millet's inheritance. The choice of examples consists of drawings and prints that are not only relevant but have also been seen by the writer.

20. 'Free spirit' is a modern term that might perhaps be used as one possible idiomatic translation of the French *brave coeur*.

21. See the Exhibition *Le Rôle du dessin dans l'œuvre de Delacroix*, Paris, Musées Nationaux, 1963, as well as the great *Delacroix Memorial Exhibition* held at the Louvre in the same year.

22. 'Le realisme devrait être defini l'antipode de l'Art . . .' (*Journal de Eugène Delacroix* ed. André Joubin, Paris, Plon, 3 vols., 1932. Entry for 22 February 1860).

23. I am aware that the word 'colour' can be used with different meanings, as in 'colour' in literature, music, and thoughts generally, apart from its scientific meaning as spectrum colour(s) transmitted to the retina by light waves of varying lengths. I also believe that 'colour' as used by artists is only relatively scientific in its application as equivalence to visual phenomena (*pace* Seurat!), and, furthermore, that it can be imagined, or felt, in black and white notations.

24. This drawing is related, of course, to his painting *L'Homme à la pipe* of the same date, for which it might be a kind of 'warm-up' in looking at the model (himself). A comparable drawing, made for a similar purpose, is of the heads of the two girls in the painting *Les Demoiselles au bord de la Seine*, in heavily applied and very greasy black chalk (Lyon, Musée des Beaux-Arts).

3 MILLET IN PARIS

1. Reported conversation with Millet in 1847, 'quoted' in Sensier *La Vie*, p.100. The striking metaphor is so characteristic of Millet that there is every reason to believe that Sensier's recollection may be correct.

2. It is hardly suprising that free translations vary. Compare two other renderings of the last phrase: 'a battle, a mill in which one is ground up' (Robert J. Wickenden, 'A Jupiter in Sabots', *Print Collectors' Quarterly*, (1), 1916, p.144); 'A complex of wheels in which one is crushed' (T.J. Clark, *The Absolute Bourgeois*, London 1973, p.72) It partly depends upon what the translator is trying to prove!

3. The ambiguity of the 'wounded man' reminds one of Goya's famous tapestry design of the worker being helped on a scaffolding, called 'wounded' but with no visible sign of damage. Sensier (*La Vie*, p.104) mentions among Millet's 'realist' paintings of *c*.1847–8 one entitled *Le Lundi de l'ouvrier*, which he describes as 'un homme ivre que deux compagnons soutenait sous chaque bras . . .'. Such an image would fit with the contemporary conception of the holiday status of the working class, as opposed to the bourgeois, where the former, unable to afford a suitable 'promenade' on Sundays, got drunk in the suburbs on a Monday instead. Visually the Cardiff painting is simply not explicit, and either title could be applied to it. *The Good Samaritan*, however, might have been a more saleable title.

4. See B. Laughton, 'Millet's *St Jerome Tempted* and *Oedipus taken down from the Tree*: the Discovery of a Lost Painting', *Bulletin of the National Gallery of Canada*, 24, 1974.

5. 'Quarriers hauling on a winch some rough-cut stones from Charonton', in Sensier, *La Vie*, p.104. No such painting has been traced.

6. Professor Gerald Finley first made this observation to me.

7. For the long ancestry of the 'Wheel of Fortune', see Helen J. Dow, 'The Rose Window', *Journal of the Warburg and Courtauld Institutes*, 20, 1957, p.269 ff. A significant Christian interpretation of the Wheel of Fortune is to see God, rather than the goddess Fortuna, as symbolised by the hub of the wheel, and Fortuna and her kings placed round the rim. Dr Dow illustrates some twelfth-century Gothic rose windows to demonstrate this, for example the 'Wheel of Fortune' on the north transept of St Etienne, Beauvais.

8. A variant of this drawing, formerly in the Dollfus collection, exaggerates the size of the man's bony elbow. The style of both drawings is related to Millet's *manière fleurie* in painting.

9. It is only known to me through the facsimile reproduction in Léonce Bénédite, *Dessins de J-F. Millet*, London (Heinemann), 1906, Plate 38, and Paris (Hachette), frontispiece.

10. See Chapter 2, n.16. A *Tailleur des pierres* is the subject of the first of the 60 engravings published after Edmé Bouchardon's drawings (1737–46), and stonemasons appear a number of times in Diderot's *Encyclopédie* plates (1762–72) under the headings of both *Maçonnerie* and *Marbrerie*, as among the more superior *métiers*. In the nineteenth century they were represented in the *Cris de Paris* of Duplessi-Bertaux (1814) and Carle Vernet (1815).

11. Maison, II, Cat. 258, tries to relate this drawing to the lithograph *Robert Macaire architecte* (LD 395) of 1837, but the small figure in the background there is so insignificant that I doubt the connection.

12. Pen-drawn lithograph, published in *Charivari*, 2 October 1834, LD 209. A prisoner enters, and a coffin exits. Very laconic.

13. LD 1780, unpublished (1848). Marked *inédit*, this proof was presumably suppressed.

14. There are only five lithographs which specifically celebrate the defeat and exile of Louis-Philippe (LD 1743–7), and the last one was not published.

15. This question is discussed at length by Dr S. Osiakovski in 'Some Political and Social Views of Honoré Daumier as Shown in his Lithoqraps', unpublished Ph. D. thesis, University 1957, p.150 ff.

16. For some further comments on the sociology of the quarriers, see Clark, *The Absolute Bourgeois*, p.78

17. See *L'Assommoir* (first published in Paris in 1877) Chapter 6 *and passim*. Zola describes a bolt and rivet factory. He stresses that Goujet is essentially a hand craftsman in his blacksmith's work, and that fine though this work is, he will soon be unemployable in the modern industrial system of Paris. He makes Goujet a republican, though not necessarily an extremist since, he says, the lessons of February and June 1848 had taught the working class to keep out of the political machinations of the bourgeois. Goujet observes riots against Napoleon III's government from a distance: he is not going to 'burn his fingers'.

18. Alexandra Murphy, *J.-F. Millet* (Exhibition Cat.), Boston Museum of Fine Arts, 1984, p.13.

19. The closely wrapped headscarf or soft cap is found on a number of Millet's female figures of this period, from nude bathers to Norman fishermen's wives, as well as on women working in indeterminate locations on the outskirrts of Paris.

20. Murphy, *Millet*.

21. R.L. Herbert, *J.-F. Millet* (Exhibition Cat.), London (Hayward Gallery), 1976, no. 27.

22. M. Moreau-Christophe, in *Les Français peints par eux-mêmes: Encyclopédie Morale du dix-neuvième siècle*, Paris (Curmer), 1840–2, Vol. IV, *Les Pauvres*, pp.97–128.

23. A whole section of Moreau-Christophe's article (ibid) is devoted to 'Enfants trouvés et abandonnés' (children abandoned without identification or given to foster parents). It is stressed that young single mothers are judged very harshly in the greater part of France especially in the western

provinces. An illustration by Pauquet shows a young woman and child begging, dressed very similarly to Millet's *La Mendiante*.

24. Proof deposited in the Bibliothèque Nationale on 5 June 1835.

25. Print deposited in the Bibliothèque Nationale on 14 March 1835.

26. For example, the very fine series of coloured lithographs of the *Cries of London*, published after Wheatley's paintings in 1795 (by Colnaghi & Co.) have a close-grained texture very like Daumier's two prints in the *Revue des Peintres*.

27. Specifically, the swaying movement at the knees is reminiscent of the nephew on the right in Titian's *Pope Paul III with his 'Nipote'* (Naples Museum).

4 DAUMIER: LITHOGRAPHS AND DRAWINGS TO 1850-1

1. Laughton, 'Daumier's Drawings for Lithographs'.

2. Lithograph published in *Charivari*, 19 March 1848, *Projet d'une médaille à frapper à l'hôtel National des Monnaies*. (LD 1745).

3. Three men, one of them a National Guardsman, talk to each other in the street about the spectre of Napoleon. Their discourse (translated), goes:
 'I tell you that I saw Bonaparte on the racecourse.'
 'But that's impossible because I just heard him at the National Assembly.'
 'You are both wrong, for I just passed Place Vendôme a moment ago and he was on top of the column.'

4. See Maison, I, p.29.

5. *Faut-y qu'il en ait fumé des pipes celur-là pour s'être culotté la tête!* . . . (LD 1670). *Charivari's* caption writers seemed to specialise in Parisian working-class patois.

6. Dr Osiakowski first suggested this suggested this interpretation. (See 'Some Political and Social Views')

7. *V'la un particulier qui doit encore être inquiet pour son nez c't'année-ci . . . vu la pidèmie qui règne toujors sur les pommes de terre! . . .* See Comment note 5.

8. 'Mountebank playing a Drum' (British Museum). See Chapter 10, Fig. 10.20, p.174.

9. For a fascinating and detailed analysis of the causes and effects of these popular demonstrations, and the organisation of the socialist clubs, see Peter H. Amman, *Revolution and Mass Democracy*, Princeton University Press, 1975.

10. LD 1688.

11. See Amann, *Revolution*, pp.264–80, on the abortive scheme for a 'banquet of the people' in the summer of 1848.

12. The full caption, for what this may be worth, reads (in translation), 'Citizenesses . . . it is being noised around that divorce is on the point of being refused to us . . . let us encamp ourselves here permanently and declare that the country is in danger! . . .'. Notice the hand appearing from offstage to ring a bell behind the speaker – like the hand of God.

13. Werner Hofmann, 'Ambiguity in Daumier (& Elsewhere)', *Art Journal*, 13(4), Winter 1983, pp. 361–4

14. LD 1848. Unpublished (1849).

15. LD 1888. Unpublished (1849).

16. LD 1912, published in *Charivari* 24 October 1849 as a double-page spread.

17. See Laughton, 'Daumier's Drawings' pp.58–9, for further details on Véron.

18. LD 1679. 'A spectacle or evening entertainment is a good thing for the people of Paris, they go to divert themselves in the evening from the rigours of the day.' The relationship of the figures in the audience to the stage is not unlike the disposition of an important oil painting of Daumier's, *La Drame*, now in Munich, which Maison dated 'about 1860', (I, Cat. I-142). Nearly all of Daumier's other representations of theatre audiences, in paintings, drawings or lithographs, show them as middle class. This lithograph and this painting are, I think, the only exceptions.

19. LD 1985 – *L'Arbre de la liberté*.

20. LD 2002. Published in *Charivari* 16 April 1850. The club is inscribed *Loi/Juré/Presse* in reverse, which suggests that Daumier inscribed it himself. The same club, with the inscription the right way round, appears in another, unpublished version, in which a wild-looking woman (like 'Marianne' of France) is being carried off with difficulty by the diminutive Thiers, in front of the National Assembly building (LD 2001). Was Daumier told to try this one again?

21. For the history of this statuette and its various castings in plaster and bronze, see Jeanne L. Wasserman, *Daumier Sculpture*, Harvard University Press, 1969, pp.161–73.

22. 'Ah! vous avez atteint en plein l'ennemi! Voilà l'idée bonapartiste à jamais pilorisé par vous!' The words, probably apocryphal but fair enough in spirit, are 'quoted' by Arsène Alexandre in *Honoré Daumier*, Paris, 1888, p.295.

23. One of the best informed and most perceptive accounts of Ratapoil as an image with multiple meanings is in Clark, *The Absolute Bourgeois*, pp.106, 116–17, etc. He also notices the odd similarity of *Ratapoil* to some of Daumier's earliest representations of Don Quixote.

24. 10 December 1848 was when Louis-Napoleon was elected President of the Republic. In a lithograph of 1850 (LD 2031) Daumier drew the members of this 'society' beating up the opposition in the street with clubs.

25. LD 2123 (1 July 1851). *Un jour de revue: Ratapoil et son État major*.

26. LD 2117 (15 June 1851). Legend translated: 'If you love your wife, your house, your field, your heifer and your calf, sign, you have no time to lose!'

27. LD 2133 (15 August 1851).

28. LD 2174 (2 December 1851). *Quand donc, messieurs, finirez de jouer à ce jeu là . . . cela commence à m'ennuyer de payer tous les frais de la partie!*

29. LD 1475. It is twice the average size of his other lithographs for *Charivari*. For a full account of how the image on the drawing could have been transferred to the lithographic stone, see Laughton, 'Daumier's Drawings for Lithographs', p.57.

30. LD 1979. Published in *Charivari* 6 July 1850. The preliminary drawing is in a private collection (repr. in Laughton, 'Daumier's Drawings for Lithographs' Plate 39.

31. LD 3486, in *Charivari* 20 Februry 1860. There are two compositional sketches for this subject, one formerly in the Claude Roger-Marx collection (Maison, II, Cat. 821), and another fine drawing in black chalk and ink or watercolour wash in the Nationalmuseum, Stockholm (repr. Laughton, 'Daumier's Drawings for Lithographs', Plate 44).

32. Wasserman, *Daumier Sculpture* pp.174–83. After extensive examination of both the technical evidence and the documentation she concludes that the earlier of the two plaster versions is the one that was until the early 1970s in the possession of the Geoffroy Dechaume family, and that the version in the Louvre is later.

33. Adhémar, *Daumier* p.39 and *passim*. Howard Vincent, in *Daumier and His World*, Northwestern University Press, 1968, p.151, suggests a reference to a second great exodus of refugees that took place in 1851–2.

34. The white gouache covers up other drawings underneath.

35. As in, for example, the painting *The Miller, his Son, and the Ass* which Daumier sent to the Salon of 1849. On the back of this drawing are some sketches for lithographs concerned with Dr Véron and his dogs (see p.44) which can be dated to 1852. These are presumably later than the drawing on the recto.

36. Maison, I, Cat. I-53, ascribes a date of *c*.1850–5.

37. See Jean Cherpin, *L'Homme Daumier*, Marseilles, 1973, pp.53–63, for the full texts and correct arguments for dating the letters.

38. It has long been observed that the system of numbering Daumier's stones, which travelled back and forth between his studio and the printing works of *Charivari*, can be used as a valuable clue to the sequences in which he worked on given lithographs (he habitually had seven or eight stones in his house at any one time). Over many years the late Louis Provost worked out a complete concordance between the stone numbers and Loys Delteil's lithograph catalogue numbers, and now that this has recently been published, together with a great deal more categorised data about the subjects, Daumier studies have been immensely facilitated. Cf. Louis Provost (ed. Elizabeth C. Childs), *Honoré Daumier, A Thematic Guide to the Oeuvre*, New York and London, 1989.

39. This was *Ferdinand de Lasterie*, a liberal politician and opponent of Louis-Napoleon. Perhaps, like the socialist deputy Louis Blanc, whom Daumier and drawn for this series in about April or May (LD 1888) but whose image was also suppressed, Daumier's editors called the tune and he had to do someone else. This theory would explain his remark to his wife on August 28, 'Je suis excessivement pressé'. The dates of these suppressed images can be deduced from the sequences of their stone numbers in relation to those which were published. (Between November 1848 and Auguse 1850, a total of eighteen plates from Daumier's two series of 'representations' of parliamentary deputies were not published – and the *quality* of these is usually high).

5 PRIVATE IMAGERY AND PUBLIC COMMISSIONS: THE SECOND REPUBLIC AND THE SALON

1. Formerly collection Mme Landesque-Millet.

2. Daumier had drawn this situation even earlier, in a more primitive style, for a print published in *Charivari* on 4 January 1834 (LD 186). This carried a more sinister suggestion of displaced persons. The legend reads, 'We amuse ourselves highly.'

3. The famous painting exhibited at the Salon of 1827, and now in the Louvre.

4. The condition of the paper is curious. It has been

torn across, about two inches from the top, and rejoined using a heavier paper as backing. The backing bears a fragment of a complex optical or geometrical diagram, with inscriptions in another hand. Daumier's brown chalk drawing on the front has been rubbed over at some time with white chalk or gouache, very thinly.

5. Dr R.W. Ratcliffe first drew my attention to the existence of this large painting, which measures 227 × 377 cm. (It is difficult to photograph the whole picture, and only the relevant detail is reproduced here.) The subject matter of *La Peste de Marseille* can be briefly summarised as follows. Le Chevalier Rose was sent from Paris to organise relief during the plague of 1720 which threatened the city. He released a hundred convicts, each one given a cloth soaked in vinegar round his nose and mouth, and gave them the job of dispatching all the rotting corpses of the plague victims into the vaults of the Roman rampart of La Tourette. They then covered the bodies with lime to prevent the spread of infection. Detroy's picture shows the removal of the corpses to the edge of the city by the harbour wall, at night, under the remains of a lurid sunset. The two figures which concern us are brightly illuminated in the foreground.

6. Dimier, *Les Peintres Français du XVIIIe siècle*, Paris, 1930, Vol. II, p.38.

7. It may be worth recalling that Daumier's ardent republican friend, the painter Jeanron, was by then Curator of the Marseilles Museum.

8. Alternatively, Cézanne may quite simply have been familiar with the painting itself, as an *Aixois* who would visit Marseilles not infrequently.

9. See Adrien Chappuis, *The Drawings of Cézanne, Catalogue Raisonné*, 2 vols, New York Graphic Society, 1973, Cat. 167. The drawing is from Delacroix's mural in the church of St Denis-du-Sacrement, Paris. R.W. Ratcliffe pointed out the relationship with the figure in Cézanne's *L'Enlèvement*.

10. See B. Laughton, 'A Group of Millet Drawings of the Female Nude', pp.44–50 and Figs. 37–42.

11. Reproduced in Lucien Lepoittevin, *Jean-François Millet*, Vol. II, (Paris, 1973), Fig. 56, as *Suzanne et les vieillards*.

12. R.L. Herbert, 'Millet Revisited', *Burlington Magazine*, 104, July 1962, p.298, and *Millet* (Centenary Exhibition), Paris, 1975, Cat. 32.

13. All the factual information given in this section about the State Competition has ben revised in the light of the recent exhibition catalogue published by Marie-Claude Chaudonneret, *La Figure de la République: Le Concours de 1848*, Paris, Réunion des musées nationaux, 1987. For a broader view of the political philosophies behind the competition, and the reasons for its ultimate failure, see Chaudonneret, '1848: "La République des Arts"', *Oxford Art Journal*, 10(1), 1987, pp.59–70.

14. It transpired that the final membership of the official commission consisted of seven members appointed by the Minister of the Interior (these included the painter Jeanron, who was at that time Director of the National Museums), and eight painters designated by the 'Section de peinture'. This was a large committee ('Le Commission des 72') consisting entirely of artists, who had constituted themselves in March, initially to be responsible for hanging exhibits at the 1848 Salon, but also charged with representing painters' interests in general. For a

thorough exposition of the problems that beset the several artists' associations and representative committees that formed in 1848, and their fundamental difficulties in functioning as negotiating bodies on a par with workers' collectives at that epoch – not least because of their own ambivalence concerning the social status of artists – see Neil McWilliam, 'Art, Labour and Mass Democracy: Debates on the Status of the Artist in France around 1848', *Art History*, (1), March 1988, pp.64–87

15. These were shown in a large gallery at the École des Beaux-Arts at the end of the year. Diaz's enlarged version was there – it was thought by the critic Gautier to be a little too *dégagée*, or sloppily done – but Daumier's was notable by its absence.

16. Daumier's biographers generally agree that he was taught the rudiments of painting by Jeanron in the early 1830s, but it remains an open question how many of his surviving paintings are pre-1848. Maison, I, Cat. I–19, postulates nineteen works, but the approximate dates are based on stylistic grounds only. All that is known for certain is that in 1847 and 1848 Daumier had been associated with artists protesting against the exclusiveness of the Salon Júries. On 15 February 1847 he was present at a meeting at the house of the sculptor Barye to discuss the foundation of an 'Independent' Salon. See Adhémar, *Daumier*, p.34, and william Hauptman, 'Juries, Protests, and Counter-Exhibitions before 1850', *Art Bulletin*, March 1985, pp.95–109.

17. 'Personne n'oubliera pas cette triste exhibition des Républiques à l'École des Beaux Arts. C'était des Républiques rouges, roses, vertes jaunes, en marbre, en pierre, en ivoire, rissolées, culottées, grattées, ratissées; des Républiques en habite à ramage, en garde nationale, en robes de soie, en robes de laine; des Républiques vêtues de chaînes, vêtues d'attributs, vêtues de rien de tout,' Champfleury (signed Bixou), 'Revue des Arts et des Ateliers', in *Le Pamphlet*, 3–6 September 1848. Quoted in Chaudonneret, *La Figure*, p.138.

18. Ibid. His review turned into a panegyric on Daumier. A very similar text, but refurbished not so well, appeared in Champfleury's *Histoire de la caricature moderne*, pp.167–9.

19. Ibid, Ch. IV, 'La République de Daumier', pp.59–66.

20. See Clark, *The Absolute Bourgeois*: Ch. 4, 'Daumier', pp.99–123.

21. The difference in their relative output of letters is, of course, very striking. Millet's prolific letter-writing exceeded even that of Rousseau, whereas Daumier wrote very few letters indeed. Those he did write (apart from the small group to his wife, mentioned earlier) are more in the form of notes or commands: short, blunt, and to the point. Here is one example:

> Mon Cher Millet
> L'affaire est arrangé venez tout de suite.
> Mon amitié à Madame Millet
> h. Daumier

(Original in Cabinet des Dessins, Musée du Louvre).

22. Sensier, *La Vie*, p.108. 'Sa *République* était d'une simplicité lacédémonienne. C'était une noble figure de femme, grande et douce, qui, à côté de ruches d'abeilles et d'instruments de travail, offrait d'une main, des gâteaux de miel, et, de l'autre, tenait une palette et des pinceaux. Millet

avait oublié ou supprimé le bonnet rouge, qu'il avait remplacé par des épis de blé.' But this description does not fit with the image of the thumbnail sketch made by Vigneron of Millet's competition entry No. 245 (see Chaudonneret, p.203, Fig. 30), which features a standing, classically draped figure with an apparently traditional crown, holding a sword in her left hand and a spray of laurel in her right, and leaning against a pedestal while she supports a flagstaff in the crook of her arm. Did he submit a second *esquisse*, as No. 246, or did Vigneron get the numbers wrong? Whereas the sign Millet chose for No. 245 was a crescent moon, the sign for No. 246 was a mason's level, a device which appears in two of his other drawings discussed in this chapter, but which also figures in the designs of several other contestants. No work by Millet is known with the configuration of Vigneron's sketch.

23. I am grateful once more to Robert Herbert for advising me of this discovery, made recently while *The Wood Sawyers* was undergoing conservation treatment by Lucia Scalisi in the Victoria Albert Museum. Ms Scalisi and I are currently pursuing a more detailed investigation into this particular problem, and our conclusions will be published as a separate article.

24. As suggested by Clark, *The Absolute Bourgeois*, p.68.

25. Photograph in Moreau-Nélaton Archive, Cabinet des Estampes, Bibliothèque Nationale, Paris.

26. The great majority of the entries for the *La République* competition represented the figure in a neo-classical style, or at least in neo-classical garb. A smaller proportion could be described as romantic (inspired by Delacroix), and very few were realist in execution. Daumier and Millet come into the last category.

27. 'Demander que le choix fait parmis les esquisses mise au concours ne soit pas trop resteint at ne se borne pas à quelques-unes. *La République* ou *la Liberté* est un sujet qui peut être interpreté de tant de façons différentes et cependant compréhensibles pour tout le monde, que ce serait resserrer l'éspace à imagination, si on se bornait au choix d'un type unique. Le symbole de la *Liberté* contient en lui tous les autres et par conséquant se pourrait varier selon sa destination: *l'Egalité, la Fraternité, la Loi, la Justice, l'Agriculture, le Commerce, la Science*, etc., avant leurs principes dans *la Liberté*, et ces divers emblèmes, étant protégés par elle, pourrait se placer dans les salles destinées à traiter ces hautes questions.' Published in Sensier, *La Vie*, p.108. Millet's original draft manuscript is preserved in the Cabinet des Dessins, Musée du Louvre. It is conceivable that he knew of the engraving, published in 1838, after J.L. David's extraordinary allegorical drawing *Le Triomphe du peuple français* (Louvre, RF 3199). Part of its description by Jules David runs thus, 'Le Peuple Français, tenant sa massue, est assis sur un char trainé par taureaux. L'Egalité, la Liberté sont assis sur ses genoux. La Science, l'Art, le Commerce, l'Abondance sont groupées sur le devant du char . . .'.

28. Chaudonneret (*La Figure*, pp.89–90), thinks both drawings are related to the State Competition, and that *L'Égalité* in particular may correspond to Millet's second submitted oil sketch. This hypothesis is based upon the 'sign' of the carpenter's level which was used to identify entry number 246 (see note 22). Herbert (1975,

Millet Centenary Exhibition Cat. 44) thinks that such drawings were made in 1848 with the object of timely private sale.

29. C.S. Lewis, *The Allegory of Love*, Oxford University Press, 1936, p.44 ff.

30. The present location of this drawing is unknown at the time of writing. It was last seen in public at a Millet Drawings exhibition held at Hector Brame's gallery (68, boulevard Maleherbes) in 1938, Cat. no. 3., where it is described as 'crayon rehaussé de couleurs'. It appears in installation photographs.

31. At this time the painting itself, which had been bought by Louis-Philippe at the Salon of 1831 and was now owned by the State, was hardly ever seen, although Delacroix made strenuous efforts to get it exhibited again in 1848. Reproductions of it were available, however, both in lithography and woodcut versions.

32. Ottawa, National Gallery. Part of *St Jerome* is beneath the same canvas.

33. London, National Gallery.

34. This now lies beneath the canvas of *Seated Shepherdess* of 1869, in Boston Museum of Fine Arts.

35. Glasgow City Art Gallery.

36. Paris, Louvre (RF 2049).

37. Not identified.

38. Montreal, Museum of Fine Arts.

39. Paris, Louvre (RF 1439).

40. See Maison, I, Cat. I-33 (*Don Quixote and Sancho going to the Wedding of Gamaches*). I am not certain about this identification.

41. Boston, Museum of Fine Arts.

42. Calais Museum. It was acquired by the State in 1863, in lieu of a commission for a *St Mary Magalene in the Desert* that Daumier never delivered.

43. Herbert, 1975, Millet Centenary Exhibition, Cat. 42, p.73.

44. Reproduced in *The Studio*, special 'Corot and Millet' issue, Winter 1902–3, Plate M26 (as coll. W. Pitcairn Knowles). Formerly in the Lutz collection, whence the size is known (37 × 27 cm).

45. The only known photograph of this lost drawing is in the Ryksbureau vor kunsthistorisches Dokumentatie in the Hague (Millet dossier).

46. *Les Ivrognes*, 24.5 × 26.2 cm, Maison, I, Cat. I-5 (as *c.*1840–5), repr. Plate 70.

47. Ibid., I, Cat. I-4, as 1838–42. I would have thought it could be nearly ten years later.

48. Ibid., II, p.252, Cat. 762, points out that Daumier could have known this painting from the engraving by N. de Lanney which, being reversed from the original, is closer to Daumier's own design.

49. This drawing contains studies which Millet utilised in several different paintings, so perhaps it hung on his wall. See note 10 above.

50. The full documentation of this complex history of evasions on Daumier's part is preserved in the Archives Nationales, Paris, AN F21–23 (Daumier). He was paid 500 francs on 29 September 1848, and 500 more on 26 May 1849, by which time the subject of his picture was established. Fifteen years later the exasperated and exhausted administration accepted *Silenus* in lieu of the never-commenced Magdalene. Maison, I, Cat. I-29, thinks that the 1849–50 oil sketch (41 × 33 cm), now in a Swiss private collection, was given to François Cavé, who was at that time in charge of the *Direction*, to show what kind of composition Daumier proposed. It is reproduced in colour in Adhémar,

Daumier, Plate 51

51. According to Herbert, 1975 Millet Centenary Exhibition, Cat. nos. 58–9, pp.94–6 (to be further discussed in Chapter 6).

52. In 'Daumier, Caricaturist', *Century Magazine* (New York/London), 17 (New Series), 1890, pp.411–12.

6 MILLET'S PEASANT IMAGERY

1. The references to this painting on the sheet of studies are quite oblique. A man leaning on his spade, in the left centre, is similar in pose to the man with the hoe, but not the same subject; and the metal blade of a hoe, which appears cut off at the top of the sheet, is the only detail taken from the painting itself.

2. In recent years, several important contributions towards the understanding of Millet's peasant iconography have been made.
 Jean-Claude Chamboredon's article, 'Peinture des rapports sociaux et invention de l'éternel paysan: Les deux manières de Jean-François Millet' (*Actes de la recherche en sciences sociales*, 17–18, 1977, pp.6–28), which posits a dualism in his imagery of peasants, showing two distinct types or classes, will be referred to in this chapter.
 Christopher Parsons and Neil McWilliam break new ground in their article '"Le Paysan de Paris": Alfred Sensier and the Myth of Rural France' (*Oxford Art Journal*, 6(2), 1983, pp.38–58). Basing their argument upon extensive use of quotations from Sensier's writings from 1865 onwards (once launched on his second career as critic, he wrote articles both under his own name and under the pseudonym, Jean Ravenel), and from his posthumously published biography of Millet, they virtually lay the charge of inventing a myth about Millet's peasants (idealised, not socialist) at Sensier's door. An additional charge is the invention of a more general myth about rural purity of spirit, as opposed to urban duplicity, which they show to be double-think on Sensier's part.
 Other ways in which the meaning of Millet's peasant imagery was manipulated by contemporary critics wary of 'socialism', and the question of whether or not his peasants were a myth of his own making, have been discussed by Clark in *The Absolute Bourgeois*, pp.94–8.
 Nicholas Green's article, 'Dealing in Temperaments: Economic Transformations of the Artistic Field in France during the Second Half of the Nineteenth Century' (*Art History*, 10(1) March 1987, pp.59–70), follows up the relationship between Sensier's myth-making and the dealer Durand-Ruel as a means of selling artists' work, with particular reference to Rousseau and Millet. (See also my reference to Michel Melot's article on the relationship of Durand-Ruel to Daumier, in Chapter 10, p.000).

3. 'Socialist' was a specialised term at this epoch which applied only to certain sections of the very loose political alliance that meant 'Republican'. The socialists – some groups of whom prefigured Marxist organisations–controlled certain of the workers' clubs that flourished during the early stages of the Second Republic. They were repressed by Louis-Napoleon by the end of 1849. Millet's own position vis-à-vis the Republicans is obscure: commentators then, as now, sometimes tried to deduce it from the

'evidence' of his pictures. For example, when Sensier wrote to him on 29 January 1851 about critical reactions to his paintings at the winter Salon, he reported that *Le Vote Universel* and *L'Union* ('légitamiste') found his *Haymakers* in good taste, but, as for *The Sower*, they decided that he was slandering the country folk. 'Slandered' was their expression. 'In effect, they find your painting too *socialist!!!!!*' *(sic)*. Many years later, when Millet wrote the letter to Sensier in answer to criticisms about his *Man with the Hoe* (30 May 1863), he began almost with an echo of Sensier's previous outburst: 'Dans quel club mes critiques m'ont ils rencontré? Socialiste!' This sentence was not, of course, quoted in the part extrapolated for *l'Autographe*.

4. The first version of the canvas dates to 1846–7 (Cardiff, National Museum of Wales). The two great 'realist' *Sower* paintings, of which one was sent to the Salon of 1850–1, are memory pictures that must have been conceived in Paris–their landscape settings are quite unlike either the plain or the forest at Barbizon.

5. At first sight she seems to be a reflection of the kind of domestic *Balayeuse* found, for example, in Bouchardon's series of drawings of *Etudes prises dans le bas peuple, oü les cris de Paris*, published as engravings between 1737 and 1746. Bouchardon represented a happy, virtuous, Chardin-like creature. But another kind of *Balayeuse*, of which Millet would also have been aware, was the street sweeper in the city, represented in illustrations of the working classes (such as Duplessi-Bertaux's engraved series of 1814), as on the starvation end of the social scale.

6. Millet drew directly on the wood blocks for this series, which were then engraved by Lavieille and published in *L'Illustration* in February 1853. The series was to be copied in its entirety later on by Vincent van Gogh, in ten canvases, which he painted at St Rémy in 1889.

7. Millet, letter to Sensier, 15 Jan. 1851. See Moreau-Nélaton, I, p.88. 'I would very much like to do, if I sell my pictures, some landscapes after nature in one of her fiercer moods.'

8. The development of Millet's landscape studies, apart from the peasants who filled so many of his foregrounds between 1850 and 1865, will be discussed in Chapter 8.

9. Reproduced in Moreau-Nélaton, I, Fig. 69.

10. Bought by Sensier in 1850 with the idea of showing it to the Minister of Fine Arts (for whom he worked), in the hope of obtaining a government commission for Millet. See Herbert 1975 Millet Centenary Exhibition Cat 54, *Les couturières*.

11. From the correspondence this appears to be a painting, but the only such image now known is the drawing (Fig. 6.2).

12. Translated from Sensier's letter to Millet, 13 January 1851.

13. 'It is necessary, my dear, over and above your pictures of children and women bathing and mythology and such that you are [now] making for sale, to set yourself to doing (if you wish to be understood) rustic scenes like your picture for the Ministry [presumably meaning *Haymakers at Rest* (Louvre) which had fulfilled a State Commission] or your picture of the haymakers [*The Haymakers* (Louvre)] in the Salon of 1850–1]'. Sensier to Millet, 29 January 1951.

14. Sensier to Millet, 27 April 1850.

15. *Weiblicher Rückenakt* (Young Lady in the Rushes, Back View), charcoal and stump, 19 ×

24 cm Bremen, Kunsthalle, Inv. no. 1956/49.

16. They were grouped together under this title in the Sensier sale of 10–12 Dec. 1877. The titles may also be found in Soullié, *Les Grands Peintres*, Paris, 1900, pp.139–43. Only a few of them may currently be located. One, *Le Fin de la moisson*, a particularly outstanding drawing in black chalk and pen and brown ink, appeared in Christie's New York sale, 25 February 1988 (153). In this scene of the return of the last harvest wagon to the courtyard of a very large farm, the celebrations of the carousing farm workers are reminiscent of Breughel, with a crowd of peasants galvanised into frenetic activity. Robert Herbert points out that it is also a remake of Léopold Robert's famous harvest picture of 1830, which was presented to the Louvre by King Louis-Philippe.

17. Two other identifiable examples are: *La Récolte des pommes de terre; effect de soir*, black chalk (E.V. Thaw, New York); and *Bûcherons dans la forêt*, black chalk and touches of watercolour (National Gallery of Scotland, Edinburgh).

18. Sensier to Millet, 25 April 1851.

19. Translated from Sensier to Millet, 17 May 1851.

20. Herbert, 'Millet Revisited', p.298.

21. See Chapter 10, p.000 ff.

22. Such imagery was not necessarily anonymous, however. Adrien van Ostade produced engravings of subjects such as wool carders at work, in Holland in the seventeenth century.

23. Chamboredon, 'Peinture des rapports sociaux', p.18. At this stage in his article, Chamboredon has found a polarity between the two 'opposed abstractions' of peasant life in artistic representation: the 'happier times' of the independent, family-group type of peasant farming which Millet associated with his youth at Gruchy (one might add, notwithstanding the extremely hard times of which his mother and grandmother complained after the 1848 revolution!), and the misery of the proletariat of his locality around Chailly, where the farm workers were yoked to daily labour for someone else. Such a thesis requires detailed analysis of concrete examples, which Chamboredon does through selected paintings, and to which I shall refer in respect to certain drawings, such as the one in question here.

24. Published in *L'Illustration* in February 1853. This was the series which Van Gogh copied (see note 6).

25. It is under this painting that Millet's lost entry for the State Competition for *La République* has recently been discovered. (See Chapter 5, note 23). The later history of this painting, once owned by the Scottish art critic W.E. Henley, and bequeathed by Alexander Ionides to the Victoria and Albert Museum, is intriguing. In 1936 the French Daumier scholar Maurice Gobin saw it in the Museum, and advanced a theory, based on stylistic grounds, that it was actually painted by Daumier – a view that was also held at one time by Kenneth Clark. The drawings connected with it, however, are plainly by Millet, and it seems unlikely that he would have left his old canvas of *La République* for Daumier to paint over!

26. Herbert, 'Millet Revisited', p.298 (see Chapter 1, p.00).

27. Millet to Sensier, 1 February 1851. Quoted in Sensier, *La Vie*, pp.129–32, and in Moreau-Nélaton, I, pp.90–1. This is basically in reply to Sensier's letters of 13 and 29 January, 1851, telling him what to paint (see above, p.78).

Henry Naegely, in *J.-F. Millet and Rustic Art*, London, 1898, published an earlier letter from Sensier to Millet's associate Carl Bodmer, dated 22 April 1850, which seems to show that Sensier wanted him to go back to painting more lighthearted, gayer pictures. In the current letter Millet begins by announcing that he has three pictures in train:

1. *Femme broyant du lin* (woman pounding flax)
2. *Paysan et paysanne allant travailler dans les champs* (later known as 'Going to Work').
3. *Rammasseurs de bois dans le forêt*.

He adds, interestingly, that he is not sure whether the word *rammaseur (sic*, for *ramasseur*: gatherer, collector, scraper-up) can be printed as a title (evidently it carried the wrong associations). Then the passage quoted – the translation is my own – gets him out of further explanations.

28. On the verso of this sheet are studies for the painting *Les Lavandières* of *c*.1853–5, now in Boston Museum, but these are probably earlier than the recto. Herbert, 1975 Millet Centenary Exhibition, Cat. 172, advanced its date to 1863–4. I would prefer to relate it to a drawing like *The Lobster Fishermen* (Fig. 8.23) in style, which would make it *c*.1857–60.

29. Chamboredon, 'Peintre des rapports sociaux', p.22 ff.

30. For example the scythes, hooks, and single-blade ploughs that he drew are found no differently represented in the Plates of Diderot's *Encyclopédie* of nearly a century earlier, and the methods of threshing and winnowing by hand are the same. See Diderot's section on *Agriculture* in the *Planches*, Vol. I. There are even illustrations of how to prepare *charbon de bois* in the woods that echo Millet's study of a charcoal burner's hut in one of his sketchbooks of the Barbizon period.

31. That is, notwithstanding the scores of artists, amateur and professional, who took to sketching in the forest during the summer months. They would have provided a useful source of revenue to people like the proprietor of the Hôtel Ganne – a small inn in Barbizon which catered for artists of all nationalities, including British, American and Canadian – but they would not have been able to penetrate into peasant life. On the other hand, Millet's neighbour, the artist Charles Jacque, with whom he had a serious quarrel over the authorship of his drawings, was despised by both Millet and Sensier for his successful negotiations in purchasing property from the locals, and his capacity for rearing farm animals – 'like a Noah's ark' (Sensier letter to Millet, 25 April 1851.) Jacque, however, later won out over Sensier as a rival property owner and also over his American neighbours, Bodmer and Hunt, when he wanted to close a right of way on his land: '... cet espèce de Robert Macaire!' wrote Millet. Since he merely rented his own cottage from Sensier, he was inclined to ironic remarks about 'les propriétaires' at Barbizon. In this context, his friendship with Daumier sounds the more credible.

32. I suspect that this sanguine drawing in Bayonne Museum (Inv. N1/1093 verso) was once part of a larger drawing which included a group of figures to the right. These figures may now be found on the verso of another sheet in Bayonne (Inv. N1/1092 verso). They are also drawn in

sanguine, and the paper has been cut on all sides. What happened was that Millet cut up his old sketch to provide paper for two much later drawings, studies for *The Wild Geese* of *c*.1865–6 (which now take up the rectos of N1/1092 and N1/1093 respectively).

33. Another sheet of drawings in the Musée Bonnat at Bayonne (Inv. N1/1080) contains small sketches connected with a number of different projects, including *Ruth and Boaz*, the *Hagar* of 1849 (another figure of exile), a *Charity*, a *Susannah*, and a shepherd and his dog. Reminiscences of Michelangelo's reclining figures on the Medici tombs may be discerned on both sheets. Another possible source for Millet's rather courtly style here could be the decorations at the Royal Palace at Fontainebleau, which he certainly knew from engravings and which he later visited.

34. It became one of the scenes in *Les Quatres Heures du jour*, engraved by Lavieille and published in 1860.

35. See Parsons and McWilliam, 'Le Paysan de Paris', on Sensier. While these authors deliver a devastating attack on Sensier's motivations in writing as he did about rural life, one would wish to avoid any suggestion of Millet working for Sensier on an ideological basis. Sensier saw in Millet what he wished to see. The sheer variety of Millet's peasant imagery suggests that he, for his part, was well aware of the different ways in which they were perceived by different viewers in his own time, from Balzac to George Sand. I do grant, however, that Sensier probably nagged Millet continually! The text of the famous lecture that Sensier delivered on landscape at Durand-Ruel's in 1870 gives away his total dependence upon Millet and Rousseau for the ultimate expression of his rural fantasy.

36. Corcoran Gallery, Washington, DC.

37. There are actually three studies in the Louvre, of which Inv. No. RF 5878 (GM 10,308) is the most important. It must directly precede the slightly more elaborated drawing in the British Museum.

38. I suggest that Alfred Sensier would have given us one kind of answer, and Daumier quite another.

39. Oil versions in Glasgow Art Gallery and in Cincinnati Art Museum. See Herbert, 1975 Millet Centenary Exhibition, Cat. 70, and 171 for this drawing. The subject is the one referred to in his letter to Sensier of 1 February 1851 (see note 27, p.000).

40. This information is taken from André Fermigier's condensed account in *J.-F. Millet*, Paris, 1977, p.48. His sources are the books and an unpublished thesis (1951) by Louis Chevalier on nineteenth-century rural and urban social history in the Paris region, and an important early witness who had lived in Barbizon, the painter J.-G. Gassies, who published '*Le Vieux Barbizon*', *Souvenirs de jeunesse d'un Paysagiste. 1852–1875*, Paris, 1907. Gassies' Chapter 8, 'Les Habitents, Les Modèles de Millet', is particularly useful. He observed that the fields immediately around the forest were dishearteningly barren, and that these were the ones owned by the inhabitants of Barbizon (p.108). The polarity of the peasants of the forest area and the peasants of the plain is stressed by Chamboredon, 'Peinture des rapports sociaux'.

41. That was the picture most fiercely attacked by contemporary critics, who saw in it some kind of threat to themselves, in so far as a peasant

who seemed monstrously ugly, brutalised by labour, should apparently be celebrated by the artist.

42. Paris, Louvre, Inv, RF 246 (GM 10,391). Black chalk, 15.7 × 11.8 cm.

43. When ordering his colours with which to commence these large canvases in his studio in Barbizon, Millet ordered very large quantities of cobalt blue. In a letter written to a Monsieur Blanchet, dated 5 February 1865, he asks for a half-litre of white, nearly as much again of Naples yellow, slightly less than that of yellow ochre, and then 20 tubes of cobalt blue, at the top of his list. These are followed by 10 tubes of vermilion, and smaller quantities of twelve other colours, including Veronese green, Mars orange, indigo and a variety of browns. (Letter in the Fondation Custodia, Paris).

44. Hélène Toussaint has put forward the ingenious suggestion that Millet's *Ceres* comes very close to the written description given by Sensier of one of his two entries for the State Competition for a *Republic* in 1848, and this is born out to some extent by the X-ray of an obliterated sketch (see Chapter 5, p.000). Toussaint 'Le réalisme de Courbet au service de la satire politique et de la propagande gouvernementale', *Bulletin de la Société de l'Histoire de l'Art français*, 1979, 1981, pp.233–4, and quoted in Chaudonneret *La Figure de la République*, p.90. The preliminary drawings also suggest such a connection.

45. Other pencil studies of exactly comparable style are, for *Ceres*, a drawing in a Paris private collection, 26.5 × 15.4 cm (also with two figures, and another study for *Christ Sleeping on the Waves* at the bottom); and for *Spring*, a drawing of an *Offering to Pan* in the Fogg Art Museum, 29.5 × 19 cm.

46. Clark, *The Absolute Bourgeois*, p.123. Admittedly my quotation is taken a little out of context; Clark refers rather to Millet's attitude 'towards the social body'.

47. See note 35. In fairness to Parsons and McWilliam, I do not think that their article suggests anything so extreme.

7 DAUMIER'S REPUBLIC

1. This line was inscribed by Daumier on the inside cover of a copy of Champfleury's *Histoire de la caricature moderne* owned by his friend M. Ducasse, together with his signature. See Arsène Alexandre, *Daumier*, Paris, 1888, frontispiece and p.203.

2. With the exception, of course, of the 'lawyers' subjects which were expansions of his famous lithograph series of 1845–8 into both oils and watercolours; these were bought by private clients well into the 1850s and 1860s. Everybody knew what they were about.

3. For *Les Cris de Paris* see Chapter 2, note 16. Duplessi-Bertaux's 1814 collections of etchings includes a 'Suite d'Ouvriers de différentes classes', as well as a 'Suite des cris des Marchands ambulants de Paris' (Paris, Bibliothèque Nationale, Cabinet des Estampes). The point made here is simply that Daumier, as a printmaker and social observer by profession, could not have been unaware of this tradition which had so recently preceded him.

4. After the 1850–1 Salon he submitted no more paintings to the jury for ten years.

5. Osiakowski, 'Some Political and Social Views', p.188 and *passim*.

6. According to Théophile Silvestre, quoted in Moreau-Nélaton, *Histoire de Corot* Paris, 1905, p.156.

7. The portrait medallions by David d'Angers, a vigorous and dynamic sculptor who was slightly older than Delacroix, were well known for their expressive characterisations of famous people. A keen patriot, he was also an ardent old-fashioned republican.

8. Canvases with the designs for pictures broadly sketched in.

9. The French text is 'Dessin d'invention'. (Original ms, in the archives of the Department of Paintings, Louvre Museum.)

10. See Wasserman, '*Daumier Sculpture*, pp.174–83.

11. Maison I, Cat. I-29 (Swiss private collection). The commission was received in 1849, but Daumier never executed this particular subject for it: this is an oil sketch. Reproduced in colour in Adhémar, *Daumier*, Plate 51.

12. It was particularly prescient of Clark (in *The Absolute Bourgeois*, p.111) to guess from the incomplete documentation in the Archives Nationales that Daumier did in fact complete this commission. The final picture was rediscovered in 1978, in the local church of Lesges (Aisne), whence the Mayor of the local community had requested it from the Direction des Beaux-Arts in Paris in June 1852. It has been published by Pierre Angrand (*Gazette des Beaux-Arts*, February 1979) and it was exhibited together with the oil sketch, which also turned up again, at the Daumier Centennial Exhibition at the Musée Cantini, Marseilles in June 1979.

13. The illustration here is of the cast in the Louvre, which is tinted brown to resemble clay.

14. See Chapter 9, p.138.

15. Auguste Préault (1809–79) was a romantic sculptor whom Daumier admired. He was an exact contemporary and, like Daumier, of working-class origins. The extreme emotional morbidity of some of Préault's imagery, and the roughness of his execution, met with disapproval by the Academicians and somewhat alienated the general public. His powerful relief *Tuerie*, a kind of sarcastic comment upon the rhetorical optimism of official art in the early years of Louis-Philippe's reign, had been accepted at the Salon of 1834, while his plaster group *Les Parias* (two lovers embracing – a scene from Delavigne's tragedy *Le Paria*) was rejected. A lithograph was published after the latter piece, which we find here on Daumier's wall. (See Hugh Honour, *Romanticism*, 1979, p.388 and Fig. viii; David Mower, 'Antoine Auguste Préault', *Art Bulletin*, 63 June 1981, pp.288–307 and Fig. 3; and Jonathan P.Ribner, 'Henri de Triqueti, Auguste Préault, and the Glorification of Law under the July Monarchy', *Art Bulletin*, 70 Sept. 1988, pp.486–501.)

16. Yet another account of Daumier's studio, by Gavarni, recorded by the Goncourts in their *Journal* in 1858 but probably recalling a date prior to 1848, mentions only lithographic equipment being in evidence, and also the presence of studio assistants.

17. Alexandre, *Daumier* p.332.

18. In other versions the woman's figure is relatively weightier and her progress along the path looks more of a struggle. Maison has attempted to date the six versions on grounds of stylistic development, see Maison I, Cat. I-137, I-142, II-13, I-43, I-85 (the Glasgow picture), I-86 and I-121, as between 1850–2 and 1858–60, but none of these dates have any hard evidence to support them. The number of times Daumier repeated this motif is more significant than when he did so.

19. A small terracotta statuette in the Walters Art Gallery, Baltimore, that has long been associated with this drawing is no longer attributed to Daumier with any certainty. It may have been inspired by one of his paintings and executed after it. See Wasserman, *Daumier Sculpture*, pp.184–8.

20. It was exhibited as *Le Marché* in Daumier's Retrospective at Durand-Ruel's in 1878 (Cat. 123). Since then attempts have been made to associate it with the theme of fugitives – presumably because of the hurrying crowd faintly drawn in the background – but I find this too speculative.

21. Maison I, Cat I-54 and Cat I-55 (as 1852–5); I-87 and I-88 (as 1855–7).

22. See note 3 above, and Fig. 2.14.

23. Maison I, Cat. II-49. Maison puts this in his 'second category' of authentic Daumier's because, he complains, it is obscured by considerable overpainting. However, the image seems to me to remain a remarkably powerful one and expressive of Daumier's intention.

24. It can be seen bleeding through the paper because of the corrosive nature of the ink used. I believe that this rather heavy ink line was used by Daumier in mid-career rather than later on. This drawing could have been made for a private client or presented to somebody, since it is signed.

25. 'Motherly care' of all kinds. For its occurrence in Millet's *oeuvre*, see Herbert, 1975 Millet Centenary Exhibition, Cat. nos.107–14, *Le Dossier de la précaution maternelle*. Although the Daumiers were childless, Daumier draws babies often enough for us to suspect that there was one around his house at some period. Mme Daumier's younger brothers held an important place in his household, after they were married.

26. Another such Rembrandt drawing, *Woman with Five Children Playing on the Ground*, in the Kunsthalle, Bremen, which belongs to the same group, is remarkably like Daumier's *Four Children Playing* (Fig. 7.11) in its observation of the positions of the little children, though the resemblance must be fortuitous.

27. See Chapter 9, p.000 and note 46.

28. Maison, I, Cat. I-95, I-96 and p.103, unearthed a total of five versions of this design in oils which he dates to the late 1850's. Neither of the two he reproduces show the expressive power of the Louvre drawing.

29. Maison, II, Cat. 321 and 322 respectively.

30. The butchers were not only a skilled trade but at the same time a very well established commercial profession. They were limited in number in Paris, by ordinance, and they amassed great personal fortunes as a result (*Histoire Économique et Sociale de la France*, ed. Fernand Brandel et Ernest Labrousse, Paris, 1970, Vol. III, p.31). This might account for Daumier's ambivalent attitude towards them.

31. The extremely traditional nature of this rendition can be understood by comparing it with one of the plates made for Diderot's *Encyclopédie*, Vol. IX, Planche I, *Serrurie, fers marchand* (general wrought-iron work of all kinds), published in 1771. Standing at the edge of a whole crew of blacksmiths hammering away, a solitary worker performs this same action, using the same system as in Daumier's drawing.

32. The final version, fully signed, is in a New York private collection. (Repr. Maison, II, Cat. 268, Plate 66).

33. Rembrandt's well-known painting of *The Slaughtered Ox* entered the Louvre in 1857, and probably inspired a number of other works such as Bonvin's *Le Cochon* shown at the Salon in 1875. Géricault had painted a picture of an abbatoir as early as 1818, though it was not a particular success.

34. The most finished version of this drawing, in a German private collection, was owned by Daumier's friend Geoffroy-Dechaume and lent to his 1878 Retrospective Exhibition with the title *Le Boucher (marché Montmartre)*.

35. Lawrence Gowing, 'Daumier at the Tate', *The Observer*, 18 June 1961.

36. The 'expressionist effect' is perhaps fortuitous, since this is a relatively unfinished study.

37. In 1857-8 he made a series of lithographs for *Charivari* which satirise the butchers' anger at losing their monopoly in selling meat. (See note 30). In the cartoons their sinister demeanour is represented as both funny and menacing, and they are pilloried as self-seeking entrepreneurs.

38. The companion drawing, also in charcoal, is Maison, II, Cat. 169, in a Paris private collection. There are two more studies of a man walking with a stick which may represent the same person: Maison II, Cat. 99, and one in the Armand Hammer collection, Cat. 189 (not in Maison).

39. As in the type of situation later envisaged by Degas. See Chapter 11.

8 LANDSCAPE

1. Oil sketch 32.5 × 41 cm, Musée Thomas Henry, Cherbourg, repr. in Herbert, Millet Centenary Exhibition, 1975, Cat. 16.

2. Oil sketch 28 × 37 cm, subtitled *Les Falaises de la Hague*, Musée Thomas Henry, Cherbourg, repr. in André Fermigier, *J.-F. Millet*, Geneva (Albert Skira) 1977, p.25. The site for this landscape can be found just beyond the end of the street of Millet's native village of Gruchy, on the cliffside looking towards Cherbourg. His transcription of the castle-shaped formation of big rocks is remarkably accurate, which suggests that this little painting was made on the spot.

3. L'Association Mensuelle was a scheme invented by Philipon, editor of both *Le Charivari* and *La Caricature*, to help pay his numerous fines for libel during his campaign against Louis-Philippe in 1832-5. It was a kind of print of-the-month club, to which private subscribers paid in advance for a monthly issue of single large lithographic prints, highly contentious political-ly, drawn by the several members of his staff of cartoonists. Daumier had contributed five prints to that famous series, of which two have been reproduced here: *Rue Transnonain, le 15 Avril 1834* (Fig. 1.1), and *Ne vous y frottez pas!* (Fig. 2.19). New laws of press censorship, which included all printed *images*, forced it out of operation in 1835.

4. See James Cuno, 'Charles Philipon, La Maison Aubert, and the Business of Caricature in Paris, 1829-41', *Art Journal*, 43(4), Winter 1983, pp.347-60.

5. Adhémar, *Daumier*, p.24. Adhémar also states that the French romantic landscapist Paul Huet,

a friend of Daumier's, drew in the backgrounds for some major Daumier prints such as *Enfoncée Lafayette!*, published in May 1834. The detailed topographical view of the Cimetière Père Lachaise in the background of this lithograph makes such an allegation possible, but does not detract from Daumier's early interest in learning to represent landscape. A number of his painter friends were landscapists.

6. Dewy F. Mosby suggests that 'Decamps prob-ably pressed the drawing against the lithographic stone in order to leave a faint impression, which would make the final product read in the same sense as the original drawing' (Mosby, *Decamps*, Garland Press, 1977, II, p.389).

7. The lithographs of these series are so good that almost any selection could be chosen to make up a quick picturebook to show Daumier's talents. A more thorough introduction would be a few days spent browsing through the eleven volumes of Delteil's total catalogue, and subse-quently working through some of the major collections of Daumeir's original prints, both those printed on the cheap paper of *Charivari* (many examples to be found in the Boston Museum of Fine Arts) or separately on more expensive paper (more in the Boston Public Library). The major collection of all Daumier's prints is of course to be found in the Cabinet des Estampes in the Bibliothèque Nationale, Paris, but there are also several very large private collections, which rival the French national collection for both quality and rare states. The most recent and probably the biggest of these is the Armand Hammer Daumier collection in Los Angeles. For the record, the examples that called up this sentence of text are Delteil numbers 1477 *(Tiens Dorethée . . . voilà ou m'a conduit . . .*, 1846); 1413 (*Ah! Ciel mama! . . .*, 1845); 1503 (*Quand il y a trente degrés de chaleur*, 1846); 1417 (*Au secours, au secours . . . mon mari qui se bat contre un taureau!*, *1845);* 1510 (*Un chapeau . . . deux chapeaux . . .*, 1847); and 1527 (*Ces artistes sont presque tous fous . . .*, 1847).

8. L.D. 3439, *Les Paysagistes* (*Charivari*, 12 May 1865).

9. On use of charcoal to bring out dramatic effects in Romantic landscape, and Corot's own change of style in the 1850s in this respect, see Vojtech and Thea Jirat-Wasiutynski, *The Uses of Charcoal in Drawing*, Introduction to exhibition at the Fogg Museum, Harvard University, 1980.

10. *Les Français peints par eux-mêmes* was finally published in nine volumes by Curmer, Paris, 1842.

11. Ibid., Vol. III, pp.24-32.

12. Maison, II, Cat. 738-9.

13. Reproduced in Fuchs, *Der Maler Daumier*, Munich, 1927, 63b, as *Une groupe sous les arbres* (no details given), and also in Lassaigne *Daumier*, Paris, 1938), 117, as *Sunday Morning*, 18.5 × 26.5, ex-Bureau Coll., David-Weill Coll., Paris.

14. The painting came from the Alexander Young collection, which was sold, via Agnews, at Christie's on 30 June, 1 July and 4 July 1910. This item was lot 188 in the 1 July sale, and catalogued as 'Daumier: A landscape. A view over a river with a peasant under some trees on the left [*sic*]. Oil on panel, 5¼ × 14'. (Bt. de Bearn 150 gns).

15. At the time of writing, this speculation is only made from the evidence of an X-ray of the covered painting. *Nabucco* was performed in Paris in the autumn of 1846.

16. Reproduced in colour in Fermigier, *J.-F. Millet*, p.41.

17. Private collection. This drawing was brought to my attention by Robert Herbert.

18. See H.R. Hoetink, *Franse Tekeningen uit de 19e Eeuw*, Museum Boymans-Boeningen, Rotter-dam, 1968, nos. 193 and 194.

19. Herbert, 1975, Millet Centenary Exhibition, Cat. 184, pp.229-30. The oil was last seen at the Henri Rouart sale, Paris 1912.

20. This is the same Georges Michel who painted views of Montmartre windmills in a style deriving from seventeenth-century Dutch land-capists, and who was admired by Van Gogh. Sensier published a monograph on him in 1873. A drawing by Millet, which should date to the early 1850s, *Le Retour du marché* (Rhode Island School of Design), with a procession of figures straggling down a country road, could well have been inspired by a Michel drawing with much the same subject in the foreground, called *Vue de Montmartre*, (Paris, Louvre, Inv. RF 3943 recto).

21. *Le Rideau d'Arbres*. Reproduced in Rosaline Bacou, *Millet Dessins*, Paris, 1975, Plate 21 (Inv. RF 5858).

22. It was bought from Rousseau's studio sale after his death (Vente Th. Rousseau, 1868, no.79) by Théophile Silvestre, and sold to Alfred Bruyas (Courbet's former patron) in 1870 along with a group of other works which included Millet's pastel *La Maison au puits à Gruchy*. Silvestre wrote two letters to Bruyas, one in 1870 and one on 22 January 1872, about a work called 'Les Bruyères de Macherin' (the Heathlands of Macherin)-apparently an earlier name for this drawing-in which he described it as 'un énergi-que poème intime de l'autour dans la solitude', and as 'ce simple germe au crayon, d'un tableau admirable, qu'il aurait peut être manqué en le finissant'. I am grateful to Mme Martine Feneyrou, of the Musée Fabre, for this informa-tion. (At the time of the 1967 Rousseau Centen-nial Exhibition some researches were carried out which suggested that Silvestre was in fact referring to another picture by Rousseau in these letters, but the thesis seems to have been disproved.) Silvestre may have been right in supposing that Rousseau could have spoiled this work by going on with it. Among the Millet correspondence is a letter, dated 13 March 1863, in which Millet reports that Tillot, a former pupil of Rousseau's, has told him some disturb-ing news about the artist's failing powers.

23. See Alexandra Murphy, *Millet*, p.80 ff., on the difficult question of how much Millet drew *plein air* and how much from memory.

24. This drawing was the subject of a very close, line-by-line copy which appeared on the art market in 1977, with a fake Millet sale stamp (see R.L. Herbert, 'Les Faux Millets', *Revue de l'art*, 21, 1973, pp.55-66. The fake drawing lacks the notional standing figure. It has pre-viously been reproduced in a book on the Barbizon school as a drawing by Rousseau!

25. Moreau-Nélaton, II, Fig. 103.

26. Alfred Sensier, *J.-F. Millet*, 1881, p.8 and illus. See also Moreau-Nélaton I, pp.2-4.

27. An undated letter to his brother Jean-Baptiste, written from Gréville, says he has made about 60 drawings, 'croquis pour le plupart', but another letter to Campredon written just after his return to Barbizon refers to 'une grande quantité de croquis: une centaine environ'. See Moreau-Nélaton, II, pp.15-16.

28. Years later he wrote letters to his friend the critic Théophile Silvestre both describing the scene and providing an autobiographical narrative significance for it. See Murphy, Millet, pp.242–3 (letters to Silvestre, 18 and 20 April 1868). Some of this seems to have been added to the picture as it progressed into the second and third versions, for example the significance of two empty chairs, one large and one small, which had just been vacated by the mother and her child. In the first version, illustrated here – perhaps it is unfinished – the image is more directly spontaneous: the child looks out to sea; the geese rush into the house.

29. As the reader who braves the Appendix will discover.

30. That is, in the modernist sense of using pastel drawings in full colour as the equivalent of high-toned paintings, as Degas did after him. This new use of pastel is to be distinguished from Millet's earlier use of the medium in some of his portraits and pastoral subjects of the 1840s, where he employed – albeit with considerable skill – a revival of the eighteenth-century rococo convention of pastel drawing used to model forms in relief as an equivalent to chiaroscuro oil painting. Pastel does lend itself, however, to the use of colour in shadows – Chardin became the arch-exponent of this in his late work – and in that sense is a true precursor of the development of the French Impressionists' technique.

31. See B. Laughton, 'J.-F. Millet in the Allier and the Auvergne', *Burlington Magazine*, 130 May 1988, pp.345–51.

32. The drawing appeared at Sotheby's London, sale of 23–4 November 1983 (lot 582). On the verso is a pencil sketch of the girl with her goats silhouetted against the sky above a convex hillside. The recto could be associated with an apocryphal story of Millet stopping by the roadside on the way to Diane, to sketch a shy goat-girl whom he saw spinning, whilst she watched her flock.

33. As an 'ideated' landscape it anticipates some of the pastel landscapes produced by Degas, probably from memory, around 1869 and later. See Lori Pauli, 'Degas Landscapes', M.A. thesis, Queen's University, 1990.

34. Maison, II, Cat. 359 and 360., It should be observed that all three versions are drawn using a pen over crayon – in the case of 359 using two thicknesses of pen nib.

9 ILLUSTRATIONS TO LITERATURE

1. Gavarni and Grandville, two of Daumier''s contemporaries on *Charivari*'s staff of cartoonists, both worked for the book trade as well as for illustrated journals.

2. In some instances 'superimposing' would be a better word than 'unifying'. In Millet's later peasant pictures, for example, the 'realist' or 'contemporary' content is often obliquely superimposed upon an older content of Christian narrative.

3. The first major nineteenth-century artist to have refused to make any works based on literature (as opposed to political polemic) was Gustave Courbet. Apart from drawing a title page for the poems of his friend Max Buchon in the early 1840s, Courbet devoted the rest of his career exclusively to painting his concrete experience (as he put it), and this exclusion also extended to his drawings. In this repect, although he was only ten years younger than Daumier and five years younger than Millet, he almost seems to belong to a different generation. Yet, as we saw in Chapter 8, on landscape, if we examine their respective manners of vision rather than just their techniques, in apprehending light and space they were both as far advanced in 'realism', if not more so, than Courbet. This is another reason why it is difficult to bring him very extensively into the discussion of this book.

4. Two were made for *Ferragus* (of which the 'death of Justin, Maulincour's valet' is particularly gruesome), one for *Père Goriot*, and one for *Les Employés*, all apparently between 1843 and 1848, for the Furne edition of Balzac's complete works. (See Eugène Bouvy, *L'Oeuvre Gravé de Daumier*, Paris, 1933, pp.734–7.) A fifth, *Valentrin*, is cited but not reproduced by Passeron, Daumier, p.137.

5. See B. Laughton, 'Daumier's Expressive Heads', *RACAR*, 14(1–2), 1987, pp.135–42 and Figs. 94–111.

6. Ibid, Fig. 100.

7. *La Némésis médicale*, by Dr François Fabre, 2 Vols., Paris, 1840. Daumier produced designs for 29 woodcut illustrations. Few of the original drawings survive, but one in pen and ink wash for the plate *Souvenirs du Cholèra-Morbus*, shows how very clear an image he could produce in line for the engraver, when required (repr. Maison, II, Cat. 733: it is in the same sense as the woodcut by A. Plon).

8. Sometimes the most popular cartoons that had appeared in *Charivari* as lithographs were issued again as woodcuts.

9. See Théodore de Banville, *Mes Souvenirs*, quoted in P. Courthion (ed.) *Daumier raconté par lui-même*, Paris, 1945, pp.145–62. Fig. 9.2 is a related drawing for this project and Fig. 9.3 seems to be a *première pensée*. The date can be established from a letter concerning payment dated 11 July 1848, published in Raymond Escholier, *Daumier*, Paris, 1923, p.186.

10. Four of Millet's original drawings for Bodmer were reunited at the Millet Centenary Exhibition in 1975, by Robert Herbert; see Cat. nos. 137–40.

11. This is a free translation from the letter to Marolle written from Barbizon on 19 July 1851, as published in Moreau-Nélaton I, pp.96–7.

12. i.e., before the high-speed camera had revealed the actual sequence of a horse's galloping legs. This horse has a 'flying' gallop, which is a conceptual rather than a perceptual representation.

13. V. Kaposy, *Bulletin du Musée des Beaux-Arts*, (Budapest), 50, 1978, p.113.

14. Just to cite one such print: a lithograph entitled *Combat boulevard des Italiens, le 28 juillet*, after Victor Adam, is such a scene of quasi-realist reportage, with men throwing their arms up as if shot, lying dead on the ground, etc. See Exhibition Cat. *Il y a cent ciquante ans . . . Juillet 1830*, Paris, Musée Carnavalet, 1980, No. 58 (repr).

15. Adhémar, *Daumier*, p.81.

16. *Moreau-Nélaton*, I, p.31, and Fig. 11.

17. La Fontaine's *Contes* consist mainly of bawdy stories with an old-fashioned, Chaucerian flavour – in the present day they would be regarded by feminists as male chauvinist in the extreme, although the male sex does get some share of sexual ridicule. In any case, the *Contes* do not have the philosophical subtlety of the *Fables*.

18. See the letter written to Daumier *père* in Paris by his wife from Marseilles in 1816, when she quotes La Fontaine on the subject of true friendship (published in Cherpin, *L'homme Daumier*, p.36 ff.).

19. At least twelve editions of La Fontaine's *Fables* appeared in Paris alone in the seventeenth century, and about twenty more in the eighteenth, with numerous re-impressions. One of the most splendid of these was the *Fables choisies* published in four volumes in 1755–9 (Jombert), with engravings after the drawings of J.B. Oudry, the celebrated animal painter. It will be suggested here that Daumier was familiar with this. Also likely to be of interest to Daumier was the Engelmann edition of 1818 with lithographic illustrations by the brothers Carle and Horace Vernet and Hippolyte Lecomte.

20. I am using the free and poetic translation by Marianne Moore in *The Fables of La Fontaine*, New York, 1954, pp.56–8.

21. See note 19. Oudry devoted five drawings to this elaborate fable, one for each of its five incidents. Scene 3 (also treated by Daumier) includes the three girl commentators; scene 4, reproduced here, includes the girls again, one of whom uses a derisive gesture not unlike that found in Daumier's painting.

22. Another painting of the same subject in a German private collection (Maison, I, Cat. I-73), variously dated within the 1850s, is a more literal translation of the same 'scene 3'. I cannot agree with Maison, however, that by comparison with this the Glasgow picture is 'a fantasy in the manner of Rubens'. None of Daumier's 'fantasies' lacked some kind of contemporary point.

23. The two drawings and the painting of this subject are often dated towards the mid-1850s because of its supposed relation with the Barbizon painters' group scheme to illustrate the *Fables*, which was hatched in 1855. This subject does not appear, however, in the list of proposed subjects which Daumier himself put forward at that time – surely because he had already done it. The Sterling-Adhémar catalogue of the Louvre's nineteenth-century French paintings (1959) is probably correct in dating the canvas to 1848–50, on stylistic grounds.

24. Letter to his wife, 'Didine', from Paris dated 22 and 23 August 1849. Published in Cherpin, *L'homme Daumier*, p.58.

25. See Laughton, 'Daumier's Drawings for Lithographs', p.60 and Fig. 4.

26. He also painted the portrait of the Consul, M. Wanner, which is now in Berne. *Tercis and Annette* is reproduced in Moreau-Nélaton, I, Fig. 29, as *Daphnis and Chloë*. It may be noted that such a pastoral, or Virgilian reading of La Fontaine was evidently acceptable to this class of patron at that time.

27. Sensier, *Souvenirs sur Théodore Rousseau*, pp.230–2. Millet himself had provided Sensier with a good deal of the source information for this book, most of which had previously appeared in monthly instalments in *La Internationale Revue de l'Art et de la Curiosité* between 15 July 1869 and 15 August 1870.

28. Ibid., p.232.

29. Respectively: Paris (Librairie Pittoresque de la Jeunesse) 1851, 100 wood-engravings and 10 lithographs, after Gavarni, E. Wattier, E.

Bataille, J-C. Demerville and Ch. Dreselhomme; Paris (Fournier, 1838–40; 4th ed. Garnier frères 1859), illus. Grandville; Paris (Mareseq) 1858, illus. Cham.

30. *Fables choisies . . . par M.de La Fontaine*, frontispiece, title page and figures by engraved by Fressard, Paris (M.E. David) 1746, was the first edition; Rousseau's was the second or third, published in 1768 (3rd ed. 1769, in Bibl. Nat. Paris). He also owned two eighteenth-century editions of the *Contes et Nouvelles*. These volumes are listed among the contents of his studio at a sale after his death (1 May 1868).

31. See note 30. Two other headpieces in Fressard's edition, for *Death and the Woodcutter* and *The Oak and the Reed* respectively, reflect the basic compositional structures of two later works by Millet, though they can hardly be thought to have 'inspired' them. All this evidence suggests that the friends looked at these illustrations together while they were discussing the project, and that some images stuck in their minds.

32. The studies are reproduced in Maison, II, Cat 339 and 400.

33. Ibid., Cat. 402. Charcoal and black chalk, 16 × 24.5 cm. Sale Paris, Palais Galliéra, 14 June 1966, lot 10 (repr. in cat.). The fable is La Fontaine I-15.

34. Since this pastel turned up in Rousseau's studio sale (Paris, 25 April 1868), it appears that the private sale was to Rousseau himself. My last record of it is in the Henri Rouart sale, Paris 1912, lot 211.

35. This fable, La Fontaine, I-16, is presented in the author's text as an *alternative*, directly deriving from Aesop, to his own invention of I-15, *(La Morte et le Malheureux) Death and the Sick Man*, which precedes it. He meant to convey the same moral as Aesop, but in more general terms: but perhaps Aesop's invention was better. Daumier, it has been noted, did his own drawing relating to La Fontaine I-15.

36. Louvre Inv. RF 5707 (GM 10312). In the top left area of the sheet is a composition study of a girl carrying a bucket in a farmyard. There are also studies of ears of corn. In the lower right area Death vigorously tugs at the woodcutter's arm. Several other studies for this subject exist.

37. He made the scene much grimmer in the large oil painting which he worked up from this theme and submitted to the Salon in 1859. Perhaps it was not suprising that it was rejected, though it was defended by his friends and exhibited in Charles Tillot's Paris studio. (Painting now in Copenhagen Museum.) This was the picture of which Alexandre Dumas wrote in *Independence Belge* in 1859, 'Millet's woodcutter-. . . is not the peasant of 1660, but the proletarian of 1859'.

38. Wyatt Eaton, 'Recollections . . .', *Century Magazine*, 1889, pp.103–5. He says that the first series was made for Millet's eldest son François (born 1849) in 1856–7, and a second group made *c*.1872–4 for his youngest daughter Marianne (born 1863), as well as other drawings for children. Some of the last drawings of this kind were made for his first grandchild, Antoine.

39. Sensier, letter to Millet, 13 April 1866.

40. Millet, letter to Sensier, 17 April 1866. The French text of the most relevant paragraph – my transcription is aided by Moreau-Nélaton's typescript, preserved in the Bibliothèque Nationale – is as follows: 'Cependant, je me suis

mis à noter sur une toile quelques unes des compositions qui m'intéressaient à faire; et, si vous croyez que ce soit bon pour moi de figurer dans cette illustration, et que ce ne soit pas une chose trop pressée, j'en ferais deux: le Chêne et roseau et le berger et la mer. Nous en causerons dimanche prochain. Si j'en faisais d'autres ce serait peut-être bien le Cerf se voyant dans l'eau et l'Oracle et l'Impie. Cela peut vous sembler étrange de me voir prendre cette dernière, qui aurait quelque intérêt. Mais je veux attendre à en avoir causé ensemble avant de me décider à rien.'

41. According to Robert Herbert, this volume was finally produced and delivered, but it has not been seen since. At the time of writing, the matter rests there.

42. Edward Wheelwright, 'Recollections of Jean-François Millet', *Atlantic Monthly*, 38, September 1876, p.272.

43. Millet, letters to Sensier, 8 and 16 November 1863.

44. Ironically, Daumier the illustrator-lithographer parodied his own conception a few months after he had received the State commission, when he drew a cartoon of his enemy Dr Véron, editor of *Le Constitutionnel*, as 'the new St Sebastian', a 'virgin and martyr' of great corpulence, tied to a tree and being shot at by an archer symbolising *Charivari* (lithograph, 25 December 1849).

45. Clark, *The Absolute Bourgeois*, pp.112–13.

46. Louvre Inv. 10,551, 10,552, & 10,553 (RF 5886, RF 5884, & RF 5885). They are all drawn in ink and are of comparable sizes, in the range of 6 × 8 inches. The principal subjects explored on them are The Woman taken in Adultery, The Betrayal of Christ, Christ before Pilate, and Christ at the Column.

47. They could have seen examples of Rembrandt's drawings in the Louvre. An indication of contemporary enthusiasm for Rembrandt is the activities of the realist painter Léon Bonnat (1833–1922) – himself also a great admirer of Millet – who in 1865 began to acquire one of the greatest individual collections of Rembrandt drawings, which he later bequeathed to the Louvre and to his native city of Bayonne.

48. Charles Blanc, *L'Oeuvre de Rembrandt*, Paris (Gide et J. Baudry), 1853.

49. Otto Benesch, *Rembrandt: Selected Drawings*, Oxford, 1947, p.22.

50. Millet, letter to Sensier, no. 328, 16 February 1864 It is clear from the previous letter, of 12 February, that he and Rousseau intended to go to the Delacroix exhibition together. Louise was Millet's second daughter, then aged 16.

51. I am greatly indebted to Professor Lee Johnson for detailed information and assistance concerning the dispersal of Delacroix's works after his Studio Sale.

52. The evidence for this lies in the sale catalogue of the effects of Mme Veuve Millet at the Hôtel Drouot, 24–5 April 1894.

53. Ibid., lot 281. 'Pure drawing' in the sense that Delacroix would have made them as drawings after Michelangelo for his own instruction, never conceiving that another artist might want to acquire them for *his* instruction.

54. It may also be significant that iconographically Millet's rendering of this story is closer to a pen drawing by Rembrandt of the same subject, where Christ is in the prow and the boat is at the same angle to the viewer (Dresden, Küpferstich Kabinett, no. C 1395). Rembrandt's drawing,

likewise, stands on its own as an illustration, very succinctly drawn.

10 PERSONAL IMAGERY IN LATE WORKS

1. For Daumier's location, see Jean Cherpin's essay 'Il est temps de détruire la légende de Daumier' (1958), republished in *L'Homme Daumier*, pp.163–8. Daumier signed his lease on his cottage in Valmondois on 1 October 1865, but he kept his apartment at 36, boulevard de Clichy until October 1878, spending only the summers at Valmondois. Sensier knew this, of course, and reminded Millet of the Paris address when asking him to send invitations to the memorial service for Rousseau. (The fact that Millet had to be reminded indicates how far they had drifted apart by 1868.) Millet replied to Sensier, on 23 December (the day after the service), that invitations to Daumier and to Théophile Silvestre (the influential critic who was a friend them both) had been sent out in very good time. Neither went, however.

2. As indicated by Cherpin, ibid. See also the Catalogue of Daumier's Retrospective Exhibition in 1878, for the names of some of his clients among the lenders, such as Madame Bureau who possessed an oil painting and 23 drawings and watercolours at that time.

3. Robert Herbert, *Impressionism: Art, Leisure and Parisian Society*, New Haven and London, 1988, p.33.

4. For Émile Gavet see Chapter 8, p.129. On the subject of the *Four Seasons* cycle and its dating, see Herbert, 1976, p.217. In the correspondence to which Herbert refers, it becomes evident that Millet was embarrassed by the claims of the rival collectors – he wanted to work for Hartmann as well as Gavet but was obliged to keep the former waiting.

5. It was Sensier who put Millet in touch with Durand-Ruel. He mentions him in a letter for the first time on 22 April 1868 (Louvre archives). In his Memoirs (*Mémoires de Paul Durand-Ruel, c*.1910) published in L. Venturi, *Les Archives de L'Impressionisme* (1939) New York edn, 1968, Vol. II, p.165, Durand-Ruel was less specific about this date, simply listing Millet among the artists he backed in his early years of dealing, after he took over the management of his father's gallery in 1865.

6. Millet had exhibited with the mixed exhibitions of the Cercle de l'Union Artistiqe at Petit's gallery in 1862, 1864 and 1865, as well as at the Galerie Martinet in 1860 and 1862, but Sensier had counselled him not to join the Societé Nationale des Beaux-Arts, formed by Martinet and Théophile Gautier with the idea of providing an alternative outlet to the Salon, because (he wrote) some of them were mediocre artists who had more need of him than he of them. Rousseau implicitly agreed with this standpoint: although he briefly joined the Societé, he wrote a verbose letter to Gautier in February 1864, complaining that Martinet was turning his gallery into something 'more like a café', and withdrawing his allegiance. (Drafts of this letter are in Louvre archives.) Later on, in 1868, Millet wrote to Sensier that a M. Lafitte was pressing him to take part in a 'Barbizon Exhibition' which was going to open in May. He considered this a persecution! (Millet-Sensier, 17 April 1868).

7. Millet could not bring himself to go and receive it in person. He wrote a letter excusing himself on the grounds of ill health.
8. Letter to Sensier (Louvre archives, 531) 10 March 1869: '. . . j'ai de la parte de M. Bruyas une commande importante pour le Musée de Montpellier . . .'. He did not get round to writing to Bruyas about this commission until 1872 (Louvre archives, *Reliés* Vol. II, 78–*Lettre à Bruyas*, Barbizon 25 April 1872), and it remains unclear what the nature of Bruyas' request was. Of the three drawings by Millet in the Musée Fabre now, one was bought by Bruyas from Théophile Silvestre in 1870, and the other two were acquired by Bruyas in 1876, after Millet's death.
9. See note 5. The sculptor Barye, closely associated with the painters living at Barbizon, was bracketed with Daumier as producing 'magnificent watercolours' for him.
10. See Jean Cherpin, 'Le Quatrième Carnet des Comtes de Daumier', *Gazette des Beaux-Arts*, 1960, pp.353–62, for a detailed summary of this account book. It appears that during the five years 1864–8 Daumier realised a total sum of 9,930 francs from the sale of 56 works – perhaps more than he got from the journals that took his lithographs over that period. Only five of these sales were paintings; the other 51 were drawings.
11. In Rousseau letters file, 'lettres adressés à Th. Rousseau', Louvre archives.
12. Albert Wolff, Daumier obituary in *Le Figaro*, 13 February 1879.
13. See note 7.
14. As opposed to the several significant artists who were elected as delegates during their absence from the capital. Among these were Corot, who had left Paris on 1 April; François Bonvin, who was in England; Manet, who was by then in the south of France; and Millet who was in Cherbourg and wrote angrily to the editor of *La France* demanding that his name be publicly retracted from the list of members.

This committee was elected, under the Commune, by the 'Federation of the Artists of Paris', itself a continuation of the original Artists' Federation which had been formed upon the declaration of a Republic on 4 September 1870, with the ostensible object of protecting the national museums and works of art from damage during the war. Courbet remained chairman throughout its existence.
15. For a recent detailed discussion of the documentary evidence on Courbet and the Commune, see Rodolphe Walter, 'Un dossier delicat: Courbet et la colonne Vendôme', *Gazette des Beaux-Arts*, 81, March 1973, pp.173–84. The same documentation was previously summarised in English by Gerstle Mack, *Courbet*, London, 1951, pp.261–70.
16. Millet, letter to Sensier, 22 September 1870.
17. Millet, letter to Sensier, 16 March 1871.
18. References to Piton are in Millet letters to Sensier of 16 March, 9 April 2 May, and 21 August; news of him in Sensier's letter to Millet of 27 March.
19. Millet to Sensier, 2 May 1871.
20. Ibid., 27 May 1981.
21. LD 3590. Death, *la mort*, has a female gender in French.
22. LD 3804, 2 September 1870.
23. Cham's cartoons are 'funny' in the old *Charivari* style, but Daumier's have a new, uncompromising note of pessimism.

24. LD 3814, 19 October 1870.
25. LD 3851. 27 February 1871.
26. LD 3845. 9 February 1871.
27. Herbert, 1975 Millet Exhibition Cat., pp.175–6.
28. This resistence to the authority of Thiers' government in Versailles was not unique. Communes were also proclaimed in the big industrial centres of Lyons, Marseilles, Toulouse and Narbonne, but they did not last as long as Paris. Other cities such as Bordeaux, Grenoble and Limoges staged demonstrations of support for them. (See Eugene Schulkind, *The Paris Commune of 1871*, The Historical Association, 1971).
29. His very few lithographs that dealt with the French army, after war had broken out the previous year, are less than enthusiastic from a militaristic point of view. His half-dozen prints published during the early days of the Commune are ambiguous in intent, and the last two that were published before *Charivari* shut up shop on 21 April are both about non-communication between Paris and versailles – admittedly at the expense of the latter, personified by Thiers in the form of an old woman (LD 3866, 3867). When he returned to *Charivari* in July, he made no reference to the fighting.
30. LD 3856, 14 March 1871.
31. LD 3859, 1 April 1871.
32. LD 3925. 'Si les ouvriers se battent, comment veut-on que l'édifice se reconstruise?' This legend is so apt to the spirit of the drawing that one must speculate whether Daumier had a colleague who understood him so completely, or whether he wrote the legend himself.
33. The idea of an identity of interests between the working-class government of the Paris Commune and the rural French peasants (the latter not to be confused with the party of the 'Rurals' who had controlled the provinces under the Second Empire), against the government of Versailles and the bourgeois landlords whom they represented, was most clearly stated by Karl Marx in his *Address of the Members of the International Working Men's Association on the Civil War in France*, which he wrote during the time of the Commune and which was published in England in mid-June 1871 and in France shortly after. (See Foreign Lnaguages Press edition, Peking, 1970, especially pp.75–7 and 187). Daumier's 'spectre' of Robert Macaire first appeared on 19 October 1871, labelled as Robert Macaire but dressed more like Ratapoil (LD 3884); again on 24 October (LD 3886) when he is carrying a flag inscribed SEDAN and stares in amazement at a peasant (or street-porter?) carrying a pole with a hook on the end, who thumbs his nose at him; then on 1 November this Macaire/Ratapoil is confronted by the amalgamated worker-peasant image (Fig. 10.6). The coincidence with Marx's views at this point is worth noting.
34. Marshall Bazaine's army had been immobilised at Metz while Napoleon III's army was cut up at Sedan. At first he refused to recognise the Republic and hoped to use his army to restore the Empire, but he surrendered on 27 October 1870. He was brought to trial before the War Council at Versailles in October 1873. In effect, he was held responsible for the great number of lives lost during the general French defeat.
35. It would, no doubt, be foolhardy to attempt to make connections between a pastel landscape, undertaken to please a client, and Millet's own psychological state at the time. However, 1869–

he could have been doing it for Gavet as late as this – did commence for him with the death of Rousseau's rather innocent and simple-minded wife in the mental hospital of Charonton. He wrote to Sensier on February 16: 'La mort terrible de cette pauvre Mme. Rousseau nous donne à tous bien de la tristesse . . . Rousseau qui cherchait tant à lui éviter tout froissement!' (Rousseau had treated her almost like a child.)
36. Sensier wrote about it twice, in the *Revue Internationale de l'Art et de la curiosité*, a journal which was backed by Durand-Ruel. On 15 April 1870, under the pseudonym Jean Ravenel, he wrote in his 'Preface au Salon de 1870': '*Novembre*, au temps où la terre labourée offre à l'oeuil ses longs sillons travaillés par la charue, scène austère qui contient tout ce que l'hiver présage, tout ce que l'homme va souffrir sous les ciels assombris de novembre' (Vol. 3(4), p.321) On 15 May 1870, as Alfred Sensier on 'Les peintres de nature', he wrote about it at much greater length. He compared Millet, 'a poetic naturalist', with Courbet (whose *Falaises d'Etretat après l'orage* was in the same Salon), 'an admirable naturalist' (Vol. 3(5), pp.382–6).
37. Reproduced in Moreau-Nélaton III, Fig. 159.
38. Vente Millet, 10–11 May 1875, lot 45, *Coup de Vent* (described), 90 × 118 cm, dated 1872–3, bt. Rouart.
39. Herbert, 1975, Millet Centenary Exhibition, pp.280–1. He also points out Millet's compositional debts to Mantegna's *Parnassus* in the Louvre, and to the format of Egyptian memorial sculpture, such as *Akhenaton and Nefertiti*, also in the Louvre.
40. Bearing in mind our earlier observation that Millet's family were independent small-scale farmers, not hired hands. The term 'peasant' is plainly relative in its application.
41. E.H. Gombrich, *Art and Illusion*, London, 1960, pp.352 ff.
42. All writers on Daumier's clowns, his comic caricatures, and his expressive heads generally must now refer to Judith Wechsler's *A Human Comedy* (London, 1982) and to Paula Hayes Harper's Ph. D thesis on 'Daumier's Clowns' (Stanford University Press 1976). Ms Wechsler's remarks on caricature in Paris are most illuminating, though her account of Daumier in particular seems to be largely derived from the published literature. Ms Harper is full of information about the great clowns in early nineteenth-century Paris; she is also informative about the clown in French literature. Arguments about dating the drawings, however, remain as disputable with her as with other writers on this topic.
43. Victor Fournel, *Les Spectacles populaires et les artistes des rues*, Paris, 1863, p.395 and *passim*. This volume was a sequel to his *Ce qu'on voit dans les Rues de Paris* (1858), and more retrospective in nature. Based on eye-witness accounts, it might be called 'ce qu'on *voyait*' in the streets of Paris in former times.
44. Fournel, in *Ce qu'on voit dans les Rues de Paris*, has a long chapter on street traders and *saltimbanques*. He writes that he has always been full of 'tender bad taste' for the race of *saltimbanques* – he likes their picturesque rags and tatters, and he likes to see them performing in the street, not in tents or sheds. Always on the move, they do not have the money to buy a horse. But then their baggage is not heavy (!).
45. Duplessi-Bertaux was a major French engraver trained in the tradition of Caillot in the *ancien*

régime, and a history painter during the first Napoleonic era. His suites of popular prints had originally been published in groups of twelve, representing types of workers, ambulant merchants, beggars, and various country scenes. The *saltimbanques*, who appear at country fairs, rate only three scattered plates which come rather low down in the list. The whole series of original etchings was reissued in 1814 as a bound volume.

46. For a knowledgeable summary of the position of *saltimbanques* under Napoleon III's rule, based on original documents dug up with gusto by a Marxist historian, see Clark, *The Absolute Bourgeois*, pp.120–1. See also Harper, op.cit., especially her conclusions on pp.197–205. Her perception of biographical references to Daumier himself in some of these images is undoubtedly correct.

47. Maison, I, Cat I-25. The oil is in the National Gallery of Washington, and surely much later than he puts it. For Clark and Harper see note 46.

48. The collection of 100 *Cris de Paris* lithographs after Carle Vernet's drawings that appeared in 1815, for example, has a passable ancestor to Daumier's violinist, in the plate called *Chanteur*.

49. *Parade du Charivari*, which shows a noisy group of young caricaturists who worked for the journal parading in front of a crowd outside the 'bureau d'abonnements' (subscription office). Daumier includes himself in the group, as a barker. Lithograph published on 6 January 1839 (LD 554).

50. The illustration in Vernet's print series shows an *escamoteur* standing behind a similar table and holding up the smallest of the coloured balls as he cries: 'La première muscade, voilà!'

51. Rouart's collection became so large and important that on his death in 1912 it had to be sold in three parts ('première vente' 9–11 December 1912; 'deuxième' 16 December 1912; 'troisième' 21 April 1913). A Preface to the first sale, written by Arsène Alexandre, tells how this collection began. Since 1870 Rouart, who had been a schoolfriend of Degas, was watched with alarm by his family and friends as *des horreurs* began to pile up in his nice new house. These *horreurs* included the *ébauches* [sic] of Manet, the *caricatures* (referring to paintings) of Daumier, the *rusticités* of Millet, and the *barbouillages* of Monet and Renoir. At his death he owned 14 Paintings by Daumier, 14 by Millet, 8 by Courbet and 43 by Corot, as well as major works by Monet, Renoir, Morisot and Cassatt; 8 by Delacroix, 5 by Degas (who, as a friend, did not like to sell to him, and Rouart did not like to accept gifts!) and 5 small paintings by Cézanne. Alexandre tells us that Rouart was introduced to Millet through Tillot (an old pupil of Rousseau's) and visited Barbizon at weekends – that must have been in the 1870s. The 'experts' at the posthumous sales were Durand-Ruel and Brame, both of whom were dealing in Daumiers and Millets in the 1870s. The third Rouart sale, which in part consisted of watercolours and drawings, again included works by Daumier, Millet and Rousseau.

52. It is known that this painting is done over a yellow ochre ground, which accounts for the pervasive yellow ochre tones in the figures at this stage of the picture's execution: more colours would have been added on top of these. (Millet-Sensier letter in Louvre archives, 17 April 1868, accurately transcribed by Herbert,

1975, p.293, 1976, p.217.)

53. See Will H. Low, 'A Century of Painting. Jean François Millet' *McClure's Magazine*, 6, May 1896, pp.509–10. The reader may be interested to know that this practice was not confined to barbaric Normandy. In the eighteenth century it was a traditional and legitimate branch of hunting sports in France, and was illustrated as such in Diderot's *Encyclopédie*, Plates Vol. III (1763), 'Chasses' Plate XIV, *Un Chasse de Nuit* (Fig. 10.24). The elegance of this engraving is in notable contrast to Millet's anguished picture of over a century later.

54. The possibilities for an iconography of rural heroism combined with a history painting of Paris were exploited brilliantly, in the event, by Puvis de Chavannes, who succeeded to this commission.

55. Moreau-Nélaton III, p.105.

56. See Chapter 8, note 3. The lithographs were: *La Rue Transnonain*, *Enfoncé Lafayette!*, *Ne vous y frottez pas* and *Le Ventre législatif*. Another separately framed was catalogued as 'La Marcheuse, lithographier, (épreuve rare)'.

57. For an account of a possible two-tier reading of the story of the Daumier exhibition, one version as a simple gesture made by his friends, and the other as an altogether more subtle 'change of discourse' for the reading of Daumier's art in 1878, engineered to 'take the sting out of his republicanism by setting it in the past', see Michel Melot, 'Daumier and Art History: Aesthetic Judgement/Political Judgement', in *The Oxford Art Journal*, 11(1), 1988. In this article, which is one of the most significant contributions to the Daumier literature in this decade, Melot pinpoints the whole difficulty of reading Daumier's politics through his art and vice versa, as an issue which has been studiously avoided by most French art historians and curators (Jean Adhémar is made an honourable exception). His article surveys the whole historiography of Daumier studies both inside and outside France, and discusses the methodologies employed, broadly by three groups: connoisseurs, social historians, and what he calls 'genuine historians *of art*'. His own, synthetic approach resolutely unravels 'the profound interaction between politics and aesthetics' which he perceives in his native country, and which as recently as 1979 made the art of Daumier something of an embarrassment to some French officials.

58. 'Mémoires de Paul Durand-Ruel', in L. Venturi, *Les Archives de l'Impressionnisme*, New York, 1939 (1968 reprint), II, p.208.

59. As Daumier had represented the 'Davidian' painter in combat with the 'realist', in a famous cartoon of 24 April 1855 (LD 2629), *Combat des Écoles–L'Idealisme et le Realisme*. The 'idealist' in that confrontation is rendered nude, in a pose like the figure of Romulus in David's *Intervention of the Sabine Women*, and he holds his palette like a shield and his mahlstick like a lance.

60. See Jean Seznec, 'Don Quixote and his French Illustrators', *Gazette des Beaux-Arts*, 6(34) 1948, pp. 173–92. He counted fifty-two translations of *Don Quixote* from 1614 to 1934, the first illustrated volume appearing in 1665. The earliest illustrated edition of the *Fables* appeared in 1669, and thereafter the number of new editions appearing was closely comparable with *Don Quixote* (see chapter 10).

61. Ibid., p.180.

62. Salon Catalogue No. 727, *Don Quichotte et*

Sancho. Maison, I, Cat. I-33 tries to identify this painting as *Don Quixote and Sancho Going to the Wedding Party of Gamaches* (Coll. Richard C. Paine), but the Paine canvas is far too small to fit a frame size of 90 × 100 cm, as given in the *Enrégistrements des Ouvrages*, no. 4944 (Louvre archives).

63. Hills and mountains can be seen looking in any direction inland from Marseilles, where Daumier spent his early childhood. I also suggested, in Chapter 8, that he might have been familiar with *Voyages Pittoresques* prints of the Auvergne (Fig. 8.34).

11 THE HERITAGE OF PISSARRO, DEGAS, CÉZANNE, SEURAT AND VAN GOGH

1. The Catalogue Preface by Thiébault Sisson refers to the 250 drawings, pastels, watercolours, *croquis* and prints which are listed in this sale, thus: 'on retrouvera [ici] en épreuves réduites *ou en germe* [my italics] toutes les grands oeuvres du maître'.

2. 'Exposition rétrospective de tableaux et dessins des maîtres modernes' [sic], Galeries Durand-Ruel, 15 July–1 October 1878. Among the 380 pictures loaned to this exhibition the largest representations were of Corot, Millet, Rousseau, Delacroix, Courbet, Gustave Ricard (a realist portrait painter from Marseilles), Diaz and Daubigny. Astonishingly, only Corot and Daubigny among these were also represented at the concurrent Exposition Universelle of 1878 – this was at the height of a 'reaction' in popular taste against these painters, and Durand-Ruel records that, while his exhibition was admired by those who came to see it (many of these would have been the lenders, his former clients!), they were few in number and he scarcely covered his costs. At this date Courbet was still very unpopular with French politicians, and the republican parties were not out of danger from conservative elements in the government, under the Presidency of MacMahon. (See Venturi, *Les Archives de l'Impressionnisme*, Paris, 1939, Vol. I, p.34 and Vol. II, pp.208–9.)

3. His inscription on this particular drawing, *Lovers Meeting* (written in English), manages to be ironic without being sentimental, anticipating what would later become Gauguin's attitude towards the primitive.

4. Caracas society, in 1852–4 when Pissarro was there, was quite prosperous as the trading centre of Venezela, and Pissarro and Melbye were taken up by a circle of musicians, writers and art *amateurs*. At the same time, the young Pissarro evidently frequented the town taverns.

5. A full account of Pissarro's early years as a draughtsman and watercolourist is given in Alfredo Boulton, *Camille Pissarro in Venezuela* (texts in Spanish, French and English), Caracas, 1966. Fritz Melbye was a Danish topographical artist of considerable merit, who travelled a great deal in the West Indies and the Americas. It was he who basically encouraged Pissarro to become an artist, and taught him how to work *en plein air* by example rather than by formal lessons.

6. Brettell and Lloyd, *Pissarro Drawings* (Catalogue of Drawings by Camille Pissarro in the Ashmolean Museum), Oxford, 1980, p.123.

7. This was *Anes au Pâturage* (three asses in a field) of 1862. See Ludovic Rodo Pissarro and Lionel-

lo Venturi, *Camille Pissarro*, Paris, 1939, I, p.80, Catalogue 19, where this part of the letter is quoted.

8. This part of the letter is published in Brettell and Lloyd, *Pissarro*, p.15.

9. See Pissarro, *Correspondence*, ed. J. Bailly-Herzberg, Vol, I, pp.157–8. This, and all the other translations from the French which follow, are my own.

10. Ibid., I, p.292.

11. Ibid., II, p.157, letter of 2 May 1887, to Lucien. At this time several of Millet's letters were being published in *Le Figaro*, taken from the Sensier/Mantz biography which was about to be published as *La Vie et l'oeuvre de J.-F. Millet* by Alfred Sensier, Paris, 1881.

12. Compare Vincent van Gogh on 'The Angelus' in the 1870s: see p.000, and n.58 below.

13. Pissarro, *Correspondence*, II, p.169.

14. Ibid., II, p.313.

15. This observation is made by Bailly-Herzberg, in Pissarro *Correspondence*, II., p.314, n.2.

16. Pissarro, *Correspondence* II, p.383 (Supplément). 'En fait de principe, nous *ne voulions pas d'école*, nous aimons Delacroix, Courbet, Daumier et tous ceux qui ont quelque chose dans le ventre, et la nature, le plein air, les différentes impressions que nous éprouvons, toute notre préoccupation. Toutes théories factices, nous les répudions.' Murer was a pastry-cook and restaurateur who took up art criticism under the pseudonym, Gène Mur.

17. Ibid., p.232. [12 May 1888].

18. Ibid., p.227, and n.4: *la Caricature du XVIIIe Siècle à nos Jours* opened 17 April. Félix Fénéon thought it showed the true Daumier *(le seul Daumier)*: 'twenty pictures profoundly coloured, *Advocates and Judges, Amateurs of Prints, Don Quixote and Sancho, Third Class Railway Carriages*, etc., and many lithographs in a grand passionate style and drawn with an expressive logic without the use of hyperbole'. However, Michel Melot, in his article 'Daumier and Art History: Aesthetic Judgement/Political Judgement', *The Oxford Art Journal*, 11(1), 1988, chooses to quote another critic, John Grand-Carteret, for whom this exhibition lacked any serious historical content and made no philosophical or aesthetic point about Daumier. He sees it as having the fault of elevating caricature into an art category collectable by amateurs. The exhibition, which also seems to have carried the title 'Les Maîtres français de la caricature et de la peinture de moeurs', was held at the École des Beaux-Arts – the same academic venue that had hosted Millet the previous year. Pissarro, however, does not seem to have been worried by these fine distinctions in interpretation of 'art'.

19. Pissarro, *Correspondence* I, pp.284–5. Letter dated 17 February 1884.

20. Ibid., I, p.287.

21. According to P.A. Lemoisne, *Degas et son oeuvre*, Paris, 1946–9, I, p.180. However, only a total of 767 items can be accounted for in the *Catalogue des Estampes . . . Collection Edgar Degas*, vente Hôtel Drouot, 6–7 November 1918. These included a number of 'collectors' pieces' printed on fine paper, a group of four 'albums' of cartoon series with about 25 plates in each, and 330 prints cut out of the pages of *Charivari*.

22. 'We know of only two men in Paris who draw as well M. Delacroix – one in an analogous and the other in a contrary manner. The first is M. Daumier, the caricaturist; the second M. Ingres,

the great painter, the artful adorer of Raphael.' Baudelaire, *Art in Paris 1845–1862*, trans. Jonathan Mayne, 1965, p.5. Degas was recorded as saying roughly the same thing to Gérôme in a café around 1883–5, by G. Jeanniot ('Souvenirs sur Degas', *Revue Universelle*, 55, 1933, p.171). More recently Theodore Reff brought them together again in his essay 'Three Great Draughtsmen', in *Degas: The Artist's Mind*, New York, 1976 (repr. 1987).

23. See p.180. It may be significant that Degas possessed impressions of the four great 'Association Mensuelle' prints which were hung framed in 1878. These are also *illustrated* in the 1918 Degas print sale catalogue.

24. *Collection Edgar Degas* sale, Galerie Georges Petit, 26–7 March 1918, nos. 23 (*Don Quixote*), 106 (2 heads), 107 (*Les Amateurs de Peinture*), 108 (*Le Tribunal*), and ibid., *2me Vente*, 15–16 November 1918, no.85 (*Étude pour 'l'Histoire ancienne'*).

25. *Gazette des Beaux-Arts*, May and June 1878, pp.429–43 and 528–44.

26. Ibid., p.439.

27. Reff, *Degas*.

28. Maison, I, Cat. II-49. In Daumier's most realist style, it should date to the early 1850s.

29. Ibid., I, Cat I-62. A small panel, now in Algiers Museum, depicting four seated men examining a print at close quarters.

30. Duranty, *Gazette des Beaux-Arts*, June 1878, pp.536–7. The French text, from which I have translated rather freely, is as follows: 'A l'exception de quelques toiles, on peut dire que toute cette oeuvre est, par essence, du dessin peu ou coloré. Parfois des forts traits noirs cernent les contours de ses images; les traits de plume ou de fusain se mêlent au lavis aux teintes d'aquarelle. Le coloriste, très-remarquable chez Daumier, est sorti du dessinateur. C'est avec le blanc et le noir du crayon qu'il s'est pénétré intimement des éclats de la lumière et des profondeurs de l'ombre. Qu'il soit préoccupé ensuite de la beauté de quelque tons, le fond de sa coloration n'en procède pas moins, avant tout, des grand masses et des demi-teintes que le noir et le blanc ont l'avantage de résumer et d'affirmer Grands *étalements* de fusain ou de lavis, grands étalements d'un même ton roux et blond, gris-bleuâtre, bleu-noir ou blanc, se correspondent de l'un à l'autre. Peintures, dessins, lithographies forment un ensemble, un tout un et indivisible.'

31. 1988–9 *Degas* Exhibition Catalogue (Paris, Ottawa and New York), Section II, no.160, pp.170–1.

32. Ibid., nos. 196 and 197.

33. Ibid., p.201 (essay by Douglas W. Druick and Peter Zegers).

34. *Lettres de Degas*, ed. Marcel Guérin, Paris, 1945, letter 32.

35. *Vente . . . Collection Degas*, 26–7 March 1918, Cat. no.231. It appers to bear the stamp of the 1894 *Mme Veuve Millet* Sale (see R.L. Herbert, 'Les Faux Millet', *Revue de l'Art*, 21, 1973, p.64, *cachet* type 1894 F). This might seem to be a late *terminus ante quem* for its acquisition by Degas, were it not that very few of Millet's early drawings of this type were in his studio sale of 1875 – not surprisingly, because most of the nudes would have been bought by private collectors long before, in the 1840s. On the other hand, Degas' friend Henri Rouart lent a *Study of a Female Nude reclining on a Bed* to Millet's Retrospective Exhibition in 1887 (Cat.

no.148), so some of these studies could have been turning up again on the market by then, and have aroused the interest of Degas.

36. See E. Havercamp-Begemann, *Drawings from the Clark Art Institute*, Yale University Press, 1964, Cat. nos. 154 and 155. This drawing, originally forming one sheet and now on the verso of these two items, relates to Degas' studies for his early historical paintings. Echoes of this group are found in several of them, not least in the well-known *Spartan Girls challenging Spartan Boys* (begun 1860) now in the London National Gallery.

37. Degas also bought Millet's portrait of his first wife, *Pauline-Virginie Ono*, at the *Mme Vve. Millet* Sale (the second wife), Paris 1894, 24–5 April (lot 82). This is the bust portrait now in Boston Museum of Fine Arts.

38. See Herbert, Millet Centenary Exhibition, 1975, Cat.34. The painting has since disappeared.

39. 1988–9 *Degas* Exh., section III, '1881–1890', p.474.

40. Herbert, Millet Centenary Exhibition, 1975.

41. See John Rewald, *Paul Cézanne: The Watercolours*, London and New York, 1983, Cat.53 (as 1872–5). A vaguely modern idyll of figures under trees, with a woman balancing a jug on her head like the one in Daumier's watercolour (Fig. 8.33), a man holding a scythe and another reaping.

42. Ibid., Cat.53 (as 1875–8). A very sculptural group of harvesters drinking from jars and resting. Reproduced in colour in Sotheby's, London, sale catalogue of 5 April 1989(303), with a newly discovered verso – a pencil drawing after a plaster cast of the Capitoline Antinous.

43. Ibid., Cat.54 (as 1878–80). Men scything in a field, with two women workers. Rewald relates it 'vaguely' to a painting catalogued by Lionello Venturi, *Cézanne, son art, son oeuvre*, 2 vols., Paris 1936, No.249, *Le Moisson*, a Poussinesque harvesting scene.

44. Such as the paintings Venturi, no.56, *Paris: Quai de Bercy – La Halle aux Vins* (*c*.1871–2) and Venturi, no.243, *La Seine à Bercy* (*c*.1873–5). Some earlier paintings of *c*.1869, which introduce factory chimneys into Provençal landscapes, employ a streaky handling reminiscent of Manet.

45. He only seems to have drawn from live models frequently between 1861 and about 1865. His drawings at the Académie Suisse sometimes look a bit summary, but the feeling of the poses is conveyed with astonishing force.

46. Adrien Chappuis, *The Drawings of Cézanne* (1973), Cat.184, as *c*.1866–9. A great deal of information about the sources of Cézanne's copies is available in this *catalogue raisonné*, due to the researches of Chappuis, Robert Ratcliffe and others.

47. Ibid., Cat.168, as *c*.1866–9.

48. Lawrence Gowing, *Cézanne: The Early Years 1859–1872*, London (Royal Academy) 1988, Cat. no. 41 (as *c*.1869–70).

49. Ibid., Cat. nos. 79 and 80. Gowing contrasts their drawing styles: one 'classic' and the other 'baroque', which he takes as complementary and both contributing to the qualities of the painted portrait.

50. Ibid.

51. I describe Daumier as 'the caricaturist' here because there is some overlap between his caricatures and his 'straight' portraits. For further discussion, see Laughton, 'Daumier's

Expressive Heads, 14, pp.135–42 and Figs. 94–111.

52. Chappuis, *Cézanne.*, Cat. nos.306–10 and 634–7.

53. See Chapter 7, note 6.

54. RF 247, Inv. 10484. There are other drawings by Millet of *Le Faucheur* in this pose, but this version is the closest to Cézanne's copy. Chappuis, *Cézanne.*, Cat.1213, dates the Cézanne drawing to *c*.1900. It is surprising to think of Cézanne visiting the Cabinet des Dessins in the Louvre at such a late date, and copying this one drawing, but not quite so surprising when we envisage it on public display, framed. Evidence to support this supposition is provided by the drawing's present condition in its solander box. The paper is discoloured and brittle, and the drawing is mounted in a very faded blue matt, with a gold stripe and a carefully lettered *François Millet* inscription in a cartouche. This is a nineteenth-century matt, and its outer edges are not faded, which suggests that it was once framed and glazed.

Cézanne's drawing is one of only five subjects in the second Enid A. Haupt sketchbook, all of which are in the Louvre Museum. The others are after sculptures by Michelangelo, Puget and Barye respectively, and after a horse by Rubens in the Medici Gallery series. All these drawings could perhaps have been made on one visit.

55. The subject is so read by R.L. Herbert in *Seurat's Drawings*, New York, 1962, p.195. It is also known by the title *Man Bending Over*. Herbert's book makes a number of excellent comparisons between Seurat, Daumier and Millet.

56. *Ibid.*, p.89.

57. For a perceptive account of the causes of van Gogh's early admiration for Millet, see Judy Sand, 'The Sower and the Sheaf: Biblical Metaphor in the Art of Vincent Van Gogh', *Art Bulletin*, 70(4) December 1988, p.160 ff.

58. *The Complete Letters of Vincent Van Gogh* (3 vols), New York Graphic Society, 2nd edn, 1959, Vol. I, p.105, LT 94.

59. *Ibid.*, Vol. I, p.210 LT 138 (Brussels 1 November 1880): 'I have drawn "The Diggers" by Millet, from a Braun photograph which I found at Schmidt's and which he lent me, together with that of "The Angelus". I sent both these drawings to father so he might see I am working.'

60. *Ibid.*, Vol. I, p.213. LT 140 (Brussels, January 1881).

61. *Ibid.*, Vol. I, p.468. LT 237 (The Hague, October 1882). The illustration is a woodcut (cf. E. Bouvy, *Daumier: l'oeuvre gravé du maître*, Paris, 1933 No. 735), the frontispiece to Balzac's *Ferragus*, Edition Furne (1843). The old man is standing watching a game of *boule*. This print was also published in *Charivari* on 20 November 1846. It has a good feeling of light in it.

62. *Ibid.*, Vol. I, p.477. LT 241 (The Hague).

63. *Ibid.*, Vol. III, p.38. LT 538 (Arles, *c*.17 September 1888).

64. *Ibid.*, Vol. II, p.361. LT 400 (Nuenen 1885).

65. He could possibly have picked up this attitude first from Camille Pissarro.

66. Van Gogh was very alert to changes in landscape reflecting social change. In 1890, nearing the end of his life, he observed how much Auvers had changed 'since Daubigny', although he did not find the 'various modern middle-class dwellings' unpleasant. *Letters*, Vol. III, p.275. LT 637 (25 May 1890).

67. If this is so, the number of 'overseers' (the men in soft hats) is not easily determined, because I suspect that Vincent drew the same figure more than once, moving around.

68. *Letters*, Vol. III, p.227. LT 613 (St Rémy, *c*.3 November 1889).

69. Bouvy, *Daumier*. Cat.935.

70. He was in a socially moralistic mood. At the same time as doing this copy he was engaged upon the now better-known one of Gustave Doré's print *The Prison Courtyard*, which represented the exercise yard in Newgate Prison in London (now in Moscow, Pushkin Museum).

71. *Letters*, Vol. I, p.534. LT 265 (The Hague, 8 February 1883). 'I found a page by Daumier He is witty and full of sentimental passion; sometimes, for instance in "The Drunkards" . . . I find a passion which can be compared to the white heat of iron.'

APPENDIX 1 THE USE OF PERSPECTIVE CONSTRUCTIONS BY DAUMIER AND MILLET

1. Such a construction is illustrated in A. Cassagne, *Traité Pratique de Perspective*, Paris, 1873 (new edn) pp.42–3. (This was drawn to my attention by B.A.R. Carter: see notes 2 & 3). Cassagne started publishing in Paris in 1862, but Carter thinks he could have been known to artists earlier than that. He adds, moreover, that *any* perspective manual would have some such construction . Millet's use of this *échelle fuyante* as an aid to his imaginary compositions can be found, for example, in his preparatory drawing for *Les Lavendières* (Louvre, Cabinet des Dessins, Inv. 10631), that is, for the painting of *c*.1853–5 in Boston Museum of Fine Arts; in a sheet of studies for figures around a cart and figures in a farmyard, also in Boston Museum (Inv. 61.630 verso, 1984 Cat. 50 as 'about 1854'); and in a sheet of studies for *La Gardeuse d'oies a Gruchy* (Bayonne, Musee Bonnat, LB2327 verso), used for the painting in the National Gallery of Wales, Cardiff, of 1854–6; as well as in Fig. A.1 discussed here.

2. Communication to the author, September 1980 and August 1985. See also B.A.R. Carter, in his article on 'Perspective', in *Oxford Companion to Art*, Clarendon Press, 1970, pp.840–81, for an analysis of Distance or Three-Point Construction (pp.851–2).

3. See Murphy, *Millet*, no. 49. She points out that the first drawing in the centre of the sheet is a quick rendering of the *Porte aux vaches* in Barbizon, made about 1853, and that the subject of the well (from Gruchy) must be about a year later.

4. Maison, II, Cat. 708.

5. Maison, I, Cat. I-41. He dates the painting 1850–2, which I think is a little early although it would make a convenient parallel with the time of Millet's known perspective studies. But I would put the painting style nearer to 1860 (from the evidence of the photograph only).

6. This whole paragraph is a condensation of an elaborate analysis accompanied by diagrams, sent to me by B.A.R. Carter (see note 2). Mr Carter is a past Professor of Perspective at the Royal Academy, and his Oxford article on Perspective (cited in note 2) is the seminal introduction to that subject.

7. A painting of the *Pont Marie* dated 1757, by N. J.-B. Reguenet (Musée Carnavalet, Paris), taken from a viewpoint probably on the old Pont Louis Philippe, shows a steep flight of steps down to the water at the Ile St Louis end. On the opposite bank there was still a sandy shore, as indeed there must have been at various places during Daumier's time.

8. *Sotto in su*: illusionistic foreshortening.

9. This is again B.A.R. Carter's view (see note 2). I think it quite likely that Daumier could have worked all this out for himself. Carter agrees with me, however, that Daumier was very 'design conscious', and points out the exact repetition of the curve of the arch of the bridge in the outline of the near figure and again, reversed, in the profile of the upper figure. He also believes that the right-hand end of the bottom step and the top of the bridge are on 'golden sections' of the lower short side and the right-hand long side of the canvas, respectively.

10. Occasionally they turn up unexpectedly. A free-hand perspective diagram is to be found on the verso of a latish drawing of a workman's head now in the British Museum, (Inv. no. 1925–11–14–3) which could have been made about 1860. The whole verso is covered with blobs of watercolour in different shades, as well as two little heads of men and the head of a dog. The diagram is drawn in black chalk *over* the watercolour marks: it appears to be a simple free-hand notation of a distance-point construction, as though Daumier were reminding himself how the construction works.

APPENDIX 2 THE 1855 SCHEME TO ILLUSTRATE LA FONTAINE'S FABLES

1. In the form of two landscape drawings appropriate to the subject: one in black chalk and pen, 18 × 24 cm (sight), Musée Bonnat, Bayonne; the other in pencil and black chalk, 45 × 54.5 cm, Musée des Beaux-Arts, Dijon, Granville Collection. Millet executed a painting of the same subject with a similar composition late in his career (see Chapter 11).

2. Again, there are drawings by Millet which may be related to this story: a very spontaneous study in black chalk, 26.5 × 19.6 cm, Paris, Louvre, Inv. RF 11286; a finished pastel, *Les Lapins en fôret*, of 1867, repr in Moreau-Nélaton III, Fig. 247.

3. Sensier (*Souvenirs sur Th. Rousseau*. Pan's, 1872, p.232) claims that Rousseau had already made a project to interpret this fable, in which 'he wished to show' a terrible winter day with frost and a livid sun, and on the ground an inert population of grasshoppers, a cloud of insects petrified by the cold wind, and in the middle, under a ray of sunlight, the proud dome of an anthill, very pleased with its economy, etc., with a provision of flies and grubs.

BIBLIOGRAPHY

The following titles do not pretend to be an exhaustive bibliography for Daumier and Millet, either separately or together. The works listed here have been chosen for their usefulness in relation to the topics under discussion in this book. Generally, works consulted for information about artists other than these two have been acknowledged only in the relevant notes. With certain exceptions, the same applies to works of a more general nature which deal with French drawing as a whole.

ARTICLES

Adhémar, Jean, 'Les lithographies de paysage en France à l'époque romantique', *Archives de l'Art Français*, (New Series.), 19 (Années 1935–1937) publ. 1938, pp.189–350. (A key article about the lithographed series of French landscapes of which the *Voyages Pittoresques* by Taylor and Nodier are both the model and the best example.)

Angrand, Pierre, 'Un tableau de Daumier retrouvé: "Le Martyr de Saint Sébastien", *Gazette de Beaux-Arts*, 6(83), Feb. 1979, pp. 95–8.

Aradi, Nóra, 'Les Tableaux de Daumier et l'art universel', *Acta Historiae Artium*, 26(1–2) Budapest 1980, pp. 93–125.

Bartlett, T.H., 'Barbizon and Jean-François Millet', *Scribner's Magazine*, 7 May–June 1890, pp.530–55, 735–55.

Baudelaire, Charles, 'Quelques Caricaturistes', *Le Présent*, 1857; more fully published in *Curiosités Aesthetiques*, Paris 1868. Trans. as 'Some French Caricaturists', in Jonathan Mayne, *The Painter of Modern Life and Other Essays*, London, 1964, pp.166–86.

Burty, Philippe, 'L'Exposition du cercle de la rue de Choiseul', *Gazette des Beaux-Arts*, series 1, April 1864, pp.366–72.

Cartwright, Julia [Mrs Ady], 'The Drawings of Jean-François Millet in the collection of Mr. James Staats-Forbes', *Burlington Magazine*, 5, 1904, pp.47–68, 118–59 (April and May); 6, pp.192–203 (Dec.); pp.361–9 (Feb. 1905).

Chamboredon, Jean-Claude, 'Peinture des rapports sociaux et invention de l'éternel paysan: les deux manières de Jean-François Millet', *Actes de la Recherche en Sciences Sociales*, 17–18, Nov. 1977, pp.6–28.

Chaudonneret, Marie-Claude, '1848: "La République des Arts" ', *The Oxford Art Journal*, 10(1) 1987, pp.59–70.

Cherpin, Jean, 'Le Quatrième Carnet de comtes de Daumier', *Gazette des Beaux-Arts*, 106, 1960, pp.352–62.

Cuno, James, 'Charles Philipon, La maison Aubert, and the Business of Caricature in Paris, 1829–41', *Art Journal*, 43(4) Winter 1983, pp.347–60.

Duranty, Edmond, 'Daumier' *Gazette des Beaux-Arts*, Series 2, 17, May and June 1878, pp.429–43, 528–44. (An important biography and critique in two parts.)

Eaton, Wyatt, 'Recollections of Jean-François Millet with Some Account of his Drawings for his Children and Grandchildren', *Century Magazine*, 38, May 1889, pp.90–104.

Filloneau, Ernest, 'Le Cercle de l'Union Artistique', *Moniteur des Arts*, 15 March 1864.

Gowing, Lawrence, 'Daumier at the Tate', *The Observer*, 19 June 1961.

Granville, P, 'Notre-Dame-de-Lorette et l'effusion spirituelle chez J-F. Millet', *Revue du Louvre*, 5–6, 1975, pp.344–53.

Green, Nicholas, 'Dealing in Temperaments: Economic Transformation of the Artistic Field in France During the Second Half of the Nineteenth Century', *Art History*, 10(1), March 1987, pp.59–78.

Green, Nicholas, 'Circuits of Production, Circuits of Consumption: the Case of Mid-Nineteenth-Century French Art Dealing', *Art Journal*, 48(1), Spring 1989, pp.29–34. (Includes comments on the Rousseau–Sensier relationship and the careful cultivation of Rousseau's own myth.)

Hauptman, William, 'Juries, Protests, and Counter-Exhibitions before 1850', *Art Bulletin*, March 1985, pp.95–109.

Henley, W.E., 'The Early Life of J.F. Millet', *Cornhill Magazine*, 45, 1882, pp.289–302.

Herbert, R.L., 'Millet Revisited', *Burlington Magazine*, 104, July 1962, pp.294–305; Sept. 1962, pp.377–86.

Herbert, R.L., 'Millet Reconsidered', *Museum Studies*, (Chicago), 1, 1966, pp.29–65.

Herbert, R.L., 'City vs. Country, the Rural Image in French Painting from Millet to Gauguin', *Artforum*, 8, Feb. 1970, pp.44–55.

Herbert, R.L., 'Les faux Millet', *Revue de l'Art*, 21, 1973, pp.56–65.

Herbert, R.L., 'La Laitière Normande à Gréville de J-F. Millet', *La Revue du Louvre*, 1, Feb. 1980, pp.14–20.

Hofmann, Werner, 'Ambiguity in Daumier (& Elsewhere)', *Art Journal*, 13(4), Winter 1983, pp.361–4.

James, Henry, 'Daumier, Caricaturist', *Century Magazine* (New York/London), 17 (new series), 1890, pp.402–3.

Jirat-Wasiutynski, Voytech and Thea, 'The Uses of Charcoal in Drawing' (Introduction to exhibition catalogue), Fogg Museum, Cambribge, Mass., 1980.

Kaposy, Veronika, 'Remarques sur deux époques importantes de l'art de Daumier dessinateur', *Acta Historiae Artium*, 14(3–4), Budapest 1968, pp.255–73.

Laughton, Bruce, 'Millet's *St. Jerome Tempted* and *Oedipus Taken down from the Tree*', *Bulletin of the National Gallery of Canada*, 24, 1974, pp.2–12.

Laughton, Bruce, 'A Group of Millet Drawings of the Female Nude', *Master Drawings*, 17(1), 1979, pp.44–50 and Plates 37–42.

Laughton, Bruce, 'Millet's *Hagar and Ishmael*', *Burlington Magazine*, 121, Nov. 1979, pp.705–11.

Laughton, Bruce, 'Daumier's Drawings for Lithographs', *Master Drawings*, 22(1), 1984, pp.55–63 and Plates 39–45.

Laughton, Bruce, 'Daumier's Expressive Heads', *RACAR*, 14(1–2) 1987, pp.135–42 and Figs. 94–107.

Laughton, Bruce, 'J-F. Millet in the Allier and the Auvergne', *Burlington Magazine*, 130, May 1988, pp.345–51.

Lehmann, Bernard, 'Daumier and the Republic', *Gazette des Beaux-Arts*, Séries 6, 27, 1945, p.105 ff.

Low, Will H, 'A Century of Painting: Jean François Millet', *McClure's Magazine*, 6 May 1896, pp.499–512.

Maison, K.E., 'Daumier Studies–I: Preparatory Drawings; II: Various Types of Alleged Daumier Drawings; III Cardiff Museum Paintings', *Burlington Magazine*, 96, Jan., March and April 1954, pp.13–17, 82–6, 105–9.

Maison, K.E., 'Further Daumier Studies–I: The Tracings; II: Preparatory Drawings for Paintings', *Burlington Magazine*, 98, May and June 1956, pp.162–7, 199–204.

Maison, K.E., 'Some Unpublished Works by Daumier', *Gazette des Beaux-Arts*, Series 6, 1958, pp.341–52.

Maison, K.E., 'Daumier's Painted Replicas', *Gazette des Beaux-Arts*, Séries 6, 57, 1961, pp.369–77.

Maison, K.E., 'Some Additions to Daumier's Oeuvre', *Burlington Magazine*, 112, 1970, pp.623–4 and Figs. 86–92.

McWilliam, Neil, 'Art, Labour and Mass Democracy: Debates on the Status of the Artist in France around 1848', *Art History*, 2(1), March 1988, pp.64–87.

Melot, Michel, 'Daumier and Art History: Aesthetic Judgement/Political Judgement', *The Oxford Art Journal*, 11(1), 1988, pp.3–24.

Millet, Pierre, 'The Story of Millet's Early Life; Millet's Life at Barbizon', *Century Magazine*, 45, Jan. 1893, pp.380–5; 47, April 1894, pp.908–15.

Osiakowski, S. *Some Political and Social Views of Honoré Daumier as Shown in His Lithographs*, unpublished Ph.D. thesis, University of London 1957.

Parsons, Christopher, and McWilliam, Neil, ' "Le Paysan de Paris": Alfred Sensier and the Myth of Rural France', *The Oxford Art Journal*, 6(2), 1983, pp.38–58.

Ravenel, Jean (Alfred Sensier), 'Preface au Salon de 1870', *Revue Internationale de l'Art et de la Curiosité*, 3(4), 15 April 1870, p.320 ff.

Sensier, Alfred (Jean Ravenel), 'Les Peintres de la nature', *Revue Internationale de l'Art et de la Curiosité*, 3(5), 15 May 1870, pp.377–96.

Sensier, Alfred. (Jean Ravenel) 'Conférence sur le paysage', *Revue Internationale de l'Art et de la Curiosité*, 4(1), 15 July 1870, pp.25–40.

Talbot, William S., 'Jean-François Millet: Return from the Fields', *Bulletin of the Cleveland Museum of Art*, 60(9), Nov. 1973, pp.259–66.

Thomson, D.C., 'The Barbizon School', *Magazine of Art*, 12, 1889, pp.375–84; 397–404.

Wasserman, Jeanne, de Caso, Jacques and Adhémar, Jean, 'Hypothèses sur les sculptures de Daumier', *Gazette des Beaux-Arts*, Séries 6, 101, Feb. 1983, pp.57–80.

Wheelwright, Edward, 'Personal Recollections of Jean-François Millet', *Atlantic Monthly*, 38 Sept. 1876, pp.257–76.

Wickenden, Robert J. 'A Jupiter in Sabots', *Print Collectors' Quarterly*, 6(1), 1916, p.131.

Zolatov, Y., 'Lettres des peintres français du XIXe siècle dans les archives sovietiques', *Revue de la Civilisation Mondiale*, 2, 1959. (In Russian; French trans. in Bibliothèque du Louvre.)

BOOKS

Adhémar, Jean, *Daumier* (Exhibition of Prints and Sculpture), Paris, Bibliothèque Nationale, 1934.

Adhémar, Jean, *Daumier*, Paris, 1954.

Adhémar, Jean, *Daumier Drawings*, trans. Eveline Winkworth, New York and Basle, 1954.

Alexandre, Arsène, *Daumier–L'Homme et l'Oeuvre*, Paris, 1888.

Amman, Peter H., *Revolution and Mass Democracy*, Princeton University Press, 1975.

Angulhon, Maurice, *Marianne into Battle*, trans. Janet Lloyd, Cambridge University Press, 1981.

Bacou, Roseline, *Millet Dessins*, Paris, 1975.

Barbey d'Aurevilly, Jules Amedée, *Le XIXe Siècle: Sensations d'Art*, Paris, 1876. pp.109–22 (includes essay on Millet as realist).

Bénédite, Léonce, *Dessins de J-F. Millet*, London, Paris and Philadelphia, 1906. (The plate numbers differ in each of the three editions.)

Bouvy, E., *Daumier: l'Oeuvre gravé du maître*, 2 vols, Paris, 1933.

Brandel, Fernand and Labrousse, Ernest, *Histoire Économique et Sociale de la France*, Vol. III, Paris, 1970.

Brazini, Luigi and Mandel, Gabriele, *Daumier: l'Opera Pittorica Completa*, Milan, 1971.

Brettell, Richard R. and Caroline B., *Painters and Peasants in the Nineteenth Century*, Geneva, 1983.

Brettell, Richard and Lloyd, Christopher, *Catalogue of the Drawings by Camille Pissarro in the Ashmolean Museum, Oxford*, Oxford, 1980.

Burger, W., *Salons de W. Burger, 1861 à 1868*, Paris, 1870.

Burty, Philippe, *Maîtres et petits-maîtres*, Paris, 1877. (Includes essays on Rousseau, 1867 and 1868; J.-F. Millet, 1875 etc.)

Burty, Philippe, *Croquis d'après mature*, Paris, 1892. (Includes account of going to see Millet etching in 1861.)

Callen, Anthea, *Techniques of the Impressionists*, QED Books, 1982 (pp.68–71, technical analysis of Millet's painting, *Autumn, the Haystacks* N.Y. Met.).

Cartwright, Julia (Mrs Ady), *J.-F. Millet: His Life and Letters*, London, 1896; 2nd edn 1902.

Champfleury (Jules Fleury, 1821–89), *Le Réalisme*, Paris, 1857 (For Courbet and Daumier).

Champfleury, *Histoire de la caricature moderne*, Paris, 1865. (On Daumier, Traviès and Monnier, with emphasis upon the first, and Appendices on Philipon, Pigal, Grandville and Gavarni.)

Chappuis, Adrien, *The Drawings of Cézanne, Catalogue Raisonné*, 2 vols, New York Graphic Society, 1973.

Chaudonneret, Marie-Claude, *La Figure de la République. Le Concours de 1848* (Exhibition), Paris, 1987.

Cherpin, Jean (Éd.), *L'Homme Daumier: un visage qui sort de L'ombre*, Marseilles, 1973.

Cherpin, Jean, *Daumier et la sculpture*, Paris, 1979.

Clark, T.J., *The Absolute Bourgeois: Artists and Politics in France 1848–1851*, London, 1973. (Chapters on Daumier and Millet respectively.)

Courthion, Pierre (Éd.), *Daumier raconté par lui-même et par ses amis*, Paris, 1945.

Curmer, L. (Éd.), *Les Français peints par eux-mêmes: Encyclopédie Morale du Dix-neuvième Siècle*, (9 vols) Paris 1840–2.

Daumier, *Exposition des peintures et dessins de H. Daumier*, Paris, Galeries Durand-Ruel, 1878. (Exhibition, with biographical notice by Champfleury.)

DAUMIER: for Paris Exhibitions, 1934, see *Adhémar* and *Sterling*. for London Exhibition, 1961, see *Maison*. for Ingelheim am Rhein Exhibition, 1971, see *Lachenal*. for Marseilles Exhibition, 1979, see *Latour*.

Daumier, *Daumier* (special number of *Arts et Livres de Provence*), Marseilles, 1948.

Delteil, Loys, *Le Peintre graveur illustré*, Vols XX–XXIX, *Daumier*, Paris, 1925–30.

De Tolnay, Charles, *History and Technique of Old Master Drawings*, New York, 1972.

Diderot, Denis (Éd.), *Encyclopédie. Planches* (11 vols), Paris, 1762–72 (most plates were engraved by Benard).

Durand-Ruel, *Mémoires . . . :* see *Venturi*.

Escholier, Raymond, *Daumier*, Paris, 1923 (the best edition).

Escholier, Raymond, *Daumier*, Paris, 1930. (Different arrangement of Plates from 1923 ed, and without the Appendix of certain letters addressed to Daumier.)

Escholier, Raymond, *Daumier et sa Monde*, Paris 1965 (rewritten text).

Fermigier, André, *J.-F. Millet*, Geneva and New York (trans. Dinah Harrison), 1977.

Fournel, Victor, *Ce qu'on voit dans les rues de Paris*, Paris, 1858.

Fournel, Victor, *Les Spectacles populaires et les artistes des rues*, Paris, 1863.

Fuchs, Eduard, *Der Maler Daumier*, Munich, 1927; 2nd edn (with supplement) 1930.

Gassies, J-G., *'Le Vieux Barbizon', Souvenirs de jeunesse d'un paysagiste, 1852–1875*, Paris, 1907.

Geffroy, Gustave and Alexandre, Arsène, *Corot & Millet* (special number of *The Studio*), London, Winter 1902–3.

Hammer: The Armand Hammer Foundation, *Honoré Daumier 1808–1879: the Armand Hammer Daumier Collection*, Los Angeles, 1982.

Harper, Paula Hayes, *Daumier's Clowns*, Stanford University Press, 1976.

Herbert, R.L., *Barbizon Revisited* (Exhibition), San Francisco, 1962.

Herbert, R.L., *Jean-François Millet* (Centenary Exhibition), Paris (Musées Naionaux), 1975.

Herbert, R.L., *Jean-François Millet* (Exhibition), London (Arts Council), 1976.

Herbert R.L., *Millet's 'Gleaners'* (Exhibition), Minneapolis Institute of Arts, 2 April–4 June 1978.

James, Henry, *Daumier, Caricaturist*, London, 1954 (new ed of 1890 article).

Johnson, W. McAllister, *French Lithography: the Restoration Salons 1817–1824*, Agnes Etherington Art Centre, Kinston, Canada, 1977.

Lachenal, François, *Honoré Daumier* (Exhibition), Ingelheim am Rhein, 1971.

Larkin, Oliver, *Daumier: Man of his Time*, London, 1967.

Lassaigne, Jules, *Daumier*, Paris, 1938.

Latour, Marielle, et al., *Daumier et ses amis républicains* (Exhibition), Marseilles, 1979.

Lepoittevin, Lucien, *Jean-François Millet, I, Portraitiste*, Paris, 1971.

Lepoittevin, Lucien, *Jean-François Millet, II, l'ambiguité de l'image*, Paris, 1973.

Lepoittevin, Lucien, *Jean-François Millet, III, Bibliographie générale et Sources*, Paris, 1980.

Low, Will H., *A Chronicle of Friendships (1873–1900)*, New York, 1908.

Mainardi, Patricia, *Art and Politics in the Second Empire*, Yale University Press, 1987.

Maison, K.E., *Daumier Drawings*, London and New York, 1960.

Maison, K.E., *Daumier. Paintings and Drawings* (Exhibition; Introduction by Alan Bowness), London, Arts Council, 1961.

Maison, K.E., *Honoré Daumier: Catalogue Raisonné*, Vol.I (Paintings), Vol. II (Watercolours and Drawings), London, 1968.

Marotte, Léon and Martine, Charles, *Honoré Daumier* (Dessins de Maîtres Français), Paris, 1924 (50 reproductions).

Marx, Karl, *The Civil War in France* (English edn), Peking, 1970.

Millet, *Catalogue descriptif . . .* , Paris, Ecole des Beaux-Arts, 1887. (Exhibition, with essay by Paul Manz.)

MILLET: for Modern Exhibitions see *Herbert*, and *Murphy*, and *Sutton*.

Moreau-Nélaton, Étienne, *Millet raconté par lui-même* (3 vols), Paris, 1921.

Mosby, Dewy F., *Alexandre-Gabriel Decamps*, New York and London (Garland), 1977.

Murphy, Alexandra, *J-F. Millet* (Exhibition), Boston, Museum of Fine Arts, 1984.

Naegely, Henry, *J-F. Millet and Rustic Art*, London, 1898.

Passeron, Roger, *Daumier: Témoin de son temps*, Fribourg, 1979 and New York (as *Daumier*, trans. Helga Harrison), 1981.

Pissarrro, Camille, *Lettres à Lucien*, ed. J. Rewald, Paris, 1950.

Pissarro, Camille, *Correspondence*, ed. J. Bailly-Herzberg, Vol. I, 1865–1885 Paris, 1980; Vol. II, 1886–1, 1886–1890, 1986; III, *1891–1894*, 1988.

Provost, Louis (ed. Elizabeth C. Childs). *Honoré Daumier. A Thematic Guide to the Oeuvre*, New York and London, 1989.

Roger-Marx, Claude, *Daumier*, Paris, 1969.

Schulkind, Eugene, *The Paris Commune of 1871*, London, The Historical Association, 1971.

Sensier, Alfred, *Souvenirs sur Théodore Rousseau*, Paris, 1872.

Sensier, Alfred, *La Vie et l'oeuvre de J.-F. Millet*, Paris, 1881.

Serullaz, Maurice, et al., *Donations Claude Roger-Marx* [au Musée du Louvre], Paris, 1980.

Silvestre, Théophile, *Histoire des Artistes Vivantes*, Paris, 1856. (Ten essays on Ingres, Delacroix, Corot, Chenevard, Decamps, Barye, Diaz, Courbet, Préault and Rude respectively.)

Silvestre, Théophile, *Les Artistes français*, Paris, 1878. (A new edition of the 1856 book, with material rearranged, new chapter on Horace Vernet. This was to be the 'first series'. A 'second series', never achieved, was to include Daumier, David d'Angers, Delaroche, the two Devièras, Dupré, Jeanron, Rousseau and Troyon.)

Silvestre, Théophile, *Les Artistes français*, Paris. 1926. (Two vols, enlarged edition ed. Elie Faure. Includes a partial recovery of elements intended for Silvestre's second volume, with essays on Millet, from *Figaro* April–May 1867, and on Rousseau, from *Figaro* 15 Jan. 1868.)

Soullié, L., *Les Grands Peintres aux ventes publiques, Jean-François Millet*, Paris, 1900.

Sterling, Charles (Éd.), *Daumier: Peintures, Aquarelles, Dessins* (Exhibition), Paris (Orangerie), 1934.

Sutton, Denys, *J.-F. Millet* (Exhibition), London (Wildenstein's), 1969.

Thoré, Théophile and Thoré-Burger: see *Burger*.

Venturi, Leonello, *Les Archives de l'Impressionisme*, 2 vols, Paris, 1939. (Includes a fully edited edition of the *Mémoires* of Paul Durand-Ruel.)

Vincent, Howard P., *Daumier and His World*, Evanston, Northwestern University Press, 1968.

Wassermann, Jeanne L., et al., *Daumier Sculpture: a Critical and Comparative Study* (Exhibition), Fogg Art Museum, Harvard University, 1969.

Wechsler, Judith, *A Human Comedy. Physiognomy and Caricature in 19th-Century Paris*, London and Chicago, 1982.

INDEX